The Expert versus the Object

The Expert versus the Object

Judging Fakes and False Attributions in the Visual Arts

EDITED BY

Ronald D. Spencer

OXFORD
UNIVERSITY PRESS

2004

OXFORD
UNIVERSITY PRESS

Oxford New York
Auckland Bangkok Buenos Aires Cape Town Chennai
Dar es Salaam Delhi Hong Kong Istanbul Karachi Kolkata
Kuala Lumpur Madrid Melbourne Mexico City Mumbai Nairobi
São Paulo Shanghai Taipei Tokyo Toronto

Published by Oxford University Press, Inc.
198 Madison Avenue, New York, New York, 10016

www.oup.com

Oxford is a registered trademark of Oxford University Press

Library of Congress Cataloging-in-Publication Data
The expert versus the object : judging fakes and false attributions
in the visual arts / edited by Ronald D. Spencer.
 p. cm.
Includes bibliographical references and index.
ISBN 978-0-19-514735-3
1. Art—Forgeries. 2. Art—Expertising. 3. Law and art.
I. Spencer, Ronald D.
N8790 .E86 2004
702'.8'7—dc22 2003023348

Acknowledgments

. . .

I wish to thank my friend Charles C. Bergman, Chairman of the Pollock-Krasner Foundation, for his generous support and warm encouragement.

It would have been much more difficult to produce this book without the superb editing skills of Sheila Schwartz.

Thanks too, to the individual contributors who freely gave the time, energy and expertise to advance scholarship.

I also wish to thank my wife, Janet, for the time and effort she invested in this project and my son, George, and daughter, Amanda, for their interest and help.

Contents

· · ·

Foreword

. . .

Eugene Victor Thaw

. . .

The problem of attributions for works of art poses a curious paradox. It can be a very complex issue involving questions of ethics, connoisseurship, and even politics. On the other hand, it is the simplest matter one can face—a work is either genuine or fake, either by the artist in question or not by him or her. This book is an attempt to answer the question "How do you know?"

The Hermitage in St. Petersburg displays two paintings by Leonardo da Vinci, only one of which is considered his own work by a consensus of scholars in the field (the *Benois Madonna*). The other is probably by Giovanni Antonio Boltraffio or some other painter in Leonardo's circle. It is too politically sensitive to challenge the attribution officially in Russia, so hordes of tourists see the two Leonardos they have been promised.

One of the key scholarly tools for judging the authenticity of paintings and drawings by well-known artists is the catalogue raisonné. Usually written by a respected scholar who has spent a lifetime studying an artist's work, these catalogues are often extensively reviewed and picked apart by other qualified experts, and become respected for their accuracy or notorious for their mistakes and unreliability.

In Europe, where heirs of an artist usually inherit the so-called *droit moral*, which includes a legal right to declare authentic or denounce as spurious any work purporting to have been made by their deceased relative, numerous tales of fraud are told whereby these heirs certify and promote for sale pieces which are later demoted, sometimes with the unwitting collaboration of the artist's primary dealer. André Derain and Fernand Léger are two artists to whom this has happened, to the detriment of their posthumous reputations.

In the case of Old Master paintings and drawings, the old-fashioned mechanism of authentication was a written "certificate" from an academic authority. Before World War II, so abused was this tradition that it became a source of essential income for grossly underpaid professors. No one but the naïve believed in these "certificates," usually written in ambiguous phrases, unless

the authority also published the work in a book or scholarly article, where his reputation was at stake. Famously, it was thought in the trade that the more certificates a painting had, the less it was likely to be authentic.

Where does the truth lie in the complex world of art objects given very high values and status by our general culture, but often not yet included in a catalogue raisonné, or included in one deemed unreliable, or caught between certificates from some authorities and denials by others. Labels on the backs of stretchers or panels showing exhibition provenance can be lost or can themselves be faked. Histories of ownership can be invented and are often impossible to check. Yet a process does exist in this highly charged, market-driven world where a Yes rather than a No can mean a difference of millions of dollars. For this reason, a consensus must develop over time about the rightness of one side or the other. Because the players in the market must risk their own large investments and because, having made costly errors, they are wiser and more experienced, the art market is the most efficient mechanism over time for sifting the real from the fraudulent or misattributed.

But before this sifting can occur, many stages need to be passed through and many reputations hung out to dry; in the process, many less experienced collectors may have their egos and their bank accounts badly hurt. Additionally, that perennial question asked in college philosophy and aesthetics courses—"If experts can't tell the difference, isn't the fake just as good as the real work of art?"—must be answered or in some way be disposed of.

All this is obviously more complicated than I have made it, and this book, with contributions from serious people whose lives are devoted to studying these questions, will, it is hoped, provide some wisdom and some useful answers.

Introduction

. . .

Ronald D. Spencer

. . .

The authenticity of a work of visual art has always been a critical issue for anyone concerned with art, not simply for the work's monetary value, but for its intrinsic worth. *Authentication* is the process by which art experts—academic or independent art historians, museum or collection curators, art dealers, or auction house experts—attribute a work of visual art (the Object) to a particular artist or specific culture or era.

The "objects" with which this book is concerned are works of visual art—paintings, drawings, and sculpture, although many of the general concepts, and certainly the emphasis on the importance of connoisseurship and the need for systematic authentication procedures, will be applicable as well to other objects, such as archaeological objects, decorative arts, and antiques.[1]

Since the process of authentication of visual art depends chiefly on the scholarship of art experts, it is especially important that the experts feel free to express scholarly opinions about the attribution of works of art. The art-minded public, unfamiliar with the attribution process, may regard it with a measure of suspicion or may put too much trust in it, believing that attributions are made and fakes disclosed as a result of scientific evidence. In fact, few are based on scientific tests; the majority are based on the connoisseurship of an expert. And here, the natural wariness about the subjectivity of an individual opinion may be compounded by numerous examples of shifts in the status of a single work—a work removed from the canonic oeuvre of an artist by a group of experts (e.g., the Rembrandt Research Project) and then, a few years later, reattributed to the same artist by the same experts.

If the art-minded public does not have a clear idea of the attribution process, it is largely because the experts have rarely articulated it in a systematic way. And why this paucity of expert explanation? Chiefly because of the experts' fear of legal liability. If you doubt this, think, for example, about the thousands of artworks that public museums acquire each year, and think, too, why one never (or rarely) sees an expert publicly challenge the authenticity

of a work on which an institution is spending millions of dollars. Why, for instance, are there are no false attribution sections in almost all catalogues raisonnés? Why are owners of an artwork usually told only whether it "will" or "will not" be "included in the catalogue" raisonné of the artist in question. And why do most American museums have policies which prohibit their curators from expressing opinions on works of art not already owned by the museum?

The question of whether a work of art is "real" or "original" implies other questions: What am I buying? What do I own? What am I looking at? And, increasingly, perhaps due in some small part to higher prices, but in larger part to the growing sophistication of the art-minded public as a result of exhibitions such as the Metropolitan Museum's 1995 "Rembrandt/Not Rembrandt," people are beginning to ask how a given attribution was arrived at. The question may be answered at several moments—when art is bought and sold in a private transaction or at public auction, when art is appraised for its value for an income or estate tax deduction, when museums and art galleries mount public exhibitions, when a scholar produces a book on the work of an artist, or simply when an owner wishes to determine the authorship or authenticity of a work.

Even as public awareness of and demand for opinions on the authenticity of art is increasing, fewer experts are willing to render these opinions for fear of being sued by a seller, buyer, or owner. This circumstance is aggravated because an art scholar authenticating a work may not ethically charge a fee related to the value of the art. For a $500 fee, why should the expert risk a million-dollar lawsuit for product disparagement or negligence? It should also be understood that, in much the same way that court decisions awarding damages for medical malpractice influence how doctors practice medicine, court decisions holding experts liable for negligent opinions with respect to attribution affect how (and indeed if) experts will provide their expertise and opinions for the benefit of the art market and the general public.

These conditions have led groups of art scholars to form boards or committees in part to defend and ensure against these potential legal claims. This attempt is bound to be only partly successful, largely because the law demands objective evidence, which conflicts with the intrinsic "subjectivity" of even group connoisseurship.

It is not just experts, art dealers, and lawyers who are interested in authentication. The public has always been fascinated to see a shrewd art forger one-up rich collectors and pompous experts, especially in the case of twentieth-century art. Here many museum goers still feel that they are being taken for a ride. Standing before an abstract or minimalist painting, they think, "My kid could do that, or better." Even this dubious visitor would, however, accept objective scientific evidence about the authenticity of a work. But, alas, when

we examine the process of attribution, we find very few decisions supported by science. Instead, as we will find in this book, we are, in the vast majority of cases, drawn back to those "pompous" experts and connoisseurs.

The public's lack of understanding of the attribution process and the experts' concern about legal liability for expressing their opinions have combined to produce fertile ground in which fakes and false attributions flourish. And the concern over legal liability has been intensified by several unfortunate court decisions in which the courts did not fully comprehend the attribution process or the expert's role.

Thus, freedom of scholarly opinion requires an understanding of the attribution process on the part of the courts and of lawyers, and would benefit from increased public awareness of the process.

Part I, "Authentication and Connoisseurship," illuminates the process through essays and interviews based on the practical experience of art world experts. Each author addresses attribution issues involving his or her particular professional concerns, an approach that presents a wide variety of professional and institutional interests.

The essays begin with an examination of the nature and history of connoisseurship. By *connoisseurship* we mean that sensitivity of visual perception, historical training, technical awareness, and empirical experience needed by the expert to attribute the object. Francis O'Connor and Peter Sutton agree on the primacy of connoisseurship in the attribution process, with the former focusing on the nature of connoisseurship and the latter on its historical development as a bona fide analytic tool. They also agree on its essentially "objective" nature.

The 1942 essay about fakes by Max Friedländer is, in part, here to remind the reader that a fake—a work created with *intent to deceive*—is but one facet of authenticity issues.[2] The larger, more important, and much more frequent problem is the examination of a work of unknown or wrongly attributed authorship.

The application of connoisseurship to an artist's entire body of work will often result in the catalogue raisonné—the principal published research document on the artist's work. In their essays on the catalogue raisonné, John Tancock, Michael Findlay, and Peter Kraus agree on the primacy of the catalogue raisonné as a research tool, and agree as well on many of the considerations which make certain catalogues unreliable. Tancock and Findlay allow the reader to see how the two major public auction houses, Sotheby's and Christie's, utilize (or do not utilize) a catalogue raisonné in the auction sale cataloguing process.

While the catalogues referred to in these essays represent the opinions of a single expert (or, at most, two or three coauthors), Eugene Victor Thaw discusses the operation of the art world and art market, as a whole, in self-

correcting misattributions. Thaw reveals how art historians, curators, art dealers, conservators, auction house experts, and collectors come, over time, to a consensus (which may change as a result of new research and analysis) about the attribution of a work of art. How this process operates in the field of Old Master drawings is the subject of the essay by Noël Annesley, an Old Master drawings expert. Through describing the analytical method by which he attributes an Old Master drawing, Annesley explains his part in the market's "self-correction."

To the layman, a signature on a painting might appear to be important evidence of authorship. In fact, it tends to be nowhere near as important to the expert as our everyday contact with bank checks, receipts, wills, deeds, and contracts would suggest. However, signatures remain important to judges in courts, and so Patricia Siegel, a handwriting expert, shows how she decides on the authenticity of an artist's signature (Jackson Pollock, in this example).

It is also important to understand how organizations and groups of experts (foundations, boards or committees of experts, as opposed to individual experts) operate in the determination of authenticity. Sharon Flescher describes the workings of the International Foundation for Art Research, although IFAR is somewhat atypical of these groups because it undertakes research on more than one artist. But, with respect to each artist, IFAR's process is rather typical in that it employs a group of experts who arrive at an opinion on attribution by consensus.

Another organization concerned with issues of authenticity and attribution is obviously the art museum. Samuel Sachs II, former director of the Frick Collection, agrees with O'Connor and other essayists in this book on the primacy of provenance and connoisseurship in determining authenticity, and on the relatively small value of signatures in this process. But there are other criteria at work in a museum. Obviously it is important not to hold out a fake as authentic; but more important than the matter of attribution (that is, who created the work) is whether the work of art is of "consummate quality."

If connoisseurship is primarily concerned with articulating visual perceptions, conservators bring to the attribution process a fairly single-minded concern with the physical structure of a work. Rustin Levinson, a conservator, describes how an examination of the physical structure of a painting can help attribute the authorship of traditional works of art. With respect to contemporary art, conservators face new challenges from artists who, in recent decades, use a variety of eccentric and often impermanent materials. The conservation of such non-traditional materials, as Levenson demonstrates in her second essay, becomes increasingly complex, both in terms of physical procedures and philosophical issues, all of which have important ramifications for attributing works of art.

While part I of this book illuminates the nature of authentication and con-

noisseurship, part II, "Authentication and Law," attempts to help the reader understand how the law resolves disputes over issues of attribution. The essays in part II should help to establish the objective and systematic standards necessary to defend, at law, art scholarship and subjective judgments about art. To this end, Theodore Stebbins, Jr., addresses the liability of art experts in law courts from the late nineteenth century to the present day. Stebbins also examines the practical methods and procedures used by art experts today, and the effect of these procedures on their potential liability for rendering an opinion on authenticity. The essays in part II deal as well with the kinds of legal claims made as a result of an attribution, and the question of whether the expert's determination, self-described as only an "opinion," gives the expert protection from legal claims (Ronald D. Spencer, "The Risk of Legal Liability for Attributions of Visual Art").

Factors which judges consider important and proposed procedures for experts to follow that would limit their liability are covered in my essay, "Authentication in Court: Factors Considered and Standards Proposed." Newly available legal protections for experts rendering opinions (such as "hold-harmless" provisions in agreements between owners of art and the experts) is the subject of my essay, "A Legal Decision in New York Gives Experts Protection. . . ." Last, French law and its complicating factor of artists' (and their heirs') moral right to attribute the artist's work is discussed by Van Kirk Reeves in "Establishing Authenticity in French Law."

One goal of this book is to help lawyers advise their clients and judges to arrive at more informed decisions (informed, that is, by a better understanding of the nature of the attribution process and its practical consequences for art scholarship and the art market). When judges and private legal advisers know something more about the "industry," a knowledge which seems quite lacking in some of the judicial decisions discussed in this book, decisions are more likely to be fair to litigants and legal advice more useful to art world participants. The essays in part I describing the process of attribution and examining the history, nature, and practical application of authentication and connoisseurship are intended to provide the legal community with just such industry knowledge.

At this point the reader may well be asking why, and to whom, authenticity in the visual arts is important. As will be seen, there has been, and continues to be, an intrinsic conflict between the subjectivity of the expert's connoisseurship and the objectivity of the law, which demands clear and compelling evidence. It is said of James McNeill Whistler that when someone showed him an alleged Velázquez, he dismissed it after a glance, and when its owner protested his curtness, he declared, "I always swoon when I see a Velázquez." One of the contributors to this book of essays can deeply sympathize with Whistler. Not that Francis O'Connor faints at the sight of a Jack-

son Pollock painting, but he knows that recognizing a copy, a mistaken attribution, or a fake comes from a lifetime of empirical experience with an artist's oeuvre. With such experience, you can perceive the wrongness of a work as quickly as you could a forgery of your own signature. But proving such immediate, visual perceptions in court is, alas, not easy.

The essential points here are two. First, as it is argued, expressly in some essays (O'Connor and Sutton) and implicitly in others, that the connoisseur's perception of an artist's form, or distinct manner, is not dissimilar from other types of "objective" evidence accepted by a court, such as handwriting analysis and forensic pathology—both of which are based on the formal characteristics of phenomena. Second, the expert must take a more systematic, organized, and careful approach to the authentication process, so subjective judgment can be supported by rational and physical analysis of the art object. Inherent, of course, in such a coherent system is that the authentication process is based on experts with no self-interest in the object in question, and not, as was common in late nineteenth- and early twentieth-century Europe, on an opinion stated in a certificate for which a substantial fee, linked directly to a positive opinion, was received or promised.

In establishing these two points, it is hoped that this book will be of use to a wide range of individuals for whom a coherent system of authenticating works of art is important, if not crucial, in their professional lives. Artists and their estates have a very real interest in defending themselves against forgeries and misattributions; dealers, collectors, scholars, curators, and auctioneers all need to know with some modicum of certainty that what they sell or re-sell, acquire, study, or exhibit is authentic.

It may be useful to detail the value of the essays to each of these interested parties.

For artists and their heirs, an active production of fakes may well prove a negative form of flattery, but it is hardly a distinction to be sought or tolerated: it devalues the real works from the artist's hand, distorting their aesthetic and economic appreciation. This has happened with a vengeance in the realm of Salvador Dalí's prints. On another level, unauthorized reproductions of an artist's work leave the artist the loser when it comes to royalties and reputation. Here, Robert Indiana's widely reproduced *LOVE* image is a notorious example. Artists and their heirs, therefore, have to fight inauthenticity on two fronts: the first, that of mistaken attributions or outright forgeries, and the second, that of intellectual property rights violations.

Dealers are often required both morally and legally to certify the authenticity of the objects they sell, so the need to establish the rightness of their wares is paramount. Both their reputations and their economic well-being require a system of authentication that is authentic in itself, being free of all questionable self-interest and recognizable as authoritative. At present, it is of-

ten the case that a dealer cannot find a recognized authority willing, even if able, to give an opinion as to the authenticity of an object because a negative opinion is too vulnerable to a lawsuit. This problem is complicated by the fact that some dishonest dealers are all too willing to pay for wildly inaccurate positive authentications, which are relatively invulnerable to challenge by knowledgeable experts for the same reason—they dare not speak out for fear of risking litigation. This book spells out the rights, duties, and vulnerabilities of art dealers faced with authentication problems, and the legal and commercial remedies available to protect them, their artists, and their clients from the consequences of fakery and misattribution in the art market.

Collectors, obviously, have a right to expect that what they buy is authentic, just as any consumer ought to be able to trust the label on a watch or a scarf. But truth in labeling does not always pertain to what changes hands in the present-day art world, leaving inexperienced collectors especially vulnerable to fakes and misattributions. Here, the collector has some obligation to perform "due diligence" before any major purchase, making sure to see such things as a complete provenance and an authoritative publication history for the object (although, as a practical matter, this information is probably not available for a large percentage of lesser works). It is hoped that the wealth of information in this book will help the fledgling as well as the experienced collector avoid the acquisition of inauthentic objects.

Scholars are perhaps the most vulnerable to the present lack of clear-cut standards and procedures for authenticating works of art. They are on the front line of defense against fakes and misattributions, especially those scholars who undertake a monographic study of an artist, or who author a catalogue raisonné of the artist's work. It is scholars who most often become the recognized authorities to whom everyone else turns for informed opinions, and until early in the twentieth century, they were able to give such opinions without inhibition.[3] However, because of concern for legal liability, they are no longer able to do so as freely as in the past. Further, since scholars are seldom economically independent, they are most vulnerable to the threat of litigation. Many oeuvre catalogues are stalled because of the consequences of listing known fakes, or omitting them, which is pretty much saying the same thing. One practical result of this book might be a change in the views of judges in future court decisions about expert opinion, so that those best qualified can make judgments on authenticity without undue concern for being ruined in the process.

Museum curators are very much in the same vulnerable situation as scholars, although somewhat more protected by their institutions. Whether to include a work deemed inauthentic in an exhibition can, however, have ramifications quite different from those faced by the scholar. If you want a certain collector to leave your museum his Picasso, do you overlook the dubious

Utrillo being pressed upon you for a current exhibition? When a certain Old Master painting suddenly appears at auction from the collection of a very famous connoisseur, how do you judge, under the pressure of the connoisseur's reputation, the conflicting opinions of experts that the painting may be (a) authentic but heavily restored; (b) the artist's copy; (c) an assistant's copy; (d) a seventeenth-century copy; (e) something more recent?

Similarly, what does the auctioneer do when required to warrant the authenticity of the same painting when it is sold, and be ready to give back the money if the buyer later balks when the conflicting opinions of experts are reported in the newspapers? Since auctioneers tend to see a greater variety of works, as well as greater numbers of dubious works, than other art world professionals, they are more dependent on reliable in-house and outside expert opinion, and more vulnerable to litigation of all sorts. Here again, it is hoped that the experts in auction houses can learn from this book.

Finally, these essays will demonstrate, despite our intuitive suspicion that art and the law do not comfortably coexist, that there is as much human empathy inherent in the formulation of a body of law as there is in the creation of a work of art. Both attempt to express, through either images or actions, a respect for what is true and real, and a rejection of what is not. It is our hope that this compilation of ideas will further that respect.

Notes

1. For a study of these other objects, see Mark Jones, *Why Fakes Matter: Essays on Problems of Authenticity* (London: British Museum Press, 1992).
2. For a study exclusively on the subject of fakes in the visual arts, see the work of Friedländer's younger contemporary, Otto Kurz, *Fakes*, 2nd rev. and enl. ed. (New York: Dover, 1967).
3. See Sir Joseph Duveen's difficulties in the 1929 case of *Hahn v. Duveen*, addressed in part II of this book.

Part I

...

Authentication and Connoisseurship

...

Authenticating the Attribution of Art

Connoisseurship and the Law in the Judging of Forgeries, Copies, and False Attributions

. . .

Francis V. O'Connor

. . .

*Francis V. O'Connor discusses the three major tools utilized by experts in determining the authenticity of a work of art—historical documentation or provenance, scientific analysis, and visual inspection by a knowing eye or connoisseur. Of these three, connoisseurship, as the author articulates the process, remains primary.—*RDS

. . .

FRANCIS V. O'CONNOR is an independent historian of American art who has published extensively on Jackson Pollock and Abstract Expressionism, New Deal art patronage programs, the American mural, and the psychology of creativity. Between 1973 and 1978, he edited, with Eugene V. Thaw, *Jackson Pollock: A Catalogue Raisonné of Paintings, Drawings, and Other Works*, and in 1995 edited *Supplement Number One* to that catalogue.

. . .

It is unlikely that the many millions of commuters who pass beneath Grand Central Station's famous "Sky Ceiling" every year are aware that the depiction of the ceiling's constellations is an inauthentic work of art.[1] Designed by the French muralist Paul Helleu (1859–1927) and painted in 1913, it was "restored" in 1945 by pasting grossly conspicuous asbestos panels over the original, then crudely copying the outline of the various zodiacal figures upon them. Fifty years later, New York's Metropolitan Transit Authority, in an otherwise commendable restoration of the entire station, spent millions of dollars to clean the fake ceiling rather than a few more to reveal the aesthetically superior original underneath. Their argument? New Yorkers were used to

the copy, so why restore the admittedly better original at greater expense? This is a typically American response to the matter of authenticity. While we would condemn a politician caught in a verbal lie, however artful, visual lies in art are somehow forgivable as a matter of public policy.

America's earliest and most prophetic critic, Alexis de Tocqueville, noticed this trait of character upon his arrival in America in 1831, when he saw along the shores of Long Island Sound a number of impressive dwellings, not a few aping the style of Greek temples. Upon closer inspection, he discovered they were constructed of whitewashed brick and wood.[2] Indeed, when teaching art history at the University of Maryland in College Park 160 years later, I could always get the students interested in the arcana of the Greek orders by first making them notice the pillars of the university's buildings: what the Greeks carved in marble, the state of Maryland had franchised out to a maker of wooden barrels. After that, fluting, capitals, and especially entasis—that subtle curvature of the drum of a classical column—were indelibly imprinted on young minds by noting the various ways the pillars' slats warped!

A people still rooted in colonial habits of mind, Americans create practical illusions of grandeur when the authentic reality is beyond our grasp— or interest. If we can't afford to live in a palace with a rusticated granite exterior, carved marble walls, coffered ceilings, and terrazzo floors, then rock-face, embossed wallpaper, tin ceilings, and linoleum will do. So long as they look trim and exclude the weather, the authenticity of materials is secondary. Given such an ingrained pragmatism—consider all those "homemade" pasta sauces that come ready-made in jars (or, for that matter, the refabrication of Marcel Duchamp's Ready-mades, which have had such an influence on our art and culture[3])—it is difficult to get Americans to worry overmuch about truth in art.

If you doubt that, think of the sale in 1995, by the U.S. Postal Service, of some 12,000 fake prints by Salvador Dalí and 1,400 other dubious works, recovered during the breakup of a Honolulu forgery ring. While most of the prints are marked as fakes, the marking was apparently so discreet that they were still marketable. A judge had ordered the sale of the fakes so that the forgers could pay the fines they were otherwise unable to afford. Further, only one member of the Art Dealers Association of America was willing to testify for the prosecution.[4] This incident not only underlines the point that the circulation of fake visual art does not seem very important, but also reveals the reluctance of art professionals to get involved in what has become the very awkward and dangerous task of authentication.

It used to be that an "original" work of art was understood to have been created by the artist, its originality proved with documents, signatures, and the informed opinion of experts. Copies and fakes of the original were distinguished by the signature—whether the contrivers signed their own names

or forged that of the artist. More recently, there has been a disturbing tendency to denigrate the authority of both artist and expert, to confuse truth with dogma, and to treat all created objects as "texts" which can be used as pretexts for new texts based on the free associations of their relativistic authors. Scholars balk at "privileging" the elitist hand of the artist over the exploitable "text" created thereby, and would probably consider rockface and linoleum more "democratic" than pricier stuffs—and fuss over their relative authenticity. Taken to extremes, such a point of view denies the objectivity of historical truth, and would deem a fake to be as culturally significant as an authentic object. Thus our present academic colonialism begs the question: What's the difference?

. . .

Aside from the moral and ethical dimensions of authenticity, rooted as they are in the integrity of an artist's oeuvre and in how we understand the past through its artifacts, there is the simple public expectation and legal requirement that what is for sale be what it is claimed to be. We hardly want our Perrier bottles filled with carbonated tap water, our jeans distinguished by forged designer labels, or our Rolexes stamped out in Brooklyn. We want truth in advertising. Thus, in New York State, an art gallery or auction house must certify what it sells as authentic, and that statement is most often based on the consensus of scholars expert in the object's creator or era. Similarly, curators in museums have a moral obligation to the public, and to history, to show art whose authenticity is based on the same criteria, and to label doubtful works as such. Scholars cataloguing the work of an artist have a similar obligation to exclude or to identify forgeries, copies, and false attributions. Yet these acts of simple integrity grow more and more difficult to perform.

An art dealer faced today with a fake Impressionist painting offered for sale with a certificate from the artist's great-granddaughter, who has inherited in France the *droit moral*, the absolute right to authenticate her ancestor's work, is confronted with a double dilemma: having to conradict an opinion that is legally valid in another country, and to deal with American libel laws under which he can be accused both of defaming the work's owner and disparaging the work's value. Similarly, if an auction house, curator, or scholar refuses to include such an object in a sale, exhibition, or catalogue, or dares to declare or publish it as unauthentic, the same risks are incurred—sometimes with serious consequences for the individual or institution involved.

Consider the case of Gary Tinterow, the Metropolitan Museum of Art's curator of European paintings. He was one of four people or institutions sued for, among other reasons, excluding a painting attributed to Georges Seurat (by the great Impressionist scholar, the late John Rewald) from a 1993 exhibition of the artist's works on the grounds that it was not authentic. Since the

owners could no longer sell the work privately or at auction, they sought damages.[5]

Situations such as this have led to a state of affairs in the art world in which it is virtually impossible to openly evaluate the authenticity of works of art, and in which the informed opinion of an expert is no longer either respected or protected. The reasons for this state of affairs are complex, but they center on a growing lack of confidence in seemingly subjective expert opinion concerning art, and the parallel lack of consistent procedures for applying such expertise.

. . .

The art historian has traditionally had three major tools for determining the authenticity of a work of art, which can be listed in the order of their seeming capacity for "truth": scientific analysis, historical documentation, and visual inspection by a knowing eye—or connoisseur. Since the ability of the connoisseur to perceive the rightness of a work usually precedes the need for the lab or the archive, the idea of connoisseurship is crucial to the whole matter of authenticity—and is the most difficult for the layperson to understand.

Once, viewing a photograph of a Jackson Pollock drawing on heavily textured rag paper, I questioned its authenticity: the signature and overall appearance seemed oddly askew despite the work's impeccable history back to the artist and the distinction and probity of the collector who owned it. Later, when the original was seen from across a room, it was obviously right—but it fell apart when closely inspected. Documentation revealed the problem: the work had been inexpertly mounted; the irregular surface of the rag paper had been crushed, causing the original facture, including the signature, to be pressed aside a fraction of an inch. From afar, Pollock's singularity of form sang out; up close it was a micro ruin, like stomped moss.

That first practical application of connoisseurship taught me that the ability to recognize the *form* of an artist, those complex characteristics identifying a particular artist's unique way of making an image, is crucial to the authentication process; documentation and technical information are of secondary importance—or so one thought.

Historically, this sense of an artist's form was established in the later nineteenth century by the Italian doctor of natural science, Giovanni Morelli. He noticed that artists working within rigid stylistic and iconographic traditions could nevertheless be distinguished from each other by the way they painted an ear or a fingernail—details in which imposed convention gave way to the singularity of the artist's personal observation. Practically, it is what anyone can see immediately when viewing his or her signature forged on a check or document—and yet it is difficult to articulate. This is not a Giotto, you confidently state. That is not my signature, you insist. But why isn't it? Prove

it to a judge and jury! The latter situation—alas, all too prevalent today—is harder than one might imagine, given the elusiveness of an artist's form and the means by which it is made manifest.

. . .

Authenticating a work of fine art is a method of judgment based on an informed perception and interpretation of the form and the facture specific to the artist who created it. It is analogous to methods used by other professionals—methods that are often accepted as systematic and scientific.

Handwriting analysts, for instance, when judging the authenticity of a signature, look to its formal characteristics—the shape of its letters, their angle in respect to a baseline, their loopings above and below that line, and others—in comparison with an authentic signature. They can see, on the basis of matured experience in perceiving such matters, that the forged signature is lacking in the salient characteristics of the authentic signature. Such expert judgments have long been accepted in courts of law, and such techniques of form perception are even taught, as a dimension of commercial security procedures, to young bank clerks or store salespersons who review checks or credit card slips for fraud.

Authenticating a work of fine art is thus not much different in essence from authenticating a signature—which also is often part of the art authentication process. It is a matter of an informed and experienced perception of form. Such empirical perception is also utilized regularly in professions of a more recognized scientific bent. Forensic pathologists and anthropologists can deduce from a wound or scrap of bone the weapon employed, the age and sex of the victim, or a human or animal provenance—often by visual inspection alone, and without elaborate laboratory testing. Similarly, medical doctors spend years learning the skills of the diagnostician under the supervision of experienced senior nosologists, who demonstrate how the look of a fingernail, or a tongue's pallor, or the droop of an eyelid, or a tiny shadow on an X ray or CAT scan can indicate a symptom's cause or hidden pathology.

Such perception of anomalies in physical form is perhaps best developed among medical psychiatrists and psychotherapists (the latter including psychoanalysts and clinical psychologists), who observe a patient's body English, emotional aura, and linguistic anomalies (which are formal on another level), the better to diagnose mental pathology or neurotic or affective dysfunction. Therapists who have seen hundreds of such patients exhibiting specific behavioral characteristics, can spot a problem instantly in terms of the various formal phenomena it manifests. (Think, for instance, of the personality of someone you know whose shoulders are always up around his or her ears.)

All these experienced perceptions of form would be considered scientific

by most reasonable persons, in the sense that they are based on a studied empiricism and interpreted according to recognized standards and theory.

The art expert, confronted with a painting of questioned authenticity, operates in much the same manner as the professionals just described. He or she has seen hundreds, maybe thousands, of works by the artist in question, and has absorbed into visual memory the artist's characteristic form—shapes, compositional devices, linear rhythms, typical colors, and habits of facture—to the extent that such an expert can tell, at a glance (and often even on the sole basis of a photograph), that the work presented is authentic or fake.

This can seem mysterious, if not laughable, to the layperson, whose education is almost always based on verbal or quantitative, not visual, criteria of meaning. This natural skepticism is compounded when the artist is notorious—as was Pollock, for instance—for his seemingly aleatory technique, alleged disregard of materials, apparent bohemian lifestyle, and fatal drunkenness. Ultimately, however, these personality quirks are irrelevant to the judgment of authenticity.

Also irrelevant to the authentication process is the testimony of any single authority, unless that authority is universally recognized as the sole expert in his or her field. Far more persuasive is the consensus of expertise to be found in a group of scholar-experts who collectively base their judgments of authenticity on a clearly defined process of formal perception that is as systematic and methodical as that of handwriting analysts in judging a signature, or of physicians in judging formal phenomena indicative of trauma, disease, or mental dysfunction.

Just how does the perception of form work?

It is important to stress first off that it has little or nothing to do with subject matter or symbolism, the artist's eccentricities, or the aesthetic quality of an individual object. Form characteristics are more fundamental and essential to the work. For instance, an artist may become famous for painting apples. He dies, and a group of works attributed to him depicting pears are offered for sale. No one has ever seen them before, or has known he painted pears. The art expert who knows his apples would not reject the pears because of their being an anomalous subject, but rather would look carefully to see if the same formal infrastructures this artist used for years painting apples are present in the pears. The point: anyone can achieve a particular subject or symbol; only the artist can paint it his way—and that way is revealed through formal and structural characteristics.

Similarly, an art expert would not reject a work because it was aesthetically flawed—ill-drawn or carelessly painted, or otherwise atypical of the artist's usual standard of excellence—any more than a doctor would refuse to act on a diagnosis of a socially embarrassing disease because the patient was a celebrity or a clergyman. Rather, a judgment would be based on whether the

work, for all its lack of resolution and finesse, nevertheless displayed the fundamental characteristics that inhered in all the artist's work—good, bad, or indifferent.

. . .

The idea of form, crucial for the connoisseur's identification of a visual artist's work, has been corrupted in the parlance of the contemporary art world. Today, the idea of form would seem to have no generally accepted definition. Early thinkers on the subject, such as the German art theorists Adolf von Hildebrand (1847–1921) and Heinrich Wölfflin (1864–1945), understood form in optical, technical, and geocultural terms (the difference, for instance, between the Italian "southern" qualities found in Raphael's classical elegance and Albrecht Dürer's more down-to-earth "northern" German qualities).[6] Later, the art historian Erwin Panofsky's (1892–1968) arguments for iconographic identification and iconological interpretation in effect permitted subject matter in art to eclipse the idea of form.[7] The latter was left to connoisseurs and philosophers of art, on the one hand, and art critics on the other. Thus, between Henri Focillon's deliquescent reasoning concerning the "life of forms in art,"[8] Clive Bell's assertively seductive "significant form,"[9] Albert Barnes's eccentric "plastic form,"[10] and Clement Greenberg's recently "influential "formalism,"[11] the idea of form lost its specificity—and utility.

This conceptual chaos is revealed by "art appreciation" books used in our colleges. Students are taught that form refers to just about everything: to physical qualities as opposed to content, to the inseparability of form and content, to systematic rather than disorderly arrangement, to both physical properties and theoretical concepts, to the total design as opposed to details, to shapes, to style, to Gestalten, and on and on. One cautious (and meaningless) glossary definition reads "Form: The shape, structure, configuration, or essence of something."[12]

Thus, the rich human basis of an artist's singularity of form—Focillon, at least, recognized the "substance of art to be human life itself"—has been reduced to the notion of contriving era-specific formats or styles. Form is not the equivalent of a historic style. Cubism is such a style, but each Cubist had a singular form—even Picasso and Braque at their most similar—which shaped the characteristics and strategies that added up to the imaging of his or her visual temperament. The artist's singular, characteristic form—the "hand," as it were (comparable to the poet's "voice," or those cadences and orchestral colors by which we distinguish one composer from another)—constitutes the primary basis for the connoisseur's determination of authenticity.

In practice, however, form has been confused with "style" (and sometimes with "shape"), and with the long hegemony of modernist "formalist" analy-

sis, has been made part of our current visual thinking by Greenberg and his followers. This method of seeing, employed for reasons of aesthetic validation and interpretive explication rather than for the identification of authorship, has often seemed to reduce the rich human basis of an artist's form to the gross notion of contriving fashionable formats.

Form is not the equivalent of style or shape.

Form is the manner or personal style of the artist that determines the characteristics and strategies which comprise his or her visual temperament.

The artist's form establishes early on an infrastructure that remains relatively constant, and is later elaborated as the artist evolves. It constitutes the foundation for any determination of authenticity.

But form is only the foundation.

Over time, things can happen to authentic works of art that assault their form, distorting the imprint of the artist's "hand." Thus form can be abraded, erased, reconstituted, or even reimagined, as well as honestly or falsely imitated. Such events pose a wide range of dilemmas as to whether or not a specific object is as authentic as when it left the originating hand. This was clearly demonstrated in the 1995 Rembrandt and Goya exhibitions at the Metropolitan Museum of Art.[13]

Both shows underlined a point that cannot be stressed too much: the attribution of art is not an exact science. Both indicated that one of the world's most distinguished museums owns a surprising number of works by two major Old Masters, the attributions of which it is now willing to question— while offering the public a rare opportunity to educate its eye. Obviously, the dealers and collectors who ultimately contributed these dubious holdings did not have access to the technical and archival resources of today's curators and scholars. Nor do such shows, concentrating on Old Masters, touch on all the problems of authentication, especially in the area of recent art. But both pointed to the seriousness of the authentication issue, and helped us see two major artists' work more clearly.

Consider the face-off between the two *Majas on a Balcony* that the Met's Goya show afforded. One, borrowed from a private collection, is indisputably authentic; the other, owned by the Met, is considered most probably a contemporary copy (figures 1.1 and 1.2). Even the least experienced eye could see that the paintings are different, even if that eye was unable to articulate the differences. The real Goya is just under life-size, ominous in subject (two shadowy men behind two gossiping women), dark in its tonalities, and compressed in its design. Its quality of psychological tension and overall menace conform to the same characteristics found in the profusion of Goya's drawings and prints in the exhibition. The Met's version is life-size, brighter, more loosely painted, and almost totally lacking in the intense relationship among the four figures found in the undisputed version. The connoisseur's eye can

find all this summed up in two telling details: the way a black mantilla is painted in both, and the contrast between the handling of the balcony railing.

The black veil in the Goya, while not a trompe l'oeil rendering, suggests the specificity of lace in its brushwork. This is totally lacking in the Met's painting, where Goya's suggestion of tightly intertwined threads (a microcosm of the four intertwined figures that fill the composition) is reduced to a mere conflation of undeft smudgings. Similarly, the railing in the Goya, painted over the completed gowns of the women, consists of seven balusters slightly tilted to the left to emphasize the conversational relation between the two women, the center baluster providing an axis for this and the dark figures in the background. The Met's railing, aside from being painted directly on the canvas along with the gowns, consists of ten balusters (and thus left a hole in the middle; only odd numbers have centers), is perfectly aligned, and does nothing for the rest of the composition, which is flaccid and without tension of any kind. In short, Goya's form can be characterized as a studied disequilibration of a dark, sinister, spatially locationless world. Indeed, as in many of the other paintings and drawings to be seen nearby, one of its salient characteristics is the placement in spatial voids of subjects composed on the bias. Note that the railing does not connect to any architecture, nor does the background denote a specific place. This attracting of tensions between essentially isolated motifs—here even to the extent of tilting the world to emphasize this sardonic taste for instability within a narrativeless context—is the essence of Goya's form. The Met's painting, in comparison (and granting the hand of later restorers), becomes, in contrast, just another pretty picture. (For another face-off, see the appendix.)

. . .

Such perceptions raise a second matter of importance in understanding both the concept of an artist's form and the process of authentication: the artist's facture. This refers, literally, to how the artist manu-*factur*-ed the work—to how the hand makes the work. Facture, then, is *the way the artist's hand expresses its possessor's temperament.*

The art dealer and connoisseur Eugene Thaw has often pointed out that the two artists most difficult to fake are Piet Mondrian and Pollock. Why? Because their highly personal and complicated facture at first seems all too easy to emulate, especially if you are looking at reproductions—which flatten the surface dimensionality of their work and erase any sense of the facture's often varying reflectivity. In a characteristic Mondrian, the black grids that determine the elegant compositions of his most typical works almost all have the reflective sheen of varnish. Technically, this is to retain the black as a "color," and to avoid reducing the grids to dull, sunken dividers. They also

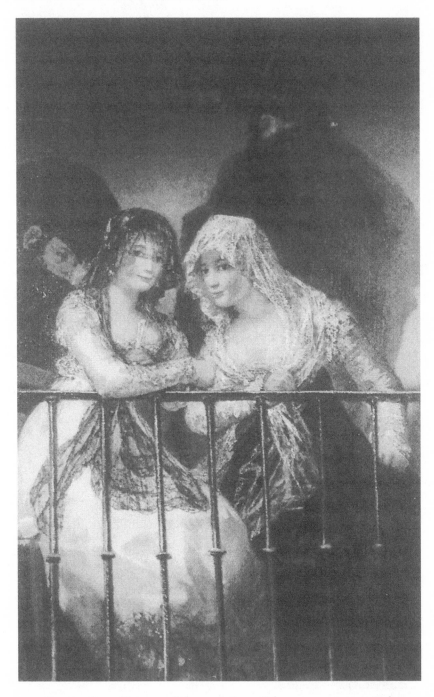

1.1 Franciso Goya, *Majas on a Balcony*, 1808–12. Oil on canvas, 63 × 42 inches. Private collection.

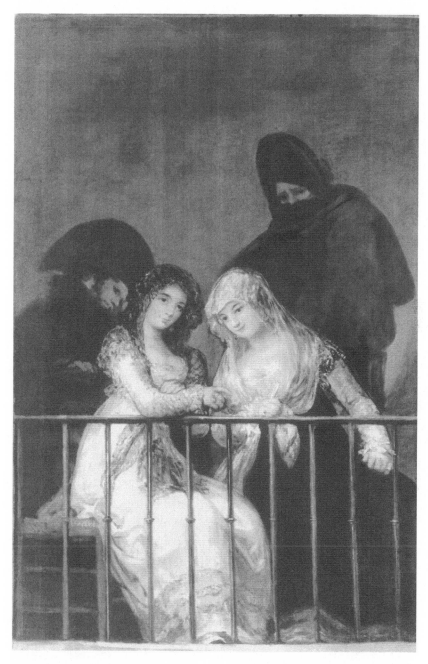

1.2 Francisco Goya (?), *Majas on a Balcony*. Oil on canvas, 76 × 49 inches. The Metropolitan Museum of Art, H.O. Havemeyer Collection. Bequest of Mrs. H.O. Havemeyer, 1929. (29.100.10).

are painted separately from the rectangles they frame, which are carefully filled in with various tones of white, gray, or the three primary colors, each laid down with mostly horizontal brushstrokes. The paint in the rectangles is usually but not always matte in comparison to the lines. There is also a lot of painterly "edge" at the meetings of the glossy black grids and the filled-in rectangles, which is most often the result of the brush carefully following the lines (and not tape, which Mondrian used only at the end of his career). In many cases, there is a slight, unpainted space between the two. In short, close inspection reveals how carefully and consistently the artist painted these works. Reproductions obliterate most of this distinctive and quite dimensional facture, leaving only the overall grid design and the colors. The typical forger would think of perfectly flat areas all neatly joined, as one might do today with acrylics. As with the "Vermeers" of Hans van Meegeren, discussed below, the style of the time often is of greater influence on the forger than that of the artist forged; experienced eyes can instantly catch such misconceptions.

While both the surface texture and the composition of a Pollock are more complex than those of a Mondrian, on the level of facture the same inimitable dimensionality prevails. The various strata of paint poured out on the ground can normally be visually distinguished. In this it is well to remember that while paintings are crafted from the bottom up—from the support to the upper surface—most often only the top is left to be seen. With Pollock, on the other hand, and in contrast to Mondrian's crafted geometries, one can usually reconstruct the entire process of creation by examining his normally centric works from the edges to the middle. Parallel to this is a certain transparency: one can almost always see down through the layerings of paint to the ground at some place in the work. Further, visual elements are countered or set in contention upon the top visual plane as well as the underlying pourings. This is often augmented by a processive progression, since Pollock's linear facture is set out on the canvas like handwriting and, especially in the larger works, its most visible surface delineations progress from left to right, as if written out. Often the address to the left edge is markedly different from that to the right—where the ground runs out and there are signs of abruptness and possible frustration. Finally, there is a calculated reflectivity far more complex than Mondrian's glossy black lines. Pollock often used together paints that dry in different finishes—matte, gloss, and with a metallic sheen—which carefully enlivens the visual field to produce spatial dynamics that would be impossible with just one finish.

Unifying this characteristic facture, as well as a number of habitual structural elements comparable with Mondrian's black lines, is a universal clarity and vividness, which Pollock achieved by keeping the various layerings of paint visually distinct; they are never muddied or puddled to the point of that

incoherence easily spotted in a fake. Indeed, this writer has never seen—in over 300 examples—a really perceptive emulation of Pollock's facture, let alone his overall form. As Pollock once said, there are people "who think it easy to splash a Pollock out." They are legion, and they are of one dumb eye!

. . .

If form is the reflection of the artist's temperament, and facture that of the artist's hand, and if style itself thus does not form, but simply contributes to, the work, then style can be eroded or lost while the work's intrinsic form survives. To use Aristotelian terms, form is "substance"; style is "accident."

For instance, does the lack of the original flesh colors on a classical statue make it any less authentic or aesthetically moving? Here, of course, we have a more complex problem. Time, and a well-established taste for the "classical purity" that time's erosion has induced, make us happy not to have the garishness of paint spoil the surviving formal elegance. So we have the original form without the original, culture-specific, styling of the form. The same situation prevails in medieval sculpture, where we certainly do not want all that color and gilt put back on winsome Madonnas and noble saints, part of whose charm lies in the picturesqueness of their abrasions. Time's depredations—and the continuity of history they signify—often have more aesthetic allure than the gross facts of a taste not our own, now long ago erased.

But how to judge authenticity in the case of David Smith (1906–1965), whose executors—urged by Clement Greenberg—removed the colors from some of his sculptures, the better to reveal his form? Ironically, the Sistine Chapel ceiling's bright, newly revealed polychrome is now also a problem, since perhaps too much Mannerist color has been revealed at the possible expense of Michelangelo's *a secco* shadings. A new sense of authenticity replaces the "Old Masterish" tonalities induced by dirt. One wonders what our reaction would be if the restorers had scrubbed harder—or if all those Japanese TV lights had blanched the ceiling to grisaille, leaving it in the same condition as ancient and medieval statues, or those scoured David Smiths. Would the monumental form suffice? I think it would.

Twentieth-century art has made these matters more complex by often permitting a simultaneity of form and style, which is more easily distinguishable in older art. Did, for instance, the seductions of a fashionable style skew the perception of those notorious Van Meegeren "Vermeers"—so steeped in the Art Deco world of their creator that they looked "right" to contemporary experts despite the forger's total innocence of the master's characteristic singularity of form?[14]

Once a Pollock that had been in a fire was restored. The heat had evaporated areas of the original pourings, leaving only ghosts on the canvas. The restorer, a skilled craftsperson, but all too much of his time—decided that this

damaged Pollock was to be treated with the very latest methodology: that is, as a text he would consider as a pretext for a new text—his own freehand pourings! This offense was perpetrated despite ample photographic evidence of the original colors and facture, the ghostly outlines of the pourings waiting to be carefully filled in, and a contract stipulating "replication," not "representation." The restorer left the world confronted with nearly one-third of a painting in dire formal conflict with the rhythm and character of what remained of the original. Eventually the work was redone as contracted. It will, of course, never be the same, but it will at least not be one-third forged. The metaphysical problem here remains, however: what is not real is seen as real. The justification, I believe, is in the preservation, to the extent possible, of the overall formal integrity—just as a wooden leg restores bodily integrity at the expense of a limp, whereas an elegant postmodernist fluted column attached to the stump would not!

Mark Rothko's famous chapel in Houston raises a more serious problem. Shortly after it was opened in 1971, the fourteen paintings were all variations of "blood red on red," and possessed that curious inner light which makes a Rothko (like a Rembrandt) so moving. About seventeen years later, they had changed radically: the color variations were blackened due to photochemical changes in the pigments. (The same thing happened to Rothko's murals at Harvard, which have had to be removed from view.) Unlike those old, once polychromed sculptures, or that deconstructed Pollock, Rothko's thin veil of resonant color was the form—and if the color changed from that intended by the artist, then the work's authenticity is now effectively compromised.[15]

Similarly, with site-specific works, such as Richard Serra's notorious *Tilted Arc*, when the formal relation to the environment is destroyed, the physical fragments of the piece become inauthentic in themselves. This did not, of course, deter the U.S. government's General Services Administration, which commissioned the work in 1979 for New York City's Federal Plaza, from removing, and thus destroying, it in 1989 over the protests of the art world.[16]

Indeed, in our litigious society, another thing compromised, if not outright destroyed, is the connoisseur's expertise. For all practical purposes, the present defamation and product disparagement laws reject the authority of expert opinion in the arts—although not in the social or natural sciences, which seem more "objective." This is perhaps because negative opinions about art seem to do more economic harm. The U.S. Supreme Court has ruled—in a non-art-related case—that an assertion of a negative "opinion" can have the same defamatory effect as an assertion of unqualified fact.[17] Saying that it is one's opinion that this object is not by Seurat or Pollock is identical in disparaging effect to saying outright that it is a fake. A doctor's diagnosis of a dislocated joint, made on the same perceptual and experiential basis as a con-

noisseur's judgment of authenticity in art, would carry more weight—and of course might be backed up with an X ray. Even a handwriting expert's judgment would be seen as having greater validity.

There are a number of reasons for this state of affairs, among them that few can see what the connoisseur sees, that the connoisseur can at times be wrong, and that works of art do not carry as much weight with public opinion and experience as does human life or a valid signature. There is also the general public's skepticism about art, especially abstract art, and the enormous prices often paid for it. More fundamentally, the art world does not have its act together when it comes to the procedures to be followed when authenticating works of art. Until it does, the whole process, necessary as it is, will be open to challenge.

. . .

But what about the archive and the lab?

There is nothing more useful to validate the judgment of the connoisseur's eye than a photograph of the artist making the work, or an entry in the artist's handlist of his works that describes it definitively, or a bill of sale from a dealer, or a listing in a collector's inventory, or clear auction or exhibition records. That is why catalogues raisonnés take so long to compile: the documentation for each object must be meticulously put into a line that leads back to the artist. Ideally, there ought to be a paper trail—a provenance (or provenience, from the Latin *provenire*, meaning "to come forth") leading from the work's current ownership back to the artist's studio from whence it came—or as near to it as feasible.

The problems connected with the various documents that prove provenance are infinite—incompleteness and ambiguity being just the main evidentiary stumbling blocks. Such faulty or unclear documentation can be a serious hindrance. Old exhibition lists, for instance, often describe works as "Untitled," and give no dimensions. The size of each work in a series can be the same, which does not help to discriminate among them. Media descriptions are often inaccurate. Even titles can change, with an artist's list of titles and those given later by a dealer or a collector being worlds apart.

Obviously, the older the work, the less continuity is going to be found in the provenance, except for the most famous works owned by the most prominent collectors. For recent works, the problems are easier to resolve in theory, though in practice some can be just as frustrating. Here, the most serious problem is the tendency on the part of collectors to hide their possession of major works, either because of security concerns or fear of the tax collector, or because the works have been stolen and/or been purchased with drug profits. Such concealment, coupled with the endemic secrecy of

art dealers and some curators, can lead to all sorts of blind alleys for the scholarly sleuth. If the object just happens to be an archaeological treasure, forget it.

When it comes to inauthentic works, there seldom is even an attempt at contriving provenances—though that can certainly happen. (I have twice seen variations on my name forged on certificates of authenticity for alleged Pollocks.) Rather, the typical forger does not have a clue about historical documentation, and usually offers, when pressed, some dead-ended situation, such as having found the work at a country auction, or in a flea market, or in a deceased relative's attic, or claims that it was once in a distinguished collection, though the claim does not pan out after investigation.

After a while it becomes clear that a work of dubious aspect, without convincing documentation, is most likely a dud, and that there is no need to go on to any kind of technical analysis unless there are compelling extenuating circumstances within the provenance that raise serious doubts or questions. These are rare, and have to be dealt with on a case-by-case basis.

. . .

If the archive cannot provide clean, definitive evidence, there is always recourse to the lab, and to our often unfounded faith that science can back up the connoisseur's eye. It is, of course, always nice to have indisputable evidence. The conservator's X ray reveals a nineteenth-century sketch of the Eiffel Tower under the alleged seventeenth-century Rubens; testing the paint underneath an alleged Renaissance portrait proves it could only have been made in Brooklyn after 1920.

Such luck, however, is rare—as the 1995 "Rembrandt/Not Rembrandt" exhibition at the Metropolitan Museum of Art indicated, and as Simon Schama brilliantly described in The New Yorker.[18] The reality is that most paintings in need of authentication bring with them no particular openness to verification by scientific analysis.

Take, for instance, the radical difference between an Old Master painting and a contemporary painting. The former is thick with the accretions of (1) complex painting techniques, often combining underpaintings and glazings, which in turn can (2) contain the peripheral contributions of studio assistants, which are then (3) overpainted by centuries of more or less misguided efforts at "restoration" and (4) inevitably compounded by centuries of dirt. Such paintings can often be x-rayed, and their strata of paint tested, with some hope of revealing their history and possibly their attribution. A contemporary work, on the other hand, often cannot be x-rayed, given the thin layering of paint that, when tested, often offers no conclusive evidence of who used it, the paint being generally available to everyone. It is, therefore, folly to

think that objective science can totally replace the connoisseur's eye, for both are equally inconclusive.

Ah, you say, the connoisseur's eye would spot the student's hand. Maybe. I, and another member of the Pollock-Krasner Authentication Board, once went to the tryout of a play about Pollock. The young actor impersonating Pollock "dripped" four works during the course of this one-act performance. Fortunately, he used acrylic on paper, a technique Pollock never employed. After the show, looking at the results still spread on the loft floor, we marveled with a certain shudder at the uncanny resemblance between his efforts and the real thing. Here is a reality the connoisseur does not—indeed, cannot— take into consideration: the psychological identification of the pupil with the master. If an actor can manage a plausible imitation of an artist's manner in the course of assuming his character in a play, how much more likely is it that an atelier apprentice of Rubens or Rembrandt, living in less self-aware times than ours, might have so identified with an idolized master that his work, done with the same materials within the same cultural imperatives, stands un-challenged today as part of the master's oeuvre? And by what method do we prove that it is not by said master?

Can computers help?

Perhaps. Computer technology has been used in the humanities since the 1980s, though mostly in literature. Cross-sorting analyses have been used for major works, such as Dartmouth's famous Dante Project, in which the text of the *Commedia* was analyzed for its linguistic characteristics and subject ref-erences, and compared against the various commentaries on its text over the centuries;[19] a funeral elegy was recently attributed to Shakespeare on the ba-sis of the conformity of its language to the poet's known vocabulary and dic-tion. Computer technology can thus be of help in analyzing and authenti-cating verbal texts. Whether it can be equally useful in dealing with visual material remains untested. But there are recent indications that point to such future utility.

For instance, a letter from Mathew Arnold had been posthumously ex-purgated by his daughter, who heavily crossed out words and phrases she felt were indiscreet. The letter was recently submitted to the University of Vir-ginia's Electronic Text Center, where it was digitized. The digitation process was capable of distinguishing the colors of the two inks—that used by Arnold and that later used by his daughter—and then proceeded to lift the latter's overscorings off the original writing, revealing the obliterated words (he had called a friend a drunk).

A similar process might be applied to paintings, where the various layer-ings of an artist's facture would be separated out and analyzed. This would give authenticators the ability to produce a set of "profiles" or "paradigms"

of an artist's hand—that is, the characteristic loopings, angles, spacings within units of measurement, and so on. These would then be matched against similar characteristics in works alleged to be by the same artist. In short, a process exists that would provide for the visual arts the same objective analysis that literary scholars can apply to the structures and idiosyncrasies—the form— of a writer's text. Such a process is technically possible, the digitation machines are harmless, and the results would have the same evidentiary weight as handwriting analysis. Whether they would be any more conclusive is an open question. But, given the seemingly subjective methods of the connoisseur, it is likely that they would provide a more solid basis for a consensus of scholarly opinion.

Seeking such a basis for consensus is necessary. The testimony of individual experts is vulnerable to all sorts of obvious challenges from a hostile opposition. The connoisseur can claim, on the basis of years of empirical experience, that he or she can look at a transparency and declare a work false, explaining the formal characteristics in words, and comparing the alleged fake against real works by the artist in question. But all of this would seem rather esoteric and not a little arbitrary and arrogant to lay observers—a judge and jury, for instance, or the press—who would not immediately grasp the visual points, whose elusive allusiveness the opposition would happily exploit.

So, given that the lay public is not necessarily going to be able to see what the individual expert can see, and whatever expert assertions are made will be challenged and mocked with all sorts of irrelevant evidence of specific errors and seeming misadventures and contradictions (how many Rembrandt committees do you need to judge a Rembrandt?), it would be helpful to have some explicit visual evidence that dissects the facture of a work, shows and explains how it is structured and what is specifically characteristic of the artist, and then demonstrates that the painting alleged to be by that artist does not possess similar structures and characteristics. Such clearly objective evidence —similar to, but in some ways more powerful than—the handwriting analyses that have been accepted by courts for years, would help balance the subjective conjectures of more or less fallible human beings.

But people cannot in the long run be replaced by machines, and there is much to be done to reorganize present methods of authentication to minimize human fallibility.

• • •

The art world has no formalized system for authenticating art that is perceived and acknowledged by all its denizens as rigorous, accountable, systematic, comprehensive, and comprehensible. In general, there have been three ways of presenting opinions about the authorship of artworks: the expert's

certificate, a committee of experts, and the judgments of individual scholars appearing in catalogues raisonnés or other scholarly publications.

Of the three, the least useful today is the expert's certificate, since long experience has shown it to be simply one person's opinion, and thus open to many invalidating factors—best summed up in the checkered career of Bernard Berenson, who dispensed certificates with often self-serving liberality. Although the certificate is still employed in Europe, where it is in some respects institutionalized in the concept of the *droit moral*, it is open to all the varieties of human fallibility, and useful only in the context of a wide professional consensus.

Far more useful is the establishment of such consensus in the form of an authentication committee. Here the Pollock-Krasner Authentication Board stands as the oldest. (Similar committees have been established for the work of Andy Warhol and Jean-Michel Basquiat.) It was established in 1990 to review the growing number of works submitted for attribution as by Jackson Pollock or his wife. The history of the Board's predecessors can be outlined in terms of three phases, beginning shortly after Pollock's death in 1956. The early submissions for authentication, which numbered fewer than twenty, were dealt with between 1956 and 1971 by his widow, Lee Krasner, with the assistance of her lawyer, Gerald Dickler, and Donald McKinney of the Marlborough Gallery. When the private art dealer Eugene Thaw assumed responsibility for a catalogue raisonné of Pollock's oeuvre in 1971, the Jackson Pollock Authentication Committee was established. It consisted of Krasner, McKinney, William S. Lieberman (then of the Museum of Modern Art), and the editors of the catalogue raisonné, Eugene Thaw and myself. This committee, which reviewed some forty-two objects, was in existence from about 1972 until the publication of the catalogue raisonné in late 1978. Between 1979 and 1990, questions of authentication were decided by Krasner (until her death in 1984) and the catalogue editors. By 1990, the increasing number of submissions, and the complexity of dealing with them, prompted the Pollock-Krasner Foundation, Krasner's heir, to establish the Board to handle these problems and to review all previous decisions. The members of the Board were the original editors, Lieberman, and Ellen G. Landau, the author of a recent catalogue raisonné of Krasner.

Over the years this evolving committee of experts passed judgment on over 325 objects, and its opinions have been accepted as credible and definitive. It has been forced to beat back three lawsuits, two of which made far-reaching claims under the Sherman Antitrust Act. The Board and the New York auction houses were accused of conspiring to restrain trade in Pollocks by, in effect, cornering the market in Pollocks. These suits were dismissed by the federal court before discovery, and the Sherman Act was ultimately declared an unsuitable vehicle for such actions.[20] These litigations nevertheless placed an

enormous burden on a benevolent foundation dedicated by its founder's wishes to supporting good, needy artists. On the other hand, the Board did provide a model for bringing a consensus of respected expert opinion to bear on the authentication of a much-forged and -copied artist, while indemnifying its members from personal liability for such professional decisions.

Far more vulnerable to litigation are individual scholars and curators, working on projects such as catalogues raisonnés or retrospective exhibitions in universities and museums. They must decide on the authenticity of works presented to them, but under the circumstances discussed above, they dare not publish their opinions or exclude doubtful objects. While universities and museums have not always been quick to protect such scholars, several strategies have been adopted, such as elaborate releases to be signed by owners requesting opinions. These, unfortunately, do not protect absolutely—the signer of a release can always sue anyway, in the hope of invalidating the agreement—and such scholars, often young and just launching careers, face ruin if they leave themselves open in any way to a lawsuit, whether or not it is winnable (a detail lawyers often forget when advising such people). What scholars need is an entity that can take them in and protect their professional judgments.

In 1995, Lee Rosenbaum wrote a piece for *The Wall Street Journal* describing two recent lawsuits involving authenticity.[21] The cases involved a drawing by Georges Braque sold by the artist's dealer but rejected by the son of the dealer, who now holds the *droit moral* for the artist, and an Alexander Calder mobile that was rejected by the artist's lifelong dealer but certified by another.[22] Rosenbaum characterized these cases as "the latest and most acrimonious installment in a series of lawsuits that is creating a body of case law as confusing in its contradictions as it is cockeyed in its connoisseurship." She urged a "better system to resolve art-market authenticity disputes." While IFAR, the Art Dealers Association of America, and the various lawyers involved in these and other such cases have been informally exploring alternatives to the present nonsystem, nothing much has yet been achieved.

What to do?

First off, any better authentication system would have to be based on clearly defined, consistent procedures, in order to provide informed opinions uninfluenced by external legal or professional pressures. That means the scholars and experts capable of providing credible authentication services need to be marshaled to the cause and secured from retribution for their decisions. What is needed to achieve this is an umbrella organization capable of administering the services of a group of wide-ranging advisory panels experienced in the various aspects of the authentication process and the various media and periods that process must address. Scholars—especially those doing catalogues raisonnés, who are at present prevented by fear of lawsuits from publishing negative opinions concerning works of art—would be able

to join this new entity as its experts, after their credentials were approved by an independent advisory committee of senior scholars and experts. Estates, artists' foundations, scholars, collectors, auctioneers, dealers, and curators would be able to apply to receive an authentication on a sliding-fee basis. Those holding the *droit moral*—to the extent they would be willing—might be encouraged to transfer, for a fee, authentication rights to this organization. The panel of relevant experts would review the work. All decisions, which would have to be unanimous, would be published. The experts would receive reasonable fees for their services and be indemnified for their decisions in perpetuity, and the umbrella organization would fight any lawsuits brought against itself and its member experts.

In all this, it is essential that no authentication decision be made by a single expert; both the appearance and the reality of consensus are essential. This means that only artists for whom three or more experts were certified could be authenticated—so that part of the organization's activities would be to nurture and recruit a large pool of available experts.

Another function of the umbrella organization would be to establish clear procedures and criteria for just when an attribution can reasonably be made from a photograph, when it is necessary to see the actual work, what forms of scientific analysis are appropriate, and what documentation is germane.

In the course of all this, the organization would also work toward establishing more convincing scientific methods to be used in the authentication process—possibly along the lines suggested above. To the extent possible, it would lobby for changes in the libel and product disparagement laws that would protect informed opinion—and, if necessary, support test cases to establish pertinent legal precedents.

Paying for such an organization would be a two-stage enterprise. In the first stage, planning funds might be solicited from major foundations such as the Getty. Implementing funding could also come from such agencies for a while, until application fees, along with contributions from the organizations most in need of such services—auction houses, dealers' groups, museums— would cover expenses. Ideally, a permanent endowment and adequate insurance (the latter possibly from public funding) ought to be sought, once the organization had proven its viability and utility. Care would have to be taken to keep funding sources at arm's length from the activities of the organization, just as strict recusal policies would have to be imposed on experts to avoid conflicts of interest.

Clearly, such an umbrella organization would be difficult to establish and expensive to maintain. Given, however, the current procedural chaos, the overall chilling of scholarship when it comes to making attributions, and the cockeyed connoisseurship imposed by the courts in a crunch, the expenditures would be worth it.

. . .

Some years ago the art critic Robert Hughes, who was not bestowing a compliment, noted that the art world remains the last bastion of laissez-faire capitalism. This is probably true, but our present-day art barons live a far more difficult and uncertain life than did Lord Duveen and his henchman, Bernard Berenson. This is because the purveyors of art then may have been more honest—perhaps the word is *honorable*—than they are today. A handshake could seal a deal, and a word given would be believed because it could be relied upon. There are indications that this is no longer the case. Indeed, one observes of the pros involved that there is today probably no more anxiety-inducing process (aside from dating in the age of AIDS—or flying in the age of terrorists) than the buying and selling of art. The stakes are considerably higher, and the old criteria of confidence, trust, and truth are no longer open to easy definition or acted on predictably. The outward sign of this anxiety is an almost pathological secrecy—which almost of necessity distorts truth for want of trust.

Fundamental, however, to the art world's credibility is trust in the truth of the authentication process. This is essential not only for the security of its economy, but for the integrity of our culture and its heritage.

However our postmodernists might revel in the delights of promiscuous misprisioning when it comes to truth in history, and however the high rollers in the game of art may pander to owners of "power" villas filled with expensive, handmade images, there are still some truths to reckon with, and for art the primordial truth is whether this image is what it is claimed to be.

If, indeed, the art world is the last redoubt of free-for-all enterprise, it is also, ironically, the last institution—along with the law—that seems dependent on truth's absolutism. Verifying the truth of an otherwise anonymous object then becomes the bottom line. If it does not, those power villas, filled with the trophies of 1990s success, may well turn out—like those neoclassic temples de Tocqueville saw adorning the shores of Long Island—to be compromised in their grandeur by brick, wood, and whitewash.

Appendix A: Pollock/Not Pollock

Figure 1.3 reproduces one of the almost 100 copies of Jackson Pollock paintings painted for Ed Harris's film *Pollock*. It copies Pollock's *Number 17, 1949* (figure 1.4). Four elements in the copy clearly indicate its difference from the original. First, the black form to the lower left is almost straight, with a very large opening at the top, whereas the original form was a sinuous curve with a much smaller opening. Second, the black forms in the upper right in no way resemble those in the original. Third, the white lines on the surface of

1.3 Copy of Jackson Pollock's *Number 17, 1949*, painted for the film *Pollock*, Berner Films, directed by Ed Harris, distributed by Sony Pictures, 2001. Courtesy The Pollock-Krasner Foundation.

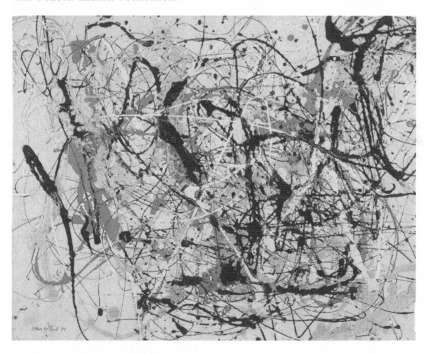

1.4 Jackson Pollock, *Number 17, 1949*, 1949. Enamel and aluminum paint on paper, mounted on composition board, 22 ½ × 28 ½ inches. Private collection. Courtesy The Pollock-Krasner Foundation.

the original, one almost straight and leaning from upper center, are missing. Finally, the centricity of the composition in the original, typical of almost all Pollock's poured paintings, is entirely lacking in the far more diffuse arrangement of linear elements in the copy. Obviously, when used as a prop, and seen momentarily from various angles in the film, such a copy may convey something of the "look" of a Pollock, but when compared against the original, it conveys nothing of the artist's typical formal strategies or linear elegance.

Notes

1. See Grace Glueck, "The Cover-up at Grand Central Station: Renovation Hides Original Celestial Sky," *The New York Observer*, February 14, 1994, pp. 1, 24.
2. Alexis de Tocqueville, *Democracy in America*, ed. Henry Steele Commager (New York: Oxford University Press, 1947), part 2 (1840), pp. 275–76.
3. See Francis Naumann, *Marcel Duchamp: The Art of Making Art in the Age of Mechanical Reproduction* (New York: Harry N. Abrams, 1999).
4. Ralph Blumenthal, "12,000 Fake Dalis Under U.S. Gavel," *The New York Times*, November 6, 1995, pp. C11ff.
5. Jonathan Napack, "Seurat Tiff Snares the Met's Tinterow," *The New York Observer*, October 18, 1993, pp. 1ff. See also Ronald D. Spencer's "Authentication in Court," in this volume.
6. See Adolf Hildebrand, *The Problem of Form in Sculpture and Painting* (1893; New York: G.E. Stechert, 1945); and Heinrich Wölfflin, *The Principles of Art History: The Problem of the Development of Style in Later Art* (1915; New York: Dover, 1950).
7. See Michael A. Holly, *Panofsky and the Foundations of Art History* (Ithaca, N.Y.: Cornell University Press, 1984).
8. Henri Focillon, *The Life of Forms in Art* (1934; New York: George Wittenborn, 1948).
9. Clive Bell, *Art* (London: Chatto and Windus, 1914).
10. Albert C. Barnes, *The Art in Painting* (Merion, Pa.: The Barnes Foundation, 1925).
11. For Greenberg's theories, see Donald B. Kuspit, *Clement Greenberg: Art Critic* (Madison: University of Wisconsin Press, 1979). Greenberg's followers were probably more "formalist" than he was.
12. There is no point in citing these miserable art appreciation books, which have misled generations of students in their understanding of art by imposing the various systems and biases of their usually uninformed authors. As for art history textbooks, their Warburg School origins made them so concerned with chronology, iconography, and iconology that they simply ignored problems of style and form, and the nature of connoisseurship. For a discussion of the historiography of these matters, see Holly, *Panofsky and the Foundations of Art History*.
13. See Hubert von Sonnenburg and Walter Liedtke, *Rembrandt/Not Rembrandt in the Metropolitan Museum of Art: Aspects of Connoisseurship*, exhibit catalogue (New York: Metropolitan Museum of Art, 1995); Susan Stein and Colta Ives, *Goya in*

the Metropolitan Museum of Art, exhibit catalogue (New York: Metropolitan Museum of Art, 1995), pp. 64–65.

14. Paul B. Coremans, *Van Meegeren's Faked Vermeers and De Hooghs: A Scientific Examination* (London: Cassell, 1949).

15. Remarks concerning the Rothko Chapel are based on the author's viewing of the paintings in 1971, shortly after they were unveiled, and again in 1988. For the Harvard panels, see Marjorie B. Cohn, ed., *Mark Rothko's Harvard Murals* (Cambridge, Mass.: Center for Conservation and Technical Studies, Harvard University Art Museums, 1988).

16. See Robert Storr, "Tilted Arc: Enemy of the People?," in Arlene Raven, ed., *Art in the Public Interest* (Ann Arbor, Mich.: UMI Research Press, 1989), pp. 269–85, for a documented account of this event.

17. The court cases mentioned in this essay are discussed and documented in detail in Ronald Spencer's "Authentication in Court," in this volume.

18. See Sonnenburg and Liedtke, *Rembrandt/Not Rembrandt*; and Simon Schama, "The Art World: Did He Do It? Sleuthing at the Met's Rembrandt Show," *The New Yorker*, November 13, 1995, pp. 114–18.

19. Robert Hollander, "Dartmouth Dante Project," *Medieval Academy News* (September 1993). See also Getty Art History Information Program, *Humanities and Arts on the Information Highway: A Profile, a National Initiative*, sponsored by the American Council of Learned Societies and the Coalition for Networked Information, September 1994.

20. The third suit, also dismissed before discovery, established the enforceability of releases signed by those seeking opinions concerning authenticity. These three cases were won by Ronald Spencer; see citations in his "Authentication in Court," in this volume.

21. Lee Rosenbaum, "Art and Experts on Trial in Authenticity Disputes," *The Wall Street Journal*, April 11, 1995, p. A18.

22. These cases are discussed in Ronald D. Spencer's "Authentication in Court," in this volume.

2

Rembrandt and a Brief History of Connoisseurship

. . .

Peter C. Sutton

. . .

Peter Sutton examines the nature of connoisseurship and its historical development. His discussion of the Rembrandt Research Project brings the function of connoisseurship in attributing works of art up to the present day.—RDS

. . .

PETER SUTTON, a specialist in Northern Baroque art, has worked for most of his career in museums. His publications include *Pieter de Hooch: Complete Edition with a Catalogue Raisonné* (Cornell University Press, 1980) and *The Age of Rubens* (Harry N. Abrams, 1993). At present, he is the executive director of the Bruce Museum in Greenwich, Connecticut.

. . .

Even if you take only a passing interest in the world of art, you will proba-bly have heard of the recent commotion over Rembrandt. The authorship of some of his best-loved paintings, such as *Man in a Golden Helmet* in the Gemäldegalerie in Berlin and *The Polish Rider* in the Frick Collection in New York, have been questioned, and the body of his accepted work seems to be shrinking. In point of fact, Rembrandt's accepted oeuvre has often swelled and contracted, burgeoning to more than 600 paintings in W. R. Valentiner's revision of Adolf Rosenberg's catalogue of the paintings (1908) and shriveling to only forty-five works in the eccentric book by John C. van Dyck (1923). However, since the 1970s, the systematic investigations of the Rembrandt Research Project, a team of Dutch scholars, have led to dramatic reassessments of the parameters of Rembrandt's production; in three volumes surveying his career chronologically to 1642, the team has winnowed the ac-cepted canon. In recent decades, the invaluable work of authors such as

Werner Sumowski on Rembrandt's pupils and associates has also helped bring the master's production into sharper focus.

The general public often misunderstands how most decisions about authenticity have been made. Although scientific and technical studies (X rays, infrared photography, micrographs, nuclear autoradiography, pigment sampling, canvas research, investigation of grounds, dendrochronology, etc.) have advanced scholarship and can expose the material inconsistencies of latter-day forgeries, they have played a relatively small role in changing opinions about individual paintings' authorship and authenticity. Material inconsistencies can exclude a work from Rembrandt's oeuvre, but scientific examination cannot provide a touchstone of proof that a painting is by the master. Nor can scientific examination assign a rejected work to one of his pupils or followers.

As the Rembrandt Research Project (Bruyn et al.) readily admits in the preface to the *Corpus*, they relied much less on science than on connoisseurship in making their judgments. The eighteenth-century French term "connoisseur" initially carried broad connotations of sensibility and discrimination which were implicitly the prerogatives of a cultured upper class. But at the dawn of the twenty-first century, connoisseurship has come to refer to the process by which we determine who made a work, when, and where. That the English language should have failed to coin its own word for ascribing works of art might seem surprising, but the use of French for such refinements has seemed fitting. However, the allied notion that the skills of a connoisseur should be the birthright of the privileged is a fiction left from an age when art was primarily an aristocratic pastime.

Differences of opinion among connoisseurs are as old as art history. They certainly occurred in Rembrandt's day. We know, for example, from documents that a jury of painters, comprising the landscapists Jacob van Ruisdael and Allart van Everdingen and the still-life painter Willem Kalff, was convened in Amsterdam in 1661 to determine the authorship of a painting purported to be by the seascapist Jan Porcellis. Each of the painters had a different opinion, and two thought it was by Porcellis's pupil Hendrick van Anthonissen; in the end, they agreed that the picture ought not to be sold as a Porcellis. And a document of 1644 records that bets were taken by several artists in Delft over whether a painting was by the local still-life painter Evert van Aelst, even though the attribution was doubted by one of the painter's own students. Perhaps the most famous case of disputed pictures in the seventeenth century involved thirteen Italian paintings from the Reynst collection which were offered by Gerrit Uylenburgh (the son of Hendrick Uylenburgh, Rembrandt's business associate and in-law) to the elector of Brandenburg in 1671. When the attributions and quality of the pictures were challenged by the elector's adviser, the painter Hendrick de Fromantiou, the

disputed works were submitted to successive juries of artists (including, among others, Gerbrand van den Eckhout, Jan Lingelbach, Philips Koninck, Adam Pynacker, Gerard de Lairesse, Willem Kalff, Lambert Doomer, Roelant Roghman, Pieter Codde, and Johannes [Jan] Vermeer). The artists' opinions ranged wide, from one that deemed the paintings outright copies to another that saw them as weak originals, worth only one tenth of the asking price. The sale to the elector was never consummated, and the paintings went to public auction.

It is noteworthy that all of the arbiters in these disputes were painters. The few art theorists who discussed connoisseurship in the seventeenth century also assign the talent exclusively to artists. Following Giorgio Vasari and other sixteenth-century Italian theorists, Abraham Bosse regarded artists as the only legitimate authorities on painting. Indeed, Rembrandt himself was asked to authenticate a painting by the landscapist Paul Bril in 1653. Giulio Mancini acknowledged the possibility of lay connoisseurs, but his writings were not published until the twentieth century, so it is unclear how widely his ideas were circulated. Rembrandt and the young Jan Lievens might enjoy the praise of an art lover, such as the stadtholder's secretary, Constantijn Huygens, but Rembrandt delighted in ridiculing the judgments of art critics. In his famous drawing in the Lehman Collection (figure 2.1), a pompous lay connoisseur is sprouting ass's ears as a young man offers his own crude critique of the expert's judgment by defecating out of sight behind the panel.

The figure of the connoisseur as an informed and impassioned amateur, a tastefully opinionated aesthete, fully emerged only in the early eighteenth century. William Hogarth realized its full satirical potential when he published a story in the daily paper that ridiculed the connoisseur's pretensions. Addressing the potential client in superior tones, the seller exclaims, "Sir I can tell you are no *connoisseur*, the picture, I assure you, is in Alesso Baldminetto's [probably Alesso Baldovinetti] second and best manner, boldly painted and truly sublime." Then, after spitting in a dirty handkerchief and rubbing it into an obscure passage of the very dark picture, the seller skips to the other side of the room and cries out in rapture: "There's an amazing touch! A man should have this picture a twelve-month before discovering half its beauties!" Then, as now, Hogarth's tale exposes the discredited aspects of connoisseurship: its social one-upmanship and condescension, its feigned display of minute discernment, and the implication that the insights are inexplicable because they are based on ineffable perceptions.

Other eighteenth-century authors, however, tried to transform connoisseurship from quackery and legerdemain into rational science. Roger de Piles helped systematize connoisseurship and raised its intellectual respectability by stressing the recognition of the artist's mind in the work of art rather than the rote memorization of his outward style. And in 1719 Jonathan Richardson

2.1 Rembrandt, *Satire on Art Criticism*. Pen and brown ink on paper, 7⅞ × 6⅛ inches. The Metropolitan Museum of Art, Robert Lehman Collection. 1975.

wrote two essays, "Art of Criticism" and "Science of Connoisseurship," which argued that judgments could be arrived at logically. He stressed the importance of basing new attributions on solid old ones and observing changes in an artist's style over time. Following Vasari, Mancini, and de Piles, he also likened the uniqueness of a painter's style to that of a person's handwriting— an observation to which we will return. Unfortunately, Richardson was a rather leaden stylist who found few followers. Antoine Dézallier d'Argenville won greater respect, arguing that since personal style was an expression of artistic genius, its study was a worthy discipline. He also made important practical observations, noting, for example, that pentimenti (the artist's own changes to a design, which become visible as the paint film ages) are found in originals but rarely in copies. Further, he stressed that provenance and documentation of a work of art can never be taken as absolute or sufficient proof of originality.

It probably is not accidental that several of the early theorists of connoisseurship were doctors of natural science: Mancini was a physician, Dézallier d'Argenville published a natural history of shellfish in 1742, and the most

revolutionary nineteenth-century figure, Giovanni Morelli, was an authority on comparative anatomy, taxonomy, and German *Naturphilosophie*. Since the Rembrandt Research Project credited Morelli with having invented their techniques of connoisseurship, it is worth briefly reviewing his approach.

Morelli's own explanation of his methods took the deceptively playful form of a dialogue between a young Russian sightseer and an elderly Italian patriot who guides the youth through the Borghese and Doria Pamphili galleries in Rome. Published in the preface to Morelli's catalogue of these collections (which first appeared in the *Zeitschrift für Kunstgeschichte* [1874] under his pseudonym, Ivan Lermoliev), the dialogue has a constant theme: the difference between the connoisseur and the art historian. Morelli had little patience for art history in its grandiloquent nineteenth-century form. He insisted that art historians were too readily distracted by tangential evidence—aesthetic platitudes, traditional attributions, provenance, and documents—while the connoisseur studied the specific physical aspects of the work of art, what he called the "true record." The individuality of the painting resided not in some vague spiritual quality but in concrete details, at times outwardly insignificant, where the pressure of artistic convention was relaxed. Morelli wrote, "Just as most men, both speakers and writers, make use of habitual modes of expression, favorite words or sayings, that they employ involuntarily, even inappropriately, so too every painter has his own peculiarities that escape him without his being aware of them." The author filled his guides with schedules and diagrams of these "material trifles"—disembodied hands, ears, and other body parts that formed a visual glossary or morphology of different Italian Renaissance masters' art (figures 2.2 and 2.3). As Edgar Wind has observed, Morelli's disconcerting method "asks us to recognize a great artist not by the power with which he moves us, nor by the importance of what he has to say, but by his nervous twitches and slight stammer that are just a little different from the quirks of his imitators."

Nonetheless, Morelli's methods found many parallels in nineteenth-century thought. In his famous essay on Michelangelo's *Moses*, Sigmund Freud compared Morelli's approach to psychoanalysis, which "divines secret and concealed things from despised or unnoticed features, from the rubbish heap, as it were of our observations." The so-called Freudian slip is still commonly assumed to reveal more about a person than is ever voluntarily divulged. Morelli's theories have even been cited as precedents for Sherlock Holmes's detective practices. Only a few years after Morelli's books appeared, Arthur Conan Doyle wrote a story titled "The Cardboard Box," in which the central clue is a pair of severed ears that arrive in a parcel addressed to an innocent old lady. The eagle-eyed Holmes immediately recognizes the resemblance between the dismembered ears and those securely attached to the elderly lady, and concludes that the victim was a close relation of the recipient.

2.2 Types of hands in Italian Renaissance painting, from Giovanni Morelli, *Italian Painters: Critical Studies of Their Works* (London, John Murray 1892–93) vol. I, p. 77.

Morelli had actual triumphs to defend his reputation as a connoisseur, including recognizing Giorgione's *Sleeping Venus*, which had long languished in the Dresden Gemäldegalerie as a copy after Titian by Sassoferrato. However, he also made his share of mistakes, and his methods were attacked almost immediately as excessively mechanistic. The famous director of the Berlin public museums, Wilhelm Bode, was one of his harshest critics. Bernard Berenson began his career as an avid admirer of Morelli's methods but grew less enchanted, maintaining later in life that their value declined with the greatness of the artist and the quality of the art. The connoisseur of early Netherlandish art, Max J. Friedländer, also criticized Morelli for ignoring quality, and even claimed that Morellian analysis was less a way of arriving at a verdict than of providing evidence after reaching a conclusion intuitively. Modern critics of Morelli, such as Richard Wollheim, have pointed out that the limitations of his methods arise from the way in which he derived his schemata, making traces of details from photographs of autograph works. As Berenson and others gradually realized through comparing countless ears, successful connoisseurship is

FRA FILIPPO. FILIPPINO. SIGNORELLI. BRAMANTINO.

MANTEGNA. GIOVANNI BELLINI. BONIFAZIO. BOTTICELLI.

2.3 Types of ears in Italian Renaissance painting, from Giovanni Morelli, *Italian Painters: Critical Studies of Their Works* (London, John Murray 1892–93) vol. 1, p. 78.

not merely a matter of matching schemata and motifs—or, to put it in geometric terms, of establishing the congruence of the same configuration of forms—but of discovering phenomenal similarities, by which we mean the same *look* or *appearance*. Textbooks on the psychology of perception remind us that geometric congruity is not identical with the same look; parallel lines or lines of the same length do not appear as such in different contexts. Similarly, a motif's context in a painting is crucial to its appearance.

This fact takes on added weight for the practices of the Rembrandt Research Project, since the members also cite as an important precursor to their method A. P. Laurie's 1930 book of detailed photographs of paintings by Rembrandt and his pupils. Although Laurie did not mention Morelli, he allowed in his brief commentary that the details he was publishing could assist in matters of attribution. These details can be viewed as a technological advance on Morelli's tracings, since they tell us more about the brushwork and facture of paint surfaces. Subsequently, the use of photographic details has proliferated in art books (in the northern Old Master paintings field one

thinks of Klaus Grimm's publications), as authors have sought to illustrate their observations and attributions. Indeed, some critics of the Rembrandt Research Project have called for more "creative photography" to support the team's lengthy verbal descriptions; for example, using raking light to illustrate the topography of the paint surface. But one scarcely need point out that all photography is creative. The seduction of photographic details speaks more of modern habits of seeing, the "cult of the fragment," and our love of artfully imbalanced, cropped, or abstracted motifs than of Baroque aesthetics. Like earlier graphic reproduction techniques, macrophotography has limited application for connoisseurship, since it, too, suffers vagaries of scale and resolution while reducing three-dimensional brushwork to two-dimensional abstract patterns.

Still more crucial is the fact that how a detail is framed is a subjective decision that dramatically affects its look. Heavy reliance on photographic details isolates the motif from its context and all-important interrelationships with surrounding forms. Laurie and his descendants are no less guilty than Morelli of studying the vocabulary of the visual language without learning its grammar or syntax. The Rembrandt Research Project has consulted handwriting experts in assaying the authenticity of signatures on the master's paintings. In refining the concept of connoisseurship, we could take another page out of the graphologist's notebook: handwriting experts recognize an individual's script not by the repetition of the same forms—repeated p's, l's, and s's—but from the constancy of the interrelationships among features, even as the individual forms may vary dramatically. Old Master paintings are properly viewed not as photographic dismemberments, but only as a whole and, ideally, "in the flesh."

One last question that might have been asked at the start: Why do we bother about connoisseurship's hairsplitting? Some modern critics of the discipline claim that it is invalidated by its subjectivity; to these purists, all works of art are equally significant as documents, archaeological shards elucidating lost societies and cultures. That great paintings by Rembrandt tend to be more eloquent witnesses to their times than paintings by his imitators or copyists is one rebuttal. There is also the more narrowly historical response: we care about matters of attribution because seventeenth-century patrons and collectors did. Sir Dudley Carlton, Rubens's patron, wanted to know which works were by the master alone and which the product of studio collaboration. Clearly, the originality of a work of art mattered to him. The fact that we now suspect that Carlton was not told the whole truth by Rubens only enhances the need for connoisseurship. At least one scholar has argued that connoisseurs' debates over the parameters of Rembrandt's oeuvre are unnecessary because the modern conception of the artist—the *Rembrandtbild*, as it were—remains the same, whether his oeuvre consists of 300, 350, or 400 paintings. However,

when the rejected pictures include some of the linchpins of the same scholar's theories about Rembrandt's patronage, their authorship suddenly becomes more pertinent. Moreover, Rembrandt becomes a very different painter if works like *The Polish Rider* in the Frick, the *Haman and Mordecai* in the Hermitage, and the *Denial of St. Peter* in the Rijksmuseum are not by his hand. The ultimate defense of connoisseurship, after all, is its promise of revealing the artist's essence, unobscured by the products of his admirers and imitators.

After the last volume of the *Corpus* appeared in 1989, many of the Rembrandt Research Project's members retired and were replaced by new participants, who reconsidered the Project's aims and methods. The decision was made to abandon the strict chronological review of Rembrandt's oeuvre, and instead to address the work according to type of painting; thus the forthcoming volume IV will be devoted to Rembrandt's self-portraits, volume V to "small-scale" paintings, and so forth. They also abandoned the so-called A-B-C (accepted-uncertain-rejected) organizational systems in favor of a systems that discussed "right" and "wrong" paintings together within their respective categories and chronology. In summing up the most important discoveries of their research to date, the Project's present leader and member of the original team, Ernst van de Wetering, noted that virtually all the doubtful paintings, many of which were once thought to be later imitations, were from Rembrandt's time and most likely from his shop. The team also realized that connoisseurship ultimately played a much larger role in their decisions than did science, and offered the cautionary conclusion, "Absolute certainty [in attributions] can only rarely be reached." While one may regret the abandonment of a strictly chronological examination of the oeuvre, especially because it will require the recapitulation of earlier works along with fresh observations about the painterly later works, which present some of the most challenging attribution questions, all the paintings will eventually be addressed. In the process, our understanding of both the art and the science of connoisseurship will be refined, to the enjoyment and edification of all, not only in Rembrandt studies but for all art history.

Works Cited and Select Bibliography

PRIMARY SOURCES

Bosse, Abraham. *Sentiments sur la distinction des diverses manières de peinture.* . . . 1649.
Dézallier, d'Argenville, A.J. *Abrégé de la vie des plus fameux peintres.* 1745–52.
Mancini, Giulio. *Considerazioni sulla pittura.* 1956–57. Written in 1621.
Morelli, Giovanni. *Italian Painters: Critical Studies of Their Works.* Vol. 1, *The Borghese and Doria-Pamfili Galleries in Rome*; vol. 2, *The Galleries of Munich and Dresden.* London, 1892–93.
Piles, Roger de. "L'Idée du peintre parfait." Preface to *Abrégé de la vie des peintres.* 1699.

Richardson, Jonathan. *The Connoisseur. . . .* London, 1719.

Vasari, Giorgio. *Le vite de' più eccellenti architetti, pittori e scultori italiani.* 1568.

SECONDARY SOURCES

Agosti, Giovanni, et al., eds. *Giovanni Morelli e la cultura dei conoscitori.* 3 vols. Bergamo, 1993.

Berenson, Bernard. *Rudiments of Connoisseurship.* 1892.

Bruyn, J. et al. *A Corpus of Rembrandt Paintings.* Stichting Foundation Rembrandt Research Project. Vols. 1–3. The Hague, Boston, and London, 1982–89.

Friedländer, Max J. *On Art and Connoisseurship.* London, 1942.

Gibson-Wood, Carol. *Studies in the Theory of Connoisseurship from Vasari to Morelli.* New York, 1988.

Gibson-Wood, Carol. *Jonathan Richardson: Art Theorist of the English Enlightenment.* New Haven, Conn., 2000.

Ginzburg, Carlo. "Morelli, Freud and Sherlock Holmes: Clues and Scientific Method." *History Workshop* 9 (1980): 5–36.

Laurie, A. P. *The Study of Rembrandt and the Paintings of His School by Means of Magnified Photographs.* London, 1930.

Rosenberg, Adolf. *Rembrandt: Des Meisters Gemälde in 643 Abbildungen.* Rev. by W. R. Valentiner. Stuttgart and Berlin, 1908.

Sumowski, Werner, ed. *Gemälde der Rembrandt Schüler.* 6 vols. Landau, 1983ff.

van de Wetering, Ernst. "Thirty Years of the Rembrandt Research Project: The Tension Between Science and Connoisseurship in Authenticating Art." *IFAR Journal* 4, no. 2 (2001): 14, 24.

Wind, Edgar, "Critique of Connoisseurship." In his *Art and Anarchy,* 35–52. London, 1963.

Wollheim, Richard. "Giovanni Morelli and the Origins of Scientific Connoisseurship." In his *On Art and the Mind,* 177–201. Cambridge, Mass., 1974.

On Forgeries

. . .

Max J. Friedländer

. . .

Originally a chapter in Friedländer's 1942 book, On Art and Connoisseurship,[1] *this essay exemplifies the earlier, Germanic style of connoisseurship in the attribution of Old Master works. In its time, Friedländer's study exerted an important influence on art history scholars and experts, and is still valid today, especially in its emphasis on the subjective and era-specific characteristics of fakes as well as of malicious, fraudulent, negligent, or simply mistaken attributions.*—RDS

. . .

MAX J. FRIEDLÄNDER (1867–1958), who served as director of the Kaiser-Friedrich-Museum in Berlin before World War II, was a renowned expert on Northern Renaissance and Baroque painting. His fourteen-volume *Early Netherlandish Painting* (1924–1937) remains an essential reference work.

. . .

Many of the principles which I have outlined when treating of copies apply also to forgeries, only that the intention to deceive causes an ethical discord to penetrate into the domain of aesthetics, and that a cunning, stealthy attitude of mind replaces the circumspectly and honestly plodding one of the copyist. In face of the disguise, the affectation and hypocrisy which defile art, the connoisseur becomes a criminologist.

At the leading string of a master the forger moves most nearly with security and achieves his aim most easily by copying. In so doing he runs, however, the risk of being caught out, as the archetype generally is known, and a glance at it threatens to expose the fraud. For this reason experienced and ingenious forgers aim at extracting from several archetypes an apparently new whole. In putting together heterogeneous parts they give themselves away. They will imitate, say, the 15th century manner of painting, but will choose a motif of movement characteristic of the 16th century; or they place a head-

gear of the 16th century on a cranium with a coiffure of the 15th century. Confusion of styles and disharmony are typical of a forgery even more than of a copy. Homogeneousness from the moment of its birth—the hall mark of originality—is lacking.

The forger will copy, closely and cleverly, a Holbein drawing; in the reverse, moreover, so as thereby also to cover up his traces a little. The beard and coiffure of a given male head denotes [*sic*] the time about 1530. The forger places on it a tall cap, of the kind that was worn about 1490, and adds a landscape background in the style of Memling.

The forger is an impostor and a child of his time, who disowns the method of vision which is natural to him. Once the consequences of this disastrous position are clearly realized there will be no difficulty in perceiving the characteristics by which his concoction differs from an original. Oscillating between uneasy cautiousness and brazenness, afraid lest his own voice may grow too loud and betray him, he succumbs to the prejudices of taste that belong to his own period the moment he will give "beauty." His pathos sounds hollow, theatrical and forced, since it does not spring from emotion.

The greatest difficulty which besets the forger is that of achieving the decisiveness of the original work—a decisiveness which springs precisely from that naïveté and certainty of instinct which the forger lacks. Deliberation and consciousness reveal themselves in artistic form as lack of life or else hesitation. The style of the forger's period betrays itself in the expression often through sentimentality, sweetness, a desire to please and insipidness. The forger differs from the master, into whose skin he slips, also in this, that he has but an inadequate knowledge of the object that the master in question had before his eyes. He does not know how a coat was cut and sewn in the 15th century. From our archaeological knowledge we are in a position to discover his mistake and unmask him easily, especially if he has not copied closely but has dared to vary.

The aristocrats among the forgers, a Bastianini or a Dossena, did not strictly speaking work by copying or combining; on the contrary, they harboured the illusion that they had penetrated so deeply into the creative methods of previous ages, that they could express themselves in the spirit, and in the style, of the Old Masters. They dared to push forward, from a "platonic" production—of which also a gifted connoisseur is capable—into the real one. Success was granted them only for a brief while. They took in only their contemporaries, and even these not permanently. Their works partake of none of that timid pettiness which is characteristic of ordinary forgeries: on the contrary, they display boastfully an audacity which, on their becoming unmasked, transforms itself into foolhardiness.

Since every epoch acquires fresh eyes, Donatello in 1930 looks different

from what he did in 1870. That which is worthy of imitation appears different to each generation. Hence, whoever in 1870 successfully produced works by Donatello, will find his performance no longer passing muster with the experts in 1930. We laugh at the mistakes of our fathers, as our descendants will laugh at us.

If only for this reason—not to speak of other considerations—it was a silly business when, towards the end of 1908, the Cologne *Madonna with the Sweet Pea* was declared to be a work of the early nineteenth century. I wrote at the time a brief article against this aspersion, and formulated in it the phrase: Forgeries must be served hot, as they come out of the oven. As the "No" man imagines that he stands above the "Yes" man—and probably also to others seems to stand higher—critics will always feel the impulse to attack genuine works in order to win the applause of the maliciously minded. The "Yes" men have done more harm, but have also been of greater usefulness, than the rigorous "No" men, who deserve no confidence if they never have proved their worth as "Yes" men.

After being unmasked every forgery is a useless, hybrid and miserable thing. Bastianini was perhaps a talented sculptor; in the style of the past he was, however, only able to bring abortions to the world.

Discussions and polemics regarding forgeries are seldom of long duration. This is the typical sequence of events: the work emerges from obscurity, is admired, then seen through, condemned, and finally sinks into limbo. Behind it are left nothing but silent shame among those that were concerned in the episode, the superior smirks among those not so concerned.

A forgery done by a contemporary is not infrequently successful from being pleasant and plausible, precisely because something in it responds to our natural habit of vision; because the forger has understood, and misunderstood, the Old Master in the same way as ourselves. Here is, say, a "Jan van Eyck"—thus the great venerable name, and yet something that has attractiveness in conformity with the taste linked up with our own time: how could it fail to gain applause under such circumstances? To many lovers of art a false Memling is the first Memling that gave pleasure.

I remember how, years ago, an art dealer submitted to me drawings after Holbein's *Dance of Death*, claiming them as originals from the master's hand and referring to the fact that pathos and emotional expression made a stronger appeal in the drawings than in the woodcuts. The observation was accurate; the drawings were, however, imitations of recent date. Holbein, in the woodcut, in the design upon a small scale, has made the motifs of movement—not the facial features—the vehicle of expression: and in this he followed the sure sense of style characteristic of him. The copyist took as his starting-point neither vision nor the requirements of the woodcut, but the intellectual signif-

icance of the tragic theme; and, by petty strokes of the pen, he heightened the expression of fear and distress in the heads.

Above all things I would not wish that my argument produced the impression that I feel sure of myself. This is by no means the case. Not only I, but also my teachers—for whom I have the greatest regard—have been taken in—though in truth, it seemed impossible to understand, later on, how this had come about.

The eye sleeps until the spirit awakes it with a question. And the question "Is this work ancient or not?" will at times not be asked, especially not when a dealer deserving of confidence submits the object with the power of suggestion springing from a good conscience and a demand for a high price.

Novel forgeries tend to be most immediately successful. It is easier to deduce from certain characteristics "This is the work of the forger I know'" than to argue negatively "This cannot be genuine." In order to give pictures the look of age, the forgers imitate the cracks of the stratum of colour, and this all the more keenly since the wrinkles in the skin of the picture are noted by less gifted amateurs as the only indications of age and genuineness. There exist many genuine pictures which show no cracks, but these are never absent in false ones. The *craquelure* caused by age differs more or less clearly from the one achieved artificially. The primitive method of making cracks by drawing or scratching with pencil or brush is held in contempt by the forgers of our days. It is customary to resort to the trick of producing false cracks by a chemical action—say by sudden heating which causes a coating and breaks up the colour surface lattice-fashion.

The natural cracks penetrate into the gesso preparation, while the artificial ones reach no farther than the colour surface. The imitation, howsoever brought about, lacks the capricious playfulness and irregularity of the network which has come into being gradually and under the influence of climate. The appearance changes according to the character of the pigments and the greater or smaller body of the impasto of colour. In one and the same surface of colour, the cracks will now be very noticeable, now not at all or very faintly discernible.

Accomplished forgers make successful use of old pictures, which they clean radically—often down to the gesso preparation—in order subsequently to superpose their forgery, glazing carefully and treating with the utmost delicacy the *craquelure*, which they leave exposed. The connoisseur is in such cases thrown back upon his sense of style, since the examination of pigments does not help him.

Genuine old pictures are made more valuable through forged signatures. It is, naturally, more convenient and hopeful to supply a good picture by Jan

van Kessel with a Ruisdael signature, than to produce a picture by Ruisdael. Signatures of obscure masters have often been cleaned off.

More danger has come to attach to the falsification—a defiling of works of art which is difficult to combat—than to the forgery in the strict sense of the word. Let us say that a dealer possesses a Dutch 17th century landscape which has suffered greatly. From certain indications he considers it—though wrongly—to be a work by Hercules Seghers, all the more gladly as the works by this master are scarce and valuable. He hands the picture over to an able restorer, supervises its cleaning, and supplies reproductions of genuine works in support of his attribution and in order to instruct the restorer. The latter, without any evil intention, is thus inspired to reinterpret certain passages in the picture "in the style of Seghers." Under the delusion that he has in front of him a work by the master, he restores it. By slow degrees, proceeding from case to case, the *bona fide* restoration approaches the malevolent falsification. At times pictures in poor condition have been shown to me. Of one such I will have said for instance: "This is in the manner of Holbein." And before long it was once again submitted to me, neatly completed and with beautiful clearness showing the style of Holbein.

A picture by Vermeer is something exceptionally precious. Of this master the dealers are dreaming. As regards their conception, his works do not differ overmuch from those of other and much smaller masters; the magic of light, colour and the individual technique of dots give his pictures their singularly exceptional quality and value. More than once has it happened that modest Dutch landscapes and scenes from daily life have been worked over in an attempt to give them, through vivifying dots of light, the appearance of Vermeer's unique handling of the brush. Tame Dutch pictures have often, by the addition of bold brush stokes, been falsified into works by Frans Hals.

As the forgers, in conformity with their view of their activities, are manufacturers they often produce several versions of a fake: and it may be particularly noted that duplicates have emerged from the Belgian workshops which, during the last few decades, have abundantly seen to the supply of early Netherlandish panels. Machines are identical, while organisms resemble each other.

Note

1. Friedländer, Max J., *On Art and Connoisseurship*, chapter XXXVI (London: Bruno Cassirer, 1942), pp. 258–66.

4

Issues of Authenticity in the Auction House

· · ·

John Tancock

· · ·

John Tancock describes the process by which a major auction house catalogues art for public sale, the extent and the limitations of reliance on catalogues raisonnés, and other forms of expert opinion.—RDS

· · ·

JOHN TANCOCK, currently senior vice president in the Impressionist and Modern Art Department at Sotheby's, New York, was an associate curator at the Philadelphia Museum of Art prior to joining Sotheby's in 1972. He is the author of *The Sculpture of Auguste Rodin* (1977).

· · ·

In a museum or in a gallery, where deadlines are seldom as pressing as they are in an auction house, it would not be uncommon for cataloguing research into works of art to continue for months or even years. In an auction house, however, sales are held regularly; even in an area with no more than two major sales a year—the Impressionist and Modern Art Department, for example—catalogue deadlines leave little time for leisurely research. In this department at Sotheby's, the period covered is from approximately 1870 to 1950, including not only the work of the French Impressionist and modern masters, but also selected artists from Germany, Italy, Great Britain, and other countries in Europe. Works by major artists in this group may be included in a published catalogue raisonné or otherwise documented. But there are also many works by artists of lesser importance which have not been studied in such great depth. The more inconsequential the work, the less likely that it will have been fully researched or documented before being consigned for sale. With such a range of potential problems, and the constant threat of publication deadlines, speed in cataloguing is essential—as is accuracy, for the responsibilities of public sale and the contingent legal liabilities allow little room for mistakes.

The specialists in the modern picture departments at Sotheby's work in the knowledge that the contents of the catalogues they are preparing will be guaranteed for a period of five years after the date of sale.[1] Faced with such responsibilities and with such a wide range of material to be investigated, the specialists need to be particularly attuned to developments in scholarly research. In fact, they need to be as rigorous in their assessment of the quality of the scholarly tools at their disposal and the reliability of experts as they are in their examination of the works to be sold. It is a daunting task, one that seems to have gained in complexity in recent years as published research becomes more readily available.

In sales of Impressionist and modern painting in the 1950s, the cataloguing was disarmingly simple. With certain major exceptions—Van Gogh (1929), Cézanne (1936), Pissarro (1939), Degas (1946), and volumes of Christian Zervos's catalogue raisonné of Picasso (published beginning in 1932)—the specialists responsible for cataloguing works in the 1940s and 1950s operated without the assistance of catalogues raisonnés. Typically, the catalogue entries would include a verbal description, the citation of an exhibition or two, the immediate provenance (though not always), and literary and exhibition references when they existed. Notes tended to be brief. At the sale of the Josef von Sternberg collection at Parke–Bernet Galleries on November 22, 1949, for example, the note on lot 89, Picasso's *La Gommeuse* (1901) read as follows: "This painting is from the artist's 'blue' period." For lot 92, Modigliani's *Le Grand Nu* (1918), the note stated tersely: "This is the most important work of the artist yet to appear at public sale in America."

During the 1960s and 1970s, the publication of numerous catalogues raisonnés devoted to major artists of the period—Gauguin, Cassatt, Daumier, Boudin, Monet, Klimt, Renoir, Toulouse-Lautrec—provided cataloguers with a great deal of information that previously had not been readily available. Without question, the standard of auction catalogues improved, although from the very beginning it was recognized that many of the newly published reference books were far from infallible. From the day it was published, for example, the Gauguin catalogue raisonné by Daniel Wildenstein was criticized by some for the inconsistency of its attributions.

Among important modern artists whose work has been widely published and catalogued, Giorgio de Chirico, Amedeo Modigliani, and Henri Rousseau present perhaps the gravest problems. In the two latter cases, the art has attracted the attention of serious scholars as well as enthusiastic amateurs, resulting in a wide array of works being published as authentic—from fully documented masterpieces to poor pastiches hopefully attached to the artist's oeuvre. The first "catalogue présumé" of Modigliani's work was published as an appendix to Arthur Pfannstiel's *Modigliani* (1929). It lists 290 works, although only 84 are reproduced. In the reissued edition, published in 1956,

sixty works were added from exhibitions in museums and galleries, but once again the book was not fully illustrated. The authoritative catalogue by Ambrogio Ceroni, *I dipinti di Modigliani* (1970), which added many works not discussed in his catalogues of 1958 and 1965, includes 337 oil paintings. In the introduction, however, Ceroni acknowledges that he omitted at least eighty works which did not hold up well when compared with authentic works and others in museum collections that he felt were open to question.

Also in 1970, Joseph Lanthemann listed 420 paintings and 633 drawings in his *Modigliani: Catalogue raisonné*, a book that includes numerous questionable works and provides neither provenance nor literature, and very few locations. Christian Parisot's *Modigliani: Catalogue raisonné* (1991), reduced the oeuvre to 242 paintings, accepting some that had first been listed by Pfannstiel and accepted by Lanthemann. Unfortunately, although published under the auspices of the Archives Légales Amedeo Modigliani, the catalogue never makes clear why some works are accepted and others rejected. Moreover, the juxtaposition of illustrations of fully documented paintings with others that are patently false does not inspire confidence. A three-volume catalogue by Osvaldo Patani (1991–1994) added little of substance. Another, sponsored by the Wildenstein Institute and prepared by Marc Restellini, was scheduled to be published in 2002, but has been postponed. And, as if it were needed, a committee has just been formed to work on yet another catalogue of this over-catalogued painter.

As with Modigliani, the work of Henri Rousseau has attracted scholars more notable for their enthusiasm than for their discernment. The catalogue raisonné by Jean Bouret, *Henri Rousseau* (1961), which listed 232 works without critical apparatus, was superseded in 1969 by the catalogue of Dora Vallier. She made the decision to distinguish between works that are entirely and indisputably authentic (268) and others, recently attributed, on which no final judgment could be made; many of the latter had been published in the Rousseau studies by Roch Grey in 1943 and Giuseppe Lo Duca in 1951. A far more ambitious catalogue by Henry Certigny, published in 1984, expanded the oeuvre to a total of 323 works, restoring many rejected by Vallier, adding some of Certigny's own discoveries, and disputing most of Vallier's proposed dates. For Certigny, Vallier's catalogue raisonné could only be called a "salmagundi" (hodgepodge). Unfortunately, some of the paintings that Certigny added to the Rousseau oeuvre are seldom above the level of a competent Sunday painter, and have not won wide acceptance in the marketplace.

With Giorgio de Chirico, it was the artist himself who made the compilation of an accurate and complete record of his work next to impossible. From the moment in the 1920s when the Surrealists turned against him as a renegade from their cause, he adopted an attitude toward his work of the Metaphysical period (1908–1917) that prepared the ground for the confu-

sion which ever since has surrounded the dating and authentication of his work. As early as 1924, he painted a replica for the poet Paul Éluard of *The Disquieting Muses*, a work originally painted in 1917. Bearing a massive grudge against the collectors who valued his early work but belittled his more recent output, De Chirico frequently questioned the authenticity and date of authentic canvases, even as he began to paint numerous replicas of earlier works. In 1979, the Italian critic Carlo Ragghianti reproduced side by side eighteen copies of *The Disquieting Muses* dating from 1945 to 1962, no doubt omitting others painted both before and after that period. Further complicating the situation, the Spanish Surrealist Oscar Domínguez painted between thirty and forty highly competent forgeries of works from the Metaphysical period; late in De Chirico's life, forgeries of all types proliferated, particularly in Italy.

Although De Chirico's later work was popular in the marketplace, the focus of scholars and critics seldom strayed much beyond 1917. It was the American scholar and curator James Thrall Soby who more than fifty years ago published two works on the early period—*The Early Chirico* (1941) and *Giorgio de Chirico* (1955)—which are still highly regarded for their scholarship and objectivity. A much more ambitious undertaking—the eight-volume *Catalogo generale Giorgio de Chirico*, by Claudio Bruni Sakraischik—was published between 1971 and 1987. Bruni, who worked with De Chirico beginning in 1965, had unparalleled access to the artist and made the decision to record works as he found them rather than attempt to trace the development of the artist systematically and chronologically. Consequently, in each of the eight volumes there are works from every period of the artist's career, although it is not always easy to find them.

When Bruni's reputation was at its height during the 1960s and 1970s, it was virtually impossible to sell a De Chirico if it was not armed with a Bruni certificate or included in Soby. Since then, scholarly studies by Maurizio Fagiolo dell'Arco and Paolo Baldacci have greatly expanded knowledge of De Chirico's work, and the Fondazione Giorgio e Isa de Chirico, established in 1986, has resumed activity and is authenticating works. When researching a work by De Chirico, there are many highly qualified experts to turn to; nevertheless, the contentious and litigious personality of the artist seems to have infected much of the current scholarly debate on his work. The innocent researcher needs to proceed with caution!

As can be seen from these examples, even with artists who lived well into the twentieth century, problems of attribution and expertise are often as extensive as they are with the greatest masters of the Renaissance and Baroque. In the auction houses, however, where decisions whether or not to sell have to be made in light of the terms of guarantee, the consideration of such mat-

ters is of more than purely academic interest. Questions have to be asked. How reliable is the catalogue raisonné? If the work is not already published, how reliable is the opinion of the expert? Are a scholar's later pronouncements regarding authenticity as valid as those given earlier in life? Does the body of received opinions known as the "art market" have enough confidence in the opinion of the expert (or committee) to accept as authentic works newly added to the canon? Is a De Chirico not in Soby or a Modigliani not published in Ceroni likely to be accepted? Each of these questions has to be asked in each case.

In the 1990s, many significant catalogues raisonnés were published. Particularly noteworthy are the volumes devoted to Magritte (1992–1997), Mondrian (1998), and Schiele (1998), and the multivolume studies of the oeuvre of Paul Klee and Kurt Schwitters still in the course of publication. The cataloguer still has to remain alert, however; even with some of the most recently published and authoritative catalogues raisonnés, it is important to read the fine print and note any disclaimers in the front matter. Uncritical use of these publications can easily lead to situations with unfortunate consequences. For example, when using *The New Complete Van Gogh: Paintings, Drawings, Sketches* (1996) by Jan Hulsker, a revised and enlarged edition of his 1977 catalogue, it is essential to understand his idiosyncratic use of the question mark.

The work of Van Gogh has been the subject of intensive scholarly inquiry for well over a hundred years. There is still debate, however, concerning a number of works that were first published in J.-B. de la Faille's catalogue raisonné of 1928 and have continued to be included in the more recent editions. Hulsker states in his introduction that "not all the works reproduced here should be considered authentic. . . . It is a well-known fact that for instance in the Auvers period, the number of works attributed to Van Gogh far exceeds the amount of work he could have done in the seventy days he stayed there before his death."[2] Hulsker decided to indicate his doubts regarding the authenticity of forty-five works by adding a question mark after their dates, not because he was uncertain of the dating, but because he was "very doubtful" about their authenticity. Strangely enough, he did not question *Street and Stairs with Two Figures*, which was published by De la Faille as number 796 in the 1928 edition of his catalogue raisonné and in all subsequent editions. On the strength of its inclusion in the standard work on the artist, this painting was illustrated on the cover of the catalogue for the sale of Impressionist and modern paintings at Sotheby's London on June 26, 1984. Six years later, however, on June 26, 1990, when the same work was offered again, its authenticity was questioned and it became necessary to withdraw it from the sale. From this example, it is clear that unquestioned re-

liance on published sources, however highly regarded, can have serious consequences.

Similarly, in the authoritative 1997 catalogue raisonné of Cézanne by John Rewald, completed after his death by Walter Feilchenfeldt and Jayne Warman, it is important to read the introduction before turning to the text. Enormously respectful of Rewald's preeminent role in Cézanne studies, Feilchenfeldt and Warman did not reject any works included in the manuscript that they were commissioned to bring to conclusion. Rewald, however, accepted as authentic certain works about which the coauthors had doubts, notably a number of paintings that had belonged to Paul Gachet and Paul Gachet *fils*. "Of the twenty-four Cézanne paintings owned by Gachet, seventeen are included in the Vollard photo archives, which means that they were recognized as authentic in Dr. Gachet's lifetime. The remaining seven, numbers 59, 204, 208, 209, 211, 232, and 355, most of which were first published by Gachet *fils*, should be given further critical examination."[3] Taken at face value, the catalogue entries would give no cause for concern to a cataloguer or to a prospective buyer. When read in conjunction with the introductory notes on authenticity, however, it becomes apparent that these works have entered a critical limbo from which it will be difficult to extract them.

So far I have concentrated on major artists whose work has been the subject of serious scholarly research, even if in some cases this research needs to be carefully interpreted. In the sales room, however, the work of any artist can be sold, provided that there is a market for it. Catalogues raisonnés have been prepared or are in the process of being prepared for most of the artists typically in the Part Two sessions, in which works of lower sales value are sold. Among second-generation Impressionists and École de Paris artists, for example, catalogues of the work of Maurice Utrillo, Moïse Kisling, and Tsugouharu Foujita have already been published, while for the work of Henri Lebasque and Henri Martin, it is necessary to consult the "expert" who is currently working on the artist. For most of the French artists who have not attracted serious art historical attention, the research is in the hands of individuals who have the artist's *droit moral*, very often a direct relative or descendant, or a dealer who has developed a particular expertise.

Many of the problems associated with research on the work of these relatively minor artists derive from the powerful role assigned to the holders of the *droit moral* under French law. Endowed with the authority to accept and reject works and to issue certificates of authenticity, they have considerable influence on the marketplace. Too often, however, it is clear that ties of blood with the artist are insufficient to guarantee unbiased appraisals of the work being adjudicated, since everything depends on the "eye" of the expert. In dealing with such issues case by case, it is always necessary to assess the qualifications and reputation of the expert and to ask whether it is worth the risk

of selling something today, armed with the expert's certificate, which might in years to come cause problems.

"Does the work have a certificate?" is one of the questions most commonly heard before a sale. In the Anglo-Saxon world there is less respect for certificates than there is in France, where they proliferate, and in Japan, where they seem to have become an indispensable adjunct to the work itself. As with catalogues raisonnés, however, the value of a certificate depends on the qualifications of the authority whose signature it bears. It also depends on whether or not it is provided "*gratuitement* (free of charge or for only a nominal fee). There is a natural tendency to suspect the motivation of an expert whose fee is based on a percentage of the value of the work.

In an auction house, a certificate is not innocent until found guilty. Rather, the reverse is true; too often the certificates provided are issued by experts who are widely regarded as unreliable or who are no longer respected. It is also an axiom within the auction house that the more documentation provided for an unpublished work of art, the less likely it is to be authentic. When these documents run to dozens of pages, generally notarized by obscure experts (more often than not Italian), one can be almost certain that the work is a fake. Quite often, certificates are carefully crafted by forgers who have only a shaky familiarity with the language in which they are writing. In Japan, for example, where Renoir is enormously popular, certificates forging the signature of the respected Renoir scholar François Daulte are extremely prevalent. Written in schoolboy French, with misplaced accents and adjectives that do not agree with nouns, these certificates circulated in an underworld that flourished with the gross distortion of the art market in Japan in the 1980s and 1990s.

In addition to paintings and works on paper, sculpture covering the period from Rodin to the late work of Henry Moore is also sold regularly in the Modern Department. Although there are comprehensive catalogues for many of the leading sculptors of the period—Degas, Brancusi, Matisse, Moore, Barbara Hepworth, and, most recently, Jacques Lipchitz—the information provided tends to be less than complete. Tracing the provenance of bronzes cast in editions is seldom feasible, and most catalogues raisonnés do not attempt to do so. With a bronze, consequently, the principal questions asked in assessing authenticity tend to focus less on the authorship of the work than on the authenticity of the cast. From a photograph it is frequently possible to assess whether a painting or a drawing is likely to be by a specific artist. With a bronze, however, it is virtually impossible to tell if a bronze is a *surmoulage* (a cast made from a cast), the most common form of forgery where bronzes are concerned. Slight differences in height, minor imperfections in the surface, a general softening in the forms, and poor or uncharacteristic patina can be seen only on personal inspection. Among the forgeries

most commonly seen are casts of Rodin's *Tête de la Luxure* and Alexander Archipenko's *Geometric Statuette*, both subject in recent years to widespread unauthorized casting.

Another complex issue that has to be considered when dealing with bronzes is the degree to which posthumous casts of a sculptor's work may be considered authentic and accepted as such in the marketplace. Among the great sculptors of the nineteenth century, there is clearly a well-established market for posthumous casts of the work of Rodin and Degas. Many of Rodin's greatest works—*The Gate of Hell* and the *Monument to Balzac*—were cast only posthumously, as was the entire sculptural oeuvre of Degas. Everything seems to depend on the public's interpretation of the artist's intentions rather than on a strict adherence to the rule of law.

For example, the bronze casts made from original sculptures in wood and stone by Gauguin and Modigliani and posthumous casts of Brancusi are authentic from a legal point of view because they were cast under the supervision of the artist's estate. But insofar as they contradict the intentions of the artists, who never authorized such casts, they would not be generally accepted by the art market. Without doubt, opinion is changing, and it is not uncommon for works that at one time were regarded as authentic to be downgraded. Many old collections contain one or more of the bronzes that Ambroise Vollard cast from Aristide Maillol's terra-cottas in the early years of the twentieth century. Impoverished when he arrived in Paris, Maillol gave a number of terra-cottas to Vollard, who did not always keep to their agreement that no more than ten bronzes would be cast from a single mold. There was a ready market for these Vollard casts fifty years ago, but they are no longer salable.

In this description of procedures inside an auction house, I have attempted to convey the range of potential problems that can arise from the use of catalogues raisonnés and outside experts in the preparation of sales catalogues. Since mistakes can be very costly, the gathering and pooling of information about the foibles of experts and the quality of their publications is an essential part of day-to-day business. Like any intelligence system, it is only as good as the information fed into it; hence the necessity of regular updating. For many of the more important works sold in this field, extensive research is not required because they are already well documented. But for works that are not, or have been published in catalogues known to be unreliable, the only recourse is to rely on personal judgment. In such cases, a conviction based on years of experience with works of art of all types and discussions with colleagues takes precedence over the opinion of an expert. More than ever, perhaps, it is recognized that the authority of an expert does not derive from some privileged relationship with the artist being researched but from the parallel development of the faculty commonly known as an "eye" and the

ability to clarify issues of provenance and stylistic development in a convincing manner.

Notes

1. The Terms of Guarantee pertain to the authorship of the work being sold, authorship being defined as "the creator, period, culture, source of origin, as the case may be, as set forth in the Capitalized Heading (e.g., ROBERT DELAUNAY)." If it is determined to the satisfaction of the house that the Capitalized Heading is incorrect, a sale will be rescinded. Sotheby's retains the right to have the purchaser obtain the opinion of two recognized experts in the field, mutually acceptable to Sotheby's and the purchaser, before Sotheby's determines whether to rescind the sale. There are exclusions: paintings, drawings, or sculptures created prior to 1870, and "authorship which on the date of sale was in accordance with the then generally accepted opinion of scholars and specialists."
2. Jan Hulsker, *The New Complete Van Gogh: Paintings, Drawings, Sketches,* rev. and enl. ed. (Amsterdam: J.M. Meulenhoff; Philadelphia: John Benjamins, 1996), p. 6.
3. John Rewald, *The Paintings of Paul Cézanne: A Catalogue Raisonné,* in collaboration with Walter Feilchenfeldt and Jayne Warman, 2 vols. (London: Thames and Hudson, 1996), vol. 1, p. 15.

5

The Catalogue Raisonné

. . .

Michael Findlay

. . .

Michael Findlay describes the catalogue raisonné, the standard reference used to attribute a work of art, and suggests ways to determine the reliability of such catalogues. He also examines issues arising from the existence of competing or unreliable scholarly publications.—RDS

. . .

MICHAEL FINDLAY is a director of Acquavella Galleries, New York. Since the early 1970s he has been a dealer in Impressionist and twentieth-century art, and from 1984 until his retirement in 2000, was a member of the staff of Christie's, where he served as international director of fine arts beginning in 1992 and frequently conducted a course entitled "Trusting Your Eye" for students of all ages.

. . .

A catalogue raisonné is a systematic listing of all known works by an individual artist, usually presented in chronological order and accompanied by details such as date, medium, dimensions, provenance, references, and sometimes exhibition history. Although catalogues raisonnés come in all shapes and sizes and vary in the amount of data provided, most include a descriptive analysis of the work, with a discussion of relevant issues, such as attribution or condition. Some also contain essays on the artist's life and work, similar to those in monographic studies. What distinguishes catalogues raisonnés from the studies is the inclusion of a work-by-work itemization.[1]

Today, the catalogue raisonné is a standard reference tool, used by scholars and critics as well as dealers and collectors to help determine or verify attribution or provenance and other matters relating to the business and study of an artist's production. In the long history of art, however, the catalogue raisonné is a relatively recent entry. The form has distant roots in the practice of making inventories of royal, aristocratic, or ecclesiastic collections. The

"life and works" focus can be traced to the "father of art history," Giorgio Vasari. Vasari's *Lives of the Painters* (first edition 1550; second edition 1568) recounts the history of Italian art from Cimabue (c. 1240–c. 1302) to his own day, each life consisting of a biography of the artist and citation of works Vasari knew (or knew of). For the next two centuries or more, Vasari's tome was imitated throughout Europe in compilations of lives of artists in other countries or regions.

All these vitae nevertheless lack features essential to a useful catalogue raisonné—information and discussion of date, medium, dimensions, condition, provenance, attribution, and other features of the works. The direct source of the catalogue raisonné as we know it today, with its scholarly apparatus and monographic focus, can be found in the catalogues of prints that began to be produced in the mid-eighteenth century by dealers, collectors, and antiquaries. Some of these works catalogued collections, often arranging the prints by artist; others were wider in scope. The first catalogue raisonné of Rembrandt's prints was published in 1751; in the 1790s, Adam von Bartsch, curator of prints at the Hofbibliothek in Vienna, published catalogues raisonnés of the prints of Guido Reni, Rembrandt, and Lucas van Leyden. So thorough and detailed are some of these compendiums that they are still in use today.

When art history emerged as a scholarly discipline in the second quarter of the nineteenth century, authors turned to the print catalogue raisonné for a suitable format in which to publish in-depth studies of an artist's oeuvre. But whereas an artist's prints were often organized by subject matter, catalogues raisonnés of painters (or sculptors) followed a chronological sequence —a prime example is the landmark study of Raphael by J. D. Passavant published in 1839, a two-volume catalogue still renowned for its exemplary documentation, descriptions, and discussion of attributions.

Passavant and his fellow scholars worked before the age of photographic reproductions—art books were either unillustrated or illustrated with engravings after the paintings that could only serve as remote aide-mémoires. Fundamental to their research, therefore, was the direct study of each work. Of course, such study remains essential today. But the advent of black-and-white photography of artworks and photographic reproductions in art books in the 1870s effectively encouraged the compilation of catalogues raisonnés: on the one hand, photographs enabled scholars to conduct comparative analyses without the impediment of geographic distance; on the other, photographically illustrated books had immeasurably greater utility for the collectors, dealers, curators, and scholars who consulted them.

Today, more than a century after the catalogue raisonné began to proliferate, it is not uncommon to find more than one catalogue raisonné of an artist's work on the library shelves. In the case of an artist with a prodigious

output (Picasso, for example), separate catalogues raisonnés by different authors may exist for painting, sculpture, and works on paper. Different catalogues raisonnés of the same artist's work sometimes range across decades, with the earlier volume superseded by the later, which takes advantage of new or updated documentation, scholarly research, and scientific condition reports. In other cases, however, the catalogues are written in the same general period, using the same available information, yet they arrive at different conclusions about chronology and attribution.

Scholarship does not mean universal agreement. In order to determine the reliability of a catalogue raisonné, some general background on the production of these catalogues—their authors, sponsors, and legal ramifications—may be useful. For the sake of clarifying complex issues, the discussion below focuses on catalogues raisonnés of modern artists.

A catalogue raisonné may come into being for various reasons, among them the initiative of an art dealer, the dedication of an individual scholar, and the requirements of an artist's estate. There are no national or international bodies that sanction catalogues raisonnés or otherwise create or maintain standards for them. At any given time, the art world accepts certain catalogues raisonnés as accurate, or conditionally accurate, and rejects others as unreliable.

The art world is a movable feast of museum curators, art gallery owners and private art dealers, auction house specialists, university-affiliated scholars, art critics, and collectors. Communication among them is unstructured and often informal, and there is rarely unanimity of opinion. Although reference is frequently made to the "international" art world, there are in fact many smaller art worlds, most of them regional. A scholar in Italy, for example, may be esteemed as the leading authority on an artist, while a different scholar holds that position in New York.

The waters of expertise and authentication are further muddied when major artists have competing catalogues raisonnés. There are few such instances for postwar American artists, primarily because the art is relatively recent, and it can take years—even decades—to prepare a catalogue raisonné. Most of these catalogues are considered to be largely reliable. Among older modernists, however, the situation can be radically different. No fewer than five published books claim to present the complete works of Amedeo Modigliani, an artist who died at age thirty-five, leaving a fairly small body of work. In addition, two more are planned by different publishers. That Modigliani is possibly the most faked twentieth-century artist and that many known fakes are included in some of the most lavishly illustrated works about him only adds to the confusion. The contentiousness reigning in this field is made clear by an announcement from the Wildenstein Institute in Paris. The Institute has sponsored more than fifty catalogues raisonnés, of which thirty have been

published to date. It stated in 2001 that it was canceling the planned publication of its catalogue raisonné of Modigliani drawings "as a result of pressures and menaces, including telephone death threats, leveled at the work's author, Marc Restellini, by art collectors and their representatives."[2]

Yet other artists of significant reputation still lack a published catalogue raisonné, among them Pierre-Auguste Renoir. The late scholar François Daulte labored much of his life on this project, but managed to publish only the first volume, in 1973, covering Renoir's portraits to 1890. Following Daulte's death in 1998, the Wildenstein Institute acquired his archives and the responsibility for completing the project.

Interested parties may be involved in the preparation of a catalogue raisonné—a living artist, for example, who actively collaborates with the authors (as in the case of Claes Oldenburg, whose catalogue raisonné is currently being written). An artist's dealer, estate, or the foundation established by the estate can also be a participant, as in the catalogues raisonnés of Willem de Kooning, Andy Warhol, and Roy Lichtenstein. A catalogue raisonné can profit from this kind of collaboration, since most vital information is available only from the artist's principal dealers and the estate. But if the catalogue is prepared solely by these parties, it may be less than entirely objective. One of the functions of a dealer, after all, is to profit from the artist's work, and one of the functions of the artist's estate or foundation is to further the artist's reputation. To avoid such conflict of interest, the primary author(s) should have no stake in the relative value or popularity of the artist's work, no motivation to exclude works of minor importance or lesser quality, or to promote some works with color reproductions while relegating others to black-and-white.

The inclusion or exclusion of a work from a catalogue raisonné (or, possibly worse, its inclusion as "dubious" or as an outright fake) can have significant financial consequences, particularly if the artist is sold successfully for high prices by dealers, galleries, and auction houses. Thus the decision to include or exclude must be absolutely free from any financial incentive. Unfortunately, this is not always the case.

I once had cause to debate with the authors of a catalogue raisonné of a major twentieth-century artist. They wanted to exclude a series of admittedly poor drawings that the artist had created during a hospital stay and then given to a friend. In some cases, the artist had appeared to misspell his name. I argued that while it was possibly appropriate to indicate the circumstances under which these drawings had been executed, it was not right to exclude them.

Some authors of catalogues raisonnés have spent years, even their entire working lives, studying an artist's work and traveling around the world to examine each work firsthand. The opinion of such authors as to which works

are or are not by an artist is thus based on extensive study and thought. Problems of authentication, however, are sometimes complicated by the *droit moral* of French law, which assigns the right to ex cathedra judgments about a dead artist's work to an individual, often a relative or descendant of the artist or someone who worked closely with the artist. A case in point is the daughter of Henri Matisse, Mme. Marguérite Duthuit, who pronounced on the authenticity of works by Matisse until her death in 1982, when the responsibility was passed on to her associate, Wanda de Guebriant.

Of course, being related to an artist does not necessarily make someone sufficiently conversant with the oeuvre to be able to authenticate a work absent access to archival information. Often holders of the *droit moral* have at best a tenuous firsthand knowledge of the artist's work; many rely on archives and memory. They do the best they can, but their opinions are by no means infallible. Despite the fact that Marguérite Duthuit was banned by her father from his studio for at least two years toward the end of his life, she pronounced not only on works produced during this period, but also on those created and sold before she was born.

The art world sometimes ignores French law, refusing to acknowledge the holder of the *droit moral* as an acceptable expert. The family of Renoir's one-time dealer, Bernheim-Jeune, holds the *droit moral*, but their attempt to produce a catalogue raisonné met with strong resistance because the consensus was that François Daulte's work was the more thorough.

The most respected catalogues raisonnés are those created by individuals or teams with access to the artist's archives and long experience examining all the works, as curators, scholars, or dealers. Sometimes committees are formed to create catalogues raisonnés or revise existing ones. The catalogue raisonné of the American Impressionist painter Mary Cassatt, published by Adelyn Breeskin in 1970, is now being revised by a team of four experts led by Jay Cantor, a former auction house specialist. His three colleagues—two scholars and a dealer—consider themselves a "vetting committee." Breeskin's integrity is not being questioned, but many consider her criteria for inclusion to have been overgenerous.

In order to decide if a particular catalogue raisonné is reliable, ask the following questions:

1. What are the qualifications of the author(s)? Being the grandson of a minor artist known to have been a friend of the subject of the catalogue is not in itself a qualification.
2. Is the catalogue still a "living" work?—that is, are revisions being planned or supplements forthcoming? If so, seek out the authors or revisers before accepting the conclusions in the original publication.

3. Are the entries illustrated equally? The way a work is reproduced—black-and-white or color, full page or quarter page—may reflect the economics of publishing rather than authorial bias. But some authors accept financial contributions from interested parties in exchange for lavish color reproductions. This is not the sign of a reliable book.

4. Is the catalogue raisonné relied on by major auction houses? The "Literature" section of an auction catalogue entry should cite all books referring to the work being offered for sale. But there is usually one catalogue raisonné in the literature on the artist that the auction house considers authoritative. If the work is not included in that catalogue, the auction house will not accept it on consignment. Auction houses have the most visible liability regarding the authenticity of the works they offer for sale and are consequently conservative about attributions and sensitive to the prevailing opinion of the art market concerning the reliability of a catalogue raisonné.

It is essential to realize that a good catalogue raisonné is a work in progress even though that work may be stalled for a generation or two. Revisions are usually necessary from time to time, even those which contradict earlier inclusions or exclusions. Scientific research may later prove that the work could not have been made during the artist's lifetime—for example, that the invention and commercial distribution of certain color compounds in a painting postdate the artist's death. Documents may come to light that either support or cast doubt on attributions. New works may surface, works which the artist either forgot to list or deliberately ignored—those given to friends and lovers or sold outside the artist's contractual obligations.

Some catalogues raisonnés provide comments about the physical condition of the works. My opinion is that such information should be included only when there is overwhelming evidence that a work has suffered significant damage or undergone very substantial restoration. No two expert conservators will render identical opinions regarding the condition of a restored work, and no two collectors (or museum curators) are likely to agree on what constitutes an acceptable or unacceptable condition. A professional report of a painting in fine condition can run to 400 words, which length alone can alarm the average collector. Conversely, the two words "some retouching" might conceal serious damage. A responsible rule of thumb for including a work in a catalogue raisonné is that not more than 25 percent of it has been restored.

Ideally, every work in a catalogue raisonné should have been examined, front and back, by the author(s). Although this is an enormously time-consuming and expensive task, it helps produce a truly superior catalogue

raisonné, such as that for Piet Mondrian (1998), virtually a life's work by Joop M. Joosten and Robert P. Welsh. All aspects of each object are exhaustively detailed in a thoroughly precise, clear, and nonjudgmental fashion.

Even with today's technological innovations, catalogues raisonnés are far more expensive to produce than virtually any other kind of specialized professional publication. For the publisher the rewards are slim, since there is a decided limit on the number of copies sold, particularly in the case of an artist whose major works are in public museums and seldom if ever traded. A prolific artist may produce a few thousand original works, but by no means does every owner, private or public, want to purchase an expensive catalogue raisonné. Distribution is ultimately limited to museums, libraries, galleries, dealers, and a handful of collectors. As a result, for most of the twentieth century, catalogues raisonnés were relatively rare, high-priced volumes boasting few color plates at best.

Recently all that has changed. In 1996 the German publisher Taschen reissued the standard five-volume Monet catalogue raisonné, originally created and published by the Bibliothèque des Arts and the Wildenstein Institute between 1974 and 1991. This new edition not only is eminently affordable, but also includes many more color illustrations. We can expect more such publications along these line from Taschen, possibly among them —finally—the complete catalogue raisonné of Renoir's paintings, currently being compiled by the Wildenstein Institute but with no publication date yet announced.

The greatest potential revolution is the on-line catalogue raisonné. Currently available online is *Tamara Lempicka* by Alain Blondel, published by Acatos in Lausanne with software by Encyclia. This software is adaptable for any catalogue raisonné. The advantages of on-line preparation and publication are immense. An artist's oeuvre can be sorted not only chronologically but also according to subject, medium, and size as well as works sold by a particular dealer or owned by a particular collector. In some cases, you can click on a literature reference and view the actual pages of the book or exhibition catalogue cited. Another great benefit of the on-line catalogue is that it is always in progress; updates can be posted at scheduled intervals or as soon as new information comes in.

The ideal approach in compiling a catalogue raisonné and the very thorny issue of authenticity were encapsulated by Walter Feilchenfeldt in his chapter "On Authenticity" in *The Paintings of Paul Cézanne* (1996), a catalogue raisonné by the late John Rewald. Of Rewald's method in deciding what was or was not a Cézanne, he wrote:

When in doubt, Rewald decided rather to include than to reject. He was guided by the philosophy of the German art historian Max J. Friedlän-

der, whose famous remark he translated as follows: "It is indeed an error to collect a forgery but it is a sin to stamp a genuine piece with the seal of falsehood!"

Notes

1. For a brief but useful overview of the history of the catalogue raisonné, including some of the material presented here, see Alex Ross, in *The Dictionary of Art* (New York: Grove Press, 1996), VI, pp. 78–79.
2. "Modigliani Catalogue Halted," *Art News*, 100 (November 2001): 75.

6

The Role of the Catalogue Raisonné in the Art Market

. . .

Peter Kraus

. . .

Peter Kraus studies the history of the catalogue raisonné as well as its present place in the worldwide art market, where it forms the bedrock on which market confidence is often based.—RDS

. . .

PETER KRAUS, an antiquarian book dealer, founded Ursus Books, New York, in 1972, which specializes in current, out-of-print, and rare art books. He currently serves on the council of the Grolier Club and is a fellow of the Pierpont Morgan Library.

. . .

Catalogue raisonné is a rather grand-sounding name for what is in fact a somewhat pedestrian object—a list. It can be a list of paintings, of sculptures, of Fabergé eggs, or of cookie jars. It can be the list of the works of a single artist or, occasionally, of a group of artists. Or it can even be a list of fakes. No matter what the subject, a catalogue raisonné is just a dry list whose goal should be comprehensiveness, objectivity, and above all accuracy. To qualify as a catalogue raisonné, the list should contain as much information as possible about the things listed: a physical description, the current location and ownership, provenance, and bibliography are the standard requirements. There is no room for abstract thought, no allowance for controversial critical opinion, no place at all for the personality of the compiler. A catalogue raisonné should be all about what is being catalogued, and not about the cataloguer. This being the case, why should so many of these lists be the subject of such heated and bitter controversy, and even, increasingly, of litigation? The answer is twofold. First, catalogues are compiled by humans, and humans are prone to error. Second, and more important, money, often vast sums, can depend on

whether something is included in or omitted from a given catalogue raisonné.

The second half of the twentieth century saw the creation of a global art market. For better or for worse, mostly for worse, art has become a commodity. At the same time, the sums of money involved have often become so large as to beggar the imagination. One has only to follow the prices of works which have been out of the marketplace for a generation or so to realize that this is not just about inflation. Increasingly, art of all sorts has become defined by its value as much as by its aesthetic merits. It is this transmogrification of the art world into a kind of stock exchange that has drastically altered the nature, purpose, and power of the catalogue raisonné.

That commerce has always been a part of the scene can be perfectly demonstrated by citing the first published catalogue of Rembrandt's prints, which was issued by the dealer Gersaint in 1751, and was as much a catalogue of his stock as a guide to the artist's work. The modern catalogue raisonné seems to stem from the eighteenth-century desire to catalogue and organize everything. Though many of the early catalogues are today little more than historical curiosities, two have become much sought-after for their importance as examples of eighteenth-century book illustration. The first is the monumental catalogue of the works of Antoine Watteau compiled by Jean de Jullienne, and issued from 1726 to 1728. The illustrations are all original etchings, of which almost a third are by François Boucher. The other work of a similar nature is the *Liber veritatis* of Claude Lorrain. The original manuscript consists of Lorrain's own drawings after his paintings. The printed book, issued between 1777 and 1819, contains 300 magnificent etchings after the drawings. These have long since been broken up and framed, and complete copies are now scarce.

The catalogue raisonné as a treasured object was to have a short life, because if there is a common thread unifying the average catalogue raisonné, it is a lack of high production values. The dryness of a catalogue raisonné's contents tends to be matched by the blandness of its appearance. Being lists, moreover, a significant number of catalogues raisonnés have even been published without illustrations. Even catalogues with illustrations tend to rely on postage-stamp-sized reproductions in black-and-white rather than full pages in color. The catalogue raisonné as bare list is perhaps most frequently encountered in the earliest serious catalogues, which almost all concerned themselves with prints. Among the first scholars to make their name synonymous with a particular catalogue raisonné was Adam von Bartsch, the curator of the print collections of the Hofbibliothek in Vienna. His works, from the 1790s, are still consulted today, some two hundred years later, and his name is omnipresent in the literature of prints.

It was almost a century after Bartsch that the first major clash of commerce and scholarship occurred. Bernard Berenson was obsessed with making lists and identifying previously anonymous Italian artists. It so happened that he established his reputation as an authority on Italian painting just at the time when the possession of Italian Old Masters became an obsession of newly rich Americans, the so-called robber barons. Nowhere is the modern conflict between scholarship and commerce so clearly illustrated as in the work of Berenson, for he was not only an independent scholar but also an adviser to the art dealer Joseph Duveen (whose clientele included many of those wealthy Americans); and the latter role, some felt, compromised Berenson's ability to offer objective scholarly advice. But however fashionable it may be these days to question Berenson's morality and probity, the fact remains that he championed the concept of connoisseurship, and his lists underlined the importance of actually looking at works of art rather than just examining photographs. His books, and the collections built with his advice, have by and large withstood the test of time. Nevertheless, the Rubicon had been crossed. Thanks to Berenson's association with Duveen, the catalogue raisonné became a force in the art market; a century later, the problem has grown exponentially.

Catalogues raisonnés in the post–Berensonian world can be largely split into two types, those for Old Masters and those for recently deceased or still living artists. Old Master catalogues raisonnés (for which the market has largely dried up) tend to be the sole domain of scholars and are published almost exclusively by university presses. When an artist's oeuvre is not too vast, the catalogue raisonné has been occasionally subsumed into the burgeoning world of exhibition catalogues. There is no shortage of controversy in the attribution of Old Master works, but since large amounts of money are rarely at stake, little interest is generated beyond the confines of academe. Perhaps the only exception is the oeuvre of Rembrandt.

Over the years, there have been numerous attempts at making a catalogue raisonné of Rembrandt's paintings. The first modern catalogue was compiled by the legendary German art historian Wilhelm von Bode, collaborating with his equally celebrated Dutch counterpart Cornelis Hofstede de Groot. It was published between 1897 and 1906 in eight massive tomes. Over the next century, distinguished art historians such as Abraham Bredius, Horst Gerson, Bob Haak, and more recently Christian Tümpel have attempted catalogues of Rembrandt's paintings. However, starting in 1968, the decision as to which paintings are in fact by Rembrandt and which are not has been the work of the Rembrandt Research Project, a committee whose findings have so far been published in three huge volumes. The prime consequence of the deliberations of this august body would seem to be the steady diminution of the

master's accepted oeuvre. Since the majority of these works repose in museums, there is little if any financial suffering caused by the committee's decisions. Countless art lovers, however, have been devastated to learn that a much loved painting by one of the greatest artists of all time is in fact either a copy, a work by someone else, or even an outright fake. Needless to say, the work of the committee has not gone without criticism—nor without self-criticism. In 2001, the chairman of the Project, Ernst van de Wetering, announced that the organization of future catalogues will be revamped; and a group of paintings long given to other artists has been newly attributed to Rembrandt's early period.

Rembrandt notwithstanding, it is safe to say that the importance of the marketplace in the world of Old Masters is not enough to corrupt the scholars who compile catalogues raisonnés. These publications can be divided into two main categories: those which replace older literature, and those which catalogue the works of artists previously undiscovered or perhaps deliberately neglected.

Since the early nineteenth century, there has been a vast improvement in printing techniques, especially for color reproductions, and so one might expect modern catalogues to represent a giant qualitative improvement over their predecessors. Alas, that is far from being the case. Most catalogues raisonnés are notable for their total absence of color plates. Moreover, given the fact that the publication of catalogues raisonnés has to be one of the most commercially unrewarding areas of publishing, the overall quality tends to be sinking. If you take the three standard catalogues raisonnés of Andrea Mantegna published over the past century, you get a good example of how standards have declined.

In 1901, Longmans Green published the English edition of Paul Kristeller's massive study and catalogue raisonné of Mantegna. It is a folio, sumptuously bound in blue cloth with elaborate gilding. The handful of plates are black-and-white, and the paper is a high-quality glossy stock. In 1955, Phaidon published the English edition of Erika Tietze-Conrat's Mantegna catalogue raisonné. This was a small quarto book in an undistinguished cloth binding. Coming as it did so soon after the war, the general production standards were poor. There are plenty of plates, and even a magnificent total of eight in color. Last, in 1986, Phaidon issued Ronald Lightbown's catalogue raisonné. This is in a format similar to Kristeller's, but not nearly so handsomely produced, although the publisher saw fit to double the number of color plates it had offered in its Tietze-Conrat edition to sixteen! Of course the Lightbown book is a handsome piece of contemporary art book publishing, but the Kristeller book is a far more handsome object.

This scenario can be repeated with any number of works as the publication of catalogues raisonnés of Old Master art continues to expand, despite

the relatively small market. Scholars are encouraged to produce new catalogues raisonnés, even where one or several already exist, because our knowledge about most painters is generally increasing or subject to corrections. And with travel far easier than ever, the compiler of a catalogue raisonné is more likely to be able to see the works firsthand, rather than rely on reproductions. Significant advances in areas such as radiography and carbon dating have also, for better or worse, given a scientific underpinning to what was formerly a matter of connoisseurship.

One might easily suppose that cataloguing the works of recently deceased, or in many cases still living, artists would be simplicity itself, compared to trying to sort out the complexities of the works of an artist dead for over three centuries. However, one would be very much mistaken, because no author cataloguing the work of a modern artist can be unaware of the financial implications of an attribution—or disattribution. Since the 1950s, as the works of the Impressionists and their successors have traded for increasingly large sums of money, determining who made what has become an ever more fraught occupation.

By the time prices began their upward trajectory in the 1950s, the works of the major artists had for the most part received at least some sort of catalogue. Many of the established artists were represented, even after death, by a gallery that oversaw the publication of the catalogue of the artist's work. Of course, the gallery would presumably be the repository of the most accurate records concerning this work, but, more important, being in control of the catalogue meant knowing where the bodies were buried—knowing who owned what in order to be able to acquire the works. Only the auction houses have a greater knowledge of ownership. But even auction houses can lose track of the works they sell, because not everything at auction is purchased directly. Many buyers prefer to act through an agent, often leaving the auction houses in the dark as to the identity of the actual buyer. Tracking down paintings not in public collections often requires incredible persistence and a certain amount of luck, and in some cases simply proves impossible.

Coincidentally, it is another Dutchman whose work has managed to create the most controversy as well as achieve the most astronomical prices. Unlike most of his fellow stars, he did not have a dealer, having been as spectacularly unsuccessful in life as he was to become successful in death. The first catalogue raisonné of Van Gogh's work was published in four massive volumes in 1928. This was followed in 1930 by a substantial volume listing no fewer than 176 fakes. The author of both works, J.-B. de la Faille, was considered the authority on Van Gogh for most of the twentieth century, and the 1928 book was reissued in 1970 in an updated version that was reprinted in 1996. However, Van Gogh is far too complex, not to mention valuable, to remain the purview of a single scholar, especially since he doesn't have a gallery.

The result is a situation very similar to the one with Rembrandt. De la Faille's catalogue has been followed by four others by various scholars. Now, however, again much like the Rembrandt project, the Van Gogh Museum in Amsterdam is sponsoring a catalogue raisonné, of which the first volume appeared in 1999. Perhaps the weight of such a key institution in the Van Gogh world will give the work the authority required to establish a canon of the artist's oeuvre once and for all.

Few other artists present the cataloguer with such complexities, involving works of iconic importance selling for correspondingly vast sums of money. However, there is one artist whose work does generate a similar amount of controversy, and that is Amedeo Modigliani. The story of the catalogues raisonnés of Modigliani's work resembles nothing so much as a soap opera. It is difficult to do justice to the intricacies of the situation within the confines of this essay, so what follows is a mere outline. Modigliani died in 1920 at the age of thirty-five. In 1929, Arthur Pfannstiel published the first serious study of his work, which was reissued in 1956 with a catalogue raisonné appended. In 1958 and 1965 an Italian scholar, Ambrogio Ceroni, published a two-volume catalogue of Modigliani's paintings and drawings. Ceroni is to this day the sole universally accepted authority on Modigliani. He died in 1970, and it is acknowledged that while everything he catalogued is indeed by Modigliani, there is a significant body of work which he omitted; and therein lies the tale.

In addition to the aforementioned works by Pfannstiel and Ceroni, there are three other competing catalogues raisonnés of Modigliani's works. One, by Joseph Lanthemann, published in 1970, is considered extremely unreliable. The other two are quite substantial in format, and appeared almost simultaneously some twenty years later. The first, by Osvaldo Patani, comprises three volumes, issued between 1991 and 1994, and covers the paintings, drawings, and sculpture. The second is by Christian Parisot. Volumes I and II appeared in 1991 and 1992, respectively; Volume IV in 1996; and Volume III is still not published. However, despite what already seems like a vast literature on a relatively small oeuvre, the plot now thickens. The renowned Wildenstein Institute in Paris, perhaps the leading publisher of catalogues raisonnés of artists whose work still appears regularly in the marketplace, had long been sponsoring new catalogues of Modigliani's paintings and drawings. The drawings catalogue, by Marc Restellini, director of the Musée du Luxembourg, was cancelled, however, because of threats made to Restellini when he rejected certain works for inclusion. The paintings catalogue has been postponed. In the meantime, not to be outdone, Parisot has formed a committee to produce yet another catalogue of Modigliani's work. Thus, anyone interested in the artist's oeuvre can look forward to a prolonged and acrimonious battle over who is qualified to produce the definitive catalogue. The only sure losers are

people with a genuine interest in establishing the exact scope of Modigliani's work.

The battle over the credentials of the people` involved in the competing Modigliani catalogues highlights the core problem of the catalogue raisonné issue. Who compiled the catalogue, and what, if any, are their qualifications? Over the years, there have been times when these questions could easily be answered. Let me cite three examples: in the case of Claude Lorrain, you had the artist himself; with Henri Fantin-Latour, it was his widow; and with Cézanne you had John Rewald, a scholar of international renown who had devoted a long life to producing the catalogue. Unfortunately, a compiler's credentials are not always so easy to corroborate. It is for this reason that the committee approach will probably become the solution to this tricky problem, especially since the possibility of expensive litigation is likely to discourage individuals from putting themselves at financial risk. This is not always a perfect solution, however, because a committee with questionable credentials is certainly not an improvement on an individual with impeccable ones.

Fortunately, the tangled web being woven around the work of Modigliani is the exception rather than the rule, in part because reproduction rights to the work of most nineteenth- and twentieth-century artists must be obtained in order to reproduce the works. Someone—often the artist's estate or an artists' rights society—holds the copyright and therefore can control the reproduction of the artist's work. It is difficult, if not impossible, for an author to produce a catalogue raisonné without reproduction permissions from the legally assigned holder of the rights. For example, a catalogue raisonné of the work of the Mexican artist Frida Kahlo, published in Germany in 1988, was declared illegal by the courts because certain reproduction rights had not been procured, and the book has been effectively suppressed. There is lengthy litigation still ongoing concerning reproduction rights for a new catalogue raisonné of the paintings of Picasso. The standard catalogue by Christian Zervos is generally acknowledged to be terribly incomplete, and a new catalogue is much needed. Since 1995, a California publisher (Wofsy) has issued twelve volumes of a projected catalogue of Picasso's paintings. However, the legality of this work has been challenged, and at the time of writing a French court had declared the work illegal and ordered all copies destroyed. The decision is being appealed. It would appear, nevertheless, that even if the courts allow the current attempt to go ahead, it, too, is bound to be incomplete because it will lack the kind of vast international cooperation that such a monumental work needs, and a significant amount of material is certain to be withheld. Although complete and accurate catalogues of Picasso's paintings and drawings may well be an impossibility, catalogues of his work in other media are not. There are currently available up-to-date and widely respected catalogues of his graphic work, sculpture, and ceramics.

As mentioned before, many of the early catalogues raisonnés were devoted to prints, and the enthusiasm for printmaking in the nineteenth and twentieth centuries has created a real demand for catalogues raisonnés of prints. In such catalogues, the issues of authenticity, location, and provenance that prevail in studies of paintings, drawings, and sculptures are replaced by the need to identify and record and, where possible, reproduce the various states. And there is one more significant difference: starting in the early twentieth century, publishers began to include original prints along with the catalogues. Sometimes these prints were included only with deluxe copies, but in the course of the twentieth century, the inclusion of original prints in catalogues raisonnés became more and more common. The standard catalogues raisonnés of the lithographs of Chagall, Miró, and Picasso were accompanied by twenty-four, thirty-two, and eight original lithographs, respectively.

The inevitable, and unfortunate, result was to create catalogues with an intrinsic value far greater than that of even the most sought-after reference books. This often puts the books beyond the financial means of many of the people who most need to use them, which does not make sense. In addition, with the vast increase in prices of prints, print sellers at the lower end of the market began to remove the original prints from the catalogues. This could hardly have been the intent of the publishers, but it was certainly the logical result of their actions. While it is safe to say that many of the catalogues raisonnés whose original prints have been removed are preserved and can still be consulted, many other such copies have no doubt been thrown away. A tragic waste and certainly adequate proof, if any is needed, that this publishing concept was misguided.

One problem which faces all purchasers of catalogues raisonnés is the price. In the 1980s, when the art market became overheated, the prices of catalogues raisonnés rose with it, especially for the works of nineteenth- and twentieth-century artists, whose auction prices were skyrocketing. With the catalogues being used as a sort of Geiger counter as well as a guarantor of authenticity, a kind of "Tulipmania" took hold, and prices spiraled ever higher. At the top of the heap, the Zervos catalogue of Picasso's paintings was selling at around $100,000, and a host of other works were selling for more than $10,000 each. The Wildenstein catalogue of Manet was selling for around $15,000. A new, albeit abridged, version for $170 quickly destroyed that price. Several high flyers were reprinted, among them the catalogues of Renoir by François Daulte (1973), Cézanne by John Rewald (1997), and Pissarro by L. Venturi and L. Pissaro (1989), resulting in similar dramatic collapses in the prices of the original publications. If anyone is buying these books as an investment, they had better think again. They are useful and occasionally indispensable tools, but by and large have little or no intrinsic value and can easily be su-

perseded. While, like most books, they do tend to increase in value, not all do, and up is not the only direction the prices can move.

So once again, but in an entirely different way, the marketplace is playing a nefarious role in what should be a world of scholarship and connoisseurship. The situation with print catalogues has a simple solution: do not include original prints in reference books. With the rest of the art world things are not so simple. It would appear to be a sad but inescapable fact that the dominance of the marketplace in the art world has put the catalogue raisonné in a position from which it cannot be extricated. The clock cannot be turned back. Art is now an international commodity, and accurate and unimpeachable catalogues raisonnés are the bedrock on which the confidence of the marketplace is based. It is to be hoped that in bitterly contested cases such as Modigliani, an objective international body can be created. The task of this group would be to nominate an impartial and recognized team to produce a catalogue that will honor the memory of the artist whose work it engages and that will be universally accepted as an example of objective scholarship.

"The Authentic Will Win Out"

. . .

Eugene Victor Thaw Interviewed by Ronald D. Spencer

. . .

The following interview, with Eugene Victor Thaw, addresses the manner in which connoisseurs, curators, scholars, collectors, dealers, and other experts come to a consensus on the attribution of a given work, and how that consensus may change over time in a process of self-correction. —RDS

. . .

EUGENE VICTOR THAW is a retired art dealer, collector, and philanthropist and an editor of the four-volume *Jackson Pollock: A Catalogue Raisonné of Paintings, Drawings, and Other Works* (Yale University Press, 1978). He is president of the Pollock-Krasner Foundation, an honorary trustee of the Metropolitan Museum of Art and the Museum of Modern Art, and a trustee of the Pierpont Morgan Library.

. . .

RDS: It's been said that almost every major picture in the Metropolitan Museum has at least one negative opinion concerning its attribution, but that, nevertheless, there is in the art market a "moving consensus" of recent scholarship about attribution of a given work. Please comment on the idea of consensus in the art market.

EVT: There is usually a generational movement of art historical scholarship and connoisseurship. It is the opinion of the current, most respected expert that is crucial for the art market. For instance, if all previous books accept a given Rembrandt as autograph but the recent [1968] Rembrandt Research Project, now run by Ernst van de Wetering, rejects it, it becomes unsalable. However, if the reverse should be true, it can be sold as a Rembrandt "recently rediscovered."

RDS: It's been said, and I believe you agree, that the art market eventually self-corrects misattributions as new information becomes known to con-

noisseurs, curators, collectors, reliable dealers, and other experts. Would you give us some illustrations of this process?

EVT: The highly publicized forgeries of Old Master drawings by Eric Hebborn are mostly now identified, but his career is still troubling the art market and art historians. It is known that he bought and sold perfectly genuine Old Master drawings, but that he lied, even in his autobiography, about which things were his own good buys and which were his forgeries. In a recent article in the *New York Times Magazine* [March 18, 2001], a former curator accused the Getty Museum of having acquired seven or eight Hebborn forgeries for rather large sums of money. All were not what they should have been, but only one, a "Bellini," was a Hebborn.

And, in the 1960s, a group of Fernand Léger gouaches, purporting to date from 1913–1914, the artist's rarest and most valuable period, appeared on the market. They were certified by Mme. Léger, the artist's widow, who had the *droit moral* under French law to establish or deny authenticity. A very few oils also surfaced from this period. At least one found its way into a major show of Cubism at the Metropolitan Museum curated by Douglas Cooper, then a great authority in the field. All these gouaches and oils were sold to dealers and collectors by Daniel-Henry Kahnweiler, the aging but highly respected dealer in Paris who had long been associated with Cubism and in the 1960s was still Picasso's dealer. But soon, numerous connoisseurs, dealers, curators, and collectors began to see the difference between these "new" Légers and those long in circulation. Today, forty years later, only a very naïve collector or dealer would be fooled by this group. In spite of the "moral right" of the widow, the works have long since stopped appearing in auction sales or exhibitions—a good example of the market self-correcting.

Another example: the multivolume catalogue raisonné of the paintings of Georges Braque has, to my knowledge, two clearly apparent forgeries in the volume of the works of his Cubist period. They are paintings which were brought to Braque for authentication when he was old and ill. He signed them on the back of the canvas. By that time, however, Braque couldn't distinguish a clever forgery from his own early work and, saintly personality that he was, did not want to disappoint the petitioner. Because he signed and certified them, the compiler of the catalogue could not legally refuse to include them, and they are now published for all time in the standard book. But the few times they have appeared at auction, they have brought diminishing prices, as the rather small world of serious major buyers learns the truth on the market grapevine.

The art market's process of self-correction is also illustrated by a painting of *Venus and Adonis*, which for many years had hung in the servants' hall of an English country house as an old copy of a Titian. Offered in

1991 in the London salesrooms, it was bought by the Getty Museum against stiff competition because the quality of the picture was reassessed; many now considered it a completely autograph version of a subject that Titian had, indeed, painted in several versions. Christie's had catalogued it as "Titian with studio assistants." It sold for more than $11 million and caused a sensation at the time. Today, most experts again consider it a work by Titian with help from studio assistants.

The Getty also purchased at auction a *Christ on the Cross* by El Greco, a newly discovered example of a subject painted repeatedly by the artist, his studio assistants, his followers, and his imitators, including his son. This new example, however, was of such high quality that nearly everyone was convinced that El Greco himself had painted it, and it, too, brought a price commensurate with a completely autograph work.

RDS: Please comment on the use of certificates of authenticity and their relation to competent opinion about the attribution of art.

EVT: In 1936, the great dealer and expert Paul Rosenberg published Lionello Venturi's catalogue raisonné of Cézanne's work. Although it was an essential and essentially accurate scholarly work, Venturi, in his old age, also gave written certificates for numerous purported Cézannes which he never published. In the era before World War II, when academic salaries in Europe were distressingly low, it became common practice for even well-known and very distinguished professors of art history to give "certificates" of authenticity for paintings and other works of art, which were usually used to help promote a sale. Among the more recent generations of dealers and collectors, such "certificates," handwritten on the back of a photograph, are treated with a certain contempt since they were written for money.

The only opinions of these scholars taken seriously are those which they published in books or scholarly periodicals. Only in that way could their attributions and opinions be subjected to equally qualified reviewers and experts. Thus, a prospective buyer of a Rembrandt drawing catalogued by Otto Benesch in his magisterial six-volume catalogue of the drawings of Rembrandt (1973), must also consult the very thorough review of this catalogue published in *The Art Bulletin* by Jakob Rosenberg of Harvard, who rejects literally dozens of the drawings accepted by Benesch. Then, finally, one needs to consult Pieter Schatborn, the current reigning connoisseur of Rembrandt's work on paper, who presides over the drawing collections of the Rijksmuseum in Amsterdam.

As a footnote in ethics to the above, I must mention the practice of Julius Held, who taught for many years at Barnard and Columbia. When he fled Germany, he carried with him to America the idea of written certificates. However, when asked to do the research for a serious opinion on

authenticity for a dealer or collector who might want to sell, he insisted on the same fee whether he confirmed or denied the authenticity—thus making his opinion free of self-interest or coercion.

RDS: You have described an ongoing process of authentication within the art world whereby art historians, art dealers, curators, and publishers sort out the issues of attribution. In this process, reviews of books and monographs on an artist, or a review of a new catalogue raisonné, themselves become essential documents in determining attribution. Could you now describe the role of the art dealer in this process of authentication?

EVT: The expertise of the art dealer usually derives from long experience and from having seen many examples of authentic work by the artist in question, as well as examples of forgeries. However, it is also the dealer's responsibility to consult all published material relevant to the case at hand and to reveal all such published opinions, favorable or negative, to a potential purchaser. In the case of a work of art with one or several negative opinions in its published history, the dealer and collector should seek the opinion of the current leading authority on the particular artist. If none is clearly known to the art world, then an acknowledged authority in the school and period should be consulted.

Presumably the art dealer, through the process of acquiring the painting or object at auction or privately, already knows much of the information and the range of expert opinion known to the previous owners or researched by the auction house. Yet, in normal practice, there is often more to be learned, more to be searched out, especially about an Old Master painting or object, which may have centuries of history or provenance, but may lack early evidence to connect it to the artist or the first owner. A Rembrandt painting with no ownership record or auction record prior to 1860, for example, would be automatically a subject of intense connoisseurship as well as technical examination—and of periodic flare-ups of doubt, even if it is unqualifiedly authentic.

A dealer's responsibility to a collector should include his own conviction about the authenticity of the object and full revelation of all that he knows about it, including the responsible opinions of others, whether published or not. If, a generation later, the best experts have changed their minds or new authorities have emerged with different viewpoints about the artist's oeuvre, the dealer, in my view, cannot be held liable for a future he could not have envisaged.

RDS: How important is scientific testing for you in the attribution of art?

EVT: The more scientific toys made available for the examination of works of art, the more I am convinced that there is no substitute for a trained human eye. Scientific tools are very useful for examining and repairing the physical condition of artworks, and they are useful in dating material com-

ponents. But when it is not a matter of clearly fraudulent pigments or other materials, when the question of yes or no is based on subtle criteria, here there is no substitute for a connoisseur's eye.

RDS: In the winter of 1999, you wrote to the *IFAR* [International Foundation for Art Research] *Journal* about the need to protect freedom of scholarly opinion concerning authentication and attribution, in light of the ease of making legal claims against the expert and the cost of defending such suits. What can the art market and its institutions do in order to better protect freedom of scholarly opinion?

EVT: In our current litigious culture, particularly in the United States, expert opinions on works of art are not easy to come by because of the threat of being drawn into a legal tangle. Even one that is frivolous in its claims can bankrupt an art expert, who lives on a professorial salary or on income from writing books and articles. Laws must be promulgated that provide a clear legal exemption from coercive lawsuits against experts who are asked for their opinions in a legitimate context and provide that expert opinion, either published or verbally, about works of art. It is now possible to be sued by an owner for loss of value even when that owner has requested the opinion and signed an agreement not to sue. Severe financial penalties for such frivolous court actions should be instituted in order to deter these kinds of claims, which so inhibit expressions of scholarly opinion.

All in all, although many frustrations may slow the process, over time the authentic will win out, no matter how severely challenged, and the inauthentic as well as the grossly misattributed will also be put in their place —despite corrupt catalogues raisonnés, certificates wrongly ascribing the work, and less than reliable dealers or auctioneers who may have temporarily suppressed negative data. While art is long and life is short, one must still have patience.

8

Attributing Old Master Drawings

. . .

Noël Annesley

. . .

Noël Annesley describes the analytical process of attributing Old Master drawings from the point of view of an expert cataloguer in an auction house, specifically addressing the role of connoisseurship and the lesser roles usually played by examination of signatures and scientific analysis.—RDS

. . .

NOËL ANNESLEY, deputy chairman of Christie's, which he joined in 1964, is renowned for his knowledge and experience of the international art market. He is also a respected authority on prints and Old Master drawings, and has made many important discoveries and reattributions in the field.

. . .

The attribution of Old Master drawings is approached from the standpoint of a seasoned cataloguer working in an auction house whose responsibilities include the accurate description of works of art submitted by a third party for evaluation, together with an assessment of their likely range of value if offered at public sale. While I am frequently called upon to express opinions on, and sometimes to prepare catalogue entries for, categories such as Old Master and British pictures, British watercolors and drawings up to the beginning of the twentieth century, and original prints by old and modern masters, it may be more illuminating to concentrate on the process I follow with Old Master drawings of all schools, my first love and my main area of expertise.

Let us consider the connoisseurship of drawings and test the application of this to the practicalities of the marketplace. It has been observed that the word connoisseur now has an old-fashioned ring to it, and indeed my favorite example of a *connoisseur* who also happened to be an art dealer, the late James Byam Shaw, was himself somewhat old-fashioned, elegantly turned out in a conservative style and the writer of catalogues and learned articles alike in

prose of lucidity and charm. During his career at the eminent London firm of Colnaghi, he managed to combine successful dealing in Old Master drawings of all schools with producing a stream of scholarly contributions to the specialist publications of the time. While he came to focus his main attention on eighteenth-century Venice, with exemplary books devoted to the drawings of Francesco Guardi and of Domenico Tiepolo, son of the great Giovanni Battista Tiepolo and his wife, Alicia, Guardi's sister, his range was far wider. The combination of scrupulous attention to detail, such as one might expect to find in a "museum man," with a broader, more practical approach honed by long exposure to the vagaries of the art market, enabled him to publish after retirement catalogues of the Old Master pictures and drawings at Christ Church, Oxford, and of the Italian drawings assembled by Frits Lugt and held at the Institut Néerlandais, Paris. These scholarly publications remain models of their kind, with concise entries and balanced judgments.

Mr. Byam Shaw was imbued with a passion for the subject, a powerful visual memory, and the kind of "eye" for quality which could range imaginatively far from what a work of art was traditionally supposed to be in search of the correct attribution, and could mercilessly distinguish between an original and an imitation by a pupil or a follower, however plausible that imitation might be. Such characteristics are necessary for all of us who, following modestly in Byam Shaw's footsteps, try to pursue our calling with integrity and success. It follows that the longer a suitably gifted person has studied a broad range of drawings, the better the connoisseur he or she will become— until, as has, alas, happened to certain in this field, failing eyesight, memory, or judgment take its toll.

Working in an auction house can be "kill or cure" in the development of connoisseurship. Already in the 1960s people were lamenting the diminishing supply of drawings coming onto the market, and yet a survey of the Old Master drawings catalogues of Christie's and Sotheby's then produced demonstrates that there was no shortage of drawings, even if the overall quality had declined since the riches of the interwar years, and, going further back, since the almost unbelievable quantities that changed hands during the nineteenth century. Unless they were already acclaimed masterpieces, familiar from exhibitions and books, drawings were often consigned to the salerooms not in ones and twos or in small groups, as is usual today, but literally in "parcels," as we sometimes described them, ill-considered trifles that had been shuffled from library to library or attic to attic—"parcels" from which the supposed "big names" had long since been extracted. It was our demanding job, as cataloguers, to sift through this unpromising material, interpreting, and usually rejecting, the evidence provided by written "signatures" or other identifying inscriptions, and then to extract the more distinguished sheets for individual

presentation and group the remainder in appropriate "lots." Working against time, we were above all concerned to minimize the occurrence of "sleepers," pitting our skills against the dealers, collectors, and museum people who would come to view the sales and hope to make their own discoveries.

As a tyro who had come straight to Christie's in 1964 from an education in classics at Oxford, armed with a certain knowledge of pictures and drawings culled from avid museum-visiting and poring over books, but with no practical experience of the art business, I was lucky enough to work for Brian Sewell, a considerable expert on painting through the centuries and a generous teacher. Together we set up a separate department to handle drawings and prints. These had previously been treated as poor relations of Old Master pictures, except when great collections such as those of Henry Oppenheimer and John Skippe came up for sale, and outside experts were called in to prepare the catalogues. The precepts Sewell laid down for me then (he was, alas, to leave Christie's two years after my arrival) seem still to hold good in the main, though the art market, cataloguing tools, and expectations look very different today.

Old Master Drawings have been traditionally understood as having been produced from the fifteenth to the nineteenth centuries, embracing artists working in Italy (the prime source), France, Germany, Switzerland, the Netherlands, and Spain. British (or, as they used to be called, English) drawings and watercolors are usually excluded from this grouping, for a number of reasons. Until, roughly speaking, the second half of the twentieth century, they largely appealed to and were collected by British nationals, apart from works by the world-famous Turner. British draftsmanship, moreover, began to be isolated from that of Continental artists with the adoption of the Protestant religion in the sixteenth century. Protestant iconoclasm stifled demand from churches and related institutions for religious painting, on which the growth and development of painting (and with it draftsmanship) in Italy and other Catholic countries depended so heavily. British patrons wanted portraits of themselves and their families, and increasingly from the 1750s favored landscape and topography. This led to the establishment of an important school of watercolor painting in most ways independent of Continental influences (and capable of extraordinary effects of grandeur and atmosphere). British artists found little need to emulate their foreign counterparts when it came to figure drawing and the invention of elaborate compositions.

That said, such subdivisions seem increasingly artificial when we consider the activity of artists now separated from us by hundreds of years. Early British drawings do sometimes overlap with Old Master drawings in technique and subject matter, and it is highly desirable for students of Old Master drawings to be knowledgeable and interested in other areas besides their

specialty. They should be conversant with painting, of course, and in particular with prints, so often connected with or a source for drawings.

Old Master drawings, of whatever school, are not often signed, and in the case of the Italians, Giovanni Domenico Tiepolo excepted, scarcely ever. They often carry inscriptions, however, which have passed as signatures, reflecting the knowledge, optimistic assessment, or sheer deceit of previous owners, and these may occur on the front of the drawing itself, on the back, or on the mount on which it is laid. Examination out of the frame is therefore obligatory. Italian drawings vaguely associable with the style of, say, Raphael or Michelangelo are liable to carry attributions to these artists which are patently ludicrous. Yet these attributions can sometimes act as a precious pointer to the truth, and from that point of view must always be pondered. Unknown drawings by the greatest masters seldom surface today (the Castle Howard Michelangelo being a glorious exception), but each year important discoveries are made of drawings by artists of the second rank—such as the three superb sheets by the early seventeenth-century painter and draftsman Willem Buytewech sold at Christie's in January 2002. These were recognized from photographs by my young colleague Nicolas Schwed, despite the traditional association with the animal specialist Frans Snyders, a name no doubt invoked because these drawings of market scenes contained dead game, and were of roughly the same date as Snyders's work and in an allied technique.

Nicolas made the connection because he retains in his mind's eye elements of the known corpus of drawings by Buytewech, a short-lived artist who had great influence on the direction taken by Netherlandish figure and genre painting and draftsmanship. Likewise, in the case of the great Italians, the connoisseur can summon up images of their easel pictures, frescoes, and drawings. Once a connection with or influence on the drawing in question has been visualized, the connoisseur can then refer to the steadily expanding literature on the artist or school of artists concerned. Since World War II, fully illustrated monographs have appeared on most of the major artists, and on many others less eminent, who nevertheless produced fascinating drawings, often much more beautiful than paintings for which they were made in preparation. An idea can be tested, too, by visiting one of the great libraries of photographic reproductions of artists' work, among which the Courtauld Institute in London is probably the most comprehensive. Moreover, as technology develops, certain avenues of research will become more readily available on the Internet.

In the normal sequence of study, however, this wider consultation comes later. The cataloguer, with the wisdom stemming from experience, will first have identified the drawing as worthy of close scrutiny—not a (crude or deceptive) copy of a known (or unknown) original, not a printed facsimile (and

these can be dangerous indeed). The next step is a painstaking analysis of the drawing technique, not only the apparent skill with which the figure or scene is represented, but also the way in which the image has been built up: the latter may afford a precious clue to the drawing's origin. A typical Italian draftsman, for instance, sketches on the paper, sometimes quite faintly, making preliminary outlines in gray-black (or red) chalk, then continues in pen and ink, following, though not slavishly, those first outlines. Volume and the effects of light are conveyed with semitransparent brown or gray ink wash applied with the brush; in many instances, the design is elaborated by heightening selected areas with opaque white body color or gouache. The draftsman may go further and "square" the drawing with a network of lines in a grid, enabling the design to be transferred on an enlarged scale to wall, canvas, or other support. Such "squaring" is of course a positive sign that we are looking at a working drawing used by its author for a finished composition that may be recorded and, indeed, may have survived. Likewise, indentation of the outlines with a sharp instrument such as a stylus indicates that the design has been transferred to another surface, possibly in preparation for an engraving or a painting. Some artists also produced highly finished drawings for sale as independent works of art.

Different artists, and different regions, develop their own particular idiosyncrasies, even eccentricities, in the treatment of figures, organization of the composition, and introduction of landscape or elements from antiquity. National traditions are stronger. Poussin's stylized figures seem almost a world apart from the graceful, meticulously observed re-creations of Raphael. These obvious differences, in some cases akin to clumsiness, can throw cataloguers off course when they try to decide on the crucial question of quality. Criteria seem so subjective. Does the drawing "work"? What is its purpose? (Few artists, after all, draw simply for pleasure.) Is it a rough sketch expressing the artist's immediate response to an idea? Or is it a perfunctory imitation by a follower who has no real grasp of the character of the original? This should, one might imagine, be easy to determine, but often it is not. The most talented artists of the second rank, while displaying admirable levels of skill and flair, are inclined to operate within the conventions of their time. It is within these conventions that such an artist develops his own particular style—the way he conveys space, movement, or foreshortening. We come to recognize these personal solutions, even shortcuts, as a hallmark of his work within the broader characteristics of drawing in his time and place. The strength of academic draftsmanship in Italy and the system of studio training set a standard of execution that enables us, in the main, to sort out the pupils, assistants, followers, and copyists from the masters, who are superior as craftsmen as well as inventors.

It is with the greatest Old Masters—Dürer, Leonardo, Raphael, Michelan-

gelo, Rubens, Rembrandt, Poussin, Watteau, Goya, to name a few—that the problems of connoisseurship have been, and remain, the most intense. Such artists dare to break with or transcend the conventions of their time and take risks in the search for expressivity, sometimes with harsh or awkward results. Both aesthetically and commercially the stakes are high, and owners have seen the value of their property increase and decrease by a thousandfold in response to shifts of scholarly opinion.

The analytical cataloguing process itself can offer significant help in assessing the quality of the drawing: the "typical" Italian technique already described is subject to wide variation, both in Italy itself and outside, too wide to be exhaustively discussed here. Most draftsmen are fluent in different media, yet have a particular preference, either throughout their working lives, as exemplified by Watteau's reliance on red chalk, or at a particular moment in a career or for a particular purpose, as with Filippino Lippi's noted predilection for silverpoint when rapidly sketching his assistants in the studio. Only a few of the finest draftsmen are left-handed, most famously Leonardo, as is quickly recognizable from the pressure of the stroke and the direction of the shading, descending diagonally from left to right. Leonardo's near contemporary Hans Holbein the Younger, the seventeenth-century Dutch landscape specialists Aelbert Cuyp and Jan Van Goyen, and the Swiss eighteenth-century virtuoso draftsman Johann Heinrich Füssli (Fuseli in his British manifestation) are other notable members of this distinguished club. Also recognizable through their left-handed shading, and most frequently encountered in the work of French eighteenth-century artists such as Watteau, Fragonard, and Hubert Robert and Jean-Baptiste Greuze, are offsets or *contre-épreuves*, usually in red chalk: a moistened sheet of blank paper is placed over the drawn surface in a printing press and a somewhat fainter (more pink than red) mirror image is thereby produced. The process yielded several benefits for the artist: the rich texture of the original drawing was stabilized and protected from smudging, and the effect of the image could be studied in the opposite direction if an engraving was envisaged. A *contre-épreuve* could also be utilized as a labor-saving device in the production of another painting; sold as an independent work of art; strengthened or modified in the same medium to enhance its salability; or drawn over in pen and ink, with wash, a frequent practice of Hubert Robert. While such *contre-épreuves* were greatly prized in the eighteenth century, sometimes changing hands for as much as half the price of the original drawings, in recent times they came to be regarded as almost valueless reproductions, and so care was needed to distinguish them from the prototypes. (It seems that the merit and interest of *contre-épreuves* are again being appreciated.)

Detailed physical examination of a drawing in strong light can bring up defining evidence. The paper (for the support is usually paper, though vellum

or other material is occasionally used) may carry an identifiable watermark in addition to the chain lines and textures associated with handmade paper. The watermark can be helpful (several comprehensive dictionaries of watermarks have been compiled) in establishing the date of the drawing, though it must be remembered that paper, an expensive commodity, was not always used at the time it was made, and drawings may be laid down on their mounts, rendering the watermark indecipherable. Inscriptions abound, sometimes in the hand of the artist, and they may shed light on the nature of the commission which gave rise to the drawing, the date, or the place. Important, too, in many instances, are indications of the drawing's history or provenance, a subject with which, largely thanks to the pioneering efforts of Frits Lugt, modern scholarship is becoming steadily more conversant.

Many drawings carry collector's stamps, annotations, or numbers, a practice begun by Giorgio Vasari (1511–1574), the Florentine painter, architect, and author of the *Lives of the Painters*. Vasari was not only the first to chronicle the achievements of his artistic predecessors and contemporaries, but also the first systematic collector of drawings, which he bound in a series of volumes and embellished with his own decorative surrounds. Painters had long inherited drawings with the studios of their masters as part of the equipment of their craft, but, in the seventeenth century, in the wake of Vasari, the tradition of collecting drawings expanded internationally outside the confines of professional artists, and with it arose the habit of affixing a collector's stamp or handwritten paraph to each sheet, sometimes with attendant inscriptions.

Great collectors and connoisseurs, such as the Earl of Arundel (c. 1586–1646) and the banker Everhard Jabach (1607/10–1695), or the portrait painters Sir Peter Lely (1618–1680) and Jonathan Richardson the Elder (1665–1745), bought with discernment from excellent sources. The appearance of their mark, or those of later collectors, among them Pierre-Jean Mariette (1694–1774) and Sir Thomas Lawrence (1769–1830), on any drawing immediately singles it out for serious consideration. Frits Lugt recorded thousands of such marks in his two-volume dictionary *Les Marques de collections*. In a separate enterprise, his *Répertoire des catalogues de ventes publiques,* he assembled details of all significant art auctions through the centuries, arranged chronologically, a large number of which were comprised of drawings or included a significant portion of drawings within the dispersal.

Many of these collectors had their drawings laid on distinctive mounts whose design, in some instances, was also recorded by Lugt. A third volume devoted to collectors' marks is currently being prepared for publication by the curator of Lugt's own collection, and this will greatly increase our knowledge of the activities of the early collectors as well as those of the twentieth century, not least because of a wider appreciation of the significance of the mounts, many of which, unfortunately, have been removed by subsequent owners.

Familiarity with the standards and tastes of earlier collectors can be a great asset when considering a drawing demonstrably from one, or indeed several, such owners. It is essential to understand the reliability of different collectors' attributions, which often arise not just from the quality of their own (measurable) sensibility but also from that of their sources, frequently descendants or patrons of the artist.

. . .

So far I have talked about the disciplines adopted by the individual cataloguer and some of the signals that the drawings may emit. But cataloguing should not necessarily be a solitary occupation. The search for identifying characteristics of individual artists and their schools, their favored techniques and subject matter, the facial types they prefer, even the attitudes of the heads and bodies is most effectively a team effort, and many of the best catalogues of the holdings of great collections have been the result of collaboration—A.E. Popham and Johannes Wilde at Windsor, and Popham and Philip Pouncey and Pouncey and John Gere at the British Museum. Where catalogues raisonnés on individual artists are concerned, Pierre Rosenberg and Louis-Antoine Prat have worked effectively together on Poussin and Watteau, and Denis Mahon and Nicholas Turner on Guercino. Even where one author alone is responsible for a monograph, he or she will have depended on an array of colleagues to bring specialist knowledge of iconography or of historical context, or simply a fresh approach to an enduring conundrum.

The more elevated the artist, the greater the need for consultation. The accepted oeuvre of Rembrandt, both as painter and as draftsman, has expanded and contracted during the last century more than that of any other artist. As befits his stature, he has attracted many of the best scholars in the field, who have attempted to sort out his work from that of a host of talented followers. His own studio practice has compounded the difficulties for the modern observer. There remains a core of securely documented pictures of outstanding quality and a body of prints and drawings which seem to us indisputably by Rembrandt, yet through most of his life, from his early twenties, he ran a busy studio which attracted to it many talented pupils as well as established artists. He seems, on occasion, to have sanctioned with his signature work only partly by his own hand, and his personality sometimes inspired lesser lights to approach his own level of achievement very closely.

It might be supposed that in the act of drawing, often acclaimed as the most personal means of expression, a great artist would always be instantly recognizable. But such is not the case. The appearance in 1963 of Otto Benesch's six-volume catalogue devoted to Rembrandt's drawings had been eagerly awaited. Here was a scholarly attempt to establish a definitive corpus of the artist's drawings, helpful to museums and to the art market alike. De-

spite the fact that Benesch's verdicts were by no means unanimously accepted, his flawed catalogue assumed faute de mieux an almost biblical status in the field. We are fortunate these days to have scholars of distinction dedicated to redefining Benesch's inflated corpus. We would be still more fortunate if our modern scholars could always agree. The 2002 sale of drawings from the collection of Dr. Anton C.R. Dreesmann nicely illustrated the Rembrandt problem. It contained no drawing presently given to Rembrandt without qualification, though it was rich in drawings associated with his school. Three of the drawings in the group had long enjoyed acceptance as autograph works. A view of the old pesthouse on the outskirts of Amsterdam, executed in a staccato pen style akin to Morse code, was dated toward the end of Rembrandt's life by Benesch, but is currently relegated to a follower, possibly developing rapid sketches by Rembrandt. One authority has even gone so far as to brand it a fake. A drawing of *David Taking Leave of Jonathan*, the figures sensitively modeled in pen and wash with two further studies of the kneeling Jonathan at the top of the sheet, was first published by an eminent predecessor to Benesch in Rembrandt scholarship, Cornelis Hofstede de Groot, and confirmed by Benesch as datable to 1650. Its status was enhanced by the existence of an old copy in a New England institution. When it appeared in the saleroom in the early 1970s, another Rembrandt specialist, one of Benesch's less sparing critics, endorsed the attribution. In subsequent years, however, some weaknesses of execution have become apparent, and matters are unresolved at the present.

Reflecting this uncertainty, we described the drawing as "attributed to Rembrandt" in the Dreesmann catalogue, and set out its critical history. Similarly described in the catalogue was a small, somewhat darkened, but intensely expressive study of an old man at a window. In the early 1970s, Dr. Dreesmann bought it as the work of Ferdinand Bol, one of Rembrandt's most gifted pupils. Recently, a younger specialist in Rembrandt's drawings, whose judgment we especially admire, claimed it for the youthful Rembrandt himself with arguments that seemed persuasive to us. Yet there was an important dissenting view, and so this drawing, too, was offered as "attributed to Rembrandt." It is possible that further evidence will emerge to solve these and similar puzzles, but equally possible that it will not. We attempted to present the arguments in short form but fairly in the light of current opinion, so that buyers could make up their own minds. Where a drawing provokes no such dissension, its commercial appeal is likely to be far greater.

These questions of attribution loom large. The case of Raphael has some similarities with that of Rembrandt. Both artists ran large and productive studios and were capable of imbuing their most talented pupils with much of their own technical skill, if not with their powers of imagination. Toward the end of his short life, Raphael had taken on so many commissions that the

work could be completed only by extensive delegation under his supervision and from his designs. The contribution of pupils can clearly be seen in decorative schemes such as the Loggia di Psiche in the Farnesina, Rome. Yet the surviving series of highly finished red chalk drawings made in preparation for this are often so beautifully drawn that it is difficult not to give them to Raphael himself rather than to an inspired Giulio Romano. No definitive answer can be found, and such uncertainty must be expressed in a catalogue entry and in the concomitant auction estimate. By contrast, in the case of the large black chalk "auxiliary cartoons" for Raphael's *Transfiguration*, no one hesitates over Raphael's authorship, even though the great altarpiece had to be completed by Giulio after Raphael's sudden death.

Each time we seek to initiate or to confirm an attribution to an artist of Raphael's caliber, we consult a network of current scholars, and tabulate current and past opinions as well as our own. Fewer Old Masters are "owned" by individual scholars or "expert committees" who pronounce on matters of authenticity than is the case with prominent artists of the nineteenth and twentieth centuries, and I like to think that the opinions proffered are carefully weighed and untainted by commercial considerations. Each generation is, however, the victim, or maybe the beneficiary, of a fresh historical and aesthetic perspective on and interpretation of the Old Masters which can on occasion render older views quite baffling. That similar feelings will be entertained about us by our successors is a sobering thought.

It remains hard, perhaps impossible, to put into words, even to feel, the criteria for certainty in attributing drawings to a great artist. Scientific analysis of materials, where it can be made without risk of damage, takes you only part of the way. Studio assistants, even later followers, had access to similar materials and were likely to use them. Idiosyncrasy of touch is a surer bet, but this, too, is liable to subjective interpretation, which is why there is sometimes widespread disagreement even over magnificent drawings. Luckily there remain many sheets which transcend criticism—though the majority of such are already in museums!

9

Signature Identification

From Pen Stroke to Brush Stroke

. . .

Patricia Siegel

. . .

For the expert, the signature is usually the last and least persuasive evidence of authenticity. But judges in law courts, accustomed to dealing with the authenticity of signatures on legal documents, hold signatures in higher regard. Patricia Siegel examines the process by which a handwriting expert decided on the (lack of) authenticity of a signature claimed to be that of Jackson Pollock.—RDS

. . .

PATRICIA SIEGEL has testified as a handwriting expert in U.S. federal and state courts, taught courses in the psychology of handwriting and handwriting identification, lectured at international congresses, and published numerous articles on handwriting. She is certified by the American Board of Forensic Examiners and is currently president of the American Society of Professional Graphologists.

. . .

The arts of writing, drawing, painting—and the act of signing one's name— all express the individuality of the artist. The writer's movement creates forms within the spatial structure of a signature that reflect the writer's habits and propensities. Each signature deviates from the one before, but an examination of multiple signatures reveals patterns within the natural variation of the writer that are uniquely his or her own. Whether by pen stroke or brush stroke, it is this individuality of repeated movements and overlapping motifs which provides the foundation for comparison. It allows the handwriting expert to differentiate one person's writing from another's and, ultimately, to determine if a signature is genuine.

9.1 Signature on a painting claimed to be by Jackson Pollock. Courtesy The Pollock-Krasner Foundation.

The Process

To illustrate the process of identification, I will review a case involving a questioned signature on a painting claimed to be by Jackson Pollock (figure 9.1). I was asked to determine whether or not the signature was a forgery. Evaluation of the authenticity of the artwork, exclusive of the signature, was in the hands of other experts.

I examined fourteen Jackson Pollock signatures on undisputed paintings executed in the approximate time frame (1948–1949) as the signature in question (figures 9.2–9.6), as well as numerous copies of his other signatures. There is considerable variability among these known signatures, and among other copies of signatures which I also examined. The erratic "irritability" of Pollock's stroke quality is, in itself, an important identifying feature that colors the individualistic imprint of all his signatures.

Pollock's signatures, as shown in his known standards were in constant flux, but their symbolic impression and his motor habits conform to each other, even when executed in different media. Each artist has a rhythm (or multiple rhythms) which permeates the flow of his or her signature. Even when there is considerable inconsistency among known signatures, as in the case of Pollock, there are still common elements.

Pollock's known signatures are identifiable by observing clusters of interrelated graphics rather than any single element. They must be evaluated as part of his changing, yet distinct, dynamics. Although the superficial appearance of the questioned signature is similar to Pollock's known signatures, a close, methodical examination reveals significant contrasting elements. These led me to conclude that the questioned signature is not genuine.

A writer's stroke quality generates the line which forms the signature. The stroke pressure of Pollock's known signatures is uneven throughout the samples, created by jerky, spontaneous movements and often seen in flooded letters, or in blotches and blurring in the production of the line. Pollock had a tendency to restart letters and would often retrace them as well. By contrast,

9.2–9.6 Jackson Pollock signatures on undisputed paintings dating 1948–1949. Courtesy The Pollock-Krasner Foundation.

the questioned signature is carefully drawn, with evenly applied pressure and a relatively smooth outline on the edges of the stroke. The consistency of the stroke quality in the questioned signature was produced by regular, undifferentiated contraction and release movements of the hand and fingers. The contraction and release movements of the known signatures, on the other hand, are abrupt, without smooth transition, creating greater angularity and tension in their stroke quality.

The spacing between the letters of the known signatures is also uneven, and differs from the questioned signature, which has more consistent spacing between letters.

Most of the letters in Pollock's known signatures are connected. There are some separations. For instance, in his first name, the *k* is usually separated from the *s*, and the *J* is occasionally separated from the *a*. In his surname, the *P* and *o,* and sometimes the two downstrokes of the terminal *k,* are separated as well. Although there tend to be fewer connections when Pollock signs with a thick brush, overall, most of the letters in his signatures are connected. In the questioned signature, line continuity is broken; there are stops between most of the letters. Such hesitations imply deliberate forethought and are classic hallmarks of a forger's uncertainty in a freehand simulation.

Usually a forger will concentrate on the general appearance of the letter forms themselves, but it is difficult to suppress one's own habits while trying to adopt someone else's patterns. Therefore, some stylistic similarity to an artist's known signatures may be achieved, but subtleties usually escape a forger's awareness or ability to duplicate. This is the case with the Jackson Pollock forgery. The more subtle the dynamics of the known signatures, the more individualistic and significant they are for identification purposes.

The forger copied the *superficial* look of Pollock's signature but had difficulty attempting to copy the letter shapes themselves. This is particularly evident in the capital *P* of the questioned signature, in which the top has a more oval shape, and is proportionally smaller relative to the length of the stem, than in the known signatures. There are differences between the questioned and known signatures in other letters as well. They are most obvious in the construction of the "son" combination in "Jackson" and the *o*'s in "Pollock."

Other graphic patterns are identified by comparing letters within a signature. For instance, in the known signatures, there is a discrepancy in size between the two *k*s, with the *k* in "Jackson" smaller and less boldly drawn than the final *k* in "Pollock." In the questioned signature, the two *k*'s are more uniform. As another example, the height of the *J* is short relative to the *k* in "Jackson" in the known signatures. The forger was not able to execute this distinction and drew the *J* and *k* with comparable height.

Handwriting is one of the most complicated tasks we learn, but once learned, it becomes an automatic part of our behavior. It is extremely diffi-

cult to ignore these tendencies and simultaneously notice and adopt the habits of someone else. This is why the Pollock forger failed to emulate a number of important characteristics of the artist's genuine signature.

In conclusion, the signature is an expression of the artist, independent of the art itself. Its individuality enables the handwriting expert to assist in proving or disproving the authenticity of the object on which it is executed. Although any two of Jackson Pollock's many known signatures may be superficially quite different from one another, as a collection of many signatures they have unity. By evaluating them as a composite of varying and habitual motor responses, the expert can discern threads of similar dynamics that are then used to differentiate the authentic signature from the forgery.

IO

The International Foundation
for Art Research

. . .

Sharon Flescher

. . .

Although there are numerous authentication committees and boards that render opinions on the authenticity of a work of an individual artist, the International Foundation for Art Research is the only institution that will take up questions of authenticity on the work of a large number of artists. Sharon Flescher describes the institution's usual authentication procedures as well as some of the issues it has faced.—RDS

. . .

SHARON FLESCHER is executive director of IFAR, editor in chief of *IFAR Journal,* and an adjunct professor at New York University. She is the author of several works on nineteenth-century French art and numerous articles on art and law published in the *IFAR Journal.*

Background

The International Foundation for Art Research (IFAR) was established in the late 1960s in the wake of several major art frauds that shook public confidence in the art market. Hearings organized by the attorney general of New York led to landmark legislation, incorporated into the state's 1968 Arts and Cultural Affairs Law, which offered protection to collectors when purchasing from dealers. But another component of the proposed legislation did not pass: protection of experts from liability when rendering opinions. Then, as now, scholars were reluctant to speak out on issues of authenticity and attribution for fear of litigation. What was needed was an authoritative, objective, not-for-profit organization to serve as a bridge between the public and the specialists. IFAR was created to fill that void. It was set up initially to be a legal and administrative framework wherein the world's greatest scholars could

render opinions on authenticity without fear of liability: opinions would not be presented in the name of the scholar but in that of IFAR.

This core activity provided a rationale for many of IFAR's other activities, such as its involvement in art fraud and, more recently, in issues concerning catalogues raisonnés. IFAR's purview later expanded to include issues of art ownership, theft, and law; it broadened its educational activities and launched a publication; and it is best known for creating the first stolen art database available to the public. Nevertheless, issues of attribution and connoisseurship have remained central to its mission.

IFAR's founders were preeminent in the art field. They included Harry Bober, the Avalon Professor of the Humanities at New York University's Institute of Fine Arts; John Rewald, the great Impressionist scholar; José López-Rey, a specialist in Spanish art, also on the faculty of the Institute of Fine Arts; and Lawrence Majeski, then chairman of the Institute of Fine Arts' Conservation Center. There were also attorneys, such as Joseph Rothman, the assistant attorney general of New York, who had spearheaded the state's art fraud hearings in the 1960s. As its first president, IFAR chose the distinguished art collector John de Menil. The stature of these people was crucial to the fledgling organization's success and to its ability to enlist the help of other specialists. Their credibility lent credibility to the organization, to its premise, and, most important, to the opinions it rendered. What, after all, gave IFAR in 1969 the "authority" to set itself up as the "expert?" Indeed, the question of "expertise" and "who judges the experts" is an important one that currently plagues many authentication boards, catalogue raisonné committees, and independent scholars.

To this day, IFAR's Art Advisory Council comprises some of the world's greatest specialists in a variety of areas, but research on a given authentication project is in no way limited to the Council; indeed, all of the specialists on a project frequently are drawn from the outside. The goal is to involve the most knowledgeable and unbiased experts in order to render the most authoritative opinion. To date, IFAR's Authentication Service has written approximately 700 full-fledged authentication reports and has reviewed additional thousands of artworks.

Criteria for Accepting Projects

Deciding whether to undertake an authentication project frequently involves many hours of time. IFAR was not designed to be the *Antiques Road Show*. At inception, it was determined that not every object in grandma's attic warranted the time or expertise of renowned specialists, particularly given the modest honoraria we could offer or the gratis advice we often needed. Pri-

ority is given to projects of art historical substance, or to those works where there is a serious difference of opinion as to authenticity or a potential for discovering an unknown work by a major artist (there have been few of the latter). Paradoxically, we may accept a work which we suspect is part of a scheme to defraud, in order to be able to alert the public. We reject projects for which we can't provide the right expertise—if, for example, the acknowledged experts won't help. Except in rare circumstances, we don't accept works by artists (usually twentieth-century artists) for whom an authentication board exists. There is no need for IFAR to reinvent the wheel. Occasionally, we turn down a project simply because we are inundated with requests relating to that artist. Such is the case with Salvador Dalí. After the director of IFAR's Authentication Service served as a witness at the 1990 fraud trial of the Center Art Gallery in Honolulu, which had knowingly sold thousands of fake Dalí prints, we couldn't handle the flood of Dalí requests. There were—and are—quite simply too many Dalí fakes! We are not the Salvador Dalí Authentication Board, nor that of any other artist, and we now refer all Dalí inquiries to the Dalí Foundation and several other Dalí specialists.

The Process

IFAR generally involves more than one, and usually several, specialists on an authentication project, in addition to researchers. The specialists' names are usually provided in our final report, but some specialists, often because of their institutional affiliation, prefer to remain anonymous, and we honor that request. (Many museums have guidelines precluding curator involvement in authentication, both because of the "taint" of commercialism and because of the potential liability against both the curator and the museum.) IFAR is under no obligation to disclose the specialists' names. Prior to 1976, all our specialists' names were kept confidential, but the policy was reversed in the belief that the renown of our specialists lent credibility to the opinions rendered.

Research may take weeks or even months, depending on the complexity of the issues involved and the schedules of the specialists. At the end of the research, IFAR issues a report stating its opinion and outlining its reasons. We believe in the transparency of the process. We do not issue "certificates" of authenticity, nor do we provide a monetary valuation. We have nothing to gain or lose from the decision. Our fee is the same whether the work is deemed authentic or not, and it barely covers IFAR's out-of-pocket costs for researchers and experts. It does not pay for overhead or other administrative expenses. Shipping, insurance, and laboratory fees are extra, and are borne by

the client. Although we can usually be categorical in our determination, when we cannot be, we explain why. Works are almost always submitted with an initial attribution. Our obligation is to confirm or reject that attribution. If we believe the work to be a fake, we say so. If it is a case of misattribution, we try to proffer an alternate one, but are under no obligation to do so.

IFAR endorses a three-pronged approach to authenticity and attribution research:

1. Connoisseurship—the "expert" eye based on intimate familiarity with an artist's oeuvre
2. Scholarly documentation, including provenance and other archival or historical evidence
3. Physical and technical examination by scholars and materials specialists.

The last sometimes entails laboratory work, such as pigment tests, infrared reflectography, X rays, and thermoluminescence; at other times it may simply involve close visual inspection of the material properties of the work by a conservator and scholars, as well as examination under magnification and ultraviolet light. The relative weight of each of these three prongs depends on the project.

Technical analysis has always been an important component of IFAR's working method, but our use of it has changed over time. In our early years, *every* work was x-rayed and subjected to pigment analysis, among other tests, to ascertain whether it was "of the period" and consistent with what might be expected of the given artist. The facilities of the New York University Institute of Fine Arts' Conservation Center, whose longtime chairman was on IFAR's Board and Advisory Council, were made available to us. We drew on other conservators and labs as well. But over the years, we became more selective in our use of tests. We found it more efficacious to proceed in stages, relying initially on simple procedures such as ultraviolet, low-power magnification, and the eyes of trained scholars, curators, and materials specialists, all of which could be handled in our office. The more costly, time-consuming, and sometimes invasive technical procedures are now reserved for questions that can't be answered in other ways. Contrary to the layperson's perception, we have found sophisticated scientific tests to be far more effective at ruling out than at ruling in. Pigment analysis may establish a date before which the work could not have been painted, and thereby rule out a twentieth-century forgery of a purported seventeenth-century work. But finding that materials are "consistent" with a given period or artist does not necessarily mean the work is "by" that artist. A crucial difference.

Moreover, science requires baseline comparisons, and the art field is only starting to build a body of evidence showing what materials and supports

were used by which artists at which times. It has taken some thirty years for the Rembrandt Research Project, working with a team of specialists on a seemingly limitless budget, to amass information about only one artist. Eventually, such data, aided by sophisticated computer technology, will yield a cornucopia of treasures, but that day has not yet come. Until it does, the trained eye of the connoisseur, despite its subjectivity, and the knowledge of the scholar will be equally, if not occasionally more, reliable than science in determining attribution and authenticity.

Liability

From its inception, IFAR established procedures to shield itself and its specialists and researchers from liability. All clients sign a contract in which they

1. Waive their right to sue IFAR for a negative opinion
2. Acknowledge IFAR's right, if desired, to withhold the names of its specialists
3. Permit IFAR to publish the results of its research, although we will not reveal the name of the owner without permission.

Significantly, IFAR has never been sued in over thirty years. But we now know, based on the court ruling in *Lariviere v. E. V. Thaw, the Pollock-Krasner Authentication Board, et al.* that the courts will uphold the contract waiver should someone try to initiate a suit (see chapter 17). More than twenty-five years ago, one disgruntled owner threatened to sue in order to force us to reveal the names of the specialists, which at that time were automatically kept confidential, but he promptly withdrew the suit without any liability or disclosure by IFAR.

Fraud

Over the years, the great majority of the works submitted to IFAR (close to 80 percent) have been deemed not to be by the artist to whom they were attributed at the time of submission. Although most of these cases involved simple misattribution, often by an overly optimistic owner at some point in the work's history, we have encountered numerous examples of fraud, such as the "ancient" Assyrian bronze that was revealed under X ray to be made by a modern sandcasting technique and put together with a modern brazing alloy.

If we become aware of a pattern of fraud, we alert our readership and cooperate with authorities, usually the FBI or police. IFAR is not a law en-

forcement agency. But born as we were in the aftermath of the art fraud hearings of the 1960s, and with an assistant attorney general of New York as a founding trustee, it is not surprising that we have always played a role in the exposure of art fraud. The Authentication Service reserves the right to publish its research as needed, both to advance scholarship and to work against fraud, thereby fulfilling IFAR's public service mission. Over the years, IFAR's expertise has been called upon time and again by the government, and IFAR has testified in many court cases, such as the Center Art Gallery trial mentioned above. We have uncovered large-scale forgery patterns relating to artists as diverse as Thomas Hart Benton, Edmund Tarbell, Raoul Dufy, and Salvador Dalí.

In the 1980s, for example, seven works on paper attributed to Benton were submitted to IFAR by different owners over a two-year period. All were determined to be fakes. Benton and his fellow figurative painters were enjoying a resurgence of interest and an increase in prices. A concomitant flurry of forgeries was appearing on the market. Armed with IFAR's information, the Los Angeles Police Department launched a fraud investigation.

In 1979, IFAR examined eighteen paintings attributed to a variety of artists, including Monet, Picasso, Braque, Childe Hassam, Gino Severini, Haim Soutine, and three works each to Kandinsky and Klee. All the works belonged to one client and all were found to be fakes, some only crude imitations but others very accomplished. One specialist described the Klees as among the best forgeries he'd ever seen. Many of the paintings came with gallery labels, which in at least five cases were also shown to be fakes. All the works were traced to a single art dealer. The deceived owner of the eighteen fakes that IFAR examined settled out of court, but as a result of IFAR's investigation and with word that other works from the same source were about to be sold, the FBI came into the picture. It seized approximately 800 works from a warehouse and eventually drove the dealer out of business.

Issues

Much has changed in the art field since IFAR was launched, and it's had an impact on our Authentication Service. The sheer number of catalogues raisonnés produced since the 1970s and the mushrooming of authentication boards is one change. As already noted, we refer people directly to such a board when one exists for the artist in question. But problems arise when boards or catalogue raisonné committees disband, and the specialists involved, who spent years gathering expertise and data, are unwilling to share them with us (or others). It is their right, of course, but our process can work only if we involve the most knowledgeable people and have access to the most up-

to-date information. The inability to enlist the necessary experts is one rea-
son why IFAR may refuse to take on a project.

Increasing fear of liability on the part of scholars and institutions has caused
many to shy away from the authentication process entirely. The fear itself
isn't new—after all, it is one of the reasons IFAR was founded in the first
place—but the extent to which it has intimidated scholars and other special-
ists is new. It threatens to stifle the free expression of scholarly opinion. Cau-
tious attorneys advise authentication boards not to share their reasons for re-
jecting a work; they advise them merely to say "yes" or "no," or that the work
will or will not be included in the catalogue raisonné. The lack of articulated
reasons leaves disappointed owners frustrated; and frequently they turn to
IFAR. But we are unlikely to accept such projects because the committee's
or board's data aren't necessarily available to us; it would be difficult to assem-
ble a team of specialists who haven't already voiced an opinion; and we don't
see ourselves as the automatic "second opinion" for rejected works, which
usually were rejected for good reason. But the situation creates frustration all
around.

The astronomical sums of money involved in the current art market and
the litigiousness of our society have contributed to liability concerns. The
threat of lawsuits has risen with escalating prices. Much rides on an authen-
ticity decision. A painting of *The Massacre of the Innocents* languished in an
Austrian monastery as the work of Jan van den Hoecke, a Rubens follower.
Recently reattributed to Rubens himself, it sold at auction for $76 million.
Given such stakes, proffering an opinion on authenticity can be a perilous af-
fair. An incorrect opinion, or one that devalues a private owner's work, es-
pecially if it is on or about to go on the market, risks a lawsuit. IFAR has been
spared these suits because of the liability waiver we insist upon and also be-
cause we rarely take on a project that might involve us in a third-party law-
suit. Moreover, we not only do not appraise and get involved in valuation
issues, we prefer not to get involved (although we occasionally do) with art-
works that have recently been bought or are about to be sold unless both the
buyer and the seller agree to our involvement.

IFAR is not obligated to arrive at a definitive opinion, although we try.
Over the years there has been surprising unanimity of opinion on virtually
every project, but sometimes—usually in the case of Old Masters—there
is a difference of opinion, which we openly state and explain. Inconclusive
opinions may not be ideal, but art history isn't perfect. Experts don't always
have the answers; documentation doesn't always exist; scientific data, which
the public places so much—perhaps too much—faith in, is just beginning
to be accumulated. Twenty or thirty years might be needed before a defini-
tive answer to an authentication question could be offered; and in some cases
the answer might never be known. The marketplace—and owners—may

not be comfortable with this situation, and it is certainly not ideal, but it is a realistic assessment of the state of art authentication, and we caution clients that they cannot always expect a yes-or-no response.

• • •

Although discoveries of unknown works by major artists are rare, IFAR has had its share—finding works by Jacob van Ruisdael, Joan Miró, Eugène Boudin, Rosa Bonheur, Joshua Reynolds, Thomas Hart Benton, and others. It is perhaps the hope of uncovering other works by important artists that keeps the Authentication Service at IFAR humming—along with the realization that IFAR is the one place in the United States, and one of the few in the world, to which an owner—whether museum, individual, or institution—can turn for an objective, informed opinion about any work of art, from ancient to modern.

II

Museums and Authenticity Issues

. . .

Samuel Sachs II Interviewed by Ronald D. Spencer

. . .

A museum director addresses issues of authenticity faced by museums and raises the issue of the unattributed work of art of consummate quality.—RDS

. . .

SAMUEL SACHS is the former director of The Frick Collection, New York. He was formerly director of the Detroit Institute of Arts (1985–1997) and the Minneapolis Institute of Arts (1973–1985).

. . .

RDS: Would you describe the kinds of authenticity issues that come up in public museums?

SS, II: To set a standard of comparison, let me begin with a work at the Frick that poses no authenticity issues whatsoever. Its authenticity cannot possibly be in doubt because its provenance can be tracked from the moment it left the artist's hand to the moment it came into The Frick Collection: the panels by Fragonard in what is known as the Fragonard Room. These were commissioned from the artist at a known date, delivered to the buyer (who immediately rejected them), and they went back into Fragonard's own hands. They hung in his house until he died, whence every owner thereafter can be traced minute by minute until Mr. Frick bought them from J. P. Morgan, who had owned and installed them in his house in London. There cannot be any serious doubt about this unbroken provenance. In legal terminology, it would be called a trail of evidence.

But there is another picture at the Frick which has been hotly debated. Known as *The Polish Rider*, it was long thought by many to be by Rembrandt. At one point, it was rejected by the so-called Rembrandt Committee [the Rembrandt Research Project], which was self-designated to fully authenticate the artist's oeuvre—an oeuvre that is muddy, to say the least. And then the picture was reinstated. The Rembrandt Committee had

winnowed down Rembrandt's oeuvre to the point where I think they accepted without question perhaps 300 paintings, and for an artist who lived as long and as productively as Rembrandt did (1606–1669), it was rather ridiculous to think that there are only 300 works. But art historians have a way of sanitizing and improving on an artist's work so that anything that isn't 100 percent perfect or 100 percent provable is subject to rejection. *The Polish Rider* has been reinstated, as I said, so it now is thought to be what I believe the Frick pretty much always believed it to be, by Rembrandt *and* someone else. Perhaps a student helped Rembrandt or repairs were made to the original canvas, but it is now unquestionably in some arguable percentage by the master's hand. Its authenticity is established.

To the yin of authentication, the perfect yang of course would be the work that is absolutely, demonstrably not by the artist. And in fact such a work also resides in The Frick Collection, but it is not on display. It is a work that Mr. Frick purchased long-distance that proved to be an error, a "Rubens" which he kept forever after as a reminder never to buy anything until he had seen it.

There are other paintings whose authorship has migrated over time. A portrait hanging in my office was once thought to be by the great French eighteenth-century artist Jacques-Louis David. Subsequently, a drawing was discovered for the painting, and the drawing was not by David, but by one of his terrific yet little-known students, to whom the painting is now attributed—Césarine-Henriette-Flore Davin-Mirvault. It is the only painting by a woman in The Frick Collection. Hers is hardly a household name—indeed, many professors and curators of French eighteenth-century painting would not recognize it, which is sad. I hope someday to have the time to further research this lady's work, because she clearly was a remarkable talent; I expect we'll find that she died quite young, or got married and dropped out of the painting scene.

More important than the matter of attribution, however, is whether the painting is a work of consummate quality, and at the end of the day this is what museums are most interested in. More so than dealers, perhaps, museums value objects regardless of their worth. Thus a work of supreme quality can have a home and be admired in a museum for its great aesthetic qualities. What it will bring on the market is of secondary interest.

Another painting that illuminates attributional issues in museums is one bought by The Frick Collection after Mr. Frick's death and thought at the time to be by Georges de La Tour. Today most experts accept it as the work of the artist's son, Étienne de La Tour. In fact, it is almost the signature piece of Étienne, the work that proves his existence and his great competence. Although regarded today as lacking some of the consummate

aesthetic hallmarks of the father, it remains a testimonial to the son's ability to closely emulate his father.

RDS: How did this reattribution come about?

SS, II: The story of the reattribution exemplifies the way so much of museum-based art history has to do with objects, with the real item rather than with photographs. There was an amazing La Tour exhibition in 1997, organized by Pierre Rosenberg, the recent director of the Louvre in Paris. He brought together pictures that were unquestionably by Georges, pictures that were perhaps by Georges, and pictures that were unquestionably by Étienne or others, and hung them all together. And when you get all these works in a room, or in a series of galleries, certain wonderful things begin to happen. You can really begin to see what museum people talk about in terms of style. If someone were to sign a check with your name, you would recognize that the signature was not yours, even though every time you sign your name it looks slightly different. Obviously, this happens with painters. Their paintings are their signatures. In a room full of works by Georges, Étienne, and possibly others, Étienne comes off as a personality, but a personality different from his father.

And this has happened before. Titian is an excellent example. For many years people were unable to understand late Titian. It was a period of his oeuvre that was not well appreciated, was not understood even in his lifetime. As a result, many pictures done toward the end of his life were thought to be by inferior students. But it is the hallmark of a truly great artist that he transcends his own audience. Today we look at a late Titian and we see it in a wholly different way, as consistent with the artist's style and personality. There is a famous truism that most forgeries are discovered within one generation of their creation. It makes a lot of sense. Gene Thaw, elsewhere in this book, has said that works that would have fooled someone twenty years ago no longer do. As time passes, we come to a more precise understanding of an artist's signature style, a style that cannot be replicated, and of the consistency of this style throughout the entire oeuvre. You can be confused if you don't understand what this style is at the beginning of a career. Today it is still hard to detect a fake or misattributed Franz Kline painting, but it is not as hard as it was two decades ago.

RDS: What about other paintings in The Frick Collection, such as the Cimabue *Flagellation of Christ?*

SS, II: The painting is interesting for our discussion on many levels. The Frick Collection bought this gold-ground painting in the 1930s, with authorship unknown. At the time, and until very recently, even in The Frick Collection, it was simply called "Tuscan School"; a picture of admirable qual-

ity but uncertain authorship. In the correspondence at the time of purchase were opinions from several scholars as to whom the artist might be. Some thought it might be Giotto. Some proposed Duccio. Some proposed other names, and one great scholar (Roberto Longhi) proposed Cimabue. But none of the attributions was provable, either by signature or by any other criteria. Gradually, as we became more familiar with the style and oeuvre of late thirteenth- and fourteenth-century Tuscan artists, certain of those names were rejected. About three years ago [1999], Sotheby's, surveying the contents of a stately English home, the Gooch country house, Benacre Hall, in Suffolk, found in a cupboard in a back room a small wooden panel that their expert thought was very similar to the picture he remembered at The Frick Collection. The English panel was almost certainly on stylistic grounds by Cimabue. Much of Cimabue's style is identifiable by the way he grouped the Madonna and Child, which was the subject of the English picture. In any event, the picture was brought to New York and was placed side by side with ours. The works are identical in size, show the same tools used to stamp the gold, and are cut from the same panel. Ergo, in the absence of any other evidence, if the English picture is by Cimabue, then arguably ours is absolutely by the same hand. And the wonderful thing is that seventy years before this comparative evidence emerged, Longhi had made an attribution to Cimabue supported by nothing but his intuitive sense of the artist's style.

RDS: When a museum is considering a major purchase of a painting, how does the museum go about satisfying itself about the authenticity of a work?

SS, II: As I mentioned in the case of the Fragonard, the provenance is, if demonstrable, one of the key pieces of evidence. If you can trace the object at hand back to the ownership of the artist without a break, you have yourself a compelling case. Of course, it has been said that there are more fake provenances than there are fake paintings. And indeed many histories which guarantee that the work was in the X collection, followed by the Y collection, are completely bogus—there were no such collections. In some cases, it takes diligent study to prove this unbroken chain of evidence.

Museums have an obligation to the public to be reasonably certain about what they buy. Even if they are not buying with public money, they are putting it on public display as an educational tool, and they are maintaining a certain level of both expertise and quality in their judgment. Expertise on the part of scholars is extremely important to museums; such expertise includes that of their own curators as well as of scholars who work in universities or sometimes scholars who are dealers. Dealers, of course, have the most on the line, the most to lose. If they make a bad de-

cision and represent a picture as being something that it isn't, they not only damage their reputation, they damage any future transactions in which they may become involved. Museums rely on reliable dealers. And dealers do an enormous amount of unsung scholarship and homework before they offer something for sale. It is always said that museum curators like to claim, "I discovered this painting," which the curator then bought for the museum, when, in fact, in most cases it was first discovered by a dealer.

Curators, however, do occasionally uncover things themselves. The Raphael *Madonna of the Carnations,* now coming to America (if the British export license is granted) is a good example. The painting, spotted ten years ago [1991] in the corridor of an English castle by Nicholas Penny, then a curator at the National Gallery in London, was long thought to be a copy. Penny believed otherwise and had the work brought to the National Gallery, where it was examined by other staff members and a group of outside experts, all of whom concluded that it was indeed the original.

Ultimately, aesthetic quality holds sway even over matters of attribution or authenticity. Museums can hang a picture that is absolutely, certifiably by artist X, but if it is a weak picture, why do it? Every artist has a bad day.

RDS: I take your point. But the logic of that position is that a museum ought to be ready to purchase a high-quality work even if there are disputes about its attribution.

SS, II: That's exactly right. If they are convinced of the quality, then they can support, or at least defend against challenges to, the attribution. But if there are serious challenges to authenticity—claims that the work may not even be of the period—museums have to be enormously careful. I have seen very, very few high-quality fakes, fakes that were so compellingly beautiful in and of themselves that you didn't care who did it.

RDS: But a fake is created with an intent to deceive. What about a work of high quality but uncertain attribution?

SS, II: I think we are wandering off into deep water here. The Davin-Mirvault in my office is a picture of undeniable quality. That it isn't by David doesn't much matter. At the end of the day it has a place in a museum because of its quality, not its authorship. Its market value, however, is undeniably less.

RDS: You say dealers do a lot of good art historical research. If a dealer with an impeccable reputation offers a painting to a museum and accompanies the offer with thorough research material, to what extent should a museum do its own research, at least on provenance?

SS, II: The museum absolutely must satisfy itself that the research purported to have been done in fact stacks up. There are holes in probably every bit of research. How serious they are, remains to be seen. Curators make mis-

takes, dealers make mistakes. I think you have to apply the "belt and suspenders" approach when making major acquisitions.

RDS: If there are conflicting expert views on the attribution of a work of admitted high quality, but the museum board of trustees is satisfied with the quality, should a museum director recommend that the board consider purchasing the work?

SS, II: It's a hypothetical question which is always hard to answer. I am not sure where the argument is. There is a difference in market value between, say, a work attributed to a master and one attributed to a pupil. But if it is a work of great quality, I can't imagine that there would be a huge difference because ultimately it is, or at least it should be, quality that dominates the market.

RDS: So, in effect, a museum is not going to be able to purchase a high-quality disputed work at a bargain price because of the dispute.

SS, II: Exactly. Now, you can have a second-rate Rembrandt or a first-rate Carel Fabritius. Fabritius commands a much lower market price normally, but a top-flight Fabritius might outprice a second-rate Rembrandt.

RDS: What about conflicting catalogues raisonnés? How does a museum deal with two catalogues raisonnés, one that includes a work, one doesn't include the work, both written by recognized authorities in the field?

SS, II: I think that it is impossible, first of all, to give a generalist answer to that question. In some cases, it is known that works are either included or, by the same measure, excluded from catalogues raisonnés because of malice or avarice or occasionally even just plain stupidity. Some paintings left out of catalogues raisonnés are completely authentic. They just weren't included because somebody's palm wasn't appropriately crossed. There have been works included in catalogues raisonnés that today are demonstrably false. Such realizations represent the advance of scholarship.

RDS: Earlier in our conversation you mentioned Franz Kline. You noted that a picture that isn't by Kline's hand is easier to spot today. Why so?

SS, II: Because more people are able to read Kline's signature style. By the same token, there used to be an old joke about Corot: that in his lifetime he painted 4,000 pictures, of which 5,500 were in America! When Corot was in great demand, there were many, many fake Corots being sold as authentic that wouldn't fool even a nonexpert today. Since demand obviously drives the art market, when demand outstrips supply, supply has to be invented. Kline's work, with its free energetic style, was something that a lot of people thought they could do. "Well, this is easy; I can tear up a New York phone book and splash ink on it." The fact is that works by Kline's own hand have an energy that can't be replicated, an energy that is immediately apparent today.

RDS: With respect to signatures on paintings, isn't it easier to fake a signature than to fake a style or method of working?

SS, II: No question about it.

RDS: Then why does the art world spend so much time thinking and talking about signatures on paintings as evidence of authenticity?

SS, II: I think they sometimes do so unproductively. For example, keeping to the world of Corot, it's very hard to find a signed painting by an artist called Paul-Désiré Trouillebert. He had a style that was thought to be very close to that of Corot, and his signatures were erased and Corot's put on instead, with a remarkable increase in sale value. A signature really isn't the be-all and end-all. It is also known that Modigliani agreed to sign works done by his friends so that they could sell them. There you have an inauthentic work with an authentic signature! Signature is of modest value.

Signatures can sometimes be wonderfully valuable if you discover one that nobody knew was there. Many Dutch pictures are signed in terribly obscure places—on chair rungs and picture rails—and hundreds of years might go by before someone noticed the signature. A newly discovered signature may settle an argument between scholars as to whether a work is by one artist or another. Nevertheless, the signature is not the most powerful piece of evidence.

RDS: I once put an image of a supposed Pollock painting before William Rubin of the Museum of Modern Art, and asked him what he thought of it. He looked at the image, and then I said, "Why don't you look at the signature?" And he said, "I never look at the signature."

SS, II: The painting is the signature at the end of the day. It's always amused me when exhibition organizers ask an artist to write a statement about his paintings. His paintings are his statement. How can it be put it into words? That's maybe for a curator to do, but not for the artist.

RDS: We covered this a little earlier, but I wonder if it might not be worthwhile revisiting the subject of works with disputed attributions, whose uncertainties are reflected in the market price. Is it your view that a museum, if it is convinced of the quality, might well purchase a "bargain" or should think seriously about it?

SS, II: Absolutely. I have done that in my own career—bought paintings that I thought were of extremely high quality but by an artist who wasn't well known at the time, and may subsequently have become better known or may still not be all that well known. Again, you can go back to the work by Davin-Mirvault, a picture that, were it on the market today, one would seriously think of buying for its quality alone. Ultimately, a museum is as much about this as it is about history. It is important to be able to show students and scholars the entire run of an artist's work to the best of one's ability. But it is equally possible to show an extremely high-quality pro-

duction of an artist who doesn't have a vast oeuvre—not only possible, but better, I would suggest, than showing completely authentic but second-rate works. And we all know they exist.

RDS: Could a museum buy a picture that had been deaccessioned by another museum for reasons of concern about its attribution?

SS, II: If a museum had questions about either a work's attribution or its quality, or both, the museum might decide to deaccession it. But it is a rather risky business for another museum to come along and say We think this is pretty good, we're going to buy it—and then subsequently prove that not only is the attribution unquestionable, but the picture is worthy of admiration. Now that does not mean that the aesthetic judgment was wrong. The picture, as we said before, still could be authentic but just not of the best quality. There are several examples of pictures that museum A has deaccessioned and museum B has bet the farm that a mistake was made. Some of those arguments have been won, some have been lost.

RDS: We spoke of the Rembrandt Research Project in relation to *The Polish Rider*. I gather that the Rembrandt Research Project is now, in its own words, abandoning a "yes or no" view of a particular work. Would you comment on this in general, as well as for Rembrandt, and on what this indicates for the direction art historical scholarship is taking?

SS, II: First of all, it is an extremely difficult task to try to assign to oneself a yes or no decision on Rembrandt, whose works, as we said, are muddy in many cases to begin with. He had an active school, had many students who absorbed great pieces of his teaching. He actively assisted, and helped paint or overpaint parts of his students' own works. In many pictures, even today, it is hard to tell where to draw the line between master and pupil. I think there exists a body of work about which one can say, These are 100 percent Rembrandt—but it would comprise a very small number of pictures and exclude many where there is some fuzziness or question. I think hard-and-fast scholarship is in demand today. Increasingly, catalogues raisonnés are trying to sort out these enormous problems, but by the same token they are doomed to a certain amount of failure unless the artist kept impeccable and immaculate records. Picasso really tracked his own work, and the multivolume catalogue raisonné by Christian Zervos is consequently thorough and dependable. Although the volumes are not without problems, the undertaking was an awful lot easier than trying to track the Modigliani oeuvre. There are reasons why certain artists don't have catalogues raisonnés. Often no one has been brave enough to tackle it. There is always a market demand for absolute yes or no answers, but I think in art history it is seldom possible.

Examining the Techniques
and Materials of Paintings

. . .

Rustin S. Levenson

. . .

Rustin Levenson, a conservator, describes the various physical layers of a work as well as methods of scientific testing currently in use.—RDS

. . .

RUSTIN LEVENSON is a painting conservator with private studios in New York and Miami. She has been on the painting conservation staff at the National Gallery of Canada and the Metropolitan Museum of Art, and has written numerous articles for conservation publications. In 2000, she co-authored *Seeing Through Paintings: Physical Examination in Art Historical Studies*, a comprehensive study of conservation issues directed to art historians.

. . .

Conservation treatments require spending large amounts of time with paintings. After weeks of hands-on consolidating, cleaning, structural treatment, and inpainting, a conservator develops an intimate sense of an artist's work. The instincts acquired through this connection constitute a conservator's primary tool in the analysis of a painting.

Beyond the experienced eye, how does a conservator go about assessing the physical evidence of a painting? The arrival of a painting in the conservation studio unleashes a cascade of questions relating to the physical materials and the state of the work. How did the artist achieve the effects of color, light, space, and surface? Has the age or condition of the painting changed these effects? Are the materials consistent with the date of the painting?

Beginning to Gather Evidence: A Visual Examination

A conservator's examination starts with removing the painting from the frame and using different types of light to study the work. Strong direct light is a good beginning.

Variations in texture and color that can indicate previous repairs or pentimenti (the artist's changes in design) are often visible in good light. Using transmitted light—holding the painting up to a light source and letting the light shine through—enables a conservator to examine cracks and damages. Raking light, which sweeps across the painting at an angle, facilitates a comparison of the pattern of the paint impasto (the brush stroke) against that of the final design. Pentimenti are often first identified by impasto textures that reveal an earlier variation of the composition. Specular, or reflected, light allows the conservator to check the uniformity of the surface gloss and to gather knowledge about the varnish application and removal.

During visual examination, a conservator considers the layers that make up a painting. The support is the structural element, usually a canvas or a panel, that carries the ground, paint, and varnish layers. The ground or preparation is the material applied to the support to give the texture and absorbency needed for the application of the paint. The paint or design layer, applied over the ground, is where the artist carries out the visual idea. The final layer is a varnish coating, applied over the paint, which saturates the colors and protects the surface of the work. As these layers are examined, more questions are raised.

The Support Layer

The choice of support and its condition have a profound effect on the look of the paint layer. Various supports have been used throughout the history of Western art. Artists primarily used wood panel supports until the Renaissance, when textile supports began to be employed. Copper supports were used occasionally by painters after the sixteenth century.

Comparing the support layer against those in other works by the artist can yield important information, from an approximate date to a determination that the composition has (or has not) been reduced, enlarged, or otherwise altered.

Wood panel supports vary considerably. The conservator first looks at a panel to see what type of wood was used. Reference books and articles supply essential data about the woods utilized by various artists. For example, Jacqueline Marette, in her book *Connaissance des primitifs par l'étude de bois*, outlines the types of wood used in European panels through the sixteenth cen-

tury. She finds that, with minor exceptions in Spain, most painters used wood from local forests.[1] Another article documents a wood support invented in the nineteenth century. On June 29, 1880, E. F. French of New York patented a board "built up of three layers of veneers with [the grain] crossing at right angles." When this early plywood was discovered supporting George Iness's *Albano, Italy*, it forced a reconsideration of the chronology of the artist's oeuvre. Long assigned a date of 1874—six years before the plywood support came on the market—the painting had to be reassessed as part of Inness's later oeuvre.[2]

Dendrochronology, the study of seasonal growth rings in trees, can be useful in dating panel paintings. If the appropriate rings are present in a panel, the date for the felling of the tree can be determined. However, panels do not always contain the rings necessary for such an analysis. Furthermore, it should be noted that the felling of the tree could considerably predate the use of the panel and that a forger could work on an antique panel.

Conservators ask many other questions as they examine a panel. Was the wood hand-primed or commercially prepared by a nineteenth-century colorist? Has the wood been cut down? Was a hand tool or an electric tool used in making any visible cuts? Manual saws will make characteristically uneven marks, while the marks left by a machine saw are very regular. Machine saw marks on a painting dated before the Industrial Revolution indicate that the format of the support has been altered or that the painting was produced at a later date.

The characteristics of the woodworking on a panel, such as joins or other carpentry details, also can offer clues about a painting's provenance because such details vary from region to region and from century to century. The addition of a "cradle" is equally informative. A cradle is a wooden lattice attached to the back of a panel, usually by a restorer attempting to repair a split or to reduce warping. The woodworking of the mobile cradles on the reverse of three Raphael paintings in the Prado Museum, for example, is similar to that on seventeenth-century Spanish furniture. It is therefore reasonable to assume that the Raphaels were in Spain by this date. Later, during the Napoleonic Wars, they were appropriated by French troops and sent to France. Although they were subsequently returned, the determination that the cradles are Spanish woodworking of the seventeenth century verifies that no support structures were added during the paintings' sojourn in France.[3]

Textiles came into regular use as supports for easel paintings around 1500. The primary advantage of fabric supports was summarized by Giorgio Vasari in his famous sixteenth-century *Lives of the Painters*: "In order to be able to convey pictures from one place to another men have invented the convenient method of painting on canvas, which is of little weight, and when rolled up is easy to transport."[4]

If a painting is on canvas, a conservator will note the type of weave, the

presence or absence of seams, and the quality of the canvas. Claude Monet characteristically used a handkerchief-fine linen as opposed to the inexpensive bast fiber canvases that often supported the Tahitian paintings of Paul Gauguin. A painting on a fabric that is unusual for an artist indicates the need for further research on the painting. Sometimes the textile support is merely an expedient piece of fabric—the red-checked tablecloth used by Vincent van Gogh in *Large Plane Trees* (Cleveland Museum of Art) or the serape used by Rufino Tamayo in *Pueblo* (University of California at Berkeley Art Museum).

Was the canvas stretched by the artist, his studio, or a professional colorist? If the support material was commercially purchased, is there a label or stamp to identify the maker? There are long bibliographies in the literature that outline the types of supports selected by artists of various eras, and that locate and date identifying makers' information. For example, a maker's mark that includes the address of a New York colorist can date a canvas quite precisely, since the stamped address can be matched to those recorded in historic business directories.[5]

If a painting is on canvas, it is important to examine the tacking margins. Are they original? If so, are the nails new or old? Is there more than one set of nail holes? Is there ground or paint on the tacking margins? Is the canvas brittle and aged at these points, or fresh and flexible? Are thread distortions resembling garlands visible next to the fold of the tacking margins? These arcing distortions are formed when a painting is stretched and prepared. Physics dictates that such scalloping should be nearly equal on opposing sides. A canvas with unequal distortions almost certainly has been cut down.

An examination of the stretcher design can play an essential role in dating the work or determining its origin. Is the woodworking in the corner join specific to a certain era or country? Are there keys or wedges for expanding the stretcher in the corners? Many corner designs were patented and thus are datable.[6]

The Ground Layer

The ground, or preparation, layer is usually not visible to the viewer except along the edges or in areas of paint loss. Examining these areas, the conservator tries to assess the color, texture, and composition of the ground layer. Has the color of the ground affected the look of the paint layer? Has the composition of the ground led to condition problems? Is the ground in keeping with the purported date of the painting? Is underdrawing or incising visible? Artists often laid out their designs on the preparation layer with chalk, ink, or paint. Some artists physically scratched the ground to lay out perspective or to outline architectural elements.

The physical evidence of a particular artist's preparation and planning process can be decisive in the process of authentication and attribution.

The Paint Layer

The paint or design layer is where the artist executes the design and is a primary factor in authenticating a work. In the paint layer, the binding medium —the liquid substance mixed with the powdered pigments—fixes the pigments to the ground and support layers. The choice of medium and pigments affects the application and aging properties of the paint. The ingredients in a painting medium vary according to the pigments and painting method. For example, a glazing layer would probably have resinous varnish added. If this quicker-drying layer is applied over a layer that is not yet dry, "alligator" cracking can occur. Pigments that fade or change can alter the appearance of a painting completely. The study of artists' materials has provided dates for the introduction of specific pigments into artistic palettes.[7] A famous example of pigment identification in art history involves the story of Hans van Meegeren, a twentieth-century forger of Vermeer whose fakes were for a long time accepted as authentic Vermeers. Van Meegeren had foreseen that there might be technical analysis of his works, and carefully purchased natural ultramarine, a pigment in use since ancient times, to paint the blues. His supplier, however, adulterated the ultramarine with cobalt blue, a nineteenth-century pigment, thus eventually confirming the forgery.[8]

As a paint layer becomes aged and brittle, and the canvas or panel beneath continues to move microscopically in response to atmospheric conditions, cracks form. Spike Bucklow has categorized these cracks using a precise set of descriptive terms. He was further able to associate *craquelure* patterns with different eras of art history.[9] Patterns of cracking can also announce events in a painting's past. A series of long, vertical cracks indicates that a canvas may have been rolled at some point. Concentric webs of craquelure indicate past blows or stress to a paint layer. A conservator will examine the pattern of craquelure to ascertain if it is in keeping with the materials used. Is it consistent with the support material, the artist's materials, and the history of the work? Paint that crosses or covers craquelure patterns, for example, has been applied after the artist completed the painting and aging occurred. On the other hand, the total absence of cracks in a paint layer on an older panel or canvas should certainly raise some questions.

Observing and comparing the opacity and gloss of the paint layer can help locate retouches or overpainting. In one case, a Manhattan bank looked forward to displaying an eighteenth-century capriccio—an imaginary view of architecture in a picturesque setting—in its boardroom. A large glossy area in

the foreground indicated the presence of overpainting. While testing this area in our studio, we found the artist's original paint beneath. Removal of the varnish and overpainting revealed a group of figures clustered around a bare-breasted Lucretia bleeding from her famous self-inflicted wound. Reclaiming the design of the artist certainly increased the authenticity of the painting, but decidedly reduced its boardroom appeal.

Because of the chemistry of the oil medium, paint becomes more transparent with age, revealing pentimenti once successfully covered. These emerging shadows speak of the history of the painting and of the artist's creative process. Some artists exhibit a sureness of conception that makes pentimenti rare in their works. Others are known for changing a painting significantly during the act of creation. An original by such an artist would be expected to show pentimenti, while a copy would have few if any compositional alterations.

The Varnish Layer

The varnish, applied over the paint layer as a saturating and protective surface, can also have a profound effect on the look of the painting. Has the varnish discolored? Is the gloss uneven? Has it been partially or completely removed in the past? Is there a pattern on the reverse of the canvas that reflects the *craquelure* of the painting? When a painting is cleaned or varnished, the liquefied resin seeps through the cracks and stains the canvas. Such stains give an indication that the work had been treated after it had aged and cracked.

Technical and Material History

The body of information about artists' materials and techniques has grown enormously since Cennino Cennini's *Il libro dell'arte*, which described the artist's craft in Padua in the late fourteenth century. In 2000, my colleague Andrea Kirsh and I published *Seeing Through Paintings: Physical Examination in Art Historical Studies*. The book details the investigation of paintings as physical objects. Using examples from the fourteenth through the twentieth centuries, we studied the historical and critical implications of the materials used by artists. The case studies demonstrate how physical evidence from all the layers of the painting can be used to arrive at art historical conclusions. The annotated bibliography presents extensive information on literature relating to artists and their materials and techniques. However, as the examples in the book illustrate, even with all the bibliographic references in the library, the material information in each painting must be carefully assessed before any conclusions are drawn.

Anyone who has ever visited an artist's studio and seen supplies piled up or shelved at random will understand how even artists themselves can be mistaken about the materials used on a specific painting. Artists also experiment, lend materials, and purchase low-budget goods. It should further be noted that artists' materials were subject to adulteration by unscrupulous suppliers and manufacturers. Besides the notorious case of Van Meegeren's supplier, examples abound of pigments and media altered for market in the eighteenth and nineteenth centuries.[10] Results that are surprising in the laboratory would have been more surprising to the artists, who had obtained the materials in good faith.

Furthermore, there are very few museum artifacts that have remained untouched by restorers, framers, owners, or other artists. The interjection of new materials into the work of an earlier era can convey misleading results, especially on tests that rely on microscopic samples. For example, if a sample for pigment analysis is taken from a twentieth-century retouch in a seventeenth-century painting, the results could be very confusing. Information obtained from materials testing is only as useful as the sample is representative.

Condition

At the same time the conservator inventories the materials and techniques of the artist, the condition of the painting is assessed. Is the work stable? If there are repairs or overpainting, in what order were they carried out? Is there structural treatment or lining evident? Why was it done? What is the age of the treatment? Has it affected the overall look of the painting? Has the work been aesthetically compromised by past treatments?

Aided Examination

Once a conservator has done a visual evaluation, the next step is to utilize aided examination. Using techniques beyond visible light, the assessments made with natural light can be confirmed and elements of a painting's structure can be specifically identified.

Ultraviolet Light

Ultraviolet, or "black," light is a light of short wavelength that causes materials on the surface of a painting to fluoresce. Aged, resinous varnish fluoresces green-yellow. Interruptions in the fluorescence of a resinous coating are usually areas where the varnish has been removed. Retouches are normally visi-

ble as lavender or purple areas. By comparative study of the retouches on a work, conservators can separate old and new retouching campaigns. Newer retouches appear as a darker purple (almost black), while old retouches are more lavender in color. A painting varnished or cleaned in the frame will show a different pattern of fluorescence around the perimeter where the frame rabbet interfered with the application or removal of the varnish. A dark purple signature over a sea of green-yellow fluorescence should prompt the examiner to check whether the signature has been added, strengthened, or overpainted.

The information obtained from ultraviolet examination is surface information only, answering questions about what has happened on the surface of the painting. As with other investigative techniques, interpretation of ultraviolet results requires experience. A painting with no greenish yellow fluorescence could have no varnish, a new resinous varnish, a synthetic varnish, or a very old, very thin resinous varnish. The lack of purple retouches could indicate a painting in good state, old retouches well covered by a veil of heavy resinous varnish, an unusual retouching medium, complete overpainting, or a masking varnish.[11] These masking varnishes have ultraviolet-filtering material added that retards the aging of the varnish and gives the painting moderate protection from ultraviolet light damage. For this reason, it also interferes with ultraviolet examination.

Infrared Examination

Infrared is at the long wavelength end of the spectrum. Because it is most sensitive to carbon-containing materials such as those found in the black pigments, black-and-white infrared studies often reveal underdrawings done with carbon inks or paints on light grounds. These underdrawings are best seen beneath reds and crimsons, which are transparent to infrared. Underdrawing done in other methods—for example, chalk drawings on dark grounds—will not be visible with infrared examination.

Infrared images can be obtained with properly sensitive photographic film (infrared photography) or with a vidicon system (infrared reflectography). Interpretation of these images, however, is not merely a matter of science. It must be done with historical knowledge about an artist's workshop practice. An underdrawing that depicts developing ideas is more likely to be by the artist. A drawing using the squared grid, called a cartoon, represents a different, more mechanical method of production that could have been carried out by an artist's workshop following the master's design.

Color infrared photography has also been found to be useful in assessing artists' materials. Color infrared film is a "false color film." Two colors that appear similar in normal light can appear to be very different with color in-

frared photography. In studies to determine the pigments in the blue areas of fourteenth-century Sienese panel paintings, the blue pigments azurite and ultramarine were easily distinguished when recorded with color infrared photography.[12]

In recent years, the publication of infrared studies has been increasing.[13] As more reference material is available, authentication research using infrared images will become more precise.

Radiography

X-ray images can expose the way a painting is created and are useful in revealing damage. Painting materials vary in transparency to X rays, with lead-containing pigments being the most absorptive. Ground layers that contain lead will reveal the weave and texture of an original canvas whose reverse is covered by a lining. Lead in the underpainting will expose the application of otherwise invisible layers of paint. Repairs, fills, and repaintings may absorb radiation differently than original paint and can become visible in an X-ray study. X rays are particularly useful in making comparisons. Within an artist's oeuvre, they can show striking similarities in paint handling or in the frequency of pentimenti. However, there are always exceptions. In midcareer, Velázquez switched from lead white to calcite white in his paint layers.[14] Without lead white, little or no design is visible in the radiograph. Comparing the resulting dissimilar X rays of works from Velázquez's midcareer and his early works would wrongly lead the examiner to question the attribution of some of his most important paintings.

Magnified Viewing

Magnified viewing begins with a jeweler's loupe. Conservators usually choose loupes that magnify the surface of the painting five to ten times. With a loupe it is easier to differentiate texture and transparency of paint, to identify retouches, and to examine cracks. Condition problems are also more evident.

Microscopic examination lets the conservator examine the cracks, the texture, and the application of the paint even more closely. Magnifications of 25x to 50x are generally the most useful. Microscopic examination can reveal signatures and inscriptions to be original to the piece, clearly worked wet on wet into the paint, or to have been added at a later time, extending over cracks or old damages. It should be kept in mind that some signatures were legitimately added long after the work was completed: the artist may have kept the work and signed it only years later; and often an artist's estate adds signatures to all the works held in its name. For this reason, some paintings

from Corot's estate appear to be signed twice—one signature inscribed by the artist at the time of painting and one added as an estate stamp.

Microscopic examination also extends to extracting and investigating cross sections of the layers of paint, which reveal the artist's working method—the sequence in which paint was applied. Cross sections are usually viewed at magnifications of 150x–250x. Special staining and lighting techniques under the microscope can enhance various layers, making identification easier. For example, microscopic staining techniques were used in an investigation of works by Albert Pinkham Ryder (1847–1917). The forgery of his works began in his lifetime, thereby complicating the detection of counterfeits. Researchers used ultraviolet light microscopy and direct reactive fluorescent dyes to examine and compare the binding media used in three autograph works and five known forgeries. In the authentic paintings, the staining revealed a complex layering. In the forgeries, the results were very different. The materials used were much more traditional, the layers were thicker, and the intricate intermixing which arose from the artist's obsessive reworking was clearly lacking.[15]

While cross sections can be very revealing, without careful interpretation and investigation they can also obscure understanding of the painting. If, for example, varnish is found between paint layers, what does it mean? Is only the work beneath the varnish the work of the original artist? Is this an artist who added a varnish between paint layers to isolate or saturate them? Could the artist have revisited the work immediately or in later years? Is the small sample being studied from an area where a varnish may have seeped between intermediate layers of paint where there was a lacuna? Is the sample from an original area at all? Could it be a resin from a later conservation treatment? Often the information conservators get from microscopic study only raises more questions.

Microchemical Testing and Polarized Light Microscopy

Microchemical testing is done using a stage microscope. The operator views a tiny sample of the paint layer as it is brought into contact with a reagent. A reaction, such as a color change or effervescence, will indicate the presence of a specific pigment. The accuracy of microchemical testing depends on the freshness of the chemicals and the careful sampling technique of original paint. Inadvertent sampling from a retouch area, for example, would yield confusing results.

Polarized light microscopy uses focused light to illuminate the sample. Manipulating the sample and the light, an experienced investigator learns to identify materials. Good results from polarized light microscopy depend on

accurate samples and on a microscopist who is familiar with the behavior of pigments and media under polarized light. Walter McCrone used polarized light microscopy to analyze the white pigments in *Ballet Espagnol* and *Infanta Margarita*, two paintings attributed to Édouard Manet. In three other works firmly attributed to Manet, he had noted the unique presence of an elongated lead white carbonate component. Comparing this white pigment against that in *Ballet Espagnol* and *Infanta Margarita*, he concluded that the two pigments "could not have been more similar if they had been squeezed from the same tube of paint."[16] McCrone's technical analysis of the pigments confirmed the attribution to Manet.

Scanning and Transmission Electron Microscopy

Scanning electron microscopy enables the conservator to view samples under 1,000x to 10,000x magnification. A scanning electron microscope can also be used to identify elements within the pigments, thereby enabling the conservator to identify the pigments themselves. Because of the very minute samples that are magnified, it is crucial to ensure that the sample taken is representative of the artist's work.

More recently, scientists have found that transmission electron microscopy is even more useful for characterizing inorganic compounds found in the paint and ground layers of paintings. This scientific tool can give more precise analytical information at the same magnifications as scanning electron microscopy.

Autoradiography

Autoradiography is quite different from radiography. Undertaking autoradiography requires transporting a painting to a nuclear physics laboratory and housing it there for several months. The painting is exposed to low levels of radiation. A succession of images is then taken that records the rates at which the materials in the work emit the radiation. The images can be very informative, showing underdrawings that cannot be seen with infrared, revealing the manner of paint application, distinguishing pigments, and recovering details of paintwork which have become obscure in dark areas. The interpretation of the multiple films obtained through autoradiography is, however, very complex. Accurate conclusions can be drawn only by considering the results in conjunction with much comparative material, supported by information about the artist and his techniques.

Other Scientific Techniques

Conservation scientists continue to work with other types of analytical equipment to identify and date supports, media, and pigments—and continue to inject a cautionary note. The refinement of radiocarbon dating, which looks at the organic materials used during the creative process, is one example. The accelerator mass spectrometer has made it possible to get results using very small samples.[17] Interpreting the results, however, requires acknowledging the limitations of the technique. Radiocarbon dating determines the date that organic material was removed from the live carbon cycle. Finding the date a tree may have been cut down does not mean it was used immediately as a painting support. Wood could have been used for a piece of furniture or a door centuries before it was recycled as a panel support for a painting. Another limitation is the margin of error inherent in mass spectroscopy, which may be too wide to allow researchers to distinguish works that are close in date.

Conclusion

Conservators, curators, art historians, collectors, auction houses, and dealers all search for the nugget of information that will attribute a painting to the hand of the artist with certainty. Nevertheless, although volumes of information about a painting's materials and techniques may be yielded by a variety of analyses, from visible light to exotic tests, the certainty of attribution remains elusive. Often the only conclusion that can be drawn from the evidence is that there is no reason the work could not be by the hand of the artist. This careful double negative best expresses the limits of our testing and knowledge, and the frustrating reality that we cannot time travel to a distant century to see the artist creating the work.

Notes

1. Jacqueline Marette, *Connaissance des primitifs par l'étude du bois* (Paris: A. & J. Picard, 1961).
2. Norman E. Muller, "An Early Example of a Plywood Support for a Painting," *Journal of the American Institute for Conservation*, 31 (Summer 1992): 257–60.
3. Raphael Alonso, "Restoration of the 'Madonna of the Oak' and Conservation of Raphael's Paintings in the Prado," in John Shearman and Marcia B. Hall, eds., *Science in the Service of Art History: The Princeton Raphael Symposium* (Princeton, N.J.: Princeton University Press, 1990), pp. 141–47.

4. G. Baldwin Brown, ed., *Vasari on Technique*, trans. Louisa S. Maclehose (repr. New York: Dover, 1960), p. 236. (First published 1907.)

5. Alexander Katlan, *American Artists' Materials: Suppliers Directory, Nineteenth Century* (Park Ridge, N.J.: Noyes Press, 1987).

6. Alexander Katlan and Peter Hastings Falk, eds., *American Artists' Materials,* vol. 2, *A Guide to Stretchers, Panels, Millboards, and Stencil Marks* (Madison, CT: Sound View Press, 1992).

7. Andrea Kirsh and Rustin S. Levenson, *Seeing Through Paintings: Physical Examination in Art Historical Studies* (New Haven, Conn.: Yale University Press, 2000), pp. 260–261.

8. Otto Kurz, *Fakes* (repr. New York: Dover, 1967), pp. 57–59, 329–34. (First published 1948.)

9. Spike Bucklow, "The Description of Craquelure Patterns," *Studies in Conservation*, 42, no. 3 (1997): 129–40.

10. Leslie Carlyle, "Authenticity and Adulteration: What Materials Were 19th-Century Artists Really Using?" *The Conservator* (United Kingdom Institute for Conservation), no. 17 (1993): 56–60.

11. Some years ago, I was examining a painting by Fernand Léger. It seemed lovely, but something about the work was slightly jarring. I had just completed a lengthy treatment on another work by Léger and had fallen in love with his gentle surfaces and resonant colors. Trying to ascertain what felt wrong with the work in front of me, I noted that the canvas showed the stiffness of a lining treatment. Even taking the slightly altered support into account, my visceral reaction persisted. "Didn't they do a good job restoring that?" the owner asked. I used my ultraviolet light to examine the surface, looking for the purple fluorescence that indicates inpainting. "Oh, you won't see anything. They used an airbrush and a special varnish. Can you believe it fell off the wall and right through a chair—torn from corner to corner?" It was remarkable. To anyone who had not spent a recent month in front of a similar work by the same artist, it probably would have appeared flawless. No evidence was left of the carnage from the back (lining) or from the front (airbrush and "special varnish").

12. Cathleen Hoeniger, "The Identification of Blue Pigments in Early Sienese Paintings by Color Infrared Photography," *Journal of the American Institute for Conservation*, 30 (Fall 1991): 115–24.

13. Kirsh and Levenson. "Sources on Infrared Reflectography," in their *Seeing Through Paintings,* p. 187.

14. Carmen Garrido, Maria Theresa Davila, and Rocia Davila, "General Remarks on the Painting Technique of Velázquez: Restoration Carried Out in the Museo del Prado," in John S. Mills and Perry Smith, eds., *Conservation of the Iberian and Latin American Cultural Heritage,* preprints of the contributions to the IIC Madrid Congress, September 9–12 (London: International Institute for Conservation, 1992).

15. Shelley A. Svoboda and Camilla J. van Vooren, "An Investigation of Albert Pinkham Ryder's Painting Materials and Techniques with Additional Research

on Forgeries," in *American Institute for Conservation, Paintings Specialty Group Post-prints* (Washington, D.C.: American Institute for Conservation, 1989).

16. Walter C. McCrone, "Polarized Light Microscopy in Conservation: A Personal Perspective," *Journal of the American Institute for Conservation*, 33 (Summer 1994): 101–14.

17. Dusan Stulik, Andrew Parker, Douglas Donahue, and Larry Toolin, "The Ulti-mate Challenge for Radiocarbon Dating: The Paint Layer," in *Postprints of the Paintings Specialty Group: 1992* (Washington, D.C.: Paintings Specialty Group of the American Institute for Conservation, 1992).

Preservation and Authenticity
in Contemporary Art

. . .

Rustin S. Levenson

. . .

Contemporary art presents conservators with nontraditional materials, resulting in interesting consequences for the authentication of contemporary art.—RDS

. . .

RUSTIN LEVENSON is a painting conservator with private studios in New York and Miami. She has been on the painting conservation staff at the National Gallery of Canada and the Metropolitan Museum of Art, and has written numerous articles for conservation publications. In 2000, she co-authored *Seeing Through Paintings: Physical Examination in Art Historical Studies*, a comprehensive study of conservation issues directed to art historians.

. . .

Twentieth-century artists employed a wider variety of materials than the Old Masters—including materials never before used in the fine arts. These non-conventional materials then became part of the meaning and impact of their pieces. In cases where the new materials prove unstable or where damage oc-curs, conservation treatments involve a very different approach, for both tech-nical and philosophical reasons.

Old Master conservators have designed structural treatments for canvas and panel supports that do not change the look of the work. In the design layer, Old Master pigments (the colorants) and the medium (the binding sub-stance that carries the pigments to form paint) do experience some alter-ations.[1] For the most part, conservators and curators have a clear under-standing and acceptance of these changes. Much testing, moreover, has been done on the materials used by conservators for cleaning, lining, consolidat-ing, retouching, and coating Old Master paintings to ascertain their effec-

tiveness, longevity, and reversibility. Thus, conservators can treat traditional paintings with a fair degree of confidence in the outcome.

Contemporary Materials: History and Scientific Examination

Jackson Pollock contended that "modern artists have found new ways and new means of making their statements. It seems to me that the modern painter cannot express this age, the airplane, the atom bomb, the radio, in the old forms of the Renaissance or of any other past culture. Each age finds its own technique."[2] The choice of artists' materials included not only traditional oil paint but also paints from commercial sources, such as house paint from hardware stores. And in the second half of the twentieth century, new varieties of acrylic and emulsion paints were manufactured specifically for artists and hobbyists. This wider choice of materials liberated artists and affected the look of their works.

Twentieth-century artists established long working relationships with paint manufacturers and explored the potential of various paints to achieve the effects they wanted. Helen Frankenthaler described her second trial with acrylic emulsion paint: "[It] was scratchy, tough, modern, once-removed— you are not as involved in métier, wrist, or medium as is often the case with oil. At its best, it fights painterliness for me."[3] It was during a visit to Helen Frankenthaler's studio with Kenneth Noland that Morris Louis was inspired to investigate the possibilities of stain painting. He was aware that oil on unprimed canvas would damage the fabric, so he proceeded to explore various types of paint media and application techniques. Louis found that Magna acrylic enabled him to realize the effects he wanted. He began a lifelong relationship with Leonard Bocour, who manufactured Magna, and after 1954 Louis never used any other type of paint.[4] Roy Lichtenstein also preferred to work with Magna, saying that he "liked the color quality [of Magna] better than [he] liked Liquitex, somehow the medium is very transparent. It doesn't look yolky. . . ."[5]

The published affinity for certain media by specific artists is important, because the Scientific Section of the Tate Gallery Conservation Department has developed two techniques for distinguishing among the various types of synthetic binders. The medium of a contemporary painting, identified with Fourier transform infrared spectroscopy (FTIR) or pyrolysis-gas chromatography mass spectrometry, can be compared against the medium in other works by an artist or against the artist's known preferences. For example, a Morris Louis painting after 1954, carried out in a paint other than Magna, should be scrutinized carefully for authenticity.

Other methods of examining contemporary paintings are similar to those used in Old Master paintings. However, because contemporary artists' mate-

rials and techniques are different, the examinations yield different results. Ultraviolet examination provides information about the surface of a painting. Old Master paintings are usually varnished, and it is the varnishes and overpaints that fluoresce under ultraviolet light, revealing data about the conservation history of the work. Because contemporary paintings lack such resinous varnishes, it is the paint layer that fluoresces, to varying degrees, depending on the binding media and pigments present. In contemporary works, ultraviolet viewing can highlight pentimenti and show retouching carried out since the work was completed.

Infrared examination shows similar information in both Old Master and contemporary painting. Like the charcoal used by Old Masters, the graphite underdrawings of contemporary artists absorb infrared light strongly, thus revealing preparatory drawings and grid marks. As with Old Masters, viewing a contemporary work with raking light illuminates areas where the impasto varies from the design, showing pentimenti or underpainting.

Permanence and Contemporary Materials

Some years ago in my New York studio, I received a newly painted Keith Haring that had been scratched on its way to the dealer. The hot pink background behind the energetic stick figure needed a minor retouch. I called Haring and offered to trade him lunch for a dollop of paint from the original tube. The trade was made—and I was surprised that after only a few days the paint no longer matched.

This experience is far from unique; the color, the look of a painting's surface, or a detail of a collage can change after a work leaves the artist's studio, altering the work irretrievably. Josef Albers carefully mixed each color separately for value and gloss, but his synthetic paints exhibit different rates and types of deterioration within the same painting.[6] By contrast, the materials used by the Old Masters, with some exceptions, aged predictably.

Artists vary in their opinions about changes in their works. On observing his *Drawing on Canvas for Vera* (1966), where the tape elements of the collage had turned from clear to amber, Robert Rauschenberg commented in 1993: "Other than the fact that it is falling off, what's wrong with it? I like the color."[7] Other artists—or scholars or conservators—are less sanguine. In many contemporary works, the focus of the piece can be the surface texture or gloss. The matte surfaces of an Ad Reinhardt masterpiece or the rugged texture and varied gloss of a Clyfford Still are the signatures of a certain era of their work. A significant alteration in the materials can move the work away from its original appearance. If the changes are pronounced, the painting is still "authentic" but no longer reflects the artist's original work.

Changes in the work can be so drastic that the work becomes an artifact of itself. Such was the case with Mark Rothko's Harvard Murals, paintings installed in the Holyoke Center in Cambridge, Massachusetts. I was among the conservators at the Fogg Art Museum responsible for checking on them after their installation. Within a short time, it became clear that the crimson works were fading radically. Unknown to Rothko, the lithol red colorant that he had used was unstable. These works now reside in storage, a part of Rothko's history. They have turned blue, and their original impact can only be imagined.

Conservation and Contemporary Materials

There is an ongoing debate about the level of conservation intervention appropriate in contemporary works. Even straightforward treatments can be problematic. Surface cleaning can be done only if the artist's materials are not sensitive to treatment solvents. A small puncture can be patched and rewoven, but it can be more difficult to integrate the retouch into the single color surface where the damage occurred. After the retouch is completed, there is no assurance that the conservator's more permanent retouching colors will change at the same rate as the artist's colors. Some treatments are focused on preventing new damage. As a work deteriorates, supportive treatments can forestall the formation of stretcher bar marks. Mounting works on a proper stretcher can quiet planar distortions.

Research into the materials and techniques of contemporary artists is key in designing treatments. Mark Rothko stated, "I became a painter because I wanted to raise painting to the level of poignancy of music and poetry."[8] Indeed, the murals in the Rothko Chapel in Houston, Texas, were created to enhance the meditative spirituality of the space. In envisioning his black-form paintings for the chapel, Rothko certainly did not intend the streaked film of white exudate that appeared on the surface of the works within a few years of their installation. Conservators and scientists were able to identify the exudate, and began to research the source of the disfiguring material.[9] Finding a safe method for removal of the substance required specific knowledge of Rothko's materials and techniques. Part of the investigation involved the re-creation of the pieces with the cooperation of Ray Kelly, who had assisted the artist in making the paintings in 1966–67. It was only with the material information from Kelly and by testing the re-created pieces that a successful treatment could be designed to conserve the original paintings.[10]

Although in the Rothko example, conservators came very close, it still wasn't the original paint. In collage pieces, there are ways to perfectly re-create faded labels or old newspapers with computers. Theoretically, these

new elements could be affixed over a faded original and yet be removable. Duane Hanson's works involve another kind of replacement of the old with the new. Concerning his sculpture *Sunbather* (1971), which included actual garments, the artist told the conservators: "Those bathing caps seem to deteriorate within six months and must be replaced. . . . The bathing suit has faded too. . . . I considered replacing it while it was on view at the Whitney but decided I like the fading color. It looks more used that way. If it gets too bad—you can replace it. I don't object to any other adjustments if it benefits the sculpture by contributing to a better—fresher—illusionism, so that papers & magazines should be replaced periodically. If any old non-faded papers & magazines from 1970 can be obtained that would be ideal, have fun."[11] Even with the blessing of the artist, conservators and curators are debating the impact and ethics of such a restoration with nonoriginal parts.

In Old Master art, conservators have to rely on scattered historical documents. Contemporary artists, however, can give information to the conservator directly. Jasper Johns once joked that he would be a richer man if he were the conservator of his paintings rather than their creator.[12] Indeed, conservators have spent much time devising successful methods for consolidation of his unique wax medium. This has been possible because of input from the artist about the specifics of the materials.

Again, unlike Old Masters, contemporary artists are often directly involved in conservation decisions. Frequently, the artist has definite opinions about the treatment or nontreatment of his paintings. Anselm Keifer told a conservator that it was "myopic for people to focus attention on his works' physical instability and unnecessary to worry about his pictures." But later in the conversation he allowed that some conservation was acceptable. He was not concerned with minor random losses, but was open to conservation intervention that might be necessary for the stability of his pieces.[13] Billy Al Bengston's *Hatari* in the Los Angeles County Museum is a worked aluminum piece sprayed with nitrocellulose lacquer. Conservators were called to repair a crease and a hole in the work. The structural damage repaired, the artist insisted that the hole be compensated with a "Japanese Style" repair using a very visible gold patch rather than the invisible compensation that the conservators would usually have done. Ultimately, the museum agreed to the artist's request, but asked that he redate the work.[14]

Some contemporary works of art are intentionally distressed. For example, Lucio Fontana makes crisp slices in a pristine canvas. If the cut areas begin to fray or distort, does this remove the element of fresh violence in a way that changes the piece irretrievably? What should a conservator's involvement be to preserve the authenticity of such a piece?

In other cases, an artist is actively involved with the surface of the work, scraping with a palette knife, or using both ends of his brush to shape the

paint. This very energy may begin a process of deterioration that eventually brings the work into the hands of a conservator. The focus of the treatment would then be to retain the balance between the stability and the authenticity of the piece.

In working with contemporary paintings, conservators must weigh their obligation to preserve works of art against many factors. The treatments require comprehensive research on the complex issues of materials and aging. The conservator must consider the artist's philosophy on its care. Furthermore, the conservator must be able to predict the impact of the treatment materials on the work, to be certain that the piece remains stable. The focus of the conservation is the look of the painting as it left the artist's easel. If the work has changed, then conservators, curators, and the artist or his agents (family members, dealers, etc.) must work together to decide if the work is still authentically representative.

The materials discussed so far, widely taken up by artists in the years after World War II, are nevertheless relatively conventional, most of them synthetic replacements for oil paint. In more recent decades, however, many artists have abandoned traditional materials altogether, employing instead such eccentric media as chocolate, mud, tires, sand, soap, crushed toys, clothes, mechanical equipment, soup cans, and many other things. Because such materials change—they decompose, dry out, rust, or break down—conservators and curators look to the artists for guidance. Petah Coyne's sculptural installations are composed of wax, tar, twine, textiles, earth, horsehair, and other organic materials. In an early work, she hung dead fish from trees around New York City. Although she attempted to preserve the fish with Rhoplex, a conservation adhesive, many became infested with maggots. Her newer works include wax-bathed birds and feathers. In 1995, she discussed some of the conservation problems of her art: "If I use regular wax for the pieces, they would never stand the test of time. I had a chemist make up a special formula. . . . In an effort to keep my work fresh, I consciously change to new materials about every five years or thereabouts. So few of the dead-fish pieces I made at the beginning are left. When you are young, you are not thinking about 'historical' or anything like that. But as you put so much of your life and energy into these pieces; you can't just think that all that's going to survive is a photograph."[15]

Fred Sandback, an installation artist, speaks of a different dynamic of conservation: "When an exhibition is over, as often as not in recent years, the physical remains go into the wastebasket, to be supplanted by fresh materials at a later date perhaps. . . . A curator will re-create a piece if she wants to and it is this will that drives the re-creation, finally, not the remnants of my will."[16] There is often no resolution of these philosophical and material challenges. The conservation of "new materials" most often consists of proactive plan-

ning, which includes interviewing the artist, obtaining "spare parts" and extra original material, and carefully evaluating environmental and exhibition requirements.

Notes

1. Andrea Kirsh and Rustin Levenson, *Seeing Through Paintings: Physical Examination in Art Historical Studies* (New Haven, Conn.: Yale University Press, 2000), pp. 152–66.
2. Jackson Pollock, 1950, quoted in a taped interview with William Wright for presentation on the Sag Harbor, N.Y., radio station, but never transmitted. Published in Hans Namuth, *Pollock Painting* (New York: Dodd, Mead, 1978), n.p.
3. Typescript of an interview with Helen Frankenthaler by John Jones, 1965; published in John Elderfield, *Frankenthaler* (New York: Harry N. Abrams, 1989), p. 166.
4. Jo Crook and Tom Learner, *The Impact of Modern Paints* (London: Tate Gallery Publishing, 2000), pp. 126–39.
5. Ibid., p. 117.
6. J. Garland, "Josef Albers: His Paintings, Their Materials, Technique, and Treatment," *Journal of the American Institute for Conservation*, 22 (1983): 22–67.
7. Ann M. Baldwin, "The Wayward Paper Object: Artist's Intent, Technical Analysis, and Treatment of a 1966 Robert Rauschenberg Diptych," *Journal of the American Institute for Conservation*, 38 (1999): 411–28.
8. Brian O'Doherty, *The Voice and Myth of American Masters* (New York: Universe Books, 1988), p. 153.
9. Carl Aufdermarsh, "The Analysis of Two Triptychs in the Rothko Chapel," *American Institute for Conservation, Paintings Specialty Group Postprints* (Washington, D.C.: American Institute for Conservation, 1989).
10. Carol Mancusi Ungaro, "The Rothko Chapel: Treatment of the Black-Form Triptych," *International Institute for Conservation of Historic and Artistic Works, Preprints of the Contributions to the Brussels Congress, September 3–7, 1990* (London: The Institute, 1990), pp. 134–37.
11. Kimberly Davenport, "Impossible Liberties: Contemporary Artists on the Life of Their Work over Time," *Art Journal*, 54, no. 2 (1995): 40–52.
12. Steven W. Dykstra, "The Artist's Intention and the Intentional Fallacy in Fine Arts Conservation," *Journal of the American Institute for Conservation*, 35 (1996): 197–218.
13. Al Albano, "Reflections on Painting, Alchemy, Nazism: Visiting with Anselm Keifer," *Journal of the American Institute for Conservation*, 37 (1998): 348–61.
14. Denise Domergue, Rosa Lowinger, and Don Menveg, "Change the Art or Change the Artist: A Question of Ethics in the Conservation of Contemporary Art," presented at American Institute for Conservation, 15th Annual Meeting, 1988, *Preprints for the A.I.C. Annual Meeting, 1988* (Washington, D.C.: American Institute for Conservation, 1988), pp. 34–42.
15. Petah Coyne, quoted in Davenport, "Impossible Liberties," p. 51.
16. Fred Sandback, quoted in Davenport, "Impossible Liberties," p. 51.

Part II

...

Authentication and the Law

...

14

The Art Expert, the Law, and Real Life

. . .

Theodore E. Stebbins, Jr.

. . .

This chapter is a historical account of art expert liability, as well as of firsthand experience rendering expert opinions in the author's area of expertise.—RDS

. . .

THEODORE STEBBINS, JR., formerly John Moors Cabot curator of American Paintings at the Museum of Fine Arts, Boston, is presently curator of American Art at the Harvard University Art Museums. He is the author of more than twenty-five studies of American painting and photography, including works on John Singleton Copley, Martin Johnson Heade, and Charles Sheeler.

. . .

As a third-year student at Harvard Law School in 1963–64, I wrote a paper dealing with the circumstances under which art experts might be sued for offering opinions about the authenticity or quality of works of art. The paper proved a success; it came to be regarded as authoritative, and was published and republished through the years.[1] However, its greater impact was on my own life. In researching the paper I interviewed a number of leading art historians, including Lloyd Goodrich, then director of the Whitney Museum of American Art in New York, and Professor Jakob Rosenberg, a greatly admired teacher and curator at Harvard University. Coming to know the art world through such people, and having taken—as part of my legal research—Professor Rosenberg's course on the connoisseurship of European drawings, I gave up law and turned to the study of art history, eventually becoming a specialist in American paintings from the eighteenth to the twentieth century.

The gist of my paper was that the art expert who, in response to an inquiry within his range of expertise, gives an opinion in good faith about a work of art, has little to fear in terms of possible tort liability. In the intervening years,

there have been significant changes in terms of case law and interpretation, but as the essays in this volume edited by Ronald Spencer demonstrate, the basic situation remains the same. The art expert who acts responsibly and honestly is generally protected when giving an opinion, and courts increasingly recognize that this serves the public interest. However, today's art experts seem just as nervous about potential liability as their predecessors in the early 1960s, and their fear—anomalously—is not entirely unreasonable, given the great changes that have occurred in the art world.

For one thing, the stakes have risen enormously due to the tremendous rise of the art market. One could take, for example, the two major donors of American art to the Museum of Fine Arts in Boston, Maxim Karolik and William H. Lane. The former built a pioneering collection of nineteenth-century American landscape and genre painting during the early 1940s, and the latter, who was active in the 1950s, amassed a magnificent holding of American modernist pictures. Neither one ever, to my knowledge, paid over $2,500 for a single work; today there are dozens of paintings in each collection which would be valued between $3 and $5 million each. Thus when a dispute arises today, millions of dollars may easily be involved, versus a few thousand in the 1960s. In addition, Karolik and Lane collected because they were moved by works of art and wanted to share them with the public. Today's much more affluent collector buys art for a wider variety of motives, including investment and prestige, and today's collectors and dealers are much more litigious—like the society as a whole—than before. Finally, it should be said that the art experts and collectors of the 1960s were considerably more likely to be social and economic peers than they are now. Today's art expert generally lives on a modest academic or museum salary, and thus has much to fear economically from even the most frivolous lawsuit.

Art historians are likely to recall at least the outlines of the most famous case in this field, *Whistler v. Ruskin,* which was heard by a London court in 1878. James A.M. Whistler, the plaintiff, was a highly talented, provocative figure who executed the first truly avant-garde paintings in the Anglo-American tradition. In 1877 Whistler exhibited at the Grovesnor Gallery his *Nocturne in Black and Gold: The Falling Rocket* (Detroit Institute of Arts), a nearly abstract night scene with a few spots of color in the sky indicating fireworks.[2] John Ruskin wrote that the gallery should not have shown such a work "in which the ill-educated conceit of the artist so nearly approached the aspect of willful imposture." He then went on, "I have seen, and heard, much of Cockney impudence before now; but never expected to hear a coxcomb ask two hundred guineas for flinging a pot of paint in the public's face."[3] Ruskin, the leading art critic of the period in England, was an advocate of the Pre-Raphaelite painters; he championed paintings in a highly detailed, realistic style. In calling the painter a "Cockney"—an ill-bred person

who speaks with an East End, lower-class accent—and a "coxcomb" (a conceited fool), Ruskin was found by the jury to have defamed the painter personally. Whistler won the suit, but it was a Pyrrhic victory; he was awarded damages of a single farthing, and he suffered significantly both financially and critically. As Steven Levy suggests, today Ruskin's criticism would likely be deemed "rhetoriocal hyperbole" insufficient to give rise to a defamation action."[4] Nonetheless, this famous lawsuit is still remembered. In the damage it did, and the notoriety it won, it seemed to prove that giving an opinion can be dangerous.

The art world has changed dramatically since the time of Whistler and Ruskin. In the United States alone, curators at hundreds of institutions ranging down in size from the Metropolitan Museum of Art in New York mount exhibitions, produce texts, and build collections. Thousands of scholars teach art history at colleges and universities. Ever-increasing numbers of collectors, dealers, and middlemen pursue a diminishing supply of works of art. The standards of study in the American (and almost every other) field have been raised by better training in the graduate schools, improved research tools, and a virtual avalanche of publications, including monographic studies of numerous artists and schools, from the little-known to the most significant, as well as thorough scholarly catalogues of many of the most important museum collections and some private ones. In addition, conservation of American paintings has improved considerably, and there now exist a number of laboratories—both museum-based and independent—where highly trained conservators work alongside scientists and technicians in examining paintings. A number of scientific tools, including X-ray, infrared, and ultraviolet examination, and analytical techniques are now available to assist the expert in making decisions about the authenticity and physical condition of works of art. In American art alone, over sixty catalogues raisonnés are now in various stages of completion, some by dealers, others by independent scholars, descendants of the artist, or museum curators.

Though many people in the field feel (and often are) competent to offer helpful opinions to the owners of objects, the difficult cases are properly passed along to the recognized expert or experts on a particular artist. In general, the field comes to acknowledge that one or two people know most about the work of a given artist, and such people become known as the expert or experts on that subject. Each of the major auction houses maintains a list of current experts, but otherwise there is no central source for this information. Frequently, the expert is the author of a recent or forthcoming publication on the artist, which can range from a short article to a catalogue raisonné.

However, such experts have a wide variety of expertise, "eye," and reliability. In some cases the expert is a dealer, who may be extremely knowl-

edgeable but who does have a built-in conflict of interest. The art world is unregulated and unorganized, which means that it can be difficult for even a sophisticated owner of a work of art to get sound, objective advice about the authenticity, condition, and especially the value of the work. All this being said, the system generally works fairly well, due largely to the fact that most noncommercial art experts have, in my experience, high ethical standards.

As the expert on the American painter Martin Johnson Heade (1819–1904), and the author of two catalogues raisonnés of his work,[5] I am consulted by dealers, auction houses, private collectors, and others whenever a new, unknown work attributed to this artist appears. For example, early in 1980, Sotheby Parke-Bernet sent me a transparency and asked for my opinion of an unknown painting entitled *Two Hummingbirds and an Orchid*. I examined the 8 x 10-inch color transparency for a few minutes, and compared it against similar Heades in my book. I then wrote to Sotheby's, stating that it was Heade's work and saying that it would be included in the next edition of my book. My practice had always been to try to see the original work but, like almost all of my colleagues, I did not hesitate to make a decision based on a photograph. Sotheby's included the work in their auction catalogue of American paintings for October 17, 1980, illustrating it as lot 132, with a note specifying that the work would be included in my next catalogue raisonné.[6]

However, I felt some nagging doubts about the painting, and I went to New York to see it on the day of the sale. By the time I arrived, the auction had begun, and only 20 minutes remained until the Heade was to be offered. Armed with a flashlight, a magnifying glass, and some comparative photos, I examined the painting, using the traditional technique of stylistic analysis. Its colors appeared both chalkier and brighter than one would expect, and the application of pigments—the artist's strokes—did not conform to what I knew of Heade. I asked Sotheby's to withdraw the work from the sale. A flurry of activity followed. Apparently the consignor was at the sale; Sotheby's staff came back to tell me of his assurances that the painting had come from the house of an old Florida family, where it had hung for generations. My experience is that provenance, or purported provenance, counts for little; a good provenance can be attached to a poor work, and it is the work itself that has to stand up under scrutiny. I said that they had every right to sell the picture, but I insisted that if they did so, the auctioneer would have to announce that I had withdrawn my "authentication" of it. In the end, Sotheby's agreed to withdraw the work, and I agreed in turn to give it a very thorough examination at the Museum of Fine Arts.

The examination was conducted there by an art historian (myself), a conservator, and a scientist. Careful stylistic and physical examination of the paint

surface and of canvas and stretcher suggested that it was a modern forgery, probably of very recent origin. This was confirmed by scientific testing of the pigments, some of which were of twentieth-century origin and had come into use after Heade's death. I was relieved, for the courts have traditionally had trouble weighing the credentials of one expert against those of another, and of following the sometimes arcane, seemingly subjective reasoning of art historians. Objective scientific analysis is reassuring to nonexperts, but it is both expensive and time-consuming, and it leads to definitive conclusions in only a minority of cases. Most expert opinions will thus continue to be based on the traditional tools of the art historian. My own practice since this incident has been to insist on visual examination of the original work before offering an opinion, and in difficult cases, to examine the object with a team including a conservator and, when necessary, a scientist, with the option of conducting technical and scientific examinations of the work. I should add that the case law allows experts to be wrong, and to change their minds on the basis of new evidence, as I did.

Most experts in the United States today continue to rely on photographs and on purely visual analysis, but both practices may well change in the future. Reliance on photographs alone is increasingly thought to be risky in terms of potential liability, but there is no case law on this point. My own experience is that in the difficult cases, the original must be examined. In addition, I believe that art historians in the future will regard collaboration with conservators and scientists to be absolutely necessary in the most difficult cases of questioned authenticity. Some of the leading legal authorities are tending in this direction. For example, Steven Levy writes: "The authenticator or appraiser who relies solely on photographs in rendering his opinions, or on a visual examination of the actual artwork without benefit of scientific tests, always runs a risk of being accused of falling below the standard of care if he later turns out to be wrong."[7] I should point out that this kind of collaboration is easily available only to experts who work for museums, and that many of my most esteemed colleagues disagree with the need for it.

There are various useful organizations in the art field, but none directly serves the interests of the art expert or the collectors, dealers, and others who rely on the experts. The Association of Art Museum Directors (AAMD) has become a significant force in terms of communication and collaboration among museums, and it has codified the ethical standards governing museum employees, including curators. A new parallel group, the Association of Art Museum Curators (AAMC) has promise, but like AAMD will not concern itself with the majority of art experts who are not members of curatorial staffs. The Art Dealers Association of America has been an important factor in bringing sense to the appraisal of works of art for gift and estate tax purposes; it could play a key role in helping the dealers work with art experts on open,

ethical terms, but it has not yet done so. As the field becomes increasingly professional, it seems highly advisable that the rules governing experts' potential conflicts of interest be clarified. Finally, mention should be made of the International Foundation for Art Research (IFAR), which has been highly effective in recent years, both in tracking stolen works of art and in raising public consciousness about developments in art law, connoisseurship, and the catalogue raisonné.

The largest organization of artists and art historians, the College Art Association (CAA), has in the past made useful attempts in this area. However, mention of the CAA brings to mind another problem of significance for the future. Since the 1980s, many of the best minds in art history have turned away from seemingly "old-fashioned" connoisseurship of works of art to a variety of theoretical approaches that mark the "new art history." Even now one worries that the experts are not expert enough; the trend toward theory in many of the leading university departments of art history suggests that in the future it may become even more difficult for dealers, collectors, and the public to find objective, skillful expertise on works of art than it is today. Professor David Lubin of Wake Forest University, one of the best known of the cultural historians in the American field, describes connoisseurship as a "very valuable but dying skill," and as a "craft tradition."[8] His belief that the work of the old-fashioned expert mainly serves the curator, dealer, and collector is widely held among historians of theoretical bent, and reminds us that such service to the marketplace is a primary reason that younger historians have turned against connoisseurship. The problem of a diminishing number of connoisseurs, with a concomitant decline in the quality of connoisseurship, has begun to affect the art field, and eventually may well have an impact on the law as well.

Experts, even within one family, follow different procedures. Thus, Abigail Booth Gerdts, director of the Lloyd and Edith Havers Goodrich catalogue raisonné of the works of Winslow Homer, follows a strict set of guidelines before commenting about a real or purported work by Homer. Dr. Gerdts, who accepts no fees, offers opinions only to the owner of a work, and only after the owner has signed a three-page form including an indemnification agreement specifying "that neither such opinion nor its communication to any third party" will be made the subject of a lawsuit. She notes that she has received over 400 inquiries since the early 1990s, each one from an owner believing or hoping to have found an unknown work by Winslow Homer. Out of this came the discovery of just one new oil painting, along with two drawings, by this painter. Dr. Gerdts concluded a conversation with me by pointing out the financial and personal risks to today's art expert, and said, "The stakes are just too high. I believe that we should all get out of the opinion-giving business."[9]

On the other hand, William H. Gerdts, professor emeritus, Graduate Center, City University of New York, who is widely regarded as the most productive (in terms of publications) and most knowledgeable expert in the field of nineteenth-century American paintings and sculpture, follows a very different policy. Professor Gerdts charges a standard fee for both verbal opinions and written ones; he writes only when he believes the work is authentic. Gerdts covers a huge range, and is consulted about still-life painting; Washington Allston, Emanuel Leutze, and other history painters; portraits; the American Impressionists; and on occasion almost anything else. He does not employ a disclaimer form, and sometimes volunteers his opinions to dealers and auctioneers whom he knows well. He and his wife, Abigail Booth Gerdts, have in common that they do not make use of conservators or of technical analysis.[10]

Obviously, in practical terms, the independent experts like Abigail Gerdts are more vulnerable than those who work for universities or museums. I have been threatened with a lawsuit only once, in a situation where I gave an opinion about a work of art to a collector who was considering its purchase. At the time, I was curator of American paintings at the Museum of Fine Arts, Boston. As soon as the suit was threatened, the museum's general counsel investigated the facts of the case and then vigorously defended me and the museum. The suit was dropped. Most major museums in the United States recognize that there is a strong public policy interest in encouraging its curators to give opinions within their areas of expertise when requested by owners of objects. The Metropolitan Museum of Art follows this policy, suggesting that its curators use the museum's standard disclaimer statement and that they offer verbal rather than written opinions, and mandating that no fees be accepted by the curators, nor any financial appraisals given. As Sharon Cott, the museum's vice president and general counsel, told me, "Our policy on giving opinions is, Do it, but be careful."[11]

Notes

1. See Theodore E. Stebbins, Jr., "Possible Tort Liability for Opinions Given by Art Experts," in Franklin Feldman and Stephen E. Weil, eds., *Art Works: Law, Policy, Practice*, 3rd ed. (New York: Practising Law Institute, 1974), pp. 988ff.

2. For a discussion of the painting, see Angela Miller, "Nocturne in Black and Gold: The Falling Rocket," in *American Paintings in the Detroit Institute of Arts, vol. 2, Works by Artists Born 1816–1847* (New York: Hudson Hills Press, 1997), pp. 237ff.

3. For the Ruskin quote, see Lawrie Schneider Adams, ed., *Art on Trial: From Whistler to Rothko* (New York: Walker & Co., 1976), p. 1.

4. Steven Mark Levy, "Liability of the Art Expert for Professional Malpractice," *Wisconsin Law Review*, no. 596 (1991): 641.

5. Theodore E. Stebbins, Jr., *Life and Works of Martin Johnson Heade* (New Haven, Conn.: Yale University Press, 1976); *The Life and Work of Martin Johnson Heade: A Critical Analysis and Catalogue Raisonné* (New Haven, Conn.: Yale University Press, 2000), with the assistance of Janet Comey and Karen Quinn.

6. *American 18th Century, 19th Century & Western Paintings, Drawings, Watercolors, & Sculpture*, auction catalog (New York: Sotheby Parke-Bernet, October 17, 1980), lot 132.

7. Levy, "Liability of the Art Expert for Professional Malpractice," p. 609; see also Kai B. Swinger, "Sotheby's Sold Me a Fake! Holding Auction Houses Accountable in Authenticating and Attributing Works of Fine Art," *Columbia-VLA Journal of Law and the Arts* vol. 23 (Spring 2000): 6.

8. Conversation with David Lubin, Wake Forest University, September 28, 2002.

9. Conversation with Abigail Booth Gerdts, July 1, 2002.

10. Conversation with William H. Gerdts, July 21, 2002.

11. Conversation with Sharon Cott, the Metropolitan Museum of Art, July 2, 2002.

The Risk of Legal Liability
for Attributions of Visual Art

. . .

Ronald D. Spencer

. . .

Art experts, scholars, dealers, and curators are increasingly concerned about legal liability for their opinions on authenticity. This chapter examines the required elements of the legal claims most usually made against experts, suggesting not only legal defenses to such claims, but also conduct by the art expert which may lessen the risk of liability. The reader should also note that the last quarter of this chapter is concerned with a very practical problem posed by the widespread practice of experts who describe their authenticity determinations as their "opinion." Of course, the expert's determination is "only" an opinion, or put another way, it is what the expert thinks or believes, based on his visual examination, experience and analysis of factual information, including the provenance of the work. And, although it seems somehow unfair that the expert needs to worry about legal liability for simply holding an opinion, the essay will provide the reader with law's view of "opinion" in the context of the attribution of visual art.

*A final point should be made. Courts, in civil cases, place the burden on the plaintiff to prove his case by a "preponderance of the evidence," that is, prove it is "more likely than not" that what the plaintiff claims is so. This standard has sometimes been described as akin to just a little better than even odds (in percentage terms perhaps 51% versus 49%). Of course this will produce a court decision for one side or the other, for or against the authenticity of the art, and the court will have accomplished its legal task, as in case of a Calder mobile, where the seller "won" because the judge decided the mobile was authentic. But such a work remains unsaleable in the art market since very few buyers or museum curators would act on a court standard of only a little better than even odds!—*RDS

. . .

Ronald D. Spencer is counsel to the New York law firm of Carter Ledyard & Milburn LLP, where he specializes in art law and foundation law. He is expert in the legal aspects of art authentication issues and has written on

these matters for *The Art Newspaper* and the *IFAR* (International Foundation for Art Research) *Journal*.

. . .

This chapter examines the six legal claims most usually made against experts —academic and independent art scholars, art dealers, museum curators, and others—who make decisions about the attribution of visual art. The first section sets out the required legal elements for each type of claim by analyzing a court decision in the context of the specific art-related facts of the case. A careful analysis of these elements suggests not only the defenses to such claims but also actions the art expert can take that will lessen the risk of liability. The second section addresses the widely held view that making authenticity or attribution decisions and styling them as "opinions" reduces the expert's potential legal liability for the decision.

With respect to the first section, it should be noted that all six legal claims contain certain common requirements. First, all the likely claims place the burden of proof on the owner/plaintiff to show, by a "preponderance of the evidence" (i.e., it is more likely than not), that the work is authentic (or not) or properly attributed (or not). Second, the plaintiff must prove, in addition, some sort of fault on the defendant's part. And for many defamation claims, the level of fault to be proved is quite high—"gross irresponsibility" in some circumstances. Thus, the "defenses" available to experts rendering decisions are very much more significant than they would at first appear to be.

Elements of the Six Most Likely Legal Claims

The six most common causes of action asserted against those who authenticate works of visual art are the following:[1]

1. Failure to exercise reasonable care
2. Product disparagement
3. Breach of contract
4. Common law fraud and negligent misrepresentation
5. False "advertising" under state consumer protection laws and the U.S. Lanham Act
6. Claims of defamation.

1. Failure to Exercise Reasonable Care

The following English case was selected for analysis because it best illustrates the principles that courts apply to a determination of negligence in a circumstance where the art owner has a relationship with the expert (usually a contractual one) such that the expert owes the owner a duty of reasonable care. Here, the English judge found an implied (not an express) provision in a contract between the art owner and a provincial auction house that the auction house must exercise a certain standard of skill in its research and valuation of the owner's art. The court went on to decide that the experts did not reach this standard of skill. Also, on the issue of damages for negligence, the trial court's analysis of judge-determined damages and their relation to the art market's valuation is well-reasoned enough to be followed by other judges in the future. On appeal from the trial court decision, the Court of Appeal was clearly unhappy about holding regional auctioneer experts to such a high standard and reversed the trial court, based on reasoning which leaves much to be desired. Hence, it seems likely that the trial court's reasoning will be an influential legal precedent for the liability of experts (other than small regional auction houses) and a precedent, too, for the determination of damages for the expert's negligence.

The Standard of Skill to Be Applied: The Expert Misses a "Sleeper"

In 1988, an English judge set out a brilliantly reasoned statement of the principles to be applied in deciding a claim that an expert breached a contractual duty to exercise reasonable skill and care. The *Luxmoore* case involved the auction sale by the defendants, provincial auctioneers, of two small paintings, each of single foxhound on a rocky seashore.[2] The paintings, which had been valued by the defendants at £30 to £50 for the pair, sold at defendants' auction for £840 and later resold for £88,000 at a Sotheby's auction, having been given a full attribution in the Sotheby's catalogue to George Stubbs (1724–1806). The paintings had been accepted from the owners/consignors by the provincial auction house with a receipt marked "for research," but were not considered by the auction house to have much merit; hence the low valuation for purposes of the auction. Having heard of the high price obtained by Sotheby's, the former owners sued the auction house, alleging that it breached an express contractual term to carry out research, and an implied term to exercise the standard of care and skill required of competent fine art experts in carrying out their obligations of research and valuation.

After a trial, Judge Simon Brown made several findings of fact. In 1985, when the paintings were taken to Sotheby's, Sotheby's David Moore-Gwyn, head of the British Paintings Department, immediately recognized the fox-

hounds as related to a celebrated Stubbs painting and consulted several experts, including Judy Egerton, who was at work on a catalogue raisonné of Stubbs's work and was universally acclaimed as the world's greatest Stubbs expert.

It was Egerton's view, *at the time of the trial of the claim in 1988,* that the two paintings were not by Stubbs, but rather were honest copies competently painted in the nineteenth century. She believed there was only about a "15 percent chance" that the paintings were genuine and an 85 percent chance that they were copies. The judge found as a fact that in her *1985* report for Sotheby's, Egerton was "clearly insecure" about the pictures and regarded them as "throwing up a lot of problems" about their proper attribution; she had not really made up her mind about them one way or the other. The judge found that in cataloguing the pictures for its 1986 auction sale with a full attribution to George Stubbs, Sotheby's had to come to its own decision. Such an attribution, according to the catalogue definition, meant "in our opinion a work by the artist," as opposed to "attributed to George Stubbs" (meaning,"in our opinion *probably* a work of the artist but less certainty as to authorship is expressed than in the preceding category"). The judge stated:

> I have reached the clear conclusion that Sotheby's were entitled to catalogue the foxhounds as they did for their March 1986 sale, and indeed it is fair to add that Mrs. Egerton herself stated in her report that she was not unduly surprised to see Sotheby's give them a full attribution. Although it was perhaps a bold decision to attribute in the language of certainty rather than probability, I am satisfied that it was not improper. Mr. Moore-Gwyn said that in any event, prospective buyers of pictures such as these would not rely solely on Sotheby's attribution but rather would have done their own research. A number he knew to have consulted Mrs. Egerton. Although Mrs. Egerton says that she was not in fact consulted by Spinks, the fine art dealers to whom these pictures were eventually knocked down, she thinks they already knew her opinion.[3]

In his legal analysis, Judge Brown noted that the defendants formulated the question to be decided as

> whether a competent auctioneer could have failed to make any attribution to Stubbs. In my judgment, that is the wrong question. In particular, it overlooks the general practitioner's need to guard against his own want of specialist knowledge and to exercise a proper caution in arriving confidently at his own conclusion. . . . The issue can, in my judgment, be restated thus: Were the defendants entitled to be as wrong as they were and yet so confident that they were right that they ruled out the need for further investigation?[4]

The *Luxmoore* judge went on to note that the defendants' chief con-
tentions were, first, that the standard is to be judged by reference only to what
may be expected of the general practitioner, not the specialist—here, provin-
cial auctioneers rather than one of the leading London auction houses, and,
second, the actual history at the provincial auction itself, which demonstrated
the failure of others besides themselves to make the Stubbs attribution. The
defendants argued that they sent the sale catalogue to approximately a thou-
sand people, including most of the main picture dealers in London and the
provinces, and several dealers at the auction failed to identify the foxhounds.
Judge Brown rejected these arguments in the following terms:

> I cannot accept these submissions. It is one thing to point out that deal-
> ers for the most part declined to speculate by entering the bidding for
> these pictures at auction, quite another to say that the defendants them-
> selves—the auctioneers directly concerned on the vendors' behalf—were
> therefore entitled to be sure of their own relatively inexpert opinion with-
> out making further investigation to guard against the risk of error. Indeed,
> it goes further than this. The fact is that two dealers *were* prepared to back
> their hunches to the extent of over £800, bidding against one another. It
> need hardly be pointed out that they, at least, plainly recognized that fur-
> ther researches were worthwhile. I reject Mr. Powell's [lawyer for defen-
> dants] submission that the underbid of itself evidences what all but the
> successful bidder considered to be the maximum value of the pictures. On
> the contrary, it represents the most that they could be confident (or were
> prepared to speculate) the pictures were worth without the benefit of fur-
> ther investigation.[5]

With regard to the question of negligence, Judge Brown concluded:

> No competent valuer could have fixed confidently upon a valuation of
> £30 to £50 without need for further investigation....
> ...all who run auction houses should be capable of recognizing paint-
> ings in the style of George Stubbs and should know where to turn for spe-
> cialist advice. Furthermore, that there were sufficient indications in these
> paintings to have to have alerted any competent valuer....
> ...
>
> No competent practitioners could have missed the signs of merit in
> these paintings and failed to recognize that they were worthy of further
> investigation. In the first place, [they were] extremely well drawn by a very
> competent artist. Second, they are in many respects anatomically realistic:
> and this feature, coupled with their subject-matter, is typical of Stubbs. In
> those circumstances, even without any specialist knowledge whatever of
> Stubbs' work, a competent valuer could not but have seen in these fox-

hounds sufficient to merit at the very least further investigation, and this in turn should have led sooner or later to their recognition as obvious candidates for attribution to Stubbs.

. . .

. . . any competent valuer must inevitably have appreciated in these pictures a substantially greater potential than ever crossed the [defendants'] mind. . . .

. . .

Lest this judgment be thought to have any wider application, it is important that I make entirely plain that I am far from concluding that every auctioneer who misses a "sleeper" is on that account necessarily to be regarded as negligent. Each case will depend on its own individual facts. The question here is whether there was enough about these foxhounds to make it unreasonable for a competent valuer to be sure he was right when in fact he was so dramatically wrong. In my judgment there was.[6]

Damages for the Expert's Negligence and the Role of the Art Market in the Determination of Damages

Having determined liability on the part of the provincial auction house, Judge Brown turned to the question of damages. He noted that Judy Egerton's current opinion (i.e., at the time of trial) was that there was only a 15 percent chance of the foxhounds being by Stubbs, although another expert thought that "on balance, the foxhounds were likely to have been painted by Stubbs." The judge referred to another foxhound painting (*Hunter*), which most experts believed had been painted by the same hand as the two paintings in question. As to *Hunter*, Judge Brown commented as follows:

> This appears first to have come to light in modern times when brought into Sotheby's in 1981. Sotheby's consulted Mrs. Egerton about it. As Mr. Moore-Gwyn told me, she was very against it. Others, however, thought differently. But because Mrs. Egerton had expressed herself with such certainty on that occasion, Sotheby's catalogued *Hunter* with the lower category of accreditation, namely as "Attributed to George Stubbs," the meaning of which I have already set out. Despite such hesitation in its attribution, however, *Hunter* sold on March 18, 1981 for £21,000. It was bought by Ackermanns, authenticated by Alfred Gates, and sold on to the Mellon Collection.[7]

In continuing his determination of damages flowing from the defendants' breach of their obligation to exercise due care, the judge cogently set out the basis for judicial self-restraint in *not* deciding on authenticity and, instead, re-

lying on the art market itself to determine the value (and, by implication, the authenticity) of a work of art.

It may be thought that the overall balance of the argument appears to lie in favour of Mrs. Egerton's conclusion. But is this an issue upon which I am required to make a decision? Is it really for this court to purport to pronounce authoritatively whether these foxhounds are genuinely the work of Stubbs or mere honest copies? I think not. On the contrary, it is I believe wholly unnecessary to arrive at a judgment of my own on the point. That being so, I shall certainly refrain from doing so. What more absurd than for me needlessly to offer my inexpert view upon the correctness or otherwise of the opinion of the acknowledged world expert? Sometimes the court is driven into such a position, but not here, and for this reason: had it not been for the defendants' breach of contract the plaintiffs would have discovered the true potential of these pictures and sold them properly, as likely as not at Sotheby's. The measure of damage in this case is, I conclude, the difference between what the foxhounds in fact realized consequent upon the defendants' breach of contract and what was their true open market value at that time. What better guide could there be to that value than the price at which these paintings happened to be knocked down at Sotheby's so shortly afterwards? The price which the international art market was willing to pay was surely *prima facie* the best evidence of the foxhounds' value. Is there anything to displace that *prima facie* conclusion?

The defendants argue first that the sale price obtained by Sotheby's was "tainted," both by the unqualified attribution given to the foxhounds and by their misleading catalogue entry. I have already expressed my views about that: I acquit Sotheby's of any impropriety. In my judgment, it is only if Sotheby's acted unlawfully in the matter, knowingly misrepresenting the position, either by giving the foxhounds an improper attribution or by intentionally conveying a false impression of Mrs. Egerton's views about them, that the defendants can escape the prima facie effect of Sotheby's auction price. And even then it would be necessary to consider whether or not the buying public had been materially misled by the alleged misrepresentations. It seems to me that the defendants would fail on that ground also. For I am not persuaded that the sale price was in the event affected by Sotheby's attribution and description. The best evidence to the contrary is surely Mrs. Egerton's own belief that Spinks, the purchasers, knew her views anyway. And it is highly relevant in this context to recall that *Hunter* sold in 1981 for £21,000 even without Sotheby's full attribution.

The defendants' second argument is that the Sotheby's sale price should be ignored and the foxhounds' value instead determined "objectively," taking into account all the information now available, including particularly Mrs. Egerton's assessment. I reject this utterly. It involves substituting the court's "objective" 1988 view for the actual 1985–86 market value. What governs market value is the art world's perception at a given point in time of a picture's provenance and attribution. Experts' opinions may of course differ and they may change. As Mr. Hancock [who declined to bid at the provincial auction] said, nothing is black and white in the art world; pictures can vary from time to time between being, as he put it, right and not right. The art world's perception of the foxhounds in 1985–86 is easily judged; enough experts thought them right to take the bidding to £88,000, and indeed to take them thereafter into the Mellon Collection. Mrs. Egerton may well be correct in her opinion and those lesser experts all wrong. Let us assume so. It is really nothing to the point. Indeed, for all one knows, but for the doubts which Mrs. Egerton has hung around these paintings, they might well have been worth yet more.

The defendants' third and most extreme argument is that the price achieved at the defendants' auction, £840, reflected the foxhounds' true value, so that the plaintiffs have not in the event suffered a loss. As I understand it, the argument runs essentially thus. The court should accept Mrs. Egerton's evidence and therefore conclude that the foxhounds had no more than a speculative value which was in fact realized. The court should also conclude that the defendants correctly described the paintings in their sale catalogue: they were not entitled to a Stubbs attribution. Put more simply and seductively, the argument is really this: given that on the most expert evidence before the court the foxhounds are probably not genuine Stubbs, why on earth should the defendants be found negligent for failing to recognize them as such, and then indeed be mulcted in damages for all the world as if they were? Superficially attractive and plausible as this first appears, it cannot succeed. Its central fallacy lies again in the supposition that it is for this court now, rather than the international art market then, to decide the authenticity and value of these foxhounds. More particularly, the argument fails to recognize that the paintings' true speculative value could not hope to be realized until such time as the art world's buyers and experts were alerted to their possibilities and given the opportunity reach their own conclusions upon them. They should have been. It is really not possible to suggest that these foxhounds were adequately valued and catalogued by the defendants. Whatever history may ultimately decide about their authenticity, there can be no question but that the defendants took the wrong view of them. As I have endeavoured to explain, their errors lay not in failing to make a positive Stubbs attri-

bution—they did not themselves have the expertise to do that any more than to conclude the contrary—but rather in their failure to spot the potential in these paintings. And with regard to cataloguing, as Mr. Moore-Gwyn said, even if auctioneers are not persuaded that a particular work is probably an original, they can nevertheless indicate its real speculative value in the catalogue by observing that some experts at least regard it as genuine. I have not the least doubt, moreover, that Mrs. Egerton herself would reject this whole argument. Although she is not yet sure how she will treat the group of five *Charlton Hunt* vignettes in her comprehensive catalogue raisonné of Stubbs' work, they will most certainly appear there. [Egerton considered the two foxhound paintings to be among five vignettes from a larger picture titled *Charlton Hunt*.] And I cannot for a moment believe that she would regard £840 as the limit of the foxhounds' speculative value, whether in 1985 or indeed now.[8]

The Court of Appeal Decides Trial Court Demands Too High a Standard of Skill

The provincial auction house appealed Judge Brown's decision to the Court of Appeal.[9] The Court of Appeal agreed with the trial court that the defendants were

> to express a considered opinion as to the sale value of the foxhound pictures and that the question was whether the defendants discharged these duties according to the standards of skill and care properly [and] reasonably to be expected of them.[10]

However, the Court of Appeal decided that the standards of skill the trial judge had demanded were too high, and listed six reasons for its conclusions.

> The factors which I regard as particularly relevant in this context are the following: (1) Dogs and other animals were subjects favoured by many artists besides Stubbs over the period in which the two foxhound pictures are thought to have been painted. Mrs. Egerton indicated that she could have named 60 or 70 other such artists. Every valuer of pictures is therefore likely to encounter numerous horse and dog paintings by insignificant or unknown artists of the eighteenth and nineteenth centuries. (2) Furthermore, in country salesrooms copies of the works of original artists abound. (3) A substantial volume of informed evidence indicates the view that these two foxhound pictures are not themselves of high quality and there are a number of anatomical errors.[11]

Three other factors influenced the Court of Appeal. First, Sotheby's recognition of the Stubbs potential depended upon knowledge of other Stubbs

paintings, which the provincial auction house need not have known; and, second, the trial court should have considered evidence that the pictures at the time of the provincial auction were "dirty and not restored." Strangely (and wrongly, I believe), it was a last factor, *the number of dealers in attendance and their actual behavior at the auction*, which carried weight with the Court of Appeal:

> To my mind very significantly, at the auction of 10 October 1985, though no evidence as to exact numbers is available, it is clear that many dealers would have been present and the bidding started at a very low figure, in the region of £40. Of all these dealers, only two were prepared even to bid for the foxhound pictures. Mr. Hancock, who only ten days before had bought a picture in the belief that it had Stubbs potential, having closely examined the foxhound pictures was not willing to put in any bid for them at all. Furthermore, this was not a case where the bidding which did take place was completed in a matter of seconds. To the irritation of the auctioneer, it advanced in slow small stages, leaving plenty of time for any other dealers present who might have been remotely interested in the pictures to reconsider their position and put in a bid; but none of them thought it worth while.[12]

Based on these six factors, the Court of Appeal decided that Judge Brown, the trial judge, had "demanded too high a standard of skill on the part of the defendants . . . in concluding that no competent valuer could have missed the signs of Stubbs potential," and that therefore, negligence on the part of the regional auction house had not been established.

2. Product Disparagement

In the circumstance where an expert declares a work to be inauthentic, the classic claim is for product disparagement. However, proving the elements of this "classic" poses substantial difficulties for a plaintiff, as the *Wildenstein* case discussed below will make clear. Generally "special damages" must be shown, that is, specific lost sales must be shown or proof that the monetary loss was caused "exclusively and directly" by the disparagement. Plaintiff must also show that the disparaging statement was made ("published") to third parties (who might have to be potential buyers, not just private individuals involved in the art market). The requirement of "malice" presents a plaintiff with yet another hurdle. Although there is a great deal of confusion in the court decisions on this point, a plaintiff art owner must show that the defendant's disparaging statement concerning the work's authenticity or attribution was, at the least, negligently made. At most (in the view of some), plaintiff must show the defendant's reckless disregard for the truth or actual knowledge of the lack of truth—a difficult burden indeed.

Further, although the *Wildenstein* decision discussed below does not address, in detail, the fourth required element of the claim—namely, falsity—proving falsity of the disparaging statement requires the plaintiff to prove by a preponderance of the evidence that his work is authentic. The *Wildenstein* case, concerned as it was with the condition of the work rather than authenticity, does not address this element. But other judges, such as U.S. Federal District Court Judge Cedarbaum, have made it clear that a plaintiff/owner must show the "falsity" of the disparaging statement by proving the authenticity of his art by a preponderance of the evidence.[13]

ELEMENTS REQUIRED TO PROVE PRODUCT DISPARAGEMENT

In *Kirby v. Wildenstein*,[14] a U.S. Federal District Court set out the elements of the tort of product disparagement.

> The phrase "product disparagement" refers to works or conduct which tend to disparage or reflect negatively on the quality and condition of a product or property.... In order to prevail on his claim of product disparagement, the plaintiff must establish the following four elements: (1) the falsity of Wildenstein's statements; (2) publication to a third person; (3) malice; (4) special damages.[15]

The plaintiff in *Wildenstein* owned a painting by the French artist Jean Béraud (1849–1935). He entered into a consignment agreement with Christie's which provided that Christie's would contact the recognized expert on Béraud, Patrick Offenstadt, to determine whether the painting would be in the catalogue raisonné which Offenstadt was preparing under the auspices of the Wildenstein Institute. Daniel Wildenstein examined the painting and, at first, concluded that the painting was either "skinned," meaning it had suffered removal of paint through overcleaning, or that it was a copy. Wildenstein later revised his opinion on its authenticity and, in a letter to Christie's, advised that the painting would be listed in the forthcoming catalogue raisonné as an authentic Béraud, but would bear the notation that the painting had been damaged by "an abusive restoration and cleaning," and that this notation as to condition should be included in the Christie's sale catalogue. Christie's declined to mention the painting's condition in its sales catalogue. There were no bids at the auction, the painting did not sell, and the plaintiff sued.

In its decision the court stressed the required element of special damages:

> Special damages are limited to losses having pecuniary or economic value and must be fully and accurately stated ... with sufficient particularity to identify actual losses.[16]

The requirement of proving "special damages" is not merely a question of the amount of monetary damages to be awarded. Without proof of special dam-

ages, the plaintiff does not make out a claim of product disparagement at all. The plaintiff's proof of special damage consisted, first, of an affidavit from Christie's that the action taken by Wildenstein "had an adverse effect on the salability of the painting" and, second, plaintiff's allegation that, at a trial, plaintiff's expert would testify that the painting (estimated in the Christie's catalogue at $160,000 to $200,000), would not be worth any more than $90,000. The court considered these allegations of damages as being too vague, stating:

> ...plaintiff has not named any person who would have bid on the painting but did not do so because of the alleged disparagement....
>
> ...
>
> The rule...that lost customers must be named where the special damages claimed are lost sales—is well-entrenched and has been consistently followed.[17]

The court admitted the patently obvious possibility that it may not be possible for the owner to find the names of those who failed to purchase, but in that circumstance, the owner is obliged to offer evidence which would exclude the possibility of the loss being the result of any other cause but the disparagement. Here, the quality and condition of the painting itself might well have caused potential bidders not to bid on the painting.

Also, plaintiff, in proving special damages, must show that his loss was causally related to Wildenstein's statements. Daniel Wildenstein insisted that he disclosed his statements only to Christie's and Wildenstein employees. The court concluded that while such disclosures were "technically adequate" to constitute the necessary element of publication, those to whom they were made were not potential purchasers, and there was no evidence that Wildenstein's statements were circulated to "outside parties," thus preventing the plaintiff from demonstrating that his losses were causally related to the disparaging statements.

The third element to be proven by a plaintiff in order to make out a claim of product disparagement is "malice." A leading text in the field states:

> It is said in many cases that "malice" is a necessary element in the tort of a product disparagement. This is misleading, however, if it suggests the need for anything like ill will, which is clearly not essential.[18]

The court decisions and the legal commentators such as Dean Prosser (reporter for *Restatement* [Second] *of Torts,* 1977) provide widely varying formulations for the definition of "malice."[19] Prosser, for example, argued that proof of mere negligence on the part of defendant for uttering an injurious falsehood concerning another's property was not sufficient to meet the malice standard. Prosser believed that, beyond "mere negligence," in order to in-

cur liability for an injurious falsehood, it must be shown that the actor/speaker "knows the matter to be otherwise than as stated or that he has not the basis for knowledge or belief proffered by his assertion."[20]

Stated another way, Prosser would, in the absence of ill will, require knowledge of falsity or reckless disregard of the truth by the defendant.[21] Other writers, however, have implied that proof of an injurious falsehood, simply negligently made (that is, without malice), could entail liability.[22] And, as a further example of these widely varying formulations of the "malice requirement," it has been proposed in the circumstance where the defendant had, for example, been trying to warn a public museum that it was buying a fake, that

> ... where the actor's principal purpose is not the gratification of ill will or selfish gain, but is instead altruistic, it would not be surprising if courts were reluctant to impose liability for statements honestly believed on reasonable grounds to be true. . . .[23]

3. Breach of Contract: Eight Important Cases

Contract disputes between buyers and sellers over authenticity or attribution usually involve a warranty by the seller as to the author of the work and the consequences of the claim that the warranty is no longer (or never was) accurate.

The Uniform Commercial Code in its relevant part, set forth below, enacted in most states of the United States, is the basic statutory law governing warranty issues. The *Bacon* case, discussed below, raises the very practical and important issue of the buyer's obtaining a warranty about the work from the seller, but then *clearly not relying upon the warranty* in his purchase decision.

The second contract case, *Avery*, raises the issue of when a seller's "puffing" or "affirmation of value" becomes a warranty upon which a buyer may rely.

When new scholarship proves that everyone—the buyer, the seller, and the art market—was wrong in their belief about the painting's attribution, the *Bierstadt* case holds that the buyer cannot get his money back. However, the *Feigen* case holds that a buyer of a painting, which both buyer and seller (but not the art market) believe to be by a certain artist, may bring a claim of mutual mistake of fact in order to rescind the sale and have his purchase price returned.

Two English cases, *Salisbury Cathedral* and *Münter*, decided almost forty years apart, suggest, at least in their language even if not by their actual decisions, that the English courts are not terribly sympathetic to claims that the authorship of a work of art is a critical fact for a determination of legal rights

of a disappointed buyer. And a recent English decision held that a painting sold by Thos. Agnew & Sons in London as by Van Dyck was a work out of Van Dyck's studio, but that Agnew's attribution represented only an opinion, not a contractual guarantee to the buyer.

Finally, a buyer of ancient Chinese pots, who had received an express warranty of their authenticity from the seller, argued that he should have his money back if the seller could not show that the pottery was authentic. The judge thought that this placed too heavy a burden on the seller. The plaintiff/buyer did not have to prove that the works were not authentic, only that the defendant/seller had no "reasonable basis in fact" for his warranty of authenticity.

American Statutory Law Concerning Warranties of Authenticity

Section 2-313 of the Uniform Commercial Code states in part:

1) Express warranties by the seller are created as follows: . . .
 (b) Any description of the goods which is made part of the basis of the bargain creates an express warranty that the goods shall conform to the description. . . .
2) It is not necessary to the creation of an express warranty that the seller use formal words such as "warranty" or "guarantee" or that he have a specific intention to make a warranty, but an affirmation merely of the value of the goods or a statement purporting to be merely the seller's opinion or commendation of the goods does not create a warranty.

The *Official Comment* to the Code states, in part:

The whole purpose of the law of warranty is to determine what it is that the seller has in essence agreed to sell. Concerning affirmations of value or a seller's opinion or commendation . . . the basic question remains the same: What statements of the seller have in the circumstances and in objective judgment become part of the basis of the bargain? . . . some statements or predictions cannot be fairly viewed as entering into the bargain. Even as to false statements of value, however, the possibility is left open that a remedy may be provided by law relating to fraud or misrepresentation.

It should be noted that New York's Arts and Cultural Affairs Law (Section 13.03) modifies U.C.C. Section 2-313 by providing that a written "seller's opinion" on authenticity by an art merchant becomes an express warranty, notwithstanding the seller's use of the word, "opinion." Compare this view of opinion to the English *Van Dyck* case discussed in this chapter below.

When the Seller Warrants Authenticity
but the Buyer Relies on His Own Research

In 1997, the U.S. Court of Appeals for the Second Circuit laid down important rules in a case involving a painting titled *Self Portrait*, and said to be by Francis Bacon, which raised the question of a buyer's disbelief, or nonreliance, upon express warranties made by the seller.[24] In order to induce the buyer to make the purchase, the bill of sale contained a warranty that the seller had no knowledge of any "challenge" to the authenticity of the painting. After his purchase, the buyer had second thoughts about the painting's authenticity and sued to get his purchase price returned, based on the seller's warranty. The seller defended on the grounds that he had disclosed enough negative information about the painting to the buyer so that the buyer had, in effect, waived the benefits of the seller's warranty.

The *Bacon* court reasoned that where a buyer has full knowledge of facts disclosed by the seller which would be a breach of seller's warranty, the buyer is foreclosed from asserting a breach of such warranty, unless the buyer expressly reserves his rights to enforce the warranty. However,

> If the seller is not the source of Buyer's knowledge, e.g., if it is merely "common knowledge" that the facts warranted are false or the buyer has been informed of the falsity of the facts by some third party, the buyer [will] prevail in his claim for breach of warranty. In these cases, it is not unrealistic to assume that the buyer purchased the seller's warranty "as insurance against any future claims" and that is why he insisted on the warranties in the bill of sale.[25]

Thus, the *Bacon* court concluded that what the buyer knew and, most important, *whether the buyer got that knowledge from the seller* are the critical questions. Interestingly, the *seller* knew of the "cloud" that hung over the painting's authenticity before he sold it to the plaintiff. Thus, the *seller knew* that the Marlborough Gallery didn't think the painting authentic; the Robert Miller Gallery had refused to purchase the painting when they learned of the Marlborough doubts; the late British art critic David Sylvester advised Miller not to buy because of the Marlborough objection (and because Sylvester himself was not sure of the painting); and the seller had received a letter from a Zurich art dealer stating that "everybody is afraid of the authenticity."

The *Bacon* court assumed that the buyer was aware of most or all of these concerns about the picture's authenticity, but noted that what the buyer knew from his own research or from third parties was "immaterial."

> Only if the seller . . . himself informed the [buyer] of doubts about the provenance or challenges to authenticity will [the buyer] be deemed to

have waived any claims for breach of warranty arising from the written representations appearing in the Bill of Sale.[26]

Here, the seller had not informed the buyer about seller's own doubts concerning the authenticity and provenance of the painting, but had merely "alluded to the controversy or problems with the Marlborough Gallery" in his conversations with the buyer. Still, the court found that these ambiguous seller communications could be considered *disclosure of facts by the seller*, in effect negating or withdrawing seller's warranty in the bill of sale. The buyer would then be deemed to have waived his claim for a breach of warranty, unless he expressly preserved his rights by stating, in effect, that disputes regarding the accuracy of the seller's warranty are unresolved and that the buyer does not waive his right to enforce the warranty.

Significance of Seller's Opinion of Value

Although section 2-313(2) of the Uniform Commercial Code provides that "an affirmation merely of . . . value . . . or a statement purporting to be merely the seller's opinion or commendation . . . does not create a warranty," a U.S. District Court in Massachusetts decided that in certain circumstances, an opinion on valuation can breach a seller's warranty.[27] Goldman had purchased two Milton Avery paintings from the Barnett Gallery based upon an appraisal of their value made by the gallery, a member of the Appraisers' Association of America. After several months, Goldman decided that his paintings were worth far less than he had agreed to pay and sued for breach of contract, namely, breach of implied covenant of good faith and fair dealing, and breach of an express warranty as to the value of the paintings. There was evidence that the appraisals were roughly four times higher than the fair market value as found by at least one other expert. Although the *Avery* court quoted section 2-313(2), the court decided that a jury could find, nevertheless, that the gallery went substantially beyond "merely affirming value" because there was evidence that the Barnett Gallery had issued an expert appraisal of the paintings' fair market value.[28]

Opinion in Conformance with Prevailing View

What is the legal result when new scholarship shows that a painting thought by both buyer and seller to be by Albert Bierstadt is by someone else?[29] In 1981, when the plaintiff purchased a painting from the Union League of Philadelphia for $500,000, both parties believed the work to be by Bierstadt and the seller warranted its authenticity. However, in the spring of 1985, some art historians began to express doubts about the attribution. In an article in a 1986 issue of *Antiques* magazine, a noted art historian expressed a firm opin-

ion that a Confederate artist, not Bierstadt, was the painter. And this view became generally accepted among art experts. As a Bierstadt, the painting was worth $500,000; as the work of another, its value was only $50,000.

Although plaintiff's claim was barred by a four-year statute of limitations, the court volunteered that it would have decided, in any event, against the buyer's contract claim that there was a mutual mistake of fact entitling the buyer to rescind the sale.

> The market value of a painting is determined by the prevailing views of the marketplace concerning its attribution. Post-sale fluctuations in generally accepted attributions do not necessarily establish that there was a mutual mistake of fact at the time of sale. If both parties correctly believed at that time that the painting was generally believed to be a Bierstadt, and, in fact, it was generally regarded as a Bierstadt, it seems unlikely that plaintiff could show that there was a mutual mistake of fact.[30]

Where No General Prevailing View as to Authenticity of the Art Existed at the Time of Purchase, a Buyer May Later Rescind His Purchase Based on "Mutual Mistake of Fact"

Art dealer Richard Feigen sold a Matisse ink drawing which had been consigned to him and paid the consignor/owner $100,000. A year after Feigen's sale, the Matisse estate determined that the drawing was a fake, and Feigen thereupon returned the sales price to his buyer. However, the consignor/owner refused to return the $100,000 Feigen had paid him. Feigen sued, claiming that his agreement with his consignor/owner should be rescinded for mutual mistake.[31]

Feigen and the consignor/owner agreed that the work was a fake and that they had been mistaken in believing it authentic. But the consignor/owner argued that Feigen was aware that the work might not be authentic, and thus was subject to the conscious ignorance exception to the doctrine of mutual mistake—that is, Feigen had entered into a contract notwithstanding this uncertainty or ignorance. The court found that while Feigen had limited knowledge about the drawing's authenticity, he believed it to be by Matisse and that he, as consignee, had no obligation to inquire into the authenticity beyond a "cursory inquiry."

Two English Cases Suggest a Disappointed Buyer Has Limited Recourse When a Painting Turns Out Not to Be Authentic

The 1950 decision in the *Salisbury Cathedral* case is, for our purposes, clouded by the inexplicable failure of the buyer to ask for damages for breach of a

warranty of authenticity. The buyer asked only that, five years after his purchase, the sale contract be rescinded and his purchase price returned to him, because he had become convinced that the painting was not by Constable. In light of the buyer's delay, the court's decision was clearly correct. But the court's view that the "subject matter of the sale," a specific picture of Salisbury Cathedral not (as it turned out) painted by John Constable, was only a mistake about the "quality" of the subject matter gives little comfort to buyers of art that turns out to be wrongly attributed.

In 1944 the plaintiff purchased a picture called *Salisbury Cathedral*, took the picture into his house, and apparently hung it there for five years. Said Judge Denning:

> That I hardly need say, is much more than a reasonable time. It is far too late for him at the end of five years to reject this picture for breach of any condition. His remedy after that length of time is for damages only, a claim which he has not brought before this court.[32]

Judge Denning went on:

> The buyer has accepted the picture. He had ample opportunity for examination in the first few days after he bought it. Then was the time to see if the condition or representation was fulfilled. Yet he has kept it all this time. Five years have elapsed without any notice of rejection. In my judgment, he cannot now claim to rescind. His only claim, if any, was for damages, which has not been made in this action.[33]
>
> . . .
>
> In my opinion, this case is to be decided according to the well known principles applicable to the sale of goods. This was a contract for the sale of goods. There was a mistake about the quality of the subject matter, because both parties believed the picture to be a Constable; and that mistake was in one sense essential or fundamental. But such mistake does not void the contract; there was no mistake at all about the subject matter of the sale. It was a specific picture, "Salisbury Cathedral." The parties were agreed in the same terms on the same subject matter, and that is sufficient to make a contract: [citation omitted.]
>
> There was a term in the contract as to the quality of the subject matter: namely, as to the person by whom the picture was painted—that it was by Constable. That term of the contract was, according to our terminology, either a condition or a warranty. If it was a condition, the buyer could reject the picture for breach of the condition at any time before he accepted it, or is deemed to have accepted it; whereas, if it was only a warranty, he could not reject it at all but was confined to a claim for damages.
>
> I think it right to assume in the buyer's favour that this term was a con-

dition, and that, if he had come in proper time he could have rejected the picture; but the right to reject, for breach of condition has always been limited by the rule that, once the buyer has accepted, or is deemed to have accepted, the goods in performance of the contract, then he cannot therefore reject, but is relegated to his claim for damages.[34]

The *Salisbury Cathedral* court's unhappiness with the buyer's claims of incorrect attribution is made more clearly by Judge Evershed, in agreeing with Judge Denning, as follows:

> The plaintiff's case rested fundamentally upon this statement which he made: "I contracted to buy a Constable. I have not had and never had, a Constable." Though that is, as a matter of language, perfectly intelligible, it nevertheless needs a little expansion if it is to be quite accurate. What he contracted to buy and what he bought was a specific chattel, namely, an oil painting of Salisbury Cathedral; but he bought it on the faith of a representation innocently made, that it had been painted by John Constable. It turns out, as the evidence now stands and as the county court judge has found that it was not so painted. Nevertheless, it remains true to say that the plaintiff still has the article which he contracted to buy. The difference is no doubt considerable, but it is, as Denning, L.J. has observed, a difference in quality and in value rather than in the substance of the thing itself.
>
> That leads me to suggest this matter for consideration; the attribution of works of art to particular artists is often a matter of great controversy and increasing difficulty as time goes on. If the plaintiff is right in saying that he is entitled, perhaps years after the purchase, to raise the question whether in truth a particular painting was rightly attributed to a particular artist, most costly and difficult litigation may result. There may turn out to be divergent views on the part of artists and critics of great eminence, and the prevailing view at one date may be quite different from that which prevails at a later date.[35]

The "Potential Arguability of Almost Any Attribution" Tends to Reduce Buyer's Rights in English Courts

Forty years after the *Salisbury Cathedral* case, Judge Nourse cited it approvingly in another case. In 1984, plaintiff[36] bought a painting for £6,000 which both buyer and seller, two art dealers, thought was by Gabriele Münter, an artist of the German Expressionist school. In 1985, the foundation which held the artist's estate told the buyer that the picture was a forgery. The plaintiff claimed that the picture was therefore not of "merchantable quality" and asked for repayment of the purchase price. The judge concluded that a pic-

ture was not "unfit for resale" just because it had been purchased for £6,000 but later turned out to be a forgery saleable for only £50 to £100.

The judge found that Hull, the seller, specialized in works of contemporary British artists and had no training, experience, or knowledge which would have enabled him to conclude from an examination of the painting whether it was by Münter or not, and that seller made this absolutely clear to the agent for the buyer, Runkl.

> ...it was Mr. Runkl's exercise of his own judgment as to the quality of the pictures, including the factor of the identity of their painter which induced him to enter the agreement with Mr. Hull.[37]

The buyers argued that the painting was not of "merchantable quality" and that this was an implied condition of the contract under the applicable Sale of Goods Act. On the question of "merchantable quality," the *Münter* court had this to say:

> It is true that the painting was defective in that it was not the work of the artist by whom it appeared to have been painted. I agree with Denning LJ in *Leaf v. International Galleries* [citation omitted] that that was a defect in the quality of the painting. But it was not one which made it unsaleable. The evidence was that it could have been resold for £50 to £100. Admittedly that would have been a very long way below the £6,000 which the plaintiff paid for it. But the question whether goods are reasonably fit for resale cannot depend on whether they can or cannot be resold without making a loss. Nor did the defect make the painting unfit for aesthetic appreciation. It could still have been hung on a wall somewhere and been enjoyed for what it was, albeit not for what it might have been.
>
> ...
>
> Having been prepared to pay £6,000 in reliance only on their own assessment, the plaintiff cannot use their own error of judgment as a basis for saying that a painting which would otherwise be reasonably fit for resale or for aesthetic appreciation is thereby rendered unfit for those purposes.[38]

Judge Nourse then went on:

> ...to add some general observations about sales of pictures by one dealer to another where the seller makes an attribution to a recognized artist. ... almost any attribution to a recognized artist, especially of a picture whose provenance is unknown, may be arguable ... many dealers habitually deal with each other on the principle of caveat emptor.
>
> ... The court ought to be exceedingly wary in giving a seller's attribution any contractual effect. To put it in lawyer's language, the potential arguability of almost any attribution being a part of the common experi-

ence of the contracting parties, is part of the factual background against which the effect, if any, of an attribution must be judged.[39]

A Recent English Case Decides That a Mere Expression of Opinion
of a Dealer About a "Van Dyck" Does Not Become a Guarantee
of Authenticity. Plus, How the Judge Decided the Picture Was a Copy

In 1998 a well-known dealer in Old Master paintings, Thos. Agnew & Sons, sold a painting for £2 million which the dealer had bought at a 1996 Sotheby's auction for £30,000, catalogued as "after Sir Anthony van Dyck."

Agnew's invoice to the buyer described the painting as "by" van Dyck and referenced "the brochure for full details." Agnew's brochure made it clear that they regarded the work as by Van Dyck while at the same time mentioning that the greatest expert on Van Dyck's English period painting, Sir Oliver Millar, thought the picture was only from Van Dyck's studio.

Mr. Justice Buckley described the issues as follows:

In general mere expressions of opinion or belief are not contractual; without more they do not become terms of any subsequent contract. Clearly, one party may be so confident in his opinion, for example, as to the authenticity or origin of an object or painting that he is prepared to contract on that basis. He may have good commercial reasons for doing so. But in such cases an objective assessment of all the circumstances must point to that conclusion. The conclusion must be that the common intention of the parties was that the content of the opinion or belief was to become a term of the contract. The obvious and sensible way to achieve that result is to say so; but the courts are often called upon to resolve cases in which the parties have not so clearly expressed their intention and although it may be tempting, it is not always just to conclude that they did not have the necessary intent simply because they did not express it.

Obviously, Agnew's references to the painting as by Van Dyck or a Van Dyck were expressions of opinion. No one could sensibly have believed that Agnew's knew, or had some magic formula for establishing, that Van Dyck himself had painted the canvas. . . . The question is whether Agnew's opinion became a term of the contract. There was no express statement to that effect in the documents. . . . That leaves for consideration whether the necessary common intention should nevertheless be imputed to the parties on an objective assessment of all the circumstances. . . . it seems to me that some of the dissenting judgments in the cases cited to me give insufficient weight to that basic point and proceed from the premise that because some descriptive words were used or written, the statutory implied term comes into effect. It only does so if the proper conclusion from all

the evidence is that the parties intended the description to be a term of the contract.[40]

Agnew's admitted that its salesperson told the buyer that the painting was by Van Dyck. Agnew's also gave the buyer a brochure in which they made the same claim. But the judge found that a "fair reading" of the brochure was that Agnew's attribution was an opinion based on their research and expertise, but there was a contrary opinion of Sir Oliver Millar, the acknowledged expert on Van Dyck's English period. And, in any event, the buyer's reliance on Agnew's opinion was limited. It was not a reliance in the sense that the buyer believed he had any contractual guarantee of authorship; rather, the buyer thought Agnew's opinion might well be correct.

Having thus disposed of the buyer's contract claim, Justice Buckley then reviewed the buyer's claim for misrepresentation: that he relied on Agnew's representations that the painting was by Van Dyck according to the salesperson's admitted oral statement of authorship and Agnew's brochure. But the justice found that the oral statement was "opinion and honestly held," and that a reasonable reader of the brochure would not expect that Agnew's "had mentioned every single conversation or piece of research on the painting." Further, the fact that two years earlier Agnew's had bought the painting for £30,000 at a Sotheby's auction, where it was catalogued as "after Sir Anthony van Dyck," and did not disclose these facts to the buyer was not a misrepresentation on which the buyer could rely. The auction information was publicly available, and

> It is after all not unusual for dealers to buy items at auction, which by virtue of their own expertise, they recognize as an object or painting . . . far more valuable than the catalogue description suggests.[41]

Having decided that Agnew's did not give a contractual guarantee of its opinion and that it did not misrepresent Van Dyck's authorship to the buyer, it is surprising that Justice Buckley went on to determine the *authenticity* of the work. But his extensive analysis of *how* he came to his decision that the picture was a copy is of real interest for this chapter. His reasoning was as follows.

> Attribution of an Old Master can depend on various matters, including: provenance, historical research and the experienced eye of an expert, usually a trained art historian. In this case neither provenance nor history gives an answer or even very much help. The knowledge of van Dyck's studio practice which art historians have acquired is certainly of some assistance, but in the end, both Sir Oliver and Mr. Agnew agreed the matter was to be resolved by eye. From listening to them both I understand that to mean

rather more than just observation. Whilst it is vital to have keen observation it is also necessary to have knowledge of an artist's methods and style and to be sufficiently familiar with his work to be able to recognize his artistic handwriting. Even that is not all. It involves also a sensitivity to such concepts as quality, emotion, mood and atmosphere. To an extent ["eye"] can be developed but, like many other human attributes it is partly born in a man or woman. Were it otherwise there would be many more true experts. This is not a digression. It is rather important to my function in this case. A judge is not bound by expert opinion. A judge may presume to find that an expert's final opinion is based on illogical or even irrational reasoning and reject it. But a judge should not himself assume an expertise he does not possess. Thus here, if the question had turned on analysis of historical data or inferences to be drawn from surviving documents, I would have been entitled, with such assistance from the experts as I had received, to have drawn my own conclusions; but it does not. It turns on eye. . . .

. . .

. . . It is agreed that Sir Oliver is one of, if not the leading expert on van Dyck's English Period. Without in any way bowing to Sir Oliver's opinion on the Painting, Mr. Agnew did acknowledge that on questions of attribution of van Dyck's English Period paintings Sir Oliver is the acknowledged expert.

. . .

. . . Sir Oliver pointed out the differences between the two paintings with particular emphasis on the head, the neck, collar and jewel and explained why he felt the Painting unsatisfactory or of lesser quality and not displaying van Dyck's handwriting albeit the Painting as a whole was of fine quality and clearly painted by a very competent assistant in van Dyck's studio. . . . Mr. Agnew said he simply could not see the differences to which Sir Oliver had referred. . . . However, I did not take him literally. I think he meant they were not significant or could be accounted for by the fact that the Painting was a repetition (as opposed to a copy which would be by someone else). I say that because, once pointed out, I could see the differences to which Sir Oliver referred me. They were not so subtle as to be invisible to the inexpert. The expertise lies in spotting them in the first place and assessing their significance. . . . Sometimes van Dyck himself would do the work in which case it is referred to by art historians as a repetition. If it was done by another artist, that is one of van Dyck's assistants, it is called a copy.

. . .

I was impressed by Mr. Agnew's expertise and obvious love of his subject. On the other hand, Sir Oliver was able to lead me to at least some of

the aspects of the painting which he believed to be of lesser quality than van Dyck himself would have produced. Whilst I could in some cases see for myself the difference between the Kenwood picture and the Painting, the significance of these matters is for the experts. For example, whether the Ickworth painting appears less good because it is a repetition, through overcleaning or because it is not by van Dyck's own hand, are matters where real expertise comes into its own.

. . .

. . . [Sir Oliver's] view is based firmly on his own assessment of the quality of the Painting drawing upon a lifetime's study and experience of van Dyck's work, and the advantage of having seen all, bar one, of the Master's known English Period works. Sir Oliver's experience, knowledge and general expertise concerning van Dyck's English Period are unrivalled. In the end I am satisfied that I should accept his evidence and conclude that the Painting should not be attributed to van Dyck. In fairness to Mr. Agnew, to whom I am grateful for all his assistance, I should say that in reaching that conclusion I have been significantly influenced by the acknowledged greater expertise that Sir Oliver possesses in relation to these works. My decision is a legal one based upon the evidence and the circumstances of the experts that I have described. I hope I have resisted the temptation to use the eye for van Dyck that I have now acquired from two such distinguished and patient teachers.[42]

There are several points to be noted about Justice Buckley's determination of authenticity in *Van Dyck*. First, he recognized the importance of the connoisseur's eye. Second, *the justice himself could see* some of the visual indicia the experts pointed out. And, third, unlike the American federal judge in the Alexander Calder case,[43] who rejected the opinion of Klaus Perls, the acknowledged Calder expert, the justice acknowledged his greater reliance on the more highly regarded expert. (See my "Authentication in Court," chapter 16 in this volume.)

What the Buyer Must Show to Prove a Breach of Warranty of Authenticity

When a seller *has* given an express warranty of authenticity with respect to art sold (unlike the *Van Dyck* case above), and the buyer claims that the art is not authentic, there remains the question as to what the buyer must prove at trial to establish that the warranty was inaccurate. The *only* American case reported on this question involved Chinese pottery.[44] The buyer took the position that in order to prevail, he only needed to prove that the works failed to conform in any respect to the descriptions the seller represented as being accurate. That is, unless it could be found that the works were unqualifiedly

what seller represented them to be, a breach of warranty would be proven, and the testimony of the seller's experts failed to establish that the works were unqualifiedly authentic. On the other hand, the seller argued that "unless the [buyer] proved by a preponderance of the evidence that the representation in the warranty were inaccurate, buyer could not prevail on his warranty claim."

Judge Bonsal said that

> attributing any of the works ... to a particular period of Chinese antiquity is by its very nature an inexact science. As the testimony of all the experts makes clear, a determination as to the proper attribution for any of these pieces is to a substantial extent a subjective judgment based upon whether an expert finds a given piece to be aesthetically consistent with other works of the period on the basis of such elusive characteristics as the quality, character, form or "feel" of the piece.[45]

Accordingly, Judge Bonsal felt it would be "unjust" to adopt the strict standard proposed by the buyer, and instead held that the buyer must prove by a fair preponderance of the evidence (i.e., it is more likely than not or, stated in shorthand, 51 percent versus 49 percent) that the representations made by the seller were "*without a reasonable basis in fact at the time the representations in the warranty were made.*"[46] The judge then examined, work by work, the factual basis which the seller had for his warranty of authenticity, finding such a factual basis for some pieces of pottery and not for others.

4. Common Law Fraud and Negligent Misrepresentation

Authenticity issues often arise in the context of claims for common law fraud and for negligent misrepresentation. The cases set forth below deal with buyer claims that the buyer did not get what he thought he was buying, a work created by a certain artist. Often the buyer discovers this unhappy fact many years after his purchase and after the applicable statute of limitations has expired (usually three years for tort claims such as product disparagement and negligence, and six years for contract warranty claims). At that late date, the buyer will attempt to prove he was defrauded by the seller. Most statutes of limitation for fraud begin to run only after the fraud is, or should have been, discovered. But the buyer then has the heavy burden of proving that the seller intended to deceive, not simply that the seller was negligently mistaken. The *Foxley* case, discussed below, dismisses another ground for a buyer's fraud claim: buyer's allegation that seller and all the art market experts knew of the lack of authenticity, and the seller knew that the buyer did *not* know.

The *Nacht* case, below, also raises the issue of what the seller knew and when he knew it in the context of plaintiff's attempt, years later, to prove seller's fraudulent intent.

Finally, as *Foxley* also shows, the claim of negligent misrepresentation sounds as if it should be very helpful to unhappy buyers. However, this claim requires a *special relation* between buyer and seller, which involves much more than a garden variety sales transaction.

"Common" or "Public" Knowledge Cannot Be the Basis for a Fraud Claim

A 1995 litigation in New York against Sotheby's raised both common law fraud and negligent misrepresentation claims.[47] In 1987 the plaintiff, Foxley, had purchased a painting said to be by Mary Cassatt at a Sotheby's auction. The auction catalogue stated that the painting would be accompanied by a letter from Adelyn Breeskin, at one time considered an authority on Cassatt, "discussing" the work.

In 1992, the plaintiff realized he did not have a copy of the Breeskin letter and, when he received a copy, learned for the first time that Breeskin's comments were predicated upon her review of a color transparency of the painting rather than of the painting itself. Plaintiff maintained he would not have bought the work had he known this; nor had he known that Breeskin had alerted the art world to Cassatt forgeries, a fact he alleged Sotheby's knew. Plaintiff also alleged that Sotheby's "intentionally hid" the fact that Breeskin had relied on a transparency to authenticate the painting. The plaintiff also alleged that Sotheby's "failed to disclose that in the late 1970's, it was common knowledge in the French/American Impressionist art community to which Sotheby's belongs, that Breeskin's authentications had become suspect, 'unreliable' and 'doubtful.' "

The *Foxley* court stated the elements of common law fraud as follows:

(1) making a false representation of (2) a material fact with (3) intent to deceive [*scienter*] and (4) plaintiff's reasonable reliance on the representation (5) which caused damage to the plaintiff.[48]

Applying these elements of the law of fraud to the plaintiff's allegation of facts, the *Foxley* court found that (1) plaintiff could not show that Sotheby's "falsely represented" that it would deliver the Breeskin letter together with the painting; (2) Sotheby's had made only one representation with respect to the Breeskin letter in its auction catalogue—that a copy of the Breeskin letter "discussing the painting would accompany the lot," not that Breeskin would authenticate the painting or that she would not rely on a photograph as opposed to examining the original. As to what was common knowledge about Breeskin's authentications, the court cited the New York Court of Appeals,[49] saying that where

facts represented are not matters peculiarly within the party's knowledge, and the other party has the means available to him of knowing, by the ex-

ercise of ordinary intelligence . . . he must make use of those means, or he will not be heard to complain that he was induced to enter into the transaction by misrepresentation.[50]

The court found it was "common knowledge in the French/American art community to which Sotheby's belonged that Breeskin's authentications had become "suspect, 'unreliable' and 'doubtful.' " Thus, the court decided that the plaintiff could not base a fraud claim on Sotheby's omission concerning the "common knowledge" of the unreliability of Breeskin's authentications since "the undisclosed information is in the public domain."[51]

The Claim of Negligent Misrepresentation Requires a "Special Relationship"

With regard to Foxley's claim of negligent misrepresentation, the *Foxley* court noted that this claim requires a "special relationship" going beyond the ordinary buyer–seller relationship. New York law requires that in order to recover for negligent misrepresentation, the defendant must owe a *fiduciary duty* to the plaintiff. It was not enough that the plaintiff had a long and "significant" business association with Sotheby's over two decades, including personal visits, private luncheons, and introductions to Sotheby's personnel.

Further, an auction house is the agent for the seller and thus owes a fiduciary duty to its consignor, but does not normally owe a fiduciary duty to a buyer. "The mere fact that a gallery holds itself out as an expert in art does not give rise to such an obligation to the purchaser of art."[52]

Knowledge of Falsity as a Required Element of Fraud

Other factual circumstances which illustrate the requirements of a fraud claim are described in *Nacht v. Sotheby's Holdings*,[53] in which a buyer at a 1981 auction of a painting said to by Francis Picabia attempted to sell the work fifteen years later and, when Sotheby's presented the painting to a newly formed committee of Picabia experts, discovered that it was of questionable authenticity. After examining the painting, the committee refused to include the work in its catalogue raisonné.

> Although the committee has not conclusively determined that the painting is not a genuine Picabia, the practical effect of its action is to greatly reduce the painting's value because it is extremely unlikely that any reputable art dealer or auction house would sell the painting as having been painted by Picabia when the committee refused to include it in the catalogue raisonné.[54]

The judge stated the obvious: that the plaintiff's breach of warranty claim had to have been brought by 1986, that is, the statute of limitations period of four years, plus an additional year afforded by Sotheby's express warranty in its auction catalogue. Therefore, plaintiff was forced to allege fraud: "...*i.e.,* that in 1981, Sotheby's induced her to buy the painting by means of false representations regarding its authenticity." Such a cause of action for fraud avoided the statute of limitations on plaintiff's warranty claim because the alleged fraud was not "discovered" by the plaintiff until fifteen years after her purchase.

> In order to recover for fraud, plaintiff must allege that Sotheby's made a representation of fact with knowledge of falsity, and that she relied on that representation to her detriment.... Gross negligence can amount to fraud. ...At the pleadings stage, this court will assume as true the allegation that at the time of plaintiff's purchase of the painting, Sotheby's knew of its questionable authenticity, yet included it in its catalogue of works for sale without noting the questionable authenticity.[55]

However, the *Nacht* court indicated its doubts that the plaintiff could prove such actual knowledge on Sotheby's part.

> The mere fact that the painting which Sotheby's guaranteed in 1981 was later found to be of questionable authenticity does not in and of itself amount to fraud. In Nacht's own affidavit, she admits uncertainty as to when Sotheby's learned of the facts regarding authenticity.[56]

Damages for Fraud Do Not Include Lost Profits

Even if plaintiff Nacht could prove fraud, she would not be awarded the present value of a painting she had purchased almost twenty years earlier. On the question of damages for fraud, the *Nacht* court noted that

> damages recoverable in a fraud case are designed to compensate the aggrieved party for what she lost due to the fraud, not to compensate her for what she might have gained. ... Under the out-of-pocket rule, there can be no recovery of profits which would have been realized in the absence of fraud.[57]

5. False "Advertising" Under State Consumer Protection Laws and the U.S. Lanham Act

Most states have consumer protection statutes which, like New York's (since 1980), provide a private right of action for injuries caused by consumer and business fraud. These statutes were intended to supplement common law causes

of action such as those for fraud by creating a new "right" as a result of a seller's deceptive act.

A plaintiff buyer bringing a common law fraud action must prove the seller's intent to deceive—a substantial burden especially for a claim brought many years after an art sale. However, the seller's intent to deceive is not an element of the claim under consumer protection statutes. The good or bad faith of the seller is irrelevant to whether the seller's representation of authenticity is actionable, that is, even if a seller reasonably believed his warranty of authenticity to be true.

These consumer protection statutes typically provide for an award of actual damages and reasonable legal fees, and, with some conditions and monetary limits, treble damages. In New York, the statute of limitations on a consumer protection claim is three years. This of course will prove to be a practical difficulty for an unhappy buyer whose discovery of a lack of authenticity may come years after his purchase.

A fairly recent development involving claims concerning authenticity or attribution of visual art has been the use by plaintiffs of the Lanham Act, a federal statute usually associated with trademark and false advertising claims. However, although the Lanham Act says that "any person" damaged by a false description of his goods may sue, the courts have held that *consumers* do not have a Lanham Act claim. The statute is limited to commercial plaintiffs and defendants who are *competitors*. Thus, competing art dealers may sue each other under the Lanham Act but the retail buyer of a falsely described work may not use the Lanham Act, nor may a private owner use the statute to sue an art expert who has expressed misgivings about the authenticity of a work.[58]

Burden of Proving Authenticity in a Lanham Act Claim Was on Plaintiffs

According to federal Judge Cedarbaum in the *Khidekel* case, the dealers (the Boules) had to prove the "falsity" (for Lanham Act purposes) of defendants' statements impugning the authenticity of the dealers' collection of paintings by the artist, Khidekel. This meant the plaintiffs (the Boules) had to prove that the their collection was in fact created by Khidekel. However, the judge found the evidence of authenticity in "equipoise," and thus the Boules did not sustain their burden of proving the essential element of falsity of the defendants' statements by a preponderance of the evidence.

The evidence which Judge Cedarbaum found in "equipoise" consisted of evidence given at trial by art historians and by technical experts on paint (for both sides) testifying as expert witnesses. Although the defendants did not prove the Boule collection was not authentic, the burden of proof was on the *plaintiffs* to prove their collection *was* authentic—a burden that could not be met by evidence from each side roughly equal in weight.[59]

6. Claims of Defamation

Claims for defamation are usually made when the plaintiff feels his *reputation* has been injured. When his *property* is injured by a false statement, the claim is usually made in terms of product disparagement or negligence. However, the same statement about art can injure both reputation and property, as the following two court decisions indicate.

The plaintiff who brings a defamation claim has more to prove than simple negligence. Thus, if the matter is one of "public concern," and authenticity issues often are, the *plaintiff bears the burden of proving the falsity of the defamatory statement, which, on issues of art attribution, means proving that the work he owns is authentic.* Also, where the matter is of public concern, in New York a defamation plaintiff must show that the defendant acted with "gross irresponsibility." And indeed, in all states of the United States there must be some degree of *fault* on defendant's part in order to meet U.S. constitutional requirements. As we will see below, even if a defamation plaintiff can show these elements, some states allow the defendant a qualified privilege to make defamatory statements.

Once a plaintiff has met these two burdens, he must prove damages with a fair degree of specificity, unless the defamatory statement harms his professional reputation. Even then, plaintiff may have to show *actual* injury to his professional reputation[60] if he wishes to have substantial monetary recovery as opposed to nominal damages and the satisfaction of being proved correct. The two court decisions discussed below, *La Farge* and the trial court's decision in *Khidekel*, well illustrate these required elements.

Elements of a Defamation Claim in the Context of Statements About Art

In 1991, a federal court in New York decided the defamation claims of dealers in John La Farge stained-glass windows. The case was brought against James Yarnell, the author of a La Farge catalogue raisonné, for his statements (a) about art the dealers owned and (b) about their reputation.[61] The *La Farge* court noted: "Statements of opinion on matters of public concern are protected under the First Amendment as long as they do not contain a provably false factual connotation."[62]

The court found that the subject of Yarnall's statements, the works of La Farge, were "clearly matters of public concern."

> Granted, the topic of La Farge may not be of interest to the population as a whole. Where, however, as here, the statements of Yarnall on authenticity and value of works attributed to La Farge affect the market for and the tax implications of donating La Farge's works among a segment of the

population that trades and works as well as the community of scholars with an interest in La Farge, such statements are of public import.[63]

Since this was a matter of "public concern," the court noted that the plaintiffs "bear the burden of showing the falsity of defamatory factual assertions contained in Yarnall's statements."

The court then went on to determine that Yarnall's three statements and a letter he wrote about the works owned by the plaintiff dealers did not contain provably false factual connotations, that is, did not contain or imply factually verifiable content or, if the conclusions did so, they were based on "disclosed facts," which themselves were not defamatory.

One of Yarnall's statements, made after a physical viewing at a gallery — that a certain window had been "irreparably damaged and the glass badly shattered due to its having been dropped," and that the window was "poorly restored" — was obviously capable of being proved true or false. However, under New York law, where the matter was of "public concern," the plaintiff had to make an additional showing that Yarnall acted with "gross irresponsibility." The court found that Yarnall was not under an obligation to make an "exhaustive investigation" of the facts which established "definitely" that the window had been broken and restored, because to hold Yarnall's conduct to be grossly irresponsible would "unduly burden the important function of those who facilitate a contemplated transaction by providing on short notice an oral opinion on the quality of a work of art."[64]

A second Yarnall statement, made in response to a request for an opinion by a proposed gallery exhibitor, about another (the Rooster) window, was that neither Yarnall nor his proposed catalogue raisonné recognized the Rooster window as being by La Farge.

The *La Farge* court noted that this statement

. . . refers to Yarnall's personal belief and to the incontrovertible fact that the Rooster Window is not currently included in the catalogue raisonné. . . . Moreover, . . . Yarnall's statement concerning the authenticity of the Rooster Window was based on facts that were disclosed at the time of the statement.[65]

A third Yarnall statement, about the Hollyhocks Window, was made on the telephone to the gallery planning a La Farge exhibition, in response to the gallery's request for an opinion. Yarnall told the gallery exhibitor that, in the opinion of the catalogue raisonné, and in his opinion, there was no certainty concerning the provenance of the window, currently owned by the McNallys, as coming from the J. Pierpont Morgan House. The La Farge court wrote:

Yarnall's statement that in the opinion of the Catalogue Raisonné and in his opinion, there was no certainty that the window featured in the invitation was originally from the J. Pierpont Morgan House is similarly not capable of being proved false. There will never be absolute certainty that McNally's window was from the J.P. Morgan House given the lack of signature on the window, and the existence of other windows featuring a Hollyhock motif. As with the Rooster Window above, moreover, Yarnall supported his statement with disclosed facts: Henry La Farge's earlier determination, and the provenance of the work.[66]

In addition to these three statements, Yarnall had written a letter on stationery of the Metropolitan Museum to the gallery exhibitor in response to having received a catalogue of the exhibition. As decided by the court:

> In substance, the August 19 letter lists the works (all of them owned by McNally) by the Exhibition Catalogue number that "are not at present considered to be by John La Farge." Yarnall states the basis for these conclusions, namely, the provenance of these works (the house of Thomas Wright), and implicitly, the study of the catalogue, which has taken him "some time to assess." Therefore, with regard to the statements as to the authenticity of the works, Yarnall has supported his conclusions with disclosed facts.[67]

Statements About the Professional Competence of an Expert as Opposed to Statements About a Work of Art

However, in that same August 19 letter, Yarnall made a statement about plaintiff McNally's professional competence: that "... it appears that Sean McNally has the history of many of the works he owns muddled, rendering anything he says about them suspect."

The *La Farge* court characterized Yarnall's statement as follows:

> Such a statement about McNally's professional competence as a dealer in La Farge works is, moreover, capable of being proved false. Furthermore, while Yarnall's other statements as to the authenticity of the objects submitted by McNally as La Farge works arguably call into question McNally's professional competence, such competence is a matter to be inferred by Yarnall's audience from his opinions as to the authenticity of the works. In contrast, the statements as to McNally's reliability as a dealer address directly McNally's competence.[68]

A Qualified Privilege in New York Law to Make a Defamatory Statement

Nevertheless, Yarnall's statements about McNally's reliability as a dealer were subject to the conditional or qualified privilege conferred by New York law for statements made in good faith on a subject matter in which the party making the statement has an interest or a duty, and in which the party about whom the statement is made has a corresponding interest or duty. However, this qualified privilege can be defeated (hence, the adjective "qualified") by a showing of *actual malice*, defined by the New York Court of Appeals as "personal spite, or ill will, or culpable recklessness or negligence."[69]

The *La Farge* court found that, for purposes of summary judgment, Mc-Nally had presented *some* evidence from which a jury might infer malice. This consisted of a professional rivalry between McNally and Yarnall "from which ill will might be inferred" by a jury at a subsequent trial.

In denying summary judgment, based on this New York qualified (as opposed to absolute and unconditional First Amendment) privilege, the *La Farge* court went on:

> Moreover, the evidence relating to the care with which Yarnall examined the items in the Exhibition Catalogue, also raises a factual issue as to Yarnall's good faith. The evidence shows that Yarnall did not look at many of the works owned by McNally that he rejects as being true La Farges. The fact that it was McNally who withheld the photographs does not erase completely this evidence of recklessness or negligence for the purpose of showing actual malice where a knowledge of the potential effect of his statements on the value of McNally's collection could fairly be ascribed to Yarnall.[70]

This denial of summary judgment in favor of the defendant, Yarnall, is troubling for experts expressing opinions on art. "Some evidence" from which a jury might infer malice on Yarnall's part consisted *only* of a professional rivalry and the fact that Yarnall had not looked at many of the works owned by McNally! From this, a jury might infer "recklessness" or even simple negligence. And for this court, simple negligence would allow a jury to decide that Yarnall had questioned the dealer's reliability out of "malice." A jury's finding of malice would defeat Yarnall's qualified privilege under New York law.

Statements About Authenticity of Art Are Held to Injure Owner's/Seller's Reputation

The *Khidekel* case, already discussed with respect to Lanham Act claims, also involved defamation claims by the owners (the Boules) of an art collection.

After a bench trial, Judge Cedarbaum found, as a fact, that the defendants, Mark and Regina Khidekel, made defamatory statements which were published in *Art News* and a Montreal newspaper, *Le Devoir*. The Montreal newspaper quoted Regina as saying that "neither she nor her husband ever authenticated anything and that fake certificates [of authenticity] were forged." Judge Cedarbaum found that

> Those statements published to the art community and newspaper reporters imply that the Boules purchased, exhibited and offered to sell fraudulent works of art; these statements are not only injurious to the Boule art collection, but injure the reputation of the Boules.
>
> In addition to the statements denying the authenticity of the Boules' collection, the Khidekel defendants' two additional statements in *Art News* and *Le Devoir*, in which the Khidekels denied that they initially endorsed the Boules' collection and denied that Mark signed certificates of authenticity, are defamatory.[71]

Judge Cedarbaum found these statements to be defamatory because

> it is reasonably understood that the Khidekels are stating that the Boules continued to exhibit and deal in forged artwork, despite having been informed by the artist's son that his father did not create the works in their collection. . . . This statement is reasonably understood as stating that the Boules possessed and publicly referred to, in conjunction with the exhibition of their collection, certificates of authenticity that were forged.[72]

Defamation Plaintiffs Have the Burden of Proving Authenticity

Having decided that these statements were defamatory, Judge Cedarbaum went on to address another element of the tort of defamation which plaintiff must prove: the *falsity* of the defamatory statement.

> If a statement involves a matter of public concern, a plaintiff suing for defamation bears the burden of proving falsity of the defamatory statement. . . . In the context of this case, statements questioning the authenticity of the Boules' collection are a matter of public concern. The Boules' collection was displayed at public exhibitions, museums and art shows throughout the world and portions of the collection were offered for sale to the public. . . .
>
> . . .
>
> Plaintiffs have been unable to prove the authenticity of their collection by a preponderance of the evidence, and, therefore, unable to prove the falsity of each statement denying the authenticity of the Boules' collection. But, plaintiffs have proved by a preponderance of the evidence the falsity

of the statements in *Art News* by Mark and Regina that they had initially informed the Boules that the works were not authentic, and in *Le Devoir*, in which Regina denied that Mark ever wrote certificates of authenticity.[73]

Defamation Plaintiffs Must Also Prove Fault

Freedom of speech, protected by the First Amendment to the U.S. Constitution requires that a defamation plaintiff must prove some degree of *fault* on the part of the person publishing the defamatory material. State law specifies the degree of fault. Under New York law, if the defamatory statement involved a matter of public concern, a private plaintiff is required to prove that the defendant was "grossly irresponsible" in making the statement. If the statement concerned a nonpublic matter, the private plaintiff need only prove that the defendant acted "negligently" in making the statements. Judge Cedarbaum noted that

> Regardless of which standard of fault is applied in this case, plaintiffs have satisfied their burden of proving fault. It is clear that Mark and Regina knew that their false and defamatory statements in *Art News* and *Le Devoir* were false at the time the statements were made. Mark and Regina knew that they had not told the Boules that their collection was inauthentic, and they each knew that Mark had signed certificates of authenticity for the Boules.[74]

Obligation to Prove Damages Caused by Defamation

Having determined that the necessary fault on the part of the defendants had been proven, the judge then turned to the question of damages. Under New York law, a plaintiff who sues for defamation must plead and prove "special damages" (meaning pecuniary damages such as out-of-pocket loss flowing directly from the injury to reputation caused by the defamation), unless the defamatory statement is deemed "libel per se" (which disparages a person in his or her profession or trade). In this context, the court said:

> The Boules have not proven special damages resulting from the two false and defamatory statements, in *Art News* and *Le Devoir*. Those statements relate to the Boules' persistence in displaying works that they had been told were inauthentic. The injury was to the Boules' reputations, not any out-of-pocket loss. Any diminution in the market value of the Boules' Khidekel collection is more likely to have been caused by the defendants' statements that the Boules' collection was not authentic than to the Boules' persistence in displaying inauthentic works.[75]

Even if Harm Is to Professional Reputation, and Is Thus a Libel
per se, Actual Harm Must Be Shown to Obtain Damages

But the plaintiffs were not professional art dealers. They were collectors and connoisseurs, and thus it could not be said that the Boules as a couple, or René Boule personally, suffered sufficient harm to their *professional* reputation to warrant a finding of "libel *per se*." However, Mrs. Boule was an art historian and a lecturer and writer in the arts, and so she had proved harm to her professional reputation (and thus a "libel per se") by reason of the defamatory statement in *Art News*, because the journal's readers would have known about her reputation as an art historian.[76] Although Mrs. Boule's good professional reputation is presumed in the circumstance of per se libel, the court found little evidence that she had suffered actual harm to her professional reputation as a result of the *Art News* article—for example, that she had been unable to take advantage of other professional opportunities. Thus, not being able to prove *actual* damages flowing from the "libel per se," Mrs. Boule was entitled only to nominal damages of $10!

Antitrust and Monopolization Claims

Only two claims[77] of unlawful restraint of trade in violation of the U.S. antitrust laws have been made in connection with the attribution of visual art. And since these claims of monopoly were both dismissed by the courts without a trial, it seems unlikely that such novel claims will again readily be brought against experts authenticating art.

It might strike antitrust lawyers as a reasonable antitrust claim that an authentication board for an artist's works whose opinions on authenticity determine what, as a practical matter, will be sold in the public auction market, and perhaps in the private sale market as well, might violate the monopoly section of the Sherman Act. This view is all the more likely if the monopolized market could be defined as one that authenticates paintings of a given artist. This, of course, is not the way the art market would look at the issue. And fortunately, at least one federal court in the cases discussed below agreed.

These two cases raise another issue of interest for opinions on authenticity: the use of court-ordered financial sanctions against the plaintiff's lawyer. This issue, as well as the signing of an agreement by the art owner not to make a claim against the expert for the expert's opinion, are discussed in detail in chapter 17 in this volume.[78]

Plaintiff, in *Vitale v. Marlborough Gallery, the Pollock–Krasner Foundation, et al.*, bought a painting that she claimed was painted by Jackson Pollock and was told that neither Sotheby's nor Christie's would sell it for her unless she had it authenticated by the Pollock-Krasner Authentication Board. In 1993,

she sued the Authentication Board as well as Sotheby's and Christie's, claiming that no work by Jackson Pollock could be sold unless it was authenticated by the Authentication Board, which meant that the defendants thereby controlled the process of authentication and sale of Pollock paintings, thus constituting an unlawful restraint of trade in violation of sections 1 and 2 of the Sherman Antitrust Act. Plaintiff alleged that the relevant market being restrained was contemporary and modern paintings, and that for Sherman Act purposes, Jackson Pollock paintings constituted a distinct and independent "submarket." Judge Leisure found for the purposes of defendants' motion to dismiss that Pollock paintings may constitute such a submarket, the monopolization of which may be unlawful under sections 1 and 2 of the Sherman Act, but he dismissed plaintiff's monopolization claim on statute of limitations grounds. But the *Vitale* court's holding that plaintiff had "adequately alleged a submarket" sufficient to state a claim for monopolization apparently encouraged another plaintiff, Kramer, to try again, with a similar claim, the following year.

In *Kramer*, the plaintiff owned a painting which the Pollock–Krasner Authentication Board refused to authenticate as a Pollock. Kramer alleged a conspiracy among the Authentication Board, the Pollock–Krasner Foundation, Sotheby's, and Christie's to exclude certain authentic Pollock pieces from Pollock's accepted oeuvre, and thereby from the art market—in an illegal attempt to increase the value of Pollock paintings owned by the Foundation and auctioned by Christie's and Sotheby's.

Kramer claimed that the market being monopolized was Pollock paintings sold "at auction." But Judge Baer declined to accept this as a market definition capable of being monopolized by defendants because potential purchasers have means other than public auctions to purchase Pollock paintings. And as to the claim that the Authentication Board had a monopoly in the authentication of Pollocks, Judge Baer said:

> As for the Board, it is not the only group of experts that can provide opinions of authenticity for Pollocks. Kramer admits that he can and has obtained authentication opinions of other art experts and that the Board's refusal to authenticate does not prevent him from selling privately. Thus, while Kramer may believe the defendants conspired to keep Pollock paintings off the market, the defendants' allegedly conspiratorial actions could equally have been prompted by lawful independent goals, which do not constitute a conspiracy.[79]

Although neither *Vitale* nor *Kramer* addressed the issue of the authenticity of plaintiff's painting in terms of proof, it seems quite clear that in order to prevail on an antitrust claim, *plaintiffs would bear the burden of proving the authenticity of their paintings.* After all, the plaintiffs could hardly claim that they

were injured by defendants' unlawful restraint of trade, which restraint prevented plaintiffs from selling their "fake" Pollocks!

There is an interesting postscript to the *Kramer* case which may suggest some practical lessons from disputes over authenticity. About three years after the decision in *Kramer*, I received a telephone call from Helen Harrison, director of the Pollock-Krasner House and Study Center in East Hampton, Long Island. She said that she had been approached by a New York art dealer to examine the paints Pollock used in connection with a painting the dealer had on consignment and hoped to sell as a Pollock. Harrison told the dealer that the image he showed her looked very much like the painting in dispute in *Kramer*—that image had appeared at the time in a magazine article describing the *Kramer* case. She suggested the dealer call me. The dealer advised me that he had a potential customer for the work at $900,000 and that the painting's owner had furnished the dealer with impressive "forensic" evidence of the painting's authenticity. On further questioning of the dealer, it seemed highly likely that the painting was, in fact, the one in dispute in *Kramer,* and that there was little beyond this "forensic" evidence to support its authenticity. As a result of this information, I then understood that the dealer was going to return the painting to the owner.

The lesson here appears to be that even after a public court decision and attendant media publicity, a work which has little likelihood of being found authentic can continue to be offered for sale, even though the owner, at least, has knowledge of many experts' serious reservations concerning its authenticity.

The "Defense" of Opinion

The first part of this chapter concerned the elements that plaintiffs must prove in order to prevail on claims against experts making decisions on the attribution of visual art. And reference has been made to so-called affirmative defenses, such as statutes of limitation, which would enable a defendant to prevail even if the plaintiff proved all the elements of his claim.

This part is concerned with a defense that is neither a required element of plaintiff's claim nor an affirmative defense. It is the well and truly held view that an *idea* can never result in liability for the person who expresses it, because ideas are so personal and subjective and because society should protect ideas as something inherently beneficial, even if they are sometimes wrongheaded. In the art attribution area this unexceptional view of the value of ideas is equated with an "opinion."

Experts who determine the authenticity of a work of art, whether in the context of the publication of a catalogue raisonné, curating an exhibition, a sale or purchase, an appraisal of the value, or a scholarly essay on the attribu-

tion of a painting, almost always describe their conclusion as their *opinion* on the authenticity or attribution of the work.

Of course, they use the term *opinion* because that is the nature of what they are rendering: their judgment, evaluation, or deduction, based upon an interpretation of existing *facts* which they have collected and analyzed, and to which they have applied their learning and experience.

There is often another motivation for characterizing their conclusion as opinion: a desire to limit or avoid legal liability in the event their conclusion is wrong. Thus, the expert's statement "*In my opinion,* the work is [or is not] by Rembrandt," is thought, if it turns out to be incorrect, to result in legal consequences different from those resulting from the statement "The work is [or is not] by Rembrandt." This view appears to have some support in the law. Thus, in 1974, U.S. Supreme Court Justice Lewis Powell's majority opinion stated by way of dictum, "Under the First Amendment, there is no such thing as a false idea. However pernicious an opinion may be, we depend for its correction, not on the conscience of judges and juries, but on the competition of other ideas."[80] Thus, even a false idea was constitutionally protected free speech under the First Amendment to the U.S. Constitution.

However, an analysis of the two statements will quickly make it apparent that they mean precisely the same thing. The addition of the words "in my opinion" to a statement of fact ("the work is not by Rembrandt") does not change this assertion of fact, which has the quality of being true or false, into an opinion which may be "good" or "bad," "reasonable" or "unreasonable," "sound or unsound."[81] And, indeed, at a simpler level, the expert may feel he is expressing his state of mind and, so long as this is so, the apparent statement of fact can *never* be false because the speaker/writer is only communicating what he *believes*, without regard to whether the subject of his belief, the factual statement, is true or false. But this is *not* how American law regards the matter, as we will see below.

Two Court Decisions Attempt to Define
Opinion Protected by the First Amendment

In 1990 the Supreme Court of the United States wrote the following:

> If a speaker says, "In my opinion, John Jones is a liar," he implies a knowledge of facts which lead to the conclusion that Jones told an untruth. Even if the speaker states the facts upon which he bases his opinion, if those facts are either incorrect or incomplete, or if his assessment of them is erroneous, the statement may still imply a false assertion of fact. Simply couching such statements in terms of opinion does not dispel these implications; and the statement, "In my opinion, Jones is a liar," can cause

as much damage to reputation as the statement, "Jones is a liar." As Judge Friendly aptly stated: "[It] would be destructive of the law of libel if a writer could escape liability for accusations of [defamatory conduct], simply by using, explicitly or implicitly, the words 'I think.'" It is worthy of note that at common law, even the privilege of fair comments did not extend to "a false statement of fact, whether it was expressly stated or implied from an expression of opinion." (*Restatement (Second) of Torts*, §566, comment a [1977])[82]

A Negative "Opinion" on the Value of Bonds Is Protected

The frequent garden-variety evaluation by financial analysts of the value of bonds and stocks seems analytically similar to an evaluation of authenticity of art. In 1999, a school district sued Moody's Investor Services[83] for publishing an article about the "negative outlook" and "ongoing financial pressures" for the school district's bonds, claiming the article was materially false. The Tenth Circuit Court of Appeals found that if those expressions had material false components, they would not be shielded by raising the word "opinion" as a shibboleth, but the "vagueness" of the two phrases indicated that the Moody's article constituted protected expression of opinion.

The *Moody* court's reasoning in coming to this decision is instructive for us in deciding whether styling a decision on authenticity as simply an opinion can be a defense to a legal claim.

> ... evaluative opinions are those that are not provably false, and a writer or speaker may not be held liable on a defamation claim for expressing them. In contrast, deductive opinions are those that state or imply assertions that may be proven false; the First Amendment does not immunize them from defamation claims.
>
> . . .
>
> In some instances, defamatory statements have been deemed too indefinite to be proven true or false. For example, . . . the Fourth Circuit concluding that a magazine article's statement that optimistic projections about a company's stock were based on "hype and hope" represented the kind of irreverent and indefinite language that indicated the writer was not stating actual facts.
>
> . . .
>
> . . . in other instances, courts have concluded that due to the subject matter involved, there is simply no objective evidence that could prove that an allegedly defamatory statement was false . . . (concluding that the statement that a product was not worth the price was not verifiable because "the worth of a given service or product is an inherently subjective

measure which turns on myriad considerations and necessarily subjective economic, aesthetic, and personal judgments").

. . .

. . . In contrast to these decisions, courts have also applied *Milkovich* to conclude that certain statements, even though couched as expressions of opinion, are provably false and therefore are not protected from defamation claims by the First Amendment. For example, the Ninth Circuit has concluded that a statement in a broadcast that a product "didn't work" would be reasonably interpreted to refer to the performance of specific functions, a matter that could be assessed by evaluating objective evidence.[84]

An "Opinion" as to a Professor's Reputation Is Protected, But Reasoning Does Not Give Art Experts Comfort

In 1978, the columnists Rowland Evans and Robert Novak wrote a newspaper column in which they said that Ollman, a professor of political science, "has no status within the profession, but is a pure and simple activist." The professor sued for defamation.[85] Although the Court of Appeals found that the statement was opinion protected by the First Amendment, for our purposes the analysis of the dissenting judges is more relevant to our concern for opinions about art.

The dissenters in *Evans/Novak* wrote:

The one major issue presented by this appeal is whether the allegedly defamatory statements of which Ollman complains are representations of fact capable of supporting an action for libel or instead, assertions of opinion unconditionally protected by the First Amendment.

. . . The First Amendment embodies a special solicitude for unfettered expression of opinion. A decade ago in *Gertz v. Welch*, the Supreme Court stated, "Under the First Amendment, there is no such thing as a false idea. However pernicious an opinion may seem, we depend for its correction not on the conscience of judges and juries, but on competition of other ideas."

This passage was the first clear verbalization by the Court of the degree to which the Constitution preempts local defamation law in the area of opinion.

. . .

. . . But while *Gertz* confirms the existence of an absolute privilege for expressions of opinion, neither that nor any other Supreme Court decision has provided much guidance for identifying statements that are opinion for First Amendment purposes.[86]

The dissenters in *Evans/Novak* went on to set out standards for separating assertions of fact from (constitutionally) protected opinion.

At one end of the continuum are statements that may appropriately be called "pure" opinion. These are expressions which are commonly regarded as incapable of being adjudged true or false in any objective sense of those terms. Matters of personal taste, aesthetics, literary criticism, religious beliefs, moral convictions, political views and social theories would fall within this category. . . .

Also, near the pure-opinion end of the continuum, . . . are "those loosely definable, variously interpretable" derogatory remarks that frequently are flung about in colloquial argument and debate . . . expressions of generalized criticism or dislike.

. . .

. . . Perhaps far more common . . . are statements that reflect the author's deductions or evaluations but are "laden with factual content." The apparent proportions of opinion and fact in these "hybrid" statements varies [*sic*] considerably. For example, a statement that "Jones is incompetent to handle that job" suggests some factual underpinning but, on the whole, imports a fairly high degree of subjective judgment. By contrast, a statement that "Smith is a murderer" appears much closer to an assertion of objective fact. Analytically, however, the accusation of murder could be regarded as an opinion, for it, like the charge of incompetence, reflects a conclusion ultimately reached by the author on the basis of an amalgamation and interpretation of underlying facts.

Hybrid statements differ from pure opinion in that most people would regard them as capable of denomination as true or false, depending upon what the background facts are revealed to be. At the same time, they generally are not propositions that a scientist or logician would regard as provable facts. The hard question is whether these kinds of statements, which both express the author's judgment and indicate the existence of specific facts warranting that judgment are within the absolute privilege for opinion.[87]

While *Moody's* and *Evans/Novak* deal only with the tort of defamation and whether a defamatory statement is protected by the First Amendment to the U.S. Constitution, courts have rejected a variety of other tort claims based on speech protected by the First Amendment. For example, a federal Court of Appeals held that state law claims for product disparagement and tortuous interference with business relationships were subject to the same First Amendment requirements that govern actions for defamation.[88]

The legal claims of product disparagement, negligent misrepresentation, tortuous interference with contract, breach of fiduciary duty, fraud, claims

under the Lanham Act, and even failure to exercise reasonable care all have as a central element *a false statement of fact*. And it's these kinds of claims which are most likely to be made against those who authenticate or attribute works of visual art. If such false statements were deemed an expression of opinion protected by the First Amendment to the U.S. Constitution, the various legal claims based on them would not be viable.

However, a statement of an expert about the authenticity of a painting, even if preceded by the phrase "I think," "I believe," or "In my opinion," is, at least, a "hybrid" opinion in the terms of *Evans/Novak*, in that it intimates the existence of specific facts and conveys the author's judgment upon, or interpretation of, those facts. Of course, there often is also an intimation of personal aesthetic taste with respect to the art, but there can be no question that the statement is based, in large part, on *express or implied facts* which can be proven true or false. As such, the expert's statement on the authenticity or the attribution of a work of art will most probably not be protected as opinion by the First Amendment, even though it is expressly stated to be mere "opinion" or "belief."

Notes

1. A seventh cause of action, antitrust violations of sections 1 and 2 of the Sherman Act, has been asserted in just two cases in the federal courts. See *Vitale v. Marlborough Gallery, the Pollock-Krasner Foundation, et al.* (SDNY, July 5, 1994), 1994 WL 654494, 1994 U.S. Dist. LEXIS 9006; and *Kramer v. the Pollock–Krasner Foundation, et al.*, 850 FSupp. 250 (SDNY, 1995). These two claims for the monopolization of the market for authenticating paintings by Jackson Pollock are discussed later in the chapter. However, antitrust claims cannot be regarded as common or likely legal claims with respect to the attribution of visual art.
2. *Luxmoore-May v Messenger May Baverstock*, 04EG115, 1 EGLR 11 (Q.B. 1989, Simon Brown, J.).
3. Ibid., pp. 13–14.
4. Ibid., p. 15.
5. Ibid.
6. Ibid.
7. Ibid., p. 17.
8. Ibid., p. 18.
9. 1 *All England Law Reports* 1067 (C.A. 1989).
10. Ibid., p. 1070.
11. Ibid., pp. 1078, 1079.
12. Ibid., p. 1079.
13. *Boule v. Khidekel*, *New York Law Journal*, April 12, 26 (2001); U.S. Dist. LEXIS 3654, p. 5.
14. *Kirby v. Wildenstein*, 784 FSupp. 1112 (SDNY, 1992).

15. Ibid., p. 1115.
16. Ibid., p. 1116.
17. Ibid., p. 1117.
18. F. Harper, F. James, and O. Gray, *The Law of Torts,* 2nd ed. (Boston: Little, Brown, 1986), vol. 2, pp. 275, 276.
19. Ibid., p. 276.
20. Ibid., p. 279.
21. Ibid., p. 280.
22. Ibid., p. 284.
23. Ibid., p. 285.
24. *Rogath v. Siebermann* 129 F3d 261(2nd Cir. 1997).
25. Ibid., p. 265.
26. Ibid., p. 266.
27. *Goldman v. Barnett,* 793 FSupp. 28 (USDC Mass. 1992).
28. Ibid., p. 32.
29. *Firestone & Parson v. Union League of Philadelphia,* 672 FSupp. 819 (1987).
30. Ibid., p. 823.
31. *Feigen v. Weil,* index no. 13935/90 N.Y. Sup. Ct. 1992), affd. *New York Law Journal,* March 18, 26 (1993).
32. *Leaf v. International Galleries,* 1 *All England Law Reports* 693 (1950), 2KB.86 90 (1950).
33. Ibid., p. 91.
34. Ibid., pp. 89, 90.
35. Ibid., p. 93.
36. *Harlingdon & Leinster Enterprises Ltd. v. Christopher Hull Fine Art Ltd.,* 1 All England *Law Reports* 737 (C.A., 1990).
37. Ibid., p. 740.
38. Ibid., p. 745.
39. Ibid., p. 746.
40. *Richard Drake v. Thos. Agnew & Sons, Ltd.,* Westlaw (QBD, 2002), pp. 6, 7. *Daily Telegraph,* 3/21/2002; 237, 113.
41. Westlaw, p. 10.
42. Ibid., pp. 12–15.
43. *Greenberg Gallery Inc. v. Bauman,* 817 FSupp. 167 (DDC 1993), affd. without opinion, DC Cir., 194 U.S.App. LEXIS 27175.
44. *Dawson v. Malina,* 463 FSupp. 461 (SDNY, 1978).
45. Ibid., p. 467.
46. Ibid.
47. *Foxley v. Sotheby's,* 893 FSupp. 1224 (SDNY, 1995).
48. Ibid., p. 1228.
49. *Danann Realty v. Harris,* 5 NY2d 317, 320 (1959).
50. *Foxley v. Sotheby's,* p. 1229.
51. Ibid., p. 1230.
52. *Nacht v. Sotheby's Holdings,* NY Sup. Ct., NY County, Index no. 100938-98 (1999).
53. Ibid.

54. Ibid., p. 3.

55. Ibid., p. 7.

56. Ibid.

57. Ibid., p. 8.

58. *Boule v. Hutton Galleries and Mark and Regina Khidekel*, 70 FSupp.2d 378 (SDNY, 1999); affirmed in part, 2003 U.S. App. LEXIS 7734 (2003).

59. *Boule v. Khidekel*, 2001 U.S. Dist. LEXIS 3654, p. 5; affirmed in part, 2003 U.S. App. LEXIS 7734 (2003).

60. *Sack on Defamation: Libel, Slander, and Related Problems*, 3rd ed. (New York: Practising Law Institute Press, 2001), vol. 1, Section 10.3.2, pp. 10-(8-12).

61. *McNally v. Yarnall and Metropolitan Museum of Art*, 764 FSupp. 838 (SDNY, 1991).

62. Ibid., p. 845.

63. Ibid., p. 846.

64. Ibid., p. 848.

65. Ibid.

66. Ibid., p. 849.

67. Ibid.

68. Ibid., p. 850.

69. Ibid.

70. Ibid.

71. *Boule v. Khidekel*, U.S. Dist.: LEXIS 3654, p. 7.

72. Ibid., p. 8.

73. Ibid.

74. Ibid.

75. Ibid., p. 9.

76. But a reasonable reader of *Le Devoir*, a daily newspaper that "reports all kinds of news," would not have known about Claude's profession, and therefore, no "libel per se" was proven for the statements in *Le Devoir*.

77. *Vitale v. Marlborough Gallery, the Pollock–Krasner Foundation, et al.* (SDNY, July 5, 1994), WL 654494 1994 U.S. Dist. Lexis 9006; and *Kramer v. the Pollock–Krasner Foundation, et al.*, 850 FSupp. 250 (SDNY, 1995).

78. See *Lariviere v. E. V. Thaw, the Pollock–Krasner Authentication Board, et al.*, NY Sup. Ct., NY County, index no. 100627 (June 26, 2000).

79. *Kramer v. the Pollock–Krasner Foundation, et al.*, p. 256.

80. *Gertz v. Robert Welch*, 323 U.S.323, 339–40 (1974).

81. Harper et al., *The Law of Torts*, vol. 2, p. 66.

82. *Milkovich v. Lorain Journal*, 497 U.S.1, 17 (1990).

83. *Jefferson County School District v. Moody's*, 175 F3d 848 (1999).

84. Ibid., pp. 852–53.

85. *Ollman v. Evans and Novak*, 750 F2d 970 (DC Cir. 1984).

86. Ibid., pp. 1016–1017.

87. Ibid., pp. 1021–22.

88. *Unelko Corp. v. Rooney*, 912 F2d 1049, 1057–58 (9th Cir. 1990).

16

Authentication in Court

Factors Considered and Standards Proposed

. . .

Ronald D. Spencer

. . .

Decisions concerning the attribution of visual art are made hundreds of times each day. A small number of disputes over such decisions end up in a court of law. What are the factors that influence a judge's decision? How can we arrive at systematic procedures and methods for experts to follow which will stand up to legal challenge?—RDS

. . .

Art authentication issues arise initially in the context of numerous private decisions by experts, scholars, dealers, and buyers and sellers. Predominantly relied on, in this context, are connoisseurship, a work's provenance, and, less frequently, scientific testing. At times, such private decisions are disputed, and the dispute may end up in court. Here, by definition, the ultimate question of authenticity will be determined by judges who are neither experts nor scholars, and who may find other factors persuasive. The *Calder* case, discussed below, is a dramatic example of this. This case involved a claim (for breach of contract) by buyers (who happened to be art dealers)of a Calder mobile, *Rio Nero*, that the mobile they purchased was a forgery. Despite the opinion of Klaus Perls, Calder's American dealer for over twenty years, that the mobile purporting to be *Rio Nero* was a forgery, a federal judge disagreed, concluding that it was "more likely than not"[1] that *Rio Nero* was "not a forgery" "but the original." The art market, however, continues to disagree with the judge (or, at least, to require more evidence of authenticity). As noted in *Art News*,

> Today, *Rio Nero* sits in storage in the 57th Street Gallery of Barbara Mathes. "It's in my bin, but it's not on the market," she says. "It's worthless. This is a bad egg."[2]

Clearly, because of the possibility of court intervention in disputes over authenticity,[3] it is important to understand how courts have decided such matters.

The first section of this chapter ("Circumstances Under Which Art Authentication Issues Arise") describes the wide variety of such factual circumstances.

The second section ("Decision-Making by the Courts") sets forth the factors which courts in the United States and abroad have taken into account in arriving at decisions on art authentication, and the weight courts have accorded such factors.

The third section ("Recommendations for Experts Authenticating Works of Visual Art") consists of a guide to systematic procedures and methods which will enable decisions of experts and art scholars, boards and committees, to stand up to legal challenge.

Circumstances Under Which Art Authentication Issues Arise

Art authentication issues arise when (1) art scholars author catalogues raisonnés; (2) curators produce retrospective exhibitions at universities, museums, or galleries; (3) art authentication boards/committees and individual experts respond to requests for authentication; (4) auction houses, art dealers, or others sell works of art; (5) under French law, the holder of an artist's *droit moral* asserts the right of attribution; (6) appraisers decide the value of a work of art for gift, income, or estate tax purposes; and (7) scholars or other experts make an unsolicited public comment/publication about a work of art.

Catalogues Raisonnés

"A catalogue raisonné is a definitive listing and accounting of the works of an artist."[4] It identifies the artist's work (or portions of it, such as drawings, paintings, or prints) and provides, for each work, information such as size, year of creation, when and where it was exhibited or referred to in publications, and a history of its owners.[5] The catalogue raisonné is prepared by art scholars and often by committees and foundations consisting of experts, including dealers and members of the artist's family.[6]

The basic decision to be made by an individual authoring a catalogue raisonné is whether a work has been created by the artist. If it has, the work is included in the catalogue raisonné; if it has not, as a rule, no mention of it is made. A minority of catalogues raisonnés contain a "false attribution" section which includes works ranging from innocent copies of an artist's style to works created with an intent to deceive (fakes). The Jackson Pollock catalogue raisonné contains a "Problems for Study" section—works that could

neither be authenticated nor be rejected by consensus of opinion—and a "False Attributions" section—works either maliciously or mistakenly misattributed to Pollock. The editor of the *Supplement* to the Pollock catalogue raisonné contemplated a section titled "Works for Further Study," which would have included works about which the authors were not able to render an opinion due to insufficient evidence of authenticity—leaving the task of authentication to future art scholars.

It has been reported that the Rembrandt Research Project, in preparing to publish its fourth volume, was considering a shift away from a definitive conclusion that a work was or was not by Rembrandt—the approach of the earlier volumes. Professor Ernst van de Wetering agreed to take over the Project on the condition that he could

> ... present all the arguments for and against attribution to Rembrandt without the need to force individual paintings into the straight-jacket of a simple "yes" or "no."[7]

For persons with an interest in a work of art purportedly by a particular artist, it is naturally of importance that the work be included in that artist's catalogue raisonné. A common practice among authors and editors of catalogues raisonnés who deem a work inauthentic is to respond to an applicant for inclusion with the seemingly innocuous and ambiguous statement that the work "will not appear in the forthcoming catalogue," rather than directly stating that the work is not by the artist.[8] The view among these authors and editors is that this approach will insulate them from a claim of product disparagement. It is my view that a court would decide there is little, if any, difference between the direct and indirect opinion concerning the work's authenticity. The art market clearly understands that a refusal to publish a work in a catalogue raisonné is a decision that the work is inauthentic.

Retrospective Exhibitions

As with catalogues raisonnés, a basic decision for a museum curator is whether the work being considered for inclusion in an exhibition of the artist's work is by the hand of an artist. When a museum declines to include a work, a lawsuit may follow. In 1992, for example, the Metropolitan Museum and its curator of European art, Gary Tinterow, were sued when they refused to include a painting in the Museum's Georges Seurat exhibition.[9] Although Tinterow believed the painting to be authentic, a cocurator of the Seurat exhibition, Robert Herbert, had "doubts" about the work's authenticity. Herbert stated in his deposition that the painting did not appear to be typical of Seurat in several respects:

The modeling of the peasant's shirt and back was not, in his opinion, characteristic of Seurat; the peasant's farm tool was too inexactly drawn to be by Seurat's hand; the treatment of the peasant's shadow was not characteristic of Seurat, who typically used shadows as "pedestals" for his figures; and the brushstrokes were too mechanical; the coloration of the Painting appeared to be from one period of Seurat's work, while the Painting's composition was typical of another period. And, the fact that the work of art had passed through the hands of a relative of an artist was no guarantee of its authenticity, because there are examples of notorious forgeries passed off by descendants of famous artists.[10]

The art dealer, Stephen Mazoh, had been interested in buying the work, but when he was informed of the Museum's refusal to include it in the Seurat retrospective, he lost interest. The owners sued him for breach of contract, and the Museum and Tinterow for product disparagement. Tinterow and the Museum defended on the grounds that (1) Tinterow's statement that Herbert had doubts about the authenticity of the painting was entitled to a qualified privilege under New York law; (2) even if the painting were authentic, Tinterow had not spoken of it with the legally required (and constitutionally defined) malice; and (3) in any event, Tinterow's comments were statements of opinion protected under the Federal and New York State constitutions. The claims against Tinterow, the Museum, and Mazoh were settled in 1995, without a court decision.

Art Authentication Boards/Committees

Art authentication boards/committees and individual art scholars respond to applications for authentication of a particular work, a work which the applicant may have owned for a long time, may recently have purchased, or may be thinking of purchasing. Sometimes the authenticating entity may, incidentally, be in the process of producing a catalogue raisonné. In any event, the applicant normally completes an application form calling for information about the work—medium, size, provenance, exhibitions, publications, and any other relevant data that tend to support the authenticity of the work. The application form usually states that in submitting the application, the applicant is agreeing to indemnify and hold the authentication committee harmless from claims of the applicant, as well as of third parties, and, further, is acknowledging that the authentication committee's "decision" is an "opinion only" and not a warranty or guarantee. The committee will reserve the right (1) not to issue an opinion (presumably because it cannot come to a decision); (2) to publish its decision and an image of the work; (3) to stamp (or otherwise permanently mark) the work to reflect its opinion; and (4) to change

its opinion at a future date (usually as the result of receiving new information or new scholarship). Often the committee will not state any (or only some) reasons for its decision—so as not to give guidance to would-be art forgers.

Sales of Art

Sales of art, both public and private, by auction houses, art dealers, and others always involve the issue of authenticity because authenticity goes to the heart of what is being sold. Determining the rights of buyers and sellers when a question of authenticity arises becomes particularly nettlesome when, as often happens, the work's authenticity is called into question many years after the sale—for example, upon the buyer's death, when the work is donated to a museum, upon resale, or even upon publication years later of new scholarly research on the artist. In the near term, most reputable art dealers will take back the work and return the sale price if the authenticity of the work is seriously questioned. Public auction houses deal with the authenticity issue in the terms of sale that appear at the front of each auction catalogue (constituting a contract between the auction house and the buyer). Thus, for example, Christie's

> warrants for a period of five years from the date of sale ... any property ... which is unqualifiedly stated to be the work of a named author ... is authentic and not counterfeit. ... The benefits of this warranty are not assignable and shall be applicable only to the original buyer of the lot and not subsequent assigns, purchasers, heirs, owners or others who have or may acquire an interest therein. ... The buyer's sole and exclusive remedy against Christie's and the seller under this warranty shall be the rescission of the sale and the refund of the original purchase price paid for the lot.

This deals with the *buyer* from Christie's. The authentication issue will also impact the transaction between Christie's and the *seller/consignor*. Christie's standard consignment agreement with the seller provides:

> Christie's, as Seller's agent is authorized to accept the return and rescind the sale of any property at any time if Christie's in its sole judgment determines that the offering for sale of any property ... may subject Christie's and/or Seller to any liability under warranty of authenticity. ... [11]

This language was invoked when Christie's sued the seller/consignor of a Georges Braque pastel, sold at a Christie's auction, for the return of the purchase price. When the buyer raised questions about the authenticity of her purchase, Christie's (which continued to believe the pastel to be authentic) sent the work to Quentin Laurens, the director of a French art gallery, who held the artist's *droit moral* under French law (that is, the right to attribute a

work to Braque). Laurens refused to issue a certificate of authenticity. The *Braque/Christie's* court held that Christie's was entitled to rely on its consignment agreement and rescind the transaction if, in good faith, it felt itself threatened by a claim from the buyer concerning authenticity.[12]

The Right of Attribution Under French Law

Where a dispute over authentication arises in France, or where French law applies, the holder of the artist's *droit moral*, or moral right, possesses the right of attribution. The holder of the *droit moral*, then, has the legal right (that is, "standing") to challenge in court the authenticity of *any* work said to be by the artist, whether the holder's opinion has been formally sought or not. As a practical matter, this has encouraged owners of an artist's works to have the holder of the right of attribution authenticate their works, and the art market to accept the holder's opinion.

However, whatever the art market may think, at least in France, *only* a French court can determine the legal rights of parties involving authentication issues. That is, the French court can decide that the opinion of the holder of the *droit moral* is not definitive. The court may also consider the opinions of other experts. Indeed, in a November 28, 1995, decision involving the work of the painter Jean Fautrier (Cour de Cassation, Pourvois nc 93-16.478) held that the opinion of the holder of the moral right of attribution did not correctly decide the issue of authenticity, and that the expert and the auctioneer who relied on the holder's opinion were negligent in not obtaining additional opinions.[13]

Appraisers Deciding on a Work's Value

Authentication issues necessarily arise when appraisers determine the value a work of art for gift, income, or estate tax purposes. The Internal Revenue Service maintains an art advisory panel that meets several times a year to review taxpayer valuations of art donated to museums and other charitable institutions. During 1997, for example, the panel reviewed 1,420 items of 128 taxpayers with a claimed value of $140.4 million.[14] Obviously, such valuations may not simply assume a work's authenticity. Thus, for example, the Internal Revenue Service states:

> In order to determine the values of items for Federal income tax purposes ... an appraisal report should accompany the return when it is filed ... an appraisal report should contain (inter alia) ... proof of authenticity ... the burden of supporting the fair market value listed on the return is the taxpayer's.[15]

Although the U.S. Tax Court does not, of course, decide questions of authenticity as such, uncertainty or a dispute as to authenticity reduces the value of the appraised work for tax purposes.[16]

Unsolicited Public Comment/Criticism of a Work

Another circumstance in which authenticity issues arise is during unsolicited public comment or publication about a work of art by art critics, scholars, and other experts. Indeed, in the famous case of *Hahn v. Duveen*,[17] Sir Joseph Duveen looked at a photograph of a supposed Leonardo da Vinci painting owned by Mrs. Andrée Hahn, and told a newspaper reporter that it was only a copy, the "real one" being in the Louvre. Mrs. Hahn sued Duveen, saying that her painting was by Leonardo, and that as a result of Duveen's disparagement, she could no longer sell the painting for its real value. After a trial, and before the jury rendered its decision, Duveen settled out of court by paying Mrs. Hahn $60,000, "forever establishing in the minds of many people that opinions are dangerous things to give."[18]

Decision-Making by the Courts

Three lines of inquiry are basic to the determination of authenticity in art: (1) the provenance of the work, (2) the application of connoisseurship to the work's visual and physical aspects, and (3) the results of scientific testing to determine the work's physical properties. The courts, as well as the art market, have accepted the importance of these three lines of inquiry. Where connoisseurs disagree, however, judges sometimes look beyond the credibility of the connoisseur in the art world to such factors as the degree of care and time spent by the expert in analyzing the work in question, and whether the expert looked at photographs or made a visual examination of the work, or to some other methodology or procedural standard for assisting the court in reaching a decision. In addition, courts have relied, to a much greater extent than the art world, on signature evidence.

This section first sets the stage for the discussion of court decision-making by summarizing the two major authentication cases, one involving an Alexander Calder mobile, and the other a painting by Egon Schiele. It then discusses the major elements relied on both by the courts and by the art market in determining authenticity: provenance, connoisseurship, and scientific testing. Finally, the section discusses additional factors considered by the courts in deciding authenticity issues.

The Calder Case

All courts agree on the importance of provenance, scientific testing, and visual inspection by a knowing eye. The following major cases, however, illustrate certain additional factors courts have deemed critical.

In the *Calder* case a group of art dealers (the buyer/dealers) bought what they believed was an Alexander Calder mobile, *Rio Nero*. After unsuccessfully trying to make it hang properly, they decided it was a fake, and sued the seller to get back their $500,000 purchase price.

The seller could establish an absolutely flawless provenance for the work. In 1959, Calder created a sheet-metal and steel-wire mobile composed of twenty-seven hanging blades (*Rio Nero*). It had been sold in 1962 by Klaus Perls, reacquired by Perls five years later, and sold to a buyer in whose house it hung until the buyer's death in 1987. Three years later, the buyer's daughter sold the disputed mobile to the buyer/dealers.

The evidence of provenance strongly favored a finding of authenticity. Notwithstanding this, the dealers were convinced that, somewhere along the line, a fake *Rio Nero* had been substituted for the real one. At a 1993 trial, connoisseurship evidence was introduced.

The buyer/dealers produced the testimony of Perls, Calder's exclusive American dealer for twenty years and a recognized expert, to the effect that the mobile was a forgery. Perls had sold "hundreds" of Calder paintings and sculptures, had seen "several thousand" Calders, and was asked to appraise the value or authenticity of Calder works several times a year. He stated that his assessment of Calders was based on "knowledge and feelings" acquired from twenty years as Calder's dealer. The seller's expert, Linda Silverman, was a dealer in Impressionist and twentieth-century art. She had had her own gallery for nine and a half years, and had worked as a cataloguer for eleven years (and later as director of Sotheby's Contemporary Art Department); in both these latter capacities, she had appraised Calders. According to the court, Sotheby's sells about ten Calder works each year, and Silverman had "examined 'hundreds and hundreds' of Calder works at Sotheby's auctions, and in art galleries, books and private homes." Silverman had "appraised or authenticated" approximately fifty Calder works, of which five or ten were formal appraisals.

While Perls stated that a Calder "forgery . . . is usually quite apparently a forgery because it does not fit in the feel of a real Calder," he based his opinion, in this case, on his usual method of comparing the mobile against an archival photograph he had made before the mobile first left his gallery in 1962. He testified that the blades he looked at were not the same as in the archival photograph and that "every blade," therefore, was not by Calder. "You just look at two or three blades and they are wrong." He conceded he did not

look at all twenty-seven blades. It is clear from the court's description that it found fault with the manner in which Perls, however expert he may have been, reached his conclusion about *this* mobile. The court said: "Perls examined the mobile for a maximum of ten minutes and looked at it again for a 'couple of minutes'" before his deposition and on both occasions Perls' examination was limited to comparing a few of the mobile's blades to his gallery's archival photograph." Perls relied "solely," said the court, on [this] methodology of . . . comparing his gallery's archival photograph to the actual mobile, although Perls conceded that even archival photographs are imperfect representations of the actual works.

Perls had said that it would be "very difficult for someone who is not as familiar as I am with Calder mobiles to authenticate a work using the archival photograph. Nevertheless, the archival photograph makes the exact shape of every blade 'quite clear.'" The court clearly was more favorably impressed by the care and time taken by the seller's expert, Ms. Silverman. She examined the mobile for an hour and a half, "checking quality of paint, connecting rods, and every blade, joint, and wire meticulously," refusing to rely on the archival photograph.

"Most important" for the court, however, was Ms. Silverman's testimony "(without contradiction by Perls) that the signature was `absolutely accurate.'" In a footnote, the court "judicially noted that handwriting, like fingerprints, are [*sic*] subject to established objective tests. . . ." The court allowed that "although Perls' credentials for an opinion . . . are vastly superior to Silverman's," Perls "conspicuously did not address the signature," and in a footnote noted:

> Plaintiffs' failure to attack, through Perls or some other expert, the validity of the "AC" signature is as important to a trier of fact as would be the prosecution's failure to offer fingerprint evidence about an article handled by a party. . . .

Despite his acknowledgment of Mr. Perls's "vastly superior" credentials compared with the seller's expert, and that Mr. Perls's judgment would destroy the value of the mobile in the art market ("this is not the market, however, but a court of law," he wrote), the judge rejected Mr. Perls's judgment because he had spent only a "few minutes" examining the mobile and did not address the "AC" signature, while the seller's expert had spent more than "one and one-half hours" examining the mobile and could point to the mobile's "impeccable provenance." The judge concluded that "the mobile is not a forgery, but the original *Rio Nero* which has been misassembled and abused to the point that, on cursory examination, it does not exactly resemble the original photo and has lost its delicate balance required for proper hanging." The seller kept the $500,000 purchase price, and the mobile reportedly sits

today in the basement of one of the dealers, excluded from the catalogue raisonné.[19]

The *Calder* case makes clear that a court will not necessarily defer to the opinion of the expert with the greatest knowledge and experience. The court will have to understand and respect the expert's methodology and the time and care used in reaching an opinion. Moreover, it tells us that, irrespective of what the art market thinks, the courts will be extremely interested in the presence of an apparently authentic signature.

The Restoration Issue—The Schiele case

The *Schiele* case is particularly interesting because it involves the question of authenticity of a painting where a restorer substantially overpaints the painting *and* the artist's initials.

In 1987, Madame de Balkany paid £500,000 at a Christie's London auction for a painting described in the auction catalogue as by Egon Schiele. In 1993, she sued Christie's for her purchase price, claiming the painting was a forgery, and an English court agreed with her.[20]

The court was ultimately satisfied that the original painting (i.e., the underpainting), was by Schiele.[21] However, sometime after Schiele's death in 1918, 94 percent of its surface area had been overpainted. Christie's argued that no amount of overpainting could make the painting a forgery if the overpainter followed the design of the original artist and reproduced as best he could the original colors used by the artist. The *Schiele* court implicitly seems to have agreed. However, for the court, this case was distinguished from other cases of substantial restoration because of the addition, by the unknown overpainter, of the blue initials "E" and "S" in the left and right corners, respectively, of the painting. Schiele's original mauve monogram, which could be seen by X ray, consisting of the initials "E" and "S" intertwined, had been overpainted with black. The judge reasoned that a restorer who simply overpaints, to a greater or less extent, is not seeking to deceive. By adding the blue E and S initials over the black paint which covered Schiele's original mauve monogram, the overpainter sought to deceive viewers that the initials were painted by Schiele. Therefore, the court ruled, the painting was a forgery and Christie's would have to return the purchase price.

The Three Basic Inquiries Recognized by the Courts:
Provenance, Connoisseurship, and Scientific Testing

PROVENANCE

J. L. Darraby defines provenance as follows:

> Provenance is a chronological history of a work of art traced to the cre-
> ator by tracking the chain of transfer of ownership and possession, loca-
> tion, publication, reproduction, and display. An analysis of provenance may
> reveal ownership, prior status, condition, restoration (hence, possible re-
> attribution), and authenticity.

> (1) ... the reliability of provenance and the degree of its accuracy is, like
> history, a function of the skills and methodologies of its researchers, avail-
> ability and accessibility of authoritative sources and materials, and the time
> and costs allocated to under-take it.... Provenance is not static; scholars in
> different time periods interpret old facts in new ways and discover new
> documents and information requiring reformation.

> (2) Provenance as history can be oral or written. Documentary sources,
> like bills of sale, bills of lading, testamentary dispositions, catalogues,
> and/or catalogues raisonnés, may contain information relevant to pro-
> venance....

> (3) Provenance is not an authentication.[22]

As Darraby points out, even if it is traced to the artist, the work may have
been substituted, damaged, badly restored, repainted, or overpainted. And
even when the history of the work is traced, there is room for mistake or out-
right fraud or fabrication. *The New York Times* reported that records at Lon-
don's Tate Gallery were improperly and secretly altered to include, as "new,"
a forged work of the British artist Ben Nicholson. When the dealer offered
the work for sale, the Tate files were given as a source from which the buyer
could verify the provenance of the work.[23]

Despite Darraby's caveats, and the alteration of records at the Tate, in the
Calder case provenance was considered a very good guide to the authentica-
tion of the work. The court approvingly quoted an expert, who stated that
the mobile's flawless provenance "is the best proof of authenticity I can think
of,"[24] and noted that "... provenance ... or the chain of ownership from the
... artist to the present owner, is accepted in the art world as persuasive evi-
dence of a work's authenticity...."[25]

In *Schiele,* the court noted the absence of a flawless provenance. While
ownership could be traced, without a break, back to an early owner, Baron

Rosenberg, it was not known from whom Rosenberg acquired the painting.[26] Interesting, too, and often an important aspect of an inquiry into the provenance of a work, there was no long history of publication or public exhibition of the work. Although it appeared in a 1972 Schiele catalogue raisonné and had been on exhibition for (only) four years in a "reputable and well-known museum" in Zurich as a painting by Schiele,[27] it was not published in any article or catalogue raisonné until 1968.[28]

It is safe to say that an impeccable provenance will be very persuasive of authenticity, and its absence will be one more reason for a court to doubt a work's authenticity.

CONNOISSEURSHIP: VISUAL INSPECTION BY A KNOWING EYE

In authentication matters all courts acknowledge the importance of visual inspection by a knowing eye. A 1990 court decision[29] noted that ". . . a painting's lack of authenticity is readily apparent to the trained eye of an art expert." And in *Hahn v. Duveen*,[30] the court told the jury that

> experts in this case can help you with their opinions . . . by their study of the methods used or materials employed by the painters or schools of painting of the period in which it is claimed the pictures were painted.

It is sometimes difficult for a layperson to understand how an expert can authenticate a work by visual inspection. The following explanations by acknowledged connoisseurs shed some light on what they do.

In 1992, the great Pollock expert William S. Rubin, director emeritus of the Department of Painting and Sculpture at the Museum of Modern Art, responded to a newspaper interviewer's assertion that it would be nearly impossible to tell the difference between a fake and a genuine Pollock poured painting, as follows:[31]

> I would guess that, in general, it is much harder to tell the work of Rembrandt at his best period from that of his students than it is to tell a real Pollock from a fake. The decision as to whether a Pollock is good or not would involve a judgment of about maybe 10 or 20 characteristics in the drawing and the way the paint is applied, and then a larger judgment of the work as a whole, which is more subjective: for example, does it come together? Does it have that sense of equilibrium recaptured at the last moment before spilling over into chaos?

In expanding on the statement that Pollock achieved a remarkable control over the flow of paint and was able to lay down complex webs of paint, one over the other, methodically—an area where most fakes come up short— Rubin noted:

There is something comparable to touch in a pianist. Any particular accent to a line, or blot or spot, could be reproduced by anybody, but the flow of them together requires not only someone of Pollock's artistic nature, but someone with his expertise in handling and controlling the flow of paint, which he didn't acquire overnight. . . . A common mistake among forgers is not allowing one web of paint to dry completely before adding the next, resulting, in a marbled effect, uncharacteristic of Pollock. . . . "Anybody can pour paint but can you do it with range, variety, continuity and touch?"[32]

Rubin was discussing the visual aspects of the Pollock painting. Sometimes expert visual evaluation of a work's physical aspects is required. In one case,[33] Rudolph Wunderlich, president of Kennedy Art Galleries in New York City, whom the court termed "a recognized expert on Americana," had deemed a bronze cast, titled *Bronco Buster*, supposedly by Frederic Remington, an excellent forgery that could fool many laymen.[34] The *Remington* court approvingly described Wunderlich's reasoning.

First, the foundry stamping is atypical. Second, the stamping identifying the casting as No. 93 is too indistinct. Third, the base of the statue is about one-half inch higher than it should be, and the statue is about seven-sixteenths of an inch too short. Finally, the ears on the horse are misshaped. Wunderlich explained that on an early casting of *Bronco Buster* such as No. 93, the horse's ears should be laid back, flat and quite small. In contrast, the horse's ears in the statue he examined are rather large and stick outward. These characteristics are found only in castings of the *Bronco Buster* numbered above 260.[35]

And Simon Schama offered a nonjuridical view of connoisseurship in an article titled "The Master's Hand?"[36] The Rembrandt Research Project, he wrote, was established in 1968 with the view of using technical means in lieu of connoisseurship ("wooly, unhistorical speculation its members believed to be the base of traditional art history") to aid in the determination of whether certain paintings were painted by Rembrandt or by others. Schama concluded, "It is difficult to think of a single painting . . . where a decisive reattribution has been made on the basis of technical evidence. Overwhelmingly, the Research Project's decisions are the product of old-fashioned connoisseurship; the comparison of stylistic traits."[37] Schama further cited the pioneering work of Giovanni Morelli, a nineteenth-century scholar who

proposed that a painter would betray his identity through involuntary traits and habits registered in ostensibly insignificant details: fingernails, earlobes, eyebrows.[38]

It is clear that by insisting on the importance of visual inspection, courts are not simply concerned with, say, the physical measurements of the height of a bronze base. In quoting with approval the expert testimony that the base was higher "than it should be," the *Remington* court was approving a subjective assumption by a connoisseur about the size and appearance of typical Remington bronzes.

SCIENTIFIC TESTING

Scientific testing cannot prove authenticity. At best, it may disprove authenticity, or may uncover restoration or overpainting which hides significant information about the author of the work. Undoubtedly, the results of scientific testing, where they contain important information, would be given substantial weight by the courts.

The following is an example of scientific testing which cast doubt on the painting's attribution to the artist whose "signature" appeared on the painting. A painting conservator, Alexander Katlan, used two tests in the course of a normal conservation restoration project—ultraviolet fluorescence and infrared reflectography—that suggested the work was not by the nineteenth-century Dutch artist Jozef Israëls (whose "signature" appeared on the lower left) but might be by Jacob Kever, whose signature on the painting was not visible to the naked eye.

> . . . Ultraviolet fluorescence examination began to raise concerns. It revealed a slightly visible signature and a thick multilayer varnish on the painting surface. Fluorescence is defined as the emission of visible light from an object when it is illuminated by ultraviolet light. This is important in conservation as areas of a painting which have been previously restored or overpainted appear purple-black under the ultraviolet or lack the typical yellow green fluorescence of oil or resin layers. Ultraviolet fluorescence records the varnish layers and anything that's been added on top of or within the varnish layers. Generally under thick multilayer varnishes, the signature is not visible at all. So the slight visibility of the signature under ultraviolet fluorescence in this case was problematic, although not in itself conclusive, since certain pigments do remain visible—appearing purple-black—under fluorescence.
>
> . . . we decided to do another laboratory test; namely a scan of the paint surface using infrared reflectography. Our hope was to reveal a second signature, in addition to the Jozef Israëls signature visible to the naked eye. Infrared reflectography is used to reveal inscriptions, signatures, and carbon-based materials. It works on a contrast and absorption and reflection basis. Infrared light—like a heat wave—passes through certain pigments to reveal line and drawings, particularly underdrawings or sketches with re-

markable clarity. Infrared reflectography is often useful with carbon-based inscriptions, such as charcoal or bone black. The infrared reflectography scan of the painting surface, which is seen on a television-like monitor, revealed an inscription (signature) on the lower left of the canvas, slightly above the present visible "Josef Israels" signature. Although illegible, the first letter of the second (original) inscription lower left was clearly a "K." The inscription/signature seems to be painted. It is not visible to the naked eye, and is revealed only under infrared reflectography. Was this second inscription intentionally concealed? We could only presume, yes.[39]

The *Schiele* case was one of the very few cases which relied to any substantial degree on scientific analysis to determine authenticity. (The issue was the authenticity of the overpainted work, but before getting to that question, it had to be determined that the underpainted work, which could not be seen by the naked eye, was authentic.)

> ... it became necessary to examine what was below the visible surface of the [Schiele] painting. This the experts were able to do by the use of x-rays (both conventional and beta radiography) and infrared reflectography, as enhanced by digital image processing through a computer. What emerges, has given rise to some dispute. In essence, there are two relatively dramatic discoveries: the first is a monogram, in mauve, with the initials E & S intertwined which is to be found on the bottom right corner of the canvas. ... the second was the discovery ... through the use of infrared photograph of ... an underdrawing in carbon black....[40]

Predictably, this objective scientific evidence in *Schiele* only raised a further dispute as to whether the monogram was typical of the artist and when it was added to the work. As noted by Schama in "Did He Do It?" "... the efficacy of using x rays to distinguish between Rembrandt and his imitators seems to depend on prior, subjective assumptions about exactly which kind of brushwork exemplified the true techniques of the Master."[41]

Schama, writing on the subject of the Metropolitan Museum's 1995 exhibition, "Rembrandt/Not Rembrandt," states with respect to the Rembrandt Research Project:

> And while the Amsterdam-based project was established in 1968, essentially as a committee of kenners, its experts were no longer willing to put their faith solely in the sharpness of their collective "eye." Instead, a new generation of techno-toys was marshaled to probe beneath the skin of the painting and to deliver final, irrefutable verdicts. No self-respecting Rembrandt exhibition catalogue these days is complete without x radiographs, infrared spectrographs, auto radiographs, canvas warp and woof counts, dendrochronological (tree ring) analysis of panels, and microscopically dif-

ferentiated strata of grounds, glazes, and pigments. But the techno-kenners had hardly donned their lab coats before it became apparent that scientific investigation was a lot stronger on promise than on delivery. For while dating wood or cloth samples could distinguish paintings made in Rembrandt's lifetime from later imitations, the vast bulk of questionable work originated from Rembrandt's own period—and in more than one instance, from the master's own studio. Technology, it seems, is good for exposing [recent] fakes but no good for winnowing out Rembrandt wannabes. . . . The exhibition presents its scientific evidence in the form of photographs and other graphic displays, but also supplies ample reason not to put much faith in such evidence.[42]

And Ernst van de Wetering, chairman of the Rembrandt Research Project, has confirmed the limits of scientific testing for the Research Project.

From the outset there were hopes that the use of scientific methods would provide more objective criteria for the attribution or de-attribution of the paintings than were previously used. Whereas initially there was strong suspicion that among the doubtful attributions there were a substantial number of later pastiches and fakes, it was thanks to results of dendrochronological investigations that we learned in the course of the 1970s that doubtful paintings in all cases were from Rembrandt's time and most likely from his workshop. This first highly significant result of the scientific investigations was later confirmed by the study of canvases and grounds. These insights added to a tendency of the RRP to shift the methodological emphasis more and more to connoisseurship, as it wasn't expected that Rembrandt's own works and those of other painters from his workshop could be distinguished from each other through scientific methods.[43]

Other Factors and Approaches Courts Have Utilized

THE SIGNATURE FACTOR

In both *Calder* and *Schiele*, the signature was greatly indicative—if not, in fact, determinative—of authenticity, irrespective of the opinions of connoisseurs. In *Calder*, the court found the presumed authentic signature (initials, actually) of Calder as compelling an indicator of authenticity as "fingerprints at the scene of a crime" are of the guilt of the accused. Presented with the converse situation, the court, in Schiele, found that the presence of an admittedly *inauthentic* signature (again, initials) relegated an otherwise authentic work (albeit overpainted) to forgery status.

Oddly enough, art experts deem signatures of little or no importance in determining authenticity. Jackson Pollock expert William S. Rubin, evaluat-

ing a transparency of a painting said to be by Pollock, declined to consider the signature in the lower right as a factor in determining authenticity, saying, "How long would it take you to learn to sign Pollock's signature, and how long would it take you to learn to *paint* like Pollock?"[44] Clearly, signatures are *not* like fingerprints, as was suggested by the *Calder* court. The unique and unchanging pattern of swirls of a finger cannot be learned or copied as a signature might be.

For art experts, a signature, apparently authentic, creates no presumption of authenticity. The possessor of an inauthentic unsigned work may find it a relatively simple operation to forge the artist's signature. Conversely, it is altogether possible that the possessor of an authentic, but unsigned, work may add a signature to "dot the i's and cross the t's," unaware that the painting itself, from the point of view of the connoisseur, is "signature" enough.

The fact is, however, that while the art world may believe signature evidence to be unreliable, the courts have not fallen into line. This reality cannot be overlooked when a painting, whose authenticity one is challenging in a court proceeding, bears a signature purporting to be that of the artist.

One approach, of course, may be to try to convince the court of the inherent unreliability of signature evidence in general. Another is to attack the genuineness of the particular signature. While the approaches are not mutually exclusive by any means, it is safe to say that one ignores the presence of an apparently authentic signature at one's peril. This was amply demonstrated in *Calder*, where the buyers claiming *Rio Nero* was a fake did not challenge the authenticity of the artist's "AC" initials before the trial court. It was only later, after the trial court's decision was rendered, and no doubt too late, that it was pointed out that the "AC" initials on the mobile at issue showed telltale tool markings not made by Calder's tools.[45]

DISTINGUISHING AMONG THE CONNOISSEURS

Courts undoubtedly recognize, as has been said, that connoisseurship is an important element in determining authenticity. The wrinkle, here, is that the courts are generally confronted with connoisseurs whose opinions are in conflict. From their decisions, we can discern approaches taken and elements relied on by the courts in dealing with these conflicts. These are set out below.

1. One way for the court to deal with conflicting expert opinion is to accept that of the expert with the superior credentials, the one who has the greatest experience and knowledge. With the exception of an English court decision involving a Van Dyck painting and the London dealer Thos. Agnew & Sons (see discussion in chapter 15 of this volume), I know of no court which has ranked experts and proceeded in such a fashion.

2. While the courts may not rank experts for their experience and knowledge, they will certainly disregard the opinion of any expert who has an in-

terest in the outcome of the proceedings. This occurred in a case involving Frederick Hartt, emeritus professor of the history of art at the University of Virginia, who attributed a statuette to Michelangelo and then wrote a book about it, *David by the Hand of Michelangelo: The Original Model Discovered*.[46] Interestingly, the court was impressed by Hartt's scholarship and concluded that he genuinely believed the work was authentic. Nonetheless, his opinion was fatally tainted because he had entered into a contract with the owner which provided that

> Mr. Hartt promises to draw up an historical, artistic and technical study of the said model.... It will be published ... during the course of the year 1987.... On the results of the eventual sale of the model, following such publication, at whatever might be the date [owner] promises to pay ... 5% ... after ... the sale."[47]

The court stated:

> The mischief caused by the Professor was that the attribution being peddled by means of a promotion contract, which resulted in the enhancement of the value of the statuette, and if the statuette was sold, would result in an amount receivable by Professor Hartt of 5% of the sale price [estimated between $40 and 50 million].[48]

It was also arranged that Hartt should talk to J. Carter Brown, director of the National Gallery in Washington, so that the National Gallery would bid for the statuette at the auction. The court said that Hartt

> was both dishonorable and deceitful enlisting the National Gallery as a bidder without informing him that he was financially interested in the sale of the statuette. Mr. Carter Brown, in my judgment, would have assumed that Professor Hartt was a disinterested scholar and was not coming to him as part of the promotion for sale purposes.... Mr. Carter Brown would have expected the Professor to be a disinterested scholar and the Professor, I have no doubt, knew full well at the time that Mr. Carter Brown presumed him to be wholly disinterested so far as money was concerned in the attribution...."[49]

The *Hartt* Court quoted approvingly from the Code of Ethics for Art Historians and Guidelines for the Professional Practice of Art History, adopted in 1979 by the directors of the College Art Association of America.[50]

> To avoid conflict of interest situations, the CAA does not recommend that scholars set fees for attribution and connoisseurship at a percentage of the sale price of a work of art. This was and is a widespread practice in Europe

and has led to the damage of reputations of foreign scholars who depended on large fees for their livelihood. Resolution: Art historians, when consulted on such matters as attributions, can avoid the suggestion of self-interest by establishing in advance fees which bear no relation to the monetary value of any work of art in question and which do not otherwise relate to the monetary effects of any research, investigation, opinion or statement by the art historian.[51]

3. Sometimes the court may be able to sidestep making any decision on authenticity where experts differ. In a case involving a valuation dispute with the Internal Revenue Service over a painting by Charles M. Russell contributed to the C. M. Russell Museum,[52] the court said there was little doubt that the opposing experts are "two of the foremost authorities on the works of Charles M. Russell."[53] Both experts agreed that the painting was unlike any Russell painting with which they were familiar. Expert Steele opined that the subject matter, the spontaneity, and the coarse canvas were characteristic of Russell and that the signature was authentic. Expert Renner opined that the artist's initials were easy to forge and that an authentic Russell painting, no matter how quickly executed, always contained certain elements of his style and skill which were not evident here—for example, well-defined figures having body, weight, volume, a three-dimensional quality; moreover, when working in oil, the artist was very deliberate. Since the foremost authorities did not agree, the *Russell* court declined to rule on authenticity and simply found that the dispute over authenticity lowered the market value of the painting for tax deduction purposes.

4. Another mechanism courts employ for avoiding a choice among expert opinions, where the buyer's connoisseur says the work is fake and the seller's that it is authentic, is to rely on the burden of proof. Thus, if the court treats each side's connoisseurs as evenly matched and their opinions as of equal weight, the claimants will not have borne their burden of proving inauthenticity.

5. The courts look for the *systematic* application of connoisseurship. It may be recalled that the *Calder* court acknowledged that Perls had the greater expertise, but it was troubled that he had not applied his connoisseurship and expertise to the mobile in a systematic way the court could understand. Decades earlier, the *Duveen* court said:

> I have profound respect for critics whose conclusions rest upon facts. . . . The opinions of any other kinds of experts are as "sounding brass and tinkling cymbals!" . . . There are also experts who admit that they have no formulas, rules . . . but who claim to have a sixth sense which enables some of them after they have seen a picture, even for five minutes, to definitely

determine whether it is genuine or not. I do not say that this faculty may not be possessed by some men, but it is not based upon enough objectiveness to convey definite meaning to a jury.[54]

Thus, the *Duveen* court, too, while emphasizing the role of the connoisseur's eye, was looking for that eye to articulate conclusions based upon objective, verifiable fact which a court can understand, and perhaps even observe. For while the connoisseur makes subjective assumptions about, for example, the kind of brushwork which characterizes the technique of the artist, the connoisseur must be able to describe the brushwork to the court in a way that the court can at least understand and, ideally, see for itself; the actual brushwork is no less "objective," after all, than the height of the base of a bronze sculpture.

6. Courts may make independent judgments as to the method used by the connoisseur. For example, a connoisseur may make an authentication decision based on a photograph. The court decisions on this are mixed. In a case involving the appraisal, for tax purposes, of certain North American Indian artifacts, it was stated that "reliance on photographs is not unusual in the appraisal of art."[55] However, the taxpayers' "own experts testified that an appraisal based on photographs makes it 'difficult, if not impossible, to determine the condition, authenticity or age of artifacts.'" And in another case,[56] in determining whether a stained-glass window was a work of art for purposes of import duties, it was noted that "there is nothing to a window beyond color and design"; hence "testimony based on a photograph alone is competent and entitled to the same weight on the issue here as if based on actual inspection of the window." Another court, however, in a case involving the authenticity of stained glass by the artist John La Farge, felt it was evidence of "recklessness" for the expert not to have looked at many of the works he rejected as not being true La Farges.[57]

The *Calder* court, for example, was critical of the expert's method of comparing the mobile (and only a few blades out of twenty-seven) against the archival photograph, "given the distortions all experts conceded are involved in photographing Calder mobiles, as well as the inherent difficulties involved in comparing a two-dimensional photograph to a three-dimensional moving piece." It spoke with evident admiration of the attention to detail by the seller's expert, who examined not photographs, but all twenty-seven blades of the mobile itself.[58]

It would seem, in summary, that one cannot be faulted for looking at the work itself, though one *may* be faulted for looking only at a photograph.

7. The courts look at the time and care spent by the expert in making a visual examination of the work. This is clear in *Calder*. Klaus Perls, the respected connoisseur, spent only a few minutes comparing a few blades against

archival photographs, whereas, the court noted approvingly, the seller's expert "examined every blade and every joint and every wire and did it very meticulously."[59] To the *Calder* court, then, once both the seller's expert and the buyer's expert were deemed "experts," their connoisseurship was entitled to more or less equal weight. At this point, the "objective" differences in the time and care they took in reaching their conclusions became a critical factor. The *Schiele* court, too, made no attempt to rank expertise and experience, and instead preferred one or another expert according to whether their reasoning persuaded the court of the accuracy of their opinion. It noted that the expert "viewed the painting with some care making use of both an ultra violet lamp and a magnifying glass."[60]

8. Some cases have shown an interesting tendency for the courts to seek a consensus of expert opinion. They thus rely not on any one expert, whether plaintiff's or defendant's, but distill and survey all the expert opinions presented to see points of agreement, almost as if it were a "head-counting" exercise. In a sense this is paralleling a development in the art world—the establishment of committees and boards of experts (partly in response to the problems generated by the traditional certificate system involving a single expert). For example, the Pollock-Krasner Authentication Board consisted, and the Andy Warhol Art Authentication Board consists, of four experts, while the Calder Foundation was advised by eleven experts in its authentication activities.[61]

Recommendations for Experts Authenticating Works of Visual Art

The recommended procedures and methods which follow, flow from court decisions in America and overseas, many of which have been discussed above. They should serve as guidelines for art experts, including art scholars and dealers, and authentication boards and committees.

CREDIBILITY ISSUES

The expert's opinion not only must be honestly arrived at, it must *appear* to have been honestly arrived at. The credibility of an expert who has a financial or other interest in the outcome of an authentication (e.g., a direct or indirect ownership interest in the work or a fee policy where the amount of the fee depends on the future sale price of the work) will be tainted, and the opinion disqualified. The conflict of interest may not be blatant. For example, in theory, an agreement could be made in advance that provided for payment, whether or not the work was determined to be authentic, of a substantial fee based on the work's value as authentic. In practice, however, an owner would be reluctant to sign such an agreement unless there were advance indications that the decision would be positive; this, in turn, would raise

the very conflict one should wish to avoid. Nevertheless, a substantial fee for authentication, unrelated to the value of the work, would be proper, although in practice many committees and boards make no charge at all for their authentication services.

PROVENANCE

A documented history of the ownership of the work from the artist's hand to the current owner, as well as of publication and public exhibition, should be prepared, if possible, because it is important evidence of authenticity. Of course, one must be mindful that a bill of sale can be faked. However, even though the chain of title from the artist's hand is flawless and gap-free, it is not conclusive evidence of authenticity. It cannot assure the expert that the work at hand is the same physical object cited in the documentation.

QUALIFICATIONS OF EXPERTS

As further outlined below under the discussion of systematic connoisseurship, one cannot overestimate the importance of the expert's methodology. Unlike the art market, courts do not seem to place much more trust in experts with the better qualifications. Once qualified before the court as experts, all experts tend to be accorded equal deference, on the condition that the expert can articulate the basis for his opinion in a way which is convincing and is based upon facts whose accuracy and relevance have been established to the court's satisfaction.

CONSENSUS OF EXPERTS

The European certificate system, whereby a single expert forms an opinion, seems to be losing ground, at least in the courts. To begin with, in the context of a dispute before a judge, there are at least two experts with differing opinions, and in practice the courts tend to "poll" all the experts for points of agreement. One can assume, therefore, that a consensus opinion of a committee or board would be given more weight by a court.

The identities of experts serving on a board, committee, or panel should *always* be revealed even though some experts may decline to serve for fear of legal liability. Unless the experts' names are known there is no way for the owner of the work or anyone else, including other experts and scholars, to judge the experts' qualifications and biases. Thus, for example, IFAR's procedure that "some specialists . . . prefer to remain anonymous and we honor that request" (see Chapter 10) should certainly not be followed.

SYSTEMATIC CONNOISSEURSHIP

It is important for the expert to follow a standard of systematic connoisseurship. Connoisseurship, or the ability of the connoisseur to visually perceive

the rightness of the work, is based upon having looked hard and carefully at many works by the artist, combined with a knowledge of the artist's ways of working and materials utilized. This is true whether the work is abstract or representational, since there is no difference in being able to visually distinguish the kind of brush stroke forming a cow's tail from the kind of brush stroke forming a bright red line curving across an otherwise blank canvas. *Systematic connoisseurship* contemplates the compilation, by the expert, of a mental checklist of factors indicative of the artist's characteristic methods of work, use of materials, and visual temperament; the verification, by visual inspection, of the presence of those factors; and the reporting or articulation of the presence or absence of these factors. This report or articulation prepared by the connoisseur should be in writing, and include drawings and sketches, if necessary, for clarity. Ideally, the expert's written records should be kept in such a way that the nonexpert would be able to read them and understand how the expert reached his or her conclusion.

In a nutshell, the difficulty for systematic connoisseurship in convincing a legal decision-maker is that critical decisions are often made by the expert on the basis of *what the expert sees and the judge does not*. Properly understood, the frequent reference in the cases to "subjective" judgments by experts is (or should be) a misnomer. Once the court accepts, as all the cases do, the importance of evidence of the connoisseur's knowing eye, it then remains only for the connoisseur to describe the relevant characteristics of the artist's work and to show these to the court so that the court can "see" them. (The determination of what is characteristic of the artist does, of course, require a subjective opinion.) If the court cannot "see" some of these visual factors, they do not thereby become subjective, any more than what a radiologist sees in an X ray is subjective because the untrained eye of the judge cannot see it.

The court decisions discussed here make it clear that judges are willing to accept the systematic connoisseur's evidence, even when the court cannot "see" some of it —provided the connoisseur has articulated for the court *why* what the expert visually perceives is important (e.g., the artist's method of working a given material), and is able to verbally describe for the court what he has seen.

CAREFUL VISUAL INSPECTION

Any expert called upon to authenticate a work would be well advised to devote a substantial amount of time to viewing, examining, measuring, and otherwise becoming fully knowledgeable about all physical aspects of the work. This remains true even though, in practice, the expert's visual experience and familiarity with the artist's style and facture often allow a determination that the work is inauthentic to be made in a glance, even by a glance at a photograph.

PHOTOGRAPHS

The courts are skeptical of authentication determinations made only on the basis of viewing a photographic image. In practice, many works often can be accurately determined to be *inauthentic* (but not authentic) on the basis of a good-quality color print or transparency. However, experience in the courts suggests that the work itself should always be viewed and examined before coming to any final decision concerning authenticity.

SIGNATURES

Although experts do not, in practice (and for good reason), place much weight on a signature on a work, any signature should be addressed with special care because the courts, at least, *do* place substantial weight here. When there is doubt, a handwriting expert should compare known signatures with the questioned specimen. If other physical or scientific evidence is available (e.g., where tools have been used to make the signature), it should be obtained and evaluated.

Notes

1. "More likely than not" is the standard which a party to a civil case must meet to prevail. Obviously, the art market and scholars require a higher standard of proof before accepting a work as authentic. A little better than even odds that a work is authentic would hardly persuade a buyer to purchase at full price.
2. Judd Tully, "When Is a Calder Not a Calder?," *Art News* (February 1997), p. 90.
3. See, for example, *Vitale v. Marlborough Gallery, the Pollock-Krasner Foundation, et al.* (SDNY, July 5, 1994), 1994 WL 654494, 1994 U.S. Dist. LEXIS 9006; *Kramer v. the Pollock-Krasner Foundation, et al.* 890 FSupp. 250 (SDNY, 1995); and *O.K. Harris Works of Art v. Andy Warhol Art Authentication Board,* N.Y. Supreme Court, N.Y. County, Index no. 112439/98 (1998).
4. *De Weerth v. Baldinger,* 658 F.Supp. 688 (SDNY, 1987), rev'd 836 F2d 103, 112 (2nd Cir. 1987), cert. denied, 486 U.S. 1056 (1988), rev'd 24 F3d 416 (2d Cir. 1994).
5. See Jessica L. Darraby, *Art, Artifact and Architecture Law* (West Group, St. Paul, MN.: 1995), pp. 2–54, 55–56.
6. For example, the Wildenstein Institute in Paris has published many catalogues raisonnés of European artists. See *Kirby v. Wildenstein,* 784 FSupp. 1112 (SDNY, 1992).
7. *The Art Newspaper* (September 1998), p. 5.
8. The catalogue raisonné project of the Calder Foundation has taken the opposite approach, writing to the applicant that the work "is not by the hand of Calder," and stating the reasons why it had formed this opinion.
9. *Gumowitz v. Wildenstein & Co., John Rewald, Stephen Mazoh, Gary Tinterow and the Metropolitan Museum of Art,* NY Sup. Ct., NY County, Index no. 10229-92, 1992.

10. Memorandum of Law in Support of Motion by Defendants Tinterow and Metropolitan Museum of Art for Summary Judgment, pp. 14, 15.

11. *Greenwood v. Koven,* 1993 U.S. Dist. LEXIS 18272; *Koven v. Christie Manson Woods,* 880 FS 186 (SDNY, 1995). (hereafter *Braque/Christie's*)

12. *Braque/Christie's,* p. 201. Christie's consignment agreement provided that "Christie's shall have complete discretion as to seeking views of any experts. . . ."

13. See the exchange of letters between J.H. Merryman and F. Feldman, Letters to the Editor, *IFAR Journal* 1 (Summer 1998): 4, 5.

14. *The Wall Street Journal,* October 21, 1998, p. A1.

15. 1966-2 C.B. 1257.

16. See Darraby, *Art, Artifact and Architecture Law,* pp. 3–15.

17. 133 Misc. 871, 234 N.Y.S. 185 (Sup. Ct. N.Y. 1929). (hereafter *Duveen*)

18. T.E. Stebbins, "Possible Tort Liability for Opinions Given by Art Experts," in Franklin Feldman and Stephen E. Weil, eds., *Art Law: Rights and Liabilities of Creators and Collectors* (Boston: Little, Brown, 1986), vol. 2, p. 517.

19. The court's decision was upheld on appeal notwithstanding a friend of the court brief submitted by the Calder Foundation which argued that the blades were not the proper gauge, that the wire was of soft (rather than Calder's hard) steel, and that the signature, relied on so heavily by the trial court, showed telltale markings not made by Calder's tools.

20. *De Balkany v. Christie Manson Woods Limited,* High Court of Justice, Queens Bench Division, 1993 D no. 1089. (hereinafter *Schiele*)

21.
> Looking below the visible surface of the painting . . . by the use of x rays (both conventional and beta radiography) and infrared reflectography as enhanced by digital image processing through a computer, there could be seen, under the surface, a monogram of the artist's initials and an underdrawing outlining certain images on the surface.

But for this under-the-surface monogram, the court would not have felt persuaded by the world's leading expert, Dr. Leopold, that under the overpainting was a Schiele. It was not "typical" of Schiele work in that it was his only truly "symmetrical" painting. However, an analysis of the paint dates the painting to the first decade of the twentieth century, when Schiele was still "developing a style." And there were

> features consistent with it being a Schiele: the style of the nude figure, the spreading of the fingers, the use of geometric patterns, the design of God's head and of his fingers protruding from the cloak, and the accentuation of the vertebrae on the boy's back which is shown in the underdrawing. The use of the colors and metallic paint was also consistent with it being Schiele's work.

None of these factors was "decisive," "either singly or taken together," especially since another expert convincingly debated all these "consistent" features. In the face of this conflicting evidence, the court, although clearly far from certain, concluded, *on a balance of probabilities,* that the underpainting was by Schiele.

22. Darraby, *Art, Artifact and Architecture Law,* pp. 2–52, 53, 54.

23. *The New York Times,* June 19, 1996, p. C-11.

24. Greenberg Gallery v. Bauman, 817 F.Supp. 167, 173 (D.C. 1993) affd. without opinion, D.C. Cir. 194 U.S. App LEXIS 27175 (hereinafter *Calder*).

25. Ibid.

26. *Schiele*, p. 232.

27. Ibid., p. 235.

28. Ibid., p. 234.

29. *Rosen v. Spanierman*, 894 F2d 28 (2nd Cir. 1990).

30. *Duveen*, p. 874.

31. The subject of the discussion was a painting which the Pollock Authentication Committee in 1973 had determined not to be by Pollock and which also had been published in the 1978 Pollock catalogue raisonné in a section titled "False Attributions."

32. *The New York Times*, August 9, 1992, Section 2, p. 1.

33. *U.S. v. Tobin,* 576 F2d, 687 (1978).

34. Ibid., p. 691.

35. Ibid.

36. Simon Schama, "The Master's Hand?," *Times Literary Supplement*, March 20, 1992, p. 17.

37. Ibid.

38. Ibid.

39. Alexander Katlan, "Conservation in Aid of Authentication," *IFAR Journal* 1, no. 3 (1998): 15–16.

40. *Schiele*, p. 248.

41. Simon Schama, "Did He Do It?," *The New Yorker*, November 13, 1995, p. 117. (Copyright Simon Schama 1995) by permission of PFD on behalf of Professor Simon Schama.

42. Ibid., p. 115.

43. Ernst van de Wetering, "Thirty Years of the Rembrandt Research Project," *IFAR Journal* 4, no. 2 (2001): 15.

44. Discussion with the author, New York, 1994.

45. The Calder Foundation's amicis curiae brief in the Court of Appeals stated, "Calder's signature was applied . . . using specialized tools and a specific technique, and it is reference to these tools and technique which is relevant to determining whether the 'AC' on the mobile is evidence of it being Calder's hand." Brief of amici curiae, The Art Dealers Association of America and The Alexander and Louisa Calder Foundation (1994), p. 26 (hereafter, Calder Foundation, *Amici Curiae Brief*).

46. *Hartt v. Newspaper Publishing, P.L.C.*, Queen's Bench Division (*The Independent*, 8 December 1989), LEXIS pp. 103–26. In 1988 *The Independent*, a London newspaper, published two articles claiming that there were reasonable grounds for suspecting that Hartt had been reckless in authenticating the work and had not objectively assessed the evidence concerning its authenticity. Thereupon Hartt sued the newspaper for libel in the English courts.

47. Ibid., p. 109.

48. Ibid.

49. Ibid.

50. Ibid., p. 118.

51. Ibid., p. 119. In commenting on the CAA Code of Ethics, the *Hartt* court noted:
 It was wrong to take a percentage of the valuation of a work of art in
 consideration of his attribution, particularly if that percentage and
 the existence of a payment by a percentage was concealed.... poten-
 tial buyers would assume that the scholar's attribution was made dis-
 interestedly and because of that assumption, would place greater weight
 on the attribution.

 The *Hartt* court also disapprovingly quoted a transaction involving another art-
 work, in which a part owner of the work authenticated the work for a buyer
 without revealing his ownership, because "a buyer would presume the expert was
 disinterested and therefore would place more reliance on the expert's attribu-
 tion."

52. *Doherty v. Commissioner of Internal Revenue*, U.S. Tax Court, 63 TCM(CCH)2112
 (1992).

53. Mr. Steele had worked as executive director of the museum and authenticated its
 entire collection of 1,800 Russell works and testified that he and Mrs. Renner,
 the IRS expert, were the "top Russell experts in the country." Mrs. Renner
 owned the largest archive on Russell art in the country and was regularly con-
 sulted by national auction houses and had authenticated over five hundred Rus-
 sell pieces.

54. *Duveen*, p. 874.

55. *Sammons v. Commissioner of Internal Revenue*, 838 F2d 330 (9th Cir. 1988).

56. *Spiers v. U.S.*, 47 CCA 118 (1960).

57. *McNally v. Yarnall*, 764 FSupp. 838 (1991).

58. Unlike Perls's approach, the Calder Foundation, in its amicus brief, based its
 opinion that the piece was not authentic on a "purely physical examination"—
 on the materials used in its construction, stylistic comparison, and "emotional im-
 pact." Calder Foundation, *Amici Curiae Brief*, pp. 21, 22.

59. *Calder*, p. 172.

60. *Schiele*, p. 238.

61. Calder Foundation, *Amici Brief*, p. 19.

A Legal Decision in New York Gives Experts Protection for Their Opinions on Authenticity

. . .

Ronald D. Spencer

. . .

Ever since Sir Joseph Duveen was sued in 1929 by the owner of a painting he publicly declared was a copy—and had to pay $60,000 (1929 dollars!) in settlement, art experts have been concerned about expressing opinions on the authenticity of a work. Seventy years later, a New York court imposed financial sanctions on both plaintiff and his lawyer and decided that an expert whose opinion is solicited can protect himself wih a "hold-harmless" agreement, thereby suggesting that enhanced legal protection may be available for the expression of opinions on authenticity.— RDS

. . .

A decision by a justice of the New York Supreme Court in 2000[1] provides significant protection to scholars and other experts who render opinions on the authenticity of works of art.[2]

In 1929, the art dealer Sir Joseph Duveen paid $60,000 in an out-of-court settlement for expressing the opinion, after having seen a photograph of a supposed Leonardo da Vinci painting owned by Mrs. Andreé Hahn, that the real *La Belle Ferronnière* was "in the Louvre."[3] Duveen's quip "forever" established "in the minds of many people that opinions are dangerous things to give."[4] Indeed, experts ever since have been concerned about their liability for rendering opinions on the authenticity of a work of art. This long-held, widespread fear has inhibited experts from expressing their opinions, even informally and verbally, even where the matter (for example, a major museum purchase) is of significant public interest.[5] Their concern is that they will be sued for product disparagement, negligence, breach of contract, and perhaps defamation.

One important consequence of this fear of claims is that scholarly publication and expert comment are inhibited and the distribution throughout the

art world of fakes, misattributions, and imitations by the dishonest, careless, or uninformed is thereby facilitated. Some relief, however, may be at hand.

In *Lariviere v. E. V. Thaw, the Pollock-Krasner Authentication Board, et al.*, the court held that an owner of a painting, alleged to be by Jackson Pollock, could not sue a group of experts who had formed an authentication board to render opinions on the authenticity of works said to be by Pollock. The owner had signed the board's application, which contained an agreement not to sue the experts for their opinion. Significantly, the court also ordered the plaintiff to pay the costs of the experts' legal defense and, in a highly unusual action, ordered financial sanctions against both the owner and his lawyer for having brought a frivolous action.

This was the first time, to my knowledge, that a court had ordered monetary sanctions in a case involving authentication. The existence of this precedent may encourage courts in the future to impose sanctions in appropriate cases. Clearly, the threat of such court action should have an inhibiting effect on frivolous claims by disappointed owners over negative opinions about the authenticity of their works of art. The useful consequence will be that the scholarly and expert art community should feel itself more free to give and publish careful, appropriate opinions with a much reduced fear of claims.

The Case

The facts of the case are these. In 1994, Kenneth Lariviere (the "owner" or "plaintiff"), a resident of Vancouver, British Columbia, contacted the Pollock-Krasner Authentication Board to have it examine his painting, titled *Vertical Infinity*, which he believed was by Jackson Pollock (figure 17.1). He signed the board's standard application and agreement form, which provided that the owner

> is requesting The Pollock-Krasner Authentication Board to give [the owner] an informal opinion on the probable inclusion of the work described below in the planned catalogue (or catalogue supplement) for the works of either Jackson Pollock or Lee Krasner.

The application and agreement further provided that the owner

> agree[s] to hold the Authentication Board and its Directors and Officers in their representative and individual capacities harmless from any liability towards [the owner] or others because of its rendition of an opinion (or its refusal to render an opinion).

A part of the application contained questions to be answered by the owner. In response to the question "How Acquired," the owner wrote: "through the

17.1 A painting titled *Vertical Infinity*, claimed to be by Jackson Pollock.

estate sale of the late Mrs. Frederick Schwankasky." (Frederick Schwankovsky was Pollock's art teacher in the late 1920s in a Los Angeles high school.)

The Authentication Board advised the owner that it had examined the same painting in 1993, when it was submitted by a previous owner for authentication, but that it was willing to examine the painting again if the owner wished it to do so. Upon examining the painting, the Authentication Board again concluded, unanimously, that it was not by Pollock, and so advised the owner. The owner sent letters to the Authentication Board arguing that his painting was authentic. He also provided an affidavit from Schwankovsky's son stating that the son had been present when his father received the painting in the mail in 1953, at which time his father exclaimed, "Jackson Pollock has sent me a painting from New York," and that Schwankovsky had told his son that the painting was "typically Pollock." Nevertheless, the Authentication Board advised the owner that if he wished to continue his efforts to obtain expert opinion authenticating his painting, he should address other Pollock experts.

The owner sued the Authentication Board and its individual members[6] in January 1999, alleging that they had failed to maintain a standard of care imposed by law. He sought monetary damages as well as an order for the Authentication Board to publish a supplement to the Pollock catalogue raisonné that included *Vertical Infinity* as a work by Pollock.

The Authentication Board moved for summary judgment against the owner, arguing that the application and agreement the owner signed in 1994 held the Authentication Board harmless from liability to the owner based on its opinion. The Board also counterclaimed that in bringing the action, the

plaintiff had breached his contract with the Board not to sue and was therefore liable for damages (legal fees and expenses incurred in defending against the plaintiff's claim).

The Authentication Board also took the position that the plaintiff could not use the courts to compel the Authentication Board to change its opinion. If the plaintiff wished a different opinion, he would have to address other Pollock experts and attempt to persuade them that his painting was authentic.

The Authentication Board also moved for sanctions against plaintiff and his lawyer under Part 130 of New York Rules of Court, which provides for sanctions for frivolous conduct. Conduct is frivolous under Part 130 if

> it is completely without merit in law; . . . or . . . it asserts material factual statements that are false. . . . In determining whether conduct undertaken was frivolous, the court shall consider among other issues . . . whether or not the conduct was continued when its lack of legal or factual basis was apparent, should have been apparent, or was brought to the attention of counsel or the party.

In addition, 22 N.Y.CRR 130-1.1a(b) states:

> By signing a paper, an attorney or party certifies that to the best of that person's knowledge, information, and belief, formed after an inquiry reasonable under the circumstances, the presentation of the paper or the contentions therein are not frivolous. . . .

The Decision

The court held that the written agreement between the owner and the Authentication Board "by its terms, clearly bars this action."[7] Thus, Justice Emily Jane Goodman granted the Authentication Board's motion for summary judgment, dismissing both the plaintiff's claim for damages and his request for a court order requiring the Authentication Board to publish the painting as authentic. The plaintiff could not avoid his agreement not to sue. The court stated:

> Where the language of the exculpatory agreement expresses in unequivocal terms the intention of the parties to relieve a defendant of liability for defendant's negligence, the agreement will be enforced.[8]

Justice Goodman also granted the Authentication Board's counterclaim for damages for the owner's breach of his agreement not to sue the Board for its opinion, stating:

defendants clearly are entitled to judgment on their contractual indemnity claim involving plaintiff's written agreement to hold defendants harmless from any claim arising from their evaluation of the painting.[9]

The justice also imposed sanctions of $1,000 each against the owner and his lawyer on the grounds that the claim was frivolous within the meaning of Rule 130.1(a)(i) of the Uniform Rules, since the action was "completely without merit in law or fact and cannot be supported by any reasonable argument for an extension, modification or reversal of existing law."[10]

The Authentication Board had argued that the owner's action was frivolous, first, because the Board's application signed by the owner clearly provided that the owner agreed not to sue over the Board's opinion; and second, because the owner had no reasonable factual basis for believing that the painting was by Pollock. While Justice Goodman did not expressly articulate the latter argument, in reaching her decision she did note factors directly related to the authenticity of the painting. For example, she noted that an inscription addressing the alleged donee of the painting on the back of the painting misspelled Pollock's name as well as that of the donee. And in reviewing the provenance of the painting alleged by the owner, the court noted that "no estate tax was ever paid on a valuable Pollock painting by any member of the Schwankovsky family," and that the painting was purchased "as a facsimile at an auction for $4,000 Canadian, 'as is.'"[11] Another factor related to the authenticity of the painting which the court noted was that the owner's expert, who had opined, based on handwriting analysis and signature comparisons, that the signature on the face of the painting was by Pollock had made his comparisons entirely from photographs of signatures, not from the paintings themselves.

Finally, also with respect to sanctions, the court noted that prior to the institution of the lawsuit, legal counsel to the Authentication Board (the author of this chapter) met with the owner's lawyer to ask if there were proof of the authenticity of the painting or any law to support the denial of the agreement in which the owner agreed not to bring the instant lawsuit. The court stated:

> Upon being informed that there was no expert opinion declaring the painting genuine and no law to avoid the written agreement, defendants' counsel warned the plaintiff's counsel that if suit were instituted, sanctions, counsel fees and costs would be sought. The plaintiff and his attorney apparently decided to risk going forward given the potential value of a genuine Jackson Pollock.[12]

Thus, seventy years after the New York Supreme Court, in *Hahn v. Duveen*, triggered concerns among experts about rendering opinions on works of art, the same court had held that an expert whose opinion is solicited can protect

himself with a "hold-harmless" agreement and a court will enforce it, thereby providing scholars and other experts with reason to feel that real legal protection is available for the expression of appropriate opinions on the authenticity of works of art.

Commentary 2002

The *Lariviere* decision marked the first time an American court had awarded financial sanctions against a plaintiff and his lawyer (or either one) for having brought a frivolous claim concerning the attribution of visual art. The New York State Supreme Court also upheld the use by a group of experts of an agreement not to sue them for their opinion (even if they might ultimately be proved negligent in rendering that opinion). The New York Supreme Court took the next step and allowed the group of experts to counterclaim for damages against the art owner for the owner's breach of his agreement not to sue these experts. The Authentication Board's damages consisted entirely of legal fees and expenses incurred in defending itself against the claim. The defendants were entitled to these damages under New York law,[13] even though their legal defense costs had been paid by their insurance carrier.

With respect to the issue of court-ordered financial sanctions against the plaintiff's lawyer, two earlier federal cases,[14] in 1994 and 1995, had considered this issue under Rule 11 of the Federal Rules of Civil Procedure and arrived at a different decision. In *Vitale*, the defendant experts, The Pollock-Krasner Authentication Board, requested the court to sanction plaintiff's lawyer under Rule 11.

Rule 11(b) of the Federal Rules of Civil Procedure states, in pertinent part:

> By presenting to the court (whether by signing, filing, submitting, or later advocating) a pleading, written motion, or other paper, an attorney or unrepresented party is certifying that to the best of the person's knowledge, information, and belief, *after an inquiry reasonable under the circumstances* [emphasis added] . . . the allegations and other factual contentions have evidentiary support or, if specifically so identified, are likely to have evidentiary support after a reasonable opportunity for further investigation or discovery.

Thus, Rule 11 imposes on any attorney who signs a paper submitted to the court an affirmative duty to conduct a reasonable inquiry into the facts alleged in the paper *before* filing it. The attorney's signature certifies that he has conducted a reasonable inquiry and has determined that the paper filed with the court is factually well-grounded.

As discussed elsewhere (see chapters 15 and 16 in this volume), the *Vitale*

and *Kramer* cases involved claims by the owners of paintings that their paintings were by the hand of Jackson Pollock and that the Authentication Board had violated the Sherman Antitrust Act by improperly refusing to authenticate their paintings—with the goal of restricting the number of authentic works and thereby driving up the market price of Pollock paintings.

The Authentication Board, defendant in both *Vitale* and *Kramer*, had argued that the plaintiff owners had to prove the authenticity of their art because the antitrust laws self-evidently could not protect an owner's right to sell a fake. And, in both *Vitale* and *Kramer*, the plaintiff owners had not found a single art expert to say that their paintings probably were, or even *might be*, by Pollock. The matter was similar to bringing an action against someone for trespass without some evidence that the plaintiff actually owned the property. Put another way, can an owner and his lawyer bring this kind of claim even though only the owner (admittedly not an expert) believes the work to be authentic, has little or no evidence to support his belief, and the owner's lawyer has conducted little or no investigation of his own to uncover such evidence?

In *Vitale*, Judge Leisure, while stating that Rule 11 "explicitly and unambiguously imposes an affirmative duty on each attorney to conduct a reasonable inquiry into the viability of a pleading before it is signed," held that

> Having reviewed the arguments raised by plaintiff's counsel in the instant case, the Court concludes that the imposition of Rule 11 sanctions is not merited. Although plaintiff's claims were dismissed by the Court, they did not rise to the level of frivolousness that would make the imposition of sanctions appropriate.[15]

Given that the plaintiff/owner, at the trial of her antitrust claim, would ultimately have to prove by a preponderance of the evidence that her painting was authentic, one wonders how little evidence of authenticity an owner must have in hand before a judge would be led to say to an owner that the owner's or her lawyer's inquiry into the authenticity of a painting is so unreasonable that the owner's claim is frivolous.

In *Kramer*, Judge Harold Baer was faced with the same arguments for sanctions against the plaintiff's lawyer as in *Vitale*, namely, as the court stated:

> The defendants moved for an order imposing sanctions, pursuant to Rule 11(b) of Federal Rules of Civil Procedure, against Kramer's counsel, Carl E. Person, for his failure to make a reasonable inquiry into the factual basis for the claims asserted in the complaint. In dismissing this complaint as a matter of law, this Court has not made an assessment of the accuracy of the complaint's factual allegations. Rather, as is required in a motion to dismiss, the Court accepted as true all factual allegations in the complaint,

and drew inferences from these allegations in the light most favorable to the plaintiff. To hold an evidentiary hearing or scrutinize conflicting affidavits for the truth of the allegations and determine whether Person sufficiently investigated them would, in my view, waste scarce judicial resources. In light of the dismissal of this action, defendants' motion for sanctions is denied as moot.[16]

Thus, Judge Baer in *Kramer* refused to hold an evidentiary hearing to determine whether the plaintiff's lawyer had "sufficiently investigated" before bringing his client's claim, because such an investigation would "waste scarce judicial resources." Putting aside the question of the scarcity of judicial resources, the defendants in *Kramer* had argued that even a minimal investigation by plaintiff's lawyer would have revealed that there was no reasonable basis for believing that his client owned a painting by Jackson Pollock. Yet plaintiff's complaint, signed by Kramer's lawyer, stated in part:

> Upon information and belief, plaintiff's Jackson Pollock painting is authentic and there are qualified art experts who are not affiliated with defendants who would be willing to authenticate the Jackson Pollock painting in writing after reasonable investigation and testing, and provide their reasons for their opinions in the letter of authentication for use in the market for Jackson Pollock Paintings.[17]

Plaintiff Kramer had purchased his painting in 1981, "believing that it could be a Jackson Pollock original and worth a substantial amount of money."[18] Although plaintiff had purchased his painting *fourteen years* prior to bringing his lawsuit against the Authentication Board, he had apparently been unable to obtain the favorable opinion of a Pollock expert in almost a decade and a half!

Although there can be no absolute definition of a "reasonable inquiry" into the factual sufficiency of a claim under Rule 11, the court will appraise an attorney's efforts according to how much time the attorney had for investigation and the feasibility of publicly verifying the facts.[19] When, however, a lawyer must rely on the client's factual allegations because the lawyer is unable to publicly verify them, the attorney must assess the validity of the client's information. The attorney must ask if the client's knowledge is direct or hearsay, and consider whether the client's version of the facts is plausible.[20] Rule 11 further requires that when an attorney can get the information necessary to certify the validity of the claim and need not rely on his client, he must do so.[21]

In *Kramer*, the defendant experts had argued that since an essential element of Kramer's claim was that he owned a genuine Jackson Pollock painting, it was incumbent on the plaintiff's lawyer, prior to signing and filing the com-

plaint, to undertake a *reasonable investigation* to determine if this were true. The plaintiff in *Kramer* had alleged that he bought his "Pollock" from a Judge Tate, a local art dealer in Santa Fe, New Mexico, who had acquired it from Pollock in the late 1940s. The defendants argued that in order to conduct such a reasonable investigation, plaintiff's lawyer should have reviewed the documents in his client's possession and investigated, at a minimum, (1) how, when, and from whom Tate acquired the painting; (2) how much Tate and Kramer each paid for the painting; (3) whether bills of sale for the painting existed; and (4) whether Kramer or Tate ever secured or even attempted to secure a written opinion that the painting was by Jackson Pollock. In light of the allegations of paragraph 33 of the plaintiff's complaint ("there are qualified art experts ... who would be willing to authenticate [Kramer's painting] in writing"), the plaintiff's lawyer was, so the defendants argued, also under an obligation to contact one or more of those "qualified art experts" to determine whether, in their opinion, Kramer's painting was—or even reasonably might be—by Jackson Pollock.

Had the lawyer performed such a minimal investigation, the defendants argued, he would have found that there was no reasonable basis for believing that his client's painting was authentic, especially given the defendants' assertions that (1) there was no provenance (other than Kramer's own undocumented assertions) to link Kramer's painting to Jackson Pollock; (2) the painting had never been displayed or publicly exhibited by anyone as a genuine Jackson Pollock painting; (3) Judge Tate, at one time, had offered the painting for sale for $15,000, a fraction of its value, if genuine; and (4) no reputable, recognized expert had ever authenticated Kramer's painting. This should have put plaintiff's lawyer on notice that he needed to investigate the authenticity of the painting more fully, and that plaintiff's lawyer could not, without such an investigation, sign a complaint and thereby certify to the court that upon "information and belief" Kramer's painting was an authentic Pollock. The plaintiff's lawyer's failure to conduct any meaningful investigation, the defendants argued, should have resulted in rule 11 sanctions.

As noted above, Judge Baer considered the issue of sanctions "moot" because he had dismissed plaintiff's claim. However, it is obvious that an alleged violation of Rule 11 by plaintiff's lawyer cannot become moot simply because a plaintiff's claim is dismissed by a judge. In this, Judge Baer was clearly wrong. It is interesting to note that the plaintiff in *Kramer* did not appeal the District Court's decision and the Authentication Board refused to pay plaintiff any money to settle plaintiff's claim and forestall an appeal. There was, in fact, no appeal, but if plaintiff Kramer had appealed, the Authentication Board would have cross-appealed Judge Baer's denial of financial sanctions.

The *Lariviere* decision discussed above, which ordered sanctions against both the lawyer and his client, came six years after *Vitale* and five years after

Kramer. It permits one to hope that, having *Lariviere* as judicial precedent for a decision to impose sanctions in appropriate factual circumstances, a federal judge faced in the future with circumstances similar to those underlying Judge Baer's 1995 decision would not consider the matter "moot," and would examine the reasonableness of the lawyer's factual inquiry under Rule 11.

Notes

This chapter is reprinted from *IFAR Journal* 3 (Spring 2000): 23–26. An updated commentary constitutes the last section of the chapter.

1. *Lariviere v. E. V. Thaw, the Pollock-Krasner Authentication Board, et al.,* 2000 N.Y.SlipOp. 5000(U); 2000 WL33965732(N.Y.Sup.); 2000 N.Y.Misc. LEXIS 648; NY Sup. Ct., NY County, index no. 100627/99 (June 26, 2000).
2. The decision concerns visual art, but the legal analysis is applicable to expert opinion on authenticity in other areas as well.
3. *Hahn v. Duveen* 133 Misc. 871, 872; 234 N.Y.S. 185 (Sup. Ct. N.Y. Co. 1929).
4. T.E. Stebbins, "Possible Tort Liability for Opinions Given by Art Experts," in Franklin Feldman and Stephen E. Weil, eds., *Art Law: Rights and Liabilities of Creators and Collectors* (Boston: Little, Brown, 1986), vol. 2, p. 519.
5. Duveen's opinion was *volunteered* to a news reporter, but in subsequent years the art community applied his lesson to circumstances where expert opinions were *solicited* by owners.
6. E.V. Thaw, William S. Lieberman, Ellen G. Landau, and Francis V. O'Connor.
7. *Lariviere v. Thaw,* p. 6.
8. Ibid., p. 5.
9. Ibid., p. 6.
10. Ibid., p. 8. The sanction was $10,000 in an earlier decision by Justice Goodman, but on motion was reduced by her to $1,000.
11. Ibid., p. 4.
12. Ibid., p. 6.
13. *Isaacs v. Jefferson Tenants Corp.* 704 N.Y.S.2d 71(App. Div. 1st Dept., March 14, 2000).
14. *Vitale v. Marlborough Gallery, the Pollock-Krasner Foundation, et al.* (SDNY, July 5, 1994), 1994 WL 654494, 1994 U.S. Dist. LEXIS 9006; and *Kramer v. the Pollock-Krasner Foundation, et al.,* 850 F Supp. 250 (SDNY, 1995).
15. *Vitale v. Marlborough,* p. 9.
16. *Kramer v. the Pollock-Krasner Foundation,* pp. 259–60.
17. Plaintiff's complaint, para. 33.
18. Ibid., paras. 13, 14.
19. *Televideo Sys., Inc., v. Mayer,* 139 F.R.D. 42, 47 (SDNY, 1991).
20. Ibid.
21. *Nassau-Suffolk Ice Cream, Inc. v. Integrated Resources, Inc.,* 114 F.R.D. 684, 689 (SDNY, 1987).

Establishing Authenticity in French Law

. . .

Van Kirk Reeves

. . .

Van Kirk Reeves, a lawyer practicing in France, addresses the often vexed question of the droit moral *(moral right) under French law as it pertains to issues of authenticity. Although the holder of this right, often an artist's heir, may not have sufficient expertise to make a sound determination of authenticity, he or she may bring or be party to litigation in which a French court is asked to decide on the authenticity of a work of art. The focus is on French law because of the long existence in France of this moral right and the many examples of its coming into play with respect to important artists, both French and non-French, whose rights are decided in French courts or by other courts applying French law. Many of the general issues raised here would be helpful in looking at specific issues under the laws of other countries.—*RDS

. . .

VAN KIRK REEVES, admitted to the bar in both France and New York, has practiced law in France for more than thirty years. He is also a lecturer at the Jean Moulin Law School, University of Lyons, France, in the postgraduate program offering a degree in art law, and a member of the board of the Art-Law Centre, Geneva, Switzerland.

. . .

French law treats a work of art as a chattel,[1] but it also empowers artists and works of art with special rights and authority that can be assessed in court.[2] The conflicts between the owners of a work, the artist, his or her heirs, and the opinions of acknowledged experts make efforts to resolve the authenticity of a work of art in French law particularly complex.

Many of the rights and powers given to an artist by French law pass to the heirs, allowing the holders of such powers to assert authority over the works of the artist. While the courts are given the duty to decide whether a work is authentic, the frailties of aging surviving spouses and the anger of

spurned children can be heard in authentication proceedings, sometimes drowning out the analytical expertise and connoisseurship developed by leading authorities.

In America and Britain, the parties in a litigation call expert witnesses upon whose testimony judges base their rulings. Decisions in such cases, however, have shown that judges can be baffled by the nature of the art market and the reliance of that market on one or a few authorities. In an American case involving the authenticity of a mobile by Alexander Calder titled *Rio Nero*, the judge ruled against the opinion of Klaus Perls, the artist's longtime dealer,[3] a man whose view on the works of Calder was relied upon by the marketplace, and English Bench of Appeal judges provided good entertainment for all but the parties involved when they ruled on a forgery purported to be *Salisbury Cathedral* by John Constable.[4] One judge focused on the issue that the buyer could not rescind the sale, but had only a right to damages; another ruled that since the subject depicted was clearly Salisbury Cathedral, the buyer had obtained the value he sought and needed no relief from the court; and another was peeved that critics of great eminence should hold such contradictory views on a single work. In fairness to their lordships, perhaps counsel did not provide a clear passageway to a more reasoned approach by making the issues of authenticity intelligible.

French courts do not follow the common law practice of permitting the parties to a lawsuit to call expert witnesses and then pick the winner of the beauty contest. Instead, courts in France seek to avoid such follies by delegating their authority, appointing their own expert to act as master on the issue of authenticity. The Court of Appeal of Paris and the Court of Cassation, the highest French court for claims that do not involve the government as a party or raise constitutional issues, keep lists of designated judicial experts in a great number of areas, including art and furnishings. The judicial experts in art are usually dealers who have been granted this designation after a review of their qualifications and moral standards. The appointment is based on academic background, past accomplishments, and the recommendations of prominent persons. The advantage of this system is that the person ruling on the authenticity of a work is knowledgeable on artistic issues and on how the art market considers the issues of authenticity.

When a case involving authenticity comes before a French court, one of these judicial experts is called upon. The court, however, can decide to make its selection outside the official list, either because the case involves special issues or because no judicial expert is qualified or chooses to undertake the case.[5]

The judicial expert is rarely a leading authority on the particular artist whose work is the subject of the litigation, or a person whose opinion is accepted in the marketplace. He or she is usually a dealer knowledgeable on the

artists of a given period. The mission of the judicial expert is to review the disputed work with recognized authorities (although authorities outside France are not normally consulted). Counsel to the two parties can submit the names of recognized authorities to the judicial expert, along with the opinion of those authorities on the work in question. Counsel to one or both parties may also request that the judicial expert provide a hearing for such witnesses as either they or the expert wish to call. Counsel may participate in these hearings; in this sense, they are not unlike proceedings involving expert witnesses in common law jurisdictions. Such hearings are not the same, however. They are often held in a backroom of the judicial expert's business premises, which means that counsel may be provided with a rickety chair next to a pile of canvases.

Since the judicial expert is more at home in a commercial setting than a court of law, the formalities of court procedure are often ignored. A devastating cross-examination is unlikely to bring positive results and will most likely be treated as an unwarranted badgering of the witness, with the potential for a negative reaction. No record is kept of testimony at such a hearing, so it is more difficult to show prejudice on the part of the judicial expert when his or her findings are reviewed by the court.[6]

The judicial expert will wish to review the work itself rather than rely on photographs, so arrangements must be made to produce the work. If a work imported into France is found to be a fake or a forgery[7]—that is, an object created to mislead a viewer into believing it was created by a given artist or at an earlier time—it is the custom of French courts to order the object destroyed. With this risk in mind, owners who are afraid that a French court could make such a ruling will have to arrange for the expert to view the work outside France, paying travel and accommodation expenses. Moreover, the risk of an unfavorable decision is compounded in that the creation of a fake or forgery is a crime, and an unfavorable ruling can implicate a party.

The French tax authorities are provided with information on all litigations in France, which can result in the hearing being more public than the parties would have wished. As a result, at least one of the parties may be exposed to a claim for taxes if unpaid taxes, such as estate taxes, are revealed by the proceedings.

The judicial expert is entitled to a fee from both parties, paid in advance. Because such advance payment may be difficult for the defendant, the plaintiff will often advance the entire amount in the expectation of reimbursement if the ruling goes in his or her favor.

A judicial expert presents a written opinion to the court after review of the authorities' written opinions and their testimony at hearings. The proceedings of the court itself involve verification that the expert has correctly fulfilled his mission. Claims may be asserted to the court of prejudice, insuf-

ficiency, and the like. When appropriate, experts with differing views may be called both at the trial and at the appeal level.

French justice does not move with unseemly haste. Three years to obtain a trial court decision would indicate that all parties have cooperated in obtaining justice; longer time periods are often involved where there are complex issues to resolve or where counsel for one party seeks to delay the proceedings.

Authenticity proceedings in France seem as likely to result in justice as those in common law jurisdictions, but the justice is provided differently. As opposed to American proceedings, there is no pretrial discovery, no interrogatories, and no depositions. Plaintiffs must make their case on the basis of the facts and evidence in their possession, including what is provided by the authorities they have recommended to the judicial expert. France's response to efforts made by foreign tribunals to take depositions in France and to require the presentation of documents located in France has been legislation that makes it a criminal offense to comply with requests for information other than as allowed by The Hague Convention, which does not permit any of these intrusive proceedings.[8]

With no trial record and no pretrial proceedings, French authentication proceedings would appear simpler than American proceedings. Indeed, one important French law simplifies the situation significantly: Where in descriptive material the name of the artist is listed without reservation, an undertaking is given that the work is by the hand of the artist.[9] This rule is particularly important because it is applicable not only to references to the work but also to listings in auction catalogues and to bills of sale. These descriptions, in the eyes of French law, constitute a guarantee that the work is by the hand of the artist.[10]

What complicates the seemingly simple French system of authentication is the rights held by artists and their heirs. French law provides for artists to be endowed with a moral right (*droit moral*) that gives them, their heirs, a number of rights seen in no other legal system. They include the right to be heard on issues of authentication and to bring a lawsuit to establish or deny the authenticity of a work purportedly by the artist. In such court proceedings, the judicial experts often defer to the opinions of holders of the moral right. Despite this deference, and the right of the artist or heir to bring an action in court, ultimately it is the judge who will decide the question of authenticity. And the judge will come to a decision following the procedures described above. In court, the opinion of the artist or heir is simply one more piece of evidence the judge will consider when determining authenticity.

In the twentieth century artists who worked in France played a most im-

pressive role, and French law and French courts hold an unusually important position, in authenticity litigation. French courts, particularly the Tribunal de Grande Instance de Paris, are knowledgeable about art and the art market, so a major hurdle is crossed when proceedings are brought in France.

It is to France's honor that it values artistic creation and seeks to protect it. Protection is provided by giving the work of art almost a legal personality, and artists and their assignees, and heirs are endowed with far-reaching pecuniary and moral rights.

These moral rights encompass the following:

1. The right to create. A person has the freedom and latitude to express his or her creativity. While this is a Right of Man, French law gives a broad license to the artist.[11]
2. The right of disclosure and completeness. The artist is the sole party who can determine if and when his or her work has been finished. Without the artist's approval of a work, it is not the work of the artist.[12] An artist can disavow a work, and an owner has no recourse. After the death of an artist, the holder of the moral right has the right to be a plaintiff or a defendant in *any* suit concerning authenticity, although the court is the ultimate judge of whether a work is authentic or not.[13]
3. The right to withdraw. Even when the work has been created, the artist has the right to disavow it. In such a case, the work is no longer authentic.[14]
4. The right of paternity. The artist is entitled to be recognized as the creator of the work.[15]
5. The right of integrity. The artist has the right to establish what the work is. It cannot be tampered with or adjusted.[16]

Perhaps the most extreme example of the right of integrity is the case of Jean Dubuffet and Régie Renault.[16] Renault, the well-known manufacturer of automobiles, had engaged Dubuffet to design a garden for the front of one of its premises. The artist created a model, received approval, and began construction. Management then determined not to complete the garden and to use the land for other purposes. The Court of Cassation held that Renault was required to complete the garden in accordance with the model in order to respect the integrity of the artist's creation. Gallantly, Dubuffet, considering himself vindicated, determined not to pursue his case to enforce his rights against the enraged Renault management.

This decision and others like it show the remarkable commitment of France to protect the integrity of an artist and his work. French law gives artists the right to call on the judicial system to protect the integrity of their creations,

regardless of whether the artist owns the work, and the right to call upon the court to order the destruction of objects that the court considers them fakes or forgeries.

The artist is permitted to bring an action to establish whether a work is authentic, and has the right to be a party in *any* litigation where the authenticity of a work reputed to be by him or her is being established.

At first analysis, such a right appears completely appropriate. It is in the interest of the state to expose and destroy forgeries and fakes; it is appropriate that artists protect their oeuvre from works that are not by their hand. If no one but Coca-Cola should have the right to sell dark brown fizzy drinks under the name Coca-Cola, and if no one but Rolex should have the right to sell watches bearing the name Rolex, it would seem self-evident that an artist should have the right to protect his creation. But artists can abuse these rights, as can their legatees and heirs.

There is an apocryphal story that places Picasso in an exceptional role, and like many such stories it casts an actual person in a role to make a point. An American couple is reputed to have called upon Picasso in his studio in the south of France. The artist received them politely, which is not always the case for collectors who seek out artists. To their great joy, the couple was able to purchase a work from him. After returning to the United States, they noticed that he had neglected to sign the work. On their next trip to France, they asked Picasso if they could call upon him again, and to their delight he consented. They were well received on this second visit, and Picasso offered them an aperitif. He then asked about the newspaper-wrapped package they had brought. They handed the package to him, and when he pulled the canvas out of its wrapping, he announced, "This is a fake." The Americans protested, "We bought it from you last year." He replied, "Why cannot Picasso create a fake?"

French courts have the authority to grant damages to the victim of an artist's arbitrariness,[18] but the story touches upon a larger issue: Artists have fallow periods, yet they continue to create even when their muse has deserted them. The art market discounts such work as atypical or uninspired and prices it accordingly. However, under French law, an artist can disclaim a work of lesser quality—remove it from his or her oeuvre—even though he or she in fact created it.

Most of the rights granted to the artist are passed to the artist's survivors. Pecuniary rights are freely transferable during the artist's life and thereafter. Moral rights also pass by will, within the artist's family or to outsiders, or by intestacy rules.[19] The principle behind these laws is that those closest to the artist are likely to be the most knowledgeable about his career and work.

In a well-managed estate, the artist's archives will be maintained, and the artist's spouse and/or issue will administer the patrimony, collect the *droit de suite* (fees for reproduction of the artist's works), and review, when requested,

works attributed to the artist. If they deem the work to be authentic, they will issue a certificate. They will also go to court to challenge forgeries and fakes, to have them adjudged as such, so that these counterfeits do not pollute the oeuvre of the artist.

French case law, however, unfortunately abounds in litigation where the high responsibilities and authority given to surviving spouses and issue have not been well respected and where an orderly market in the works of the artist can be disrupted by the egregious interference of an elderly spouse or disappointed or venal children and grandchildren, their judgment clouded by their estrangement. Even where the spouse, issue, or legatees are acting in good faith, they may lack the professional critical faculties to pass valid judgment.

The 1999 litigation concerning the works of Louis-Robert Latapie shows that even within the family, issues of authenticity can be controversial.[20] The son of the artist had authenticated 141 drawings which the artist's daughter felt were fakes. They had inherited the moral rights of their father, so the daughter was able to bring an action against her brother, which led to a decision of the trial court that the works were fake. On appeal, the court reached a Solomon-like solution, holding that the works were not fakes, which pleased the son, but that they had been misattributed to Latapie. The court did not reach a judgment as to the artist of the disputed objects, but instead of ordering that the works be destroyed as fakes, merely requested that the studio seals, which confirmed the works as by Latapie, be removed. The decision destroyed the value of the works in the marketplace and is unlikely to have restored harmony among the siblings.

The Euripidean tragedies of the lives of artists and their families in France—of spurned children, attempted suicides, serial divorces, drug and alcohol abuse, and beyond-the-grave hatred—are played out in the unlikely theater of French courts seeking to establish whether an object is by the hand of a given artist. Perhaps such hearings are appropriate, in that family law and authenticity are areas in which a court must inquire into matters where the imperatives of passion rule out common sense.

Notes

Certain of the ideas contained in this chapter and some of the text were developed by the author at the IFAR conference "Catalogues Raisonnés and the Authentication Process: Where the Ivory Tower Meets the Marketplace," New York, December 14–15, 2001.

1. Civil Code, art. 544.
2. Law no. 57-298 of March 11, 1957.
3. *Greenberg Gallery Inc. v. Bauman*, 817 F. Supp. 167 (D.D.C. 1993), affirmed (1994 U.S. App. LEXIS 27175).

4. *Leaf. v. International Galleries*, 2KB.86 (1950).

5. *Horvitz v. Latreille*, Tribunal de Grande Instance, 1st Chamber, 1st Section (October 10, 2001).

6. French court proceedings do not provide transcripts, and the profession of court stenographer is unknown.

7. The copying of works is completely licit. Indeed, the making of copies is part of the traditional training of an artist. A fake or forgery, on the other hand, is an exercise designed to deceive. Often the signing of a copy with the signature of a purported artist turns what would otherwise be an academic exercise into a criminal act. Code le la Propriété Littéraire et Artistique, art. L. 335-2.

8. Law no. 80-538 of July 16, 1980

9. Law no. 57-298 of March 11, 1957.

10. The Appeal Court of Paris (1st Chamber), in its decision of October 10, 2001, expressed doubt as to whether the mere listing of the artist's name gave a purchaser the right to seek the rescission of an auction sale of a work which was subsequently adjudged not to be by the artist, when the buyer had not demanded a certificate of authenticity from the seller. A subsequent judgment of the same court and same chamber reaffirmed, on January 15, 2002, that the sale of a work titled by the seller as being the work of a named artist gave to the buyer the right to rescind the sale where the court expert had ruled that the work was not authentic. Further judgments may reveal the logic of these seemingly conflicting decisions.

11. French Law also protects the honor and reputation of an artist against the mistreatment of his or her work. The right to honor and reputation is sometimes referred to as a moral right, but this is incorrect.

12. Law no. 57-298 of March 11, 1957, art. 19.

13. *Eden c.Whistler* (1898), judgment of March 14, 1900, Cass. Civ. (1900), Dalloz Périodique et Critique, I 497. In this case, the artist refused to deliver a portrait and painted another face on the sitter. The artist was not required to deliver the work, but he was subject to damages, which were increased, possibly for his willfulness.

14. Law no. 57-298 of March 11, 1957, art. 32.

15. Ibid., art. 6.

16. A simple case embodying this principle is that of the well-known Bernard Buffet refrigerator painted by the artist as a single unit. Buffet was able to stop the sale of dismantled parts; *Buffet c. Fersig Cour d'Appel de Paris* (1962) Recueil Dalloz (D.Jur.) 570; Gaz. Pal. II, p. 126 Cour de Cassation, 1st Chamber (1965); J.C.P. 1965, II, no. 14339, concl. Lindon.

17. *Dubuffet v. Regil Renault*, Cour de Cassation, 1st Chamber (March 16, 1983), R.I.D.A., juel. 1983, p. 80.

18. *Eden c.Whistler* (1898).

19. Law no. 57-298 of March 11, 1957. For an excellent discussion concerning the transfer of such rights and particularly the right of disclosure and completeness, called also the right of divulgation, see John Henry Merryman, "The Moral Right of Maurice Utrillo," *American Journal of Comparative Law* 43 (Summer 1995) Number 3, pp. 445–454.

20. Tribunal de Grande Instance, Paris, 1st Chamber, 1st Section (April 23, 1997); Ct. App. Paris, 1st Chamber, Sec. B (March 12, 1999).

Index

. . .

Printed in the USA/Agawam, MA
January 12, 2012

563485.085

DEMCO